Basic Motion Picture Technology

LIBRARY OF IMAGE AND SOUND TECHNOLOGY

COLOUR FILM FOR COLOUR TELEVISION

RODGER J. ROSS

WIDE SCREEN CINEMA AND STEREOPHONIC SOUND

MICHAEL Z. WYSOTSKY

ACOUSTICS OF STUDIOS AND AUDITORIA

V. S. MANKOVSKY

BASIC
MOTION PICTURE
TECHNOLOGY

L. BERNARD HAPPÉ

FOCAL PRESS LIMITED

LONDON & NEW YORK

Printed and bound in Great Britain by
A. Wheaton & Co. Exeter.

Contents

Foreword

The production of motion pictures calls for the combination of a wide range of crafts and sciences whether the results are seen in the cinema theatre, on the television screen or in educational or commercial applications. This book is intended to provide a brief outline of the technical basis of professional cinematography from the initial recording of picture and sound up to the various forms of final presentation but there is no attempt to include the many creative skills and operations which contribute so vitally to the art. The work of the script writer, the set and costume designer, the make-up artist and the director himself can therefore find no place in this volume and even the functions of the lighting director and the editor in their creative roles can be mentioned only briefly.

Even within the field of technology thus limited, the treatment possible in a work of this size is necessarily restricted. Each of the divisions here dealt with as a chapter has provided subject matter for a complete text-book, so that those who are expert in any particular area are bound to find the outline given here elementary and even superficial. I must add, however, that the avoidance of mathematical analysis and chemical formulation and the use of simplified descriptive diagrams are intended to offer a treatment acceptable to a wide readership on all sides of the industry.

I trust that this attempt at an overall survey of the basic technology of motion pictures will prove of general interest. At the present time, colour is at last the familiar standard for both film and television with various forms of wide-screen presentation for the cinema theatre, but as we enter the 1970's we face new developments which can significantly modify established practices. Photographic and electronic recording methods are converging and film and television production techniques are profoundly affecting one another. The resultant cross-fertilisation will be fruitful during the next few years and it will be important for the technicians of the near future to recognise these influences and apply their potentialities. Electronic recording of the original information with photographic reproduction for general distribution may in due course bring about as fundamental a change in handling the picture image as it did in sound recording twenty years ago.

Some of the diagrams which I have included originally appeared as illustrations to articles in the Focal Encyclopedia of Film and Television Techniques (1969). I am glad to acknowledge with thanks the publisher's permission to use them again in this present volume.

I am indeed grateful to all my many friends within the cinematograph and television industries whose knowledge and experience has helped me in the preparation of this book: the list is far too long to enumerate individually. But the oversimplifications, the omissions and the errors which they will immediately recognise are, I fear, the sole responsibility of the author.

Twickenham, 1970

Bernard Happé

1 Principles and history

In common with the popular illustrated press, the gramophone, radio and television, the cinema is a mass medium of communication and entertainment whose present structure is based on a wide range of technologies which have come into existence only during the twentieth century. Although the seeds of modern motion picture processes are to be found in the work of inventors, engineers, scientists and craftsmen of the previous hundred years, the establishment of that form of entertainment which we now recognise as the cinema may be regarded as coinciding closely with the opening of the twentieth century, and its development has paralleled the technical advances of the last seventy years. Unlike the other reproduction and distribution media, the motion picture brought into being a new form of dramatic experience which could be claimed as a new art form, and the whole history of film shows an interplay between the demands of the creative artist and technical resources available to him. The development of motion picture technology has meant more than just the improvement of practical processes, it has been a contribution, and often a challenge, to the creative artist. This is soon realised when we consider the transformation from the scientific novelty of the 1890's to the world-wide entertainment of the present day.

The beginnings

What has been termed 'the archeology of the cinema' is a fascinating subject. As a technical starting point, we may take the recognition early in the nineteenth century that if an observer were shown a number of pictures in very rapid succession the characteristic of the eye known as persistance of vision would cause them to be seen not as separate images but fused into a changing pattern. If the pictures shown represented the successive stages of an action, presented rapidly they would give the appearance of that action as a continuous movement. In the period from about 1835 there were numerous scientific toys based on this principle. A series of ten or twelve drawings showing the sequence of a simple repetitive action such as a jumping clown or a skipping child could be

viewed rapidly one after the other through a series of slots or by a series of mirrors to appear as a continuously moving picture. Sometimes these drawings were arranged in a circle on a disc but in another case they formed a strip which could be mounted as a continuous band around the circumference of a cylinder. Since only a limited number of drawings could be used the actions shown had to be very simple and repetitive but the names given to the various devices were elaborate – Phenakistiscope, Chorentoscope, Zoötrope, Praxinoscope, and one which has survived to-day with a somewhat different meaning, Stroboscope.

An elaboration of the simple viewing device combined the same basic principle with the magic lantern so that the moving image could be projected on a screen in a darkened room, but the action was of course still limited to that obtained from a limited series of drawings.

The discovery of photography, to which many inventors contributed during

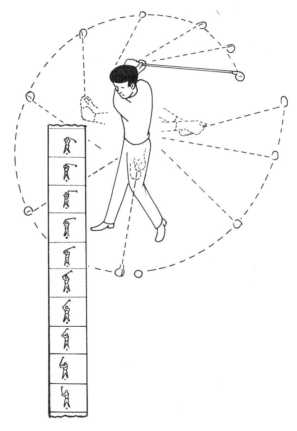

ANALYSIS OF MOVEMENT
If a series of drawings representing the successive steps of an action are shown in rapid succession, the eye's persistence of vision gives the impression of movement taking place.

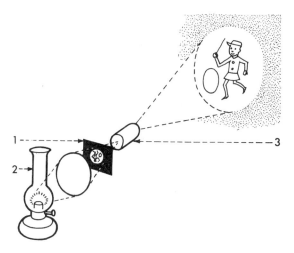

THE MAGIC LANTERN
In its simplest form, light from a lamp (2) illum-
inates a transparency (1) which is projected by the lens
(3) to throw a picture on the wall of a darkened room.

the second quarter of the nineteenth century, provides the next contribution to the pre-history of the cinema. In its early stages the time for which a photo-graphic plate in a camera had to be exposed to record an image was very long—many minutes—and the subject had to remain motionless during the whole period. However, improvements both in the sensitivity of photographic materials and in the efficiency of camera lenses allowed this exposure period to be made shorter and shorter until by the 1870's it was possible to expose a photograph in a comparatively small part of a second, so that it was now possible to take a picture of a moving object. In 1878 Eadweard Muybridge, an English photographer working in San Francisco, arranged a series of 24 cameras to take a sequence of photographs of the action of a galloping horse in order to settle a bet of $25,000, and we may regard this as the starting point of the analysis of motion by photographic means.

Even before this time cameras were being developed to allow a series of pictures to be taken in succession on a single photographic plate, and one of these, called the photographic gun, exposed twelve images in the period of one second on a circular disc. In another form, a magazine was loaded with a series of 25 plates which could be rapidly exposed one after another. Shortly after-wards, in 1887, came the introduction by the French scientist Marey of an idea which was fundamental to the future cinema: the use of a continuous strip of photographic paper in place of glass plates, allowing a series of forty pictures to be taken on one band. The essential features of motion picture technology were now clearly to be seen.

Edison and Lumiere

There then followed a period of rapid and individual development in all the major industrial countries, as a result of which the fundamental invention of the cinema has been heatedly claimed for at least one of its citizens working at this

13

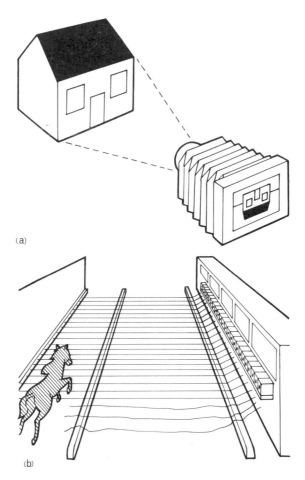

(a)

(b)

THE STILL CAMERA
(a) The camera lens forms an image of the scene on a photographic plate, where its light and shade is recorded by the light-sensitive emulsion coating. (b) The photographer, Muybridge, in 1880, used a battery of 24 still cameras operated by trip wires to photograph the action of a running horse.

time by the United States, France, Germany, Great Britain, Russia, Italy and no doubt many other countries. This controversy will never be settled to everyone's satisfaction since genuine contributions from many different sources can be clearly recognized. But here specific mention must be made of the work of Edison and his associate Dickson in the United States and of the Lumière brothers in France.

Edison's contributions to mechanical design were outstanding but it is strange to realise that they were actually produced originally as a side-line to his invention of the phonograph, later renamed the gramophone. Edison had

14

succeeded in recording sound and he sought a means of presenting an associated visual image at the same time. His first experiments paralleled the approach he had adopted for sound—very small pictures being arranged in a spiral on a cylinder. Subsequently he used strips of photographic material, at first on a collodion base, and soon after, on celluloid, using the photographic film which had been commercially produced for still photography by George Eastman shortly before. In 1888 Edison produced a camera, which he called the Kineto-graph, which could expose a series of some 600 pictures on a strip of film about fifty feet in length. This allowed scenes with action lasting almost a minute to be photographed and therefore may be regarded as the direct parent of the motion picture camera of to-day.

Edison was not however the initiator of the cinema theatre as we know it. He first worked on apparatus for showing moving pictures to one person at a time in a form of peep-show cabinet, an apparatus called the Kinetoscope, in which the films taken by his camera could be viewed as a continuous loop repeating the action over and over again. In this he was perhaps influenced by the application of the previous inventions in sound; the telephone was a device for individual personal communication, the phonograph was originally an apparatus for individual sound reproduction through ear-tubes and the kineto-scope was similarly a piece of equipment for individual viewing at a peep-hole eye-piece. Edison did not originally think of his apparatus in the form of projecting a moving picture on a screen to an audience and in fact he seems to have regarded this as commercially undesirable compared with his personal peep-show. As a result the combination of the photographic image on a strip of film with the magic lantern optical projector was first developed in other hands, particularly those of the Lumière brothers in France.

Auguste and Louis Lumière were the owners of a photographic factory in Lyons and had been working on the development of motion picture photography for some time before their basic invention of a combined camera and projector was achieved during 1894. Its derivation from Edison was indicated by the original title under which it was patented—Kinetoscope de Projection—but shortly after, they changed the name of their apparatus to Cinématographe, a name which has continued to represent the art and science of the motion picture ever since. The first demonstration of the Lumière's films took place in Paris in 1895 and by the end of that year public presentations to paying audiences were organised. Within a year or so hundreds of short films (lasting about a minute) were available showing scenes from foreign countries, brief story incidents, comic actions, records of spectacular official occasions and even trick effects, and cinematograph shows were being given in many of the principal cities of Europe.

Edison's Kinetoscope cabinets had been commercially available from about 1893, first in New York, and subsequently in Europe and he had produced a large number of short films for that use. However, the success of Lumière's moving picture projector, which was shown in New York in the middle of 1896, and of other similar devices about that time, showed that commercial returns were to be obtained from the group audience rather than the individual viewer and Edison now followed this lead. The Lumière brothers did, on the other hand, recognise the significance of some of Edison's practical innovations, and modified their Cinematographe so that it could use Kinetoscope films. We may therefore recognise that by 1897 the main features of present day motion picture technology had been realised and the first tentative steps towards uniform procedures had been taken.

The early cinema

At this point it is convenient to summarise those features of cinematography which had become established and which continued as the basis of operating practice: a camera exposing a series of still pictures on a continuous strip of transparent photographic film to record the original action, and a projector displaying an enlarged image of these same pictures on a screen in a darkened theatre to present the appearance of movement. It had been established fairly early on that a rate of at least twelve pictures each second was necessary to give a reasonably smooth appearance to continuous movement, and a speed of sixteen pictures per second was used by Edison and others. The celluloid-based photographic film supplied by Eastman to Edison was 1⅜ inches, (or approximately 35 mm) in width and a similar size was adopted by Lumière. Although many other, larger, sizes were used by different inventors about this period, the commercial success and extensive programme material of the Kinetoscope and Lumière Companies encouraged the use of 35 mm on an increasingly wide scale.

Edison had also been responsible for the introduction of perforated holes along the margin of the strip so that the film could be moved uniformly through the mechanism by toothed sprocket wheels and the size and position of each picture image made consistent. These sprocket holes were rectangular in shape and located at regular close intervals along the film edge. The Edison camera exposed a picture area approximately one inch wide and three-quarters of an inch high and there were four sprocket holes in the length corresponding to the

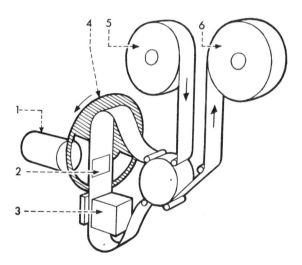

BASIC CINE CAMERA

 The lens (1) forms an image of the scene on a strip of photographic film (2) which is moved forward intermittently by the mechanism (3); a shutter (4) prevents light from the lens reaching the film except while it is stationary. The strip is fed into the camera continuously from the feed roll of film (5) and wound up after exposure on a similar take-up roll (6).

16

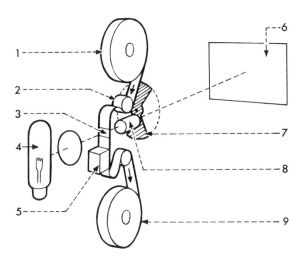

BASIC CINE PROJECTION

Transparent film (2) with a series of action pictures is moved intermittently by the mechanism (5) past an aperture (3) where it is illuminated by a lamp and optical system (4); a lens (8) projects an enlarged image of the pictures on a screen (6) in rapid succession to give the impression of movement. A shutter (7) prevents light reaching the screen while the film in the aperture moves from one picture to the next. The strip of film is fed from an upper feed roll (1) and wound up after use on the take-up roll (9).

height of each picture. Lumière, who had invented an intermittent cam-operated claw mechanism to move the film picture by picture in his equipment, originally used only one circular perforation hole on each edge of the film opposite the picture but later modified his equipment to correspond to Edison's four hole system. Thus it was that a film 35 mm wide, having 64 rectangular sprocket holes per foot length along each margin became commercially established. On this film a picture frame area approximately 24×18 millimetres, or just under $1 \times \frac{3}{4}$ inches, was exposed at a rate of 16 pictures per second. One foot of film therefore passed through the camera or projector each second, or 60 feet a minute. All these characteristic features had become firmly established practice by the first years of the new century and in 1907 a voluntary agreement on certain standard dimensions for motion picture film had been reached in the interests of international exchange. Despite the proposals of other inventors and occasional developments for special forms of presentation these character-istics continued almost unchanged as the basis for professional cinematography for more than twenty years.

One objectionable feature of early motion picture projection was the flicker effect. A frequency of sixteen images a second was sufficient to provide a reasonable appearance of continuous movement but the eye was very much aware of the alternation of light and dark on the screen as each projected picture was succeeded by a dark period while the next frame was moved into position. When more powerful lamps were used to show brighter pictures this effect

17

became accentuated. It was known that if the frequency of the light-dark alternation was increased the appearance of flicker would be reduced. But as the picture frequency was already fixed, to provide a more rapid alternation it was necessary to break up the light period while the picture was stationary – by adding further dark periods. This led to the adoption of a rotating shutter with three blades in the light beam which gave three light-dark changes during the projection of each frame. The frequency was thus increased to 48 changes per second and the picture appeared reasonably free from flicker under normal circumstances. However, the colloquial term 'the flicks' for motion pictures remained in popular use for many years after.

The early 1900's saw the build-up of the cinema as an industry to provide international entertainment on the technical foundations already laid down. The brief glimpses provided by the first moving pictures were lengthened to allow several different viewpoints to be shown in a single sequence and the technique of telling a dramatic story by using actors in a series of scenes grew out of the original short films of self-contained incidents. While the early subjects produced by Edison and Lumière had each lasted only a minute or less, films lasting three minutes or more were being made by 1900 and in 1903 the film drama reached a new scale with *The Great Train Robbery*, running for more than 13 minutes. It was during these years that the various divisions in the industry, which are still recognisable, first took shape: studios at which films were photographed, laboratories at which the exposed film was processed and at which copies were made, and cinema theatres at which the result was exhibited to the public who paid for their entertainment at the box office. Alongside these developed the associated business and financial interests, from the entrepreneur organising the production of a series of films, through the groups concerned with the marketing

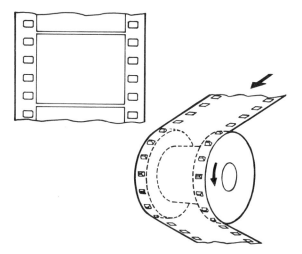

FILM PERFORATIONS AND SPROCKET
Cinematograph film is moved uniformly by the rotation of toothed sprocket wheels engaging with holes perforated at regular intervals along the edge of the strip. Edison introduced a film 35 mm wide with four perforations on each side for each picture image, and this is still the basis of professional motion picture photography.

18

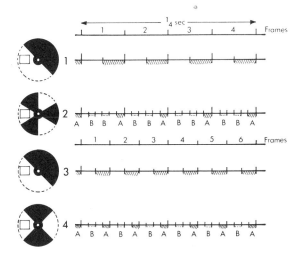

FLICKER SHUTTERS

When films are photographed at a speed of 16 pictures per second the single shutter (1) used in the camera was found to give a flickering effect on a projector so that a three-bladed shutter (2) was used to increase the frequency. The film is only moved in the projector during every third dark interval (A) and is stationary during the others (B). When sound films were introduced the speed of photography was increased to 24 pictures per second (3), so that only a two-bladed shutter was necessary on projection (4) to give the same flicker frequency.

and distribution of copies, to the eventual showman determined to ensure by bright lights, posters and publicity that the cash-paying public should be attracted to patronise his particular theatre and not that of his competitors.

The War of 1914–18 almost extinguished the developing film production industries of the countries of western Europe and left the United States after 1919 in a dominant position as the supplier of motion picture entertainment to the cinema theatres of the rest of the world. Within the United States itself production activities had become increasingly centred in the suburb of Los Angeles known as Hollywood, whose name has been practically synonymous with the commercial cinema ever since.

Consolidation in the 1920's

During this period the cinema theatre became established almost throughout the world as a form of entertainment which owed nothing to previous media. The first short films of Lumière and others had often been presented as individual items in the course of the programme at a regular music hall theatre. Somewhat later small cinema theatres specialising in films appeared in the centres of the major cities, but as long as the unit film remained only a few minutes in length the programmes were bound to be limited and organised on the same basis as the fairground novelty show. The realisation that the motion picture could be

19

used dramatically to tell a lengthy story with emotional effect led to the production of longer films, Longer dramatic films brought into being large theatres designed for the mass audience. Some of these were in fact converted music halls and live theatres. But the growing appeal of motion picture entertainment required outlets where the regular theatre had never become established, and purpose-built cinema theatres began to appear in suburban fringes, small towns and country villages throughout the United States and western Europe. In the shopping districts of the newly expanding suburbs the picture palace always offered an impressive frontage, within which the new medium of entertainment could be shown to audience groups as large as 1500 or 2000 under comfortable conditions, and even comparative luxury.

Technically, the twenty years from 1907 were a period of consolidation rather than fundamental change. Accurate and reliable engineering designs for cameras and projectors were developed and manufactured, and printing and processing machinery and methods were improved in quality and efficiency. Advances in photographic chemistry led to continued improvements in the film material itself and the images it could record, although highly inflammable cellulose nitrate, developed a generation earlier was still used as the film base. During the 1920's the first practical methods were introduced for the production of films in colour by direct photographic means rather than by hand-tinting black and white copies, as had been done earlier in the century, especially in France. The new methods, however, were not employed extensively. They were more expensive both in original production and in the manufacture of copies, and the range of colour reproduction was limited.

Many inventors, from Edison onwards, had worked on modifications of the standard cinema theatre apparatus to provide smaller portable equipment using a narrower gauge of film for home entertainment and in the early 1920's two such systems became available to the amateur. In France, Pathé introduced a projector using film 9½ mm in width, while in the United States Kodak made a 16 mm wide film for motion pictures in the home. Although both systems were intended to show reduced copies of professional theatrical films, it was not long before both manufacturers produced narrow-gauge cameras so that the amateur could photograph his own films. Thus started the now widely popular hobby of home movies. From the first, it was realised that the fire hazards of highly inflammable celluloid film were too great to be allowed in the home and films for amateur cinematography have always been manufactured using the more expensive but much safer cellulose acetate, known as 'non-flam.'

Introduction of the sound film

It was not in fact until 1928–29 that a new technical development effected a major change in the professional cinema. This was the feature on which Edison had initially worked more than forty years previously – the combination of moving pictures with sound reproduction. Early acoustic phonographs could never produce sufficient volume of sound to be heard throughout even a small cinema theatre, but in the 1920's the rapid advances in electrical sound reproduction associated with radio broadcasting had transformed the situation. Electrical sound recording methods had been developed for gramophone discs and electrically powered loud-speaker reproducing systems were in use for both radio and gramophone. Among the first attempts to provide sound associated with the image on motion picture film were systems using large gramophone discs run in mechanical synchronisation with the cinema projector and repro-

20

duced through electrical amplifiers by loudspeakers placed near the screen. However, separate picture and sound records were extremely inconvenient to use and such devices soon disappeared when systems for recording the sound on the same film as the picture became available.

The invention of the telephone in the previous century had been based on the conversion of air vibrations, which we call sound, into electrical signals, by a device now termed a microphone, placed at the transmitting end of the line. At the receiving end these electrical impulses were made to cause vibrations in a thin diaphragm and these when conveyed through the air to the listener reproduced at least some part of the original sound. Despite Edison's close association with the invention of the telephone he preferred in his sound reproducer, the phonograph, to use the more direct mechanical system. The original sound vibrations, by action on a diaphragm, were made to cause physical indentations or displacements through a stylus which moved over a surface of thin tin-foil or wax along a spiral or helical path. When such a recording was reproduced, a similar stylus traversing the surface caused vibrations which were heard as sound in an attached diaphragm.

Even in the early pioneering days of the cinema a number of inventors had devised schemes for recording and reproducing sound on film, and one of them, Ernest Lauste, had outlined in 1907 the complete system eventually adopted some twenty years later, although unfortunately the electrical technology available to him did not permit the practical application of his ideas at that time.

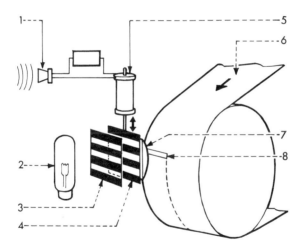

LANSTE'S SOUND RECORDING SYSTEM

Sounds received by the microphone (1) produce electrical signals which cause vibrations in the moving core of a coil (5). This core was linked to a grating of clear and opaque bars (4) whose movement relative to a fixed grating (3) varied the amount of light from the lamp (2) passing through the lens (7) to expose the film (6) at the slit (8). Half the width of the film was used for the sound record and half for the picture. The inertia of the grating light valve and the lack of suitable amplifiers greatly limited the system's response.

All sound-on-film systems make use of film which is in steady uniform motion, rather than the intermittent movement required to expose the series of still picture images in the camera. If the moving film passes a narrow slit at which a beam of light can be rapidly varied in intensity by the electrical signals from a microphone, a photographic image will be produced which varies in its light and shade along the length of the film and which represents a record of the sound which the microphone received. For reproduction the film is again moved uniformly past a narrow slit illuminated by a lamp; the light and shade of the film causes the intensity of light passing through the slit to vary and if this light is made to fall on the surface of a photo-sensitive cell it will give rise to varying electrical signals which can be amplified and transmitted as sound by the diaphragm of a telephone receiver or loudspeaker.

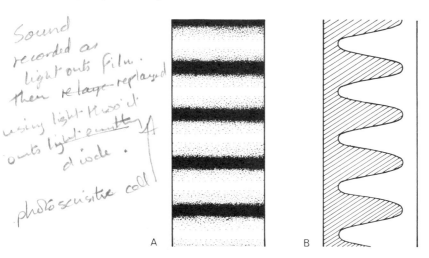

TYPES OF SOUND TRACK

In the Variable Density system (A) the sound is converted to electrical signals which cause variations in the intensity of the exposure of the film, while in the Variable Area system (B) these signals produce variations in the width of the image.

In practice, this method of varying the intensity of the light to record the sound as a pattern of light and shade on the film was only one of the methods adopted and was known as the variable density system. In the other, the electrical signals from the microphone were linked to a light valve in a path of light reaching the film through a slit. As the sound was recorded, the width of the valve opening varied in response to the signals, registering them on the film in the form of a wavy outline boundary between black and white. When the film was run on the reproducer with a small light shining through it this wavy outline varied the intensity of light reaching the photo-cell and allowed the reproduction of sound through the amplifier and loudspeaker. This method was known as the variable area system. Although the two methods involved different types of recording equipment the resultant sound records on film could both be reproduced by the same apparatus.

22

Technical changes to the film

The introduction of sound-on-film was a major revolution which affected all aspects of the motion picture industry from initial studio production to the final presentation in the theatre. On the technical side even the format of the film image had to be altered. The 35 mm film size had however, been firmly established for many years and any departure from it would have meant an upheaval for the photographic manufacturers, and rendered obsolete the laboratory processes and all the camera and projection equipment in use throughout the world. So the sound had to be accommodated somehow in the basic material, which remained unchanged.

To make room for the sound record on 35 mm film the size of the picture frame was reduced to leave a strip approximately one-tenth of an inch or $2\frac{1}{2}$ millimetres wide inside the perforations on one side and this band was known as the sound track area. The four-perforation high picture area was fundamental to established camera and projector mechanisms so this was retained, but the height of the exposed frame was reduced in the same way as the width, so that the proportions of the picture remained as before, at a ratio of 4:3, width to height. This new picture image size, approximately 21×16 millimetres, was known as the reduced aperture (RA) to distinguish it from the original full aperture (FA) occupying the full width of the film between the perforation holes. The dimensions for picture and sound images on 35 mm film were established as standards by the American Academy of Motion Picture Art and Sciences in 1929 and have continued as the basis for professional motion pictures ever since.

The second important alteration to the film image resulting from the introduction of sound was the speed of running. Since the early days a frequency of 16

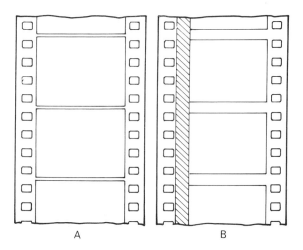

A B

SILENT AND SOUND FILM FORMATS
The original full-width picture area (A) used for silent films had to be reduced in width on the introduction of sound films to allow room for the track area (B). The height of the picture was correspondingly reduced to maintain the proportions of width to height of 4:3.

23

pictures per second had been found adequate for recording movement giving a running speed of one foot of 35 mm film per second, or sixty feet a minute. When sound was recorded on film, however, the pitch of the highest note which could be recorded or reproduced was determined by the height of the slit and the speed of the film. With a slit one-thousandth of an inch high it is only possible to record clearly five hundred bars of light and shade over a one inch length of film, or 6000 over one foot. When the film is running at a speed of one foot per second the highest frequency which can be reproduced is thus 6000 cycles per second (6000 hertz). Although such a frequency limit is more or less adequate for the reproduction of spoken dialogue, it does not allow the satisfactory presentation of musical instruments and loses much of the quality of voices in speech. It was therefore decided with the introduction of sound-on-film processes that the speed of the film movement must be increased to allow higher frequencies to be recorded and reproduced. A 50% increase to 18 inches per second, or ninety feet a minute was adopted to allow sound frequencies up to 9000 Hz to be obtained and the filming rate was correspondingly increased to 24 pictures per second. This speed has remained the standard for regular professional sound films ever since. *sound frequencies better at 18"/sec*

Equipment changes for sound

Apart from the changes in picture size and running speed the introduction of sound required little alteration to the cameras of the period apart from the need to provide very accurate and uniform speed control and to eliminate the noise of the operating mechanism so that it was not picked up by the microphone recording the sound. In the studio the sound was recorded on to a separate strip of film in its own sound camera and it was not until prints were made of the finally edited picture and sound that the two were combined on a single strip of film for eventual presentation. These 'married' prints carried the picture and sound images in their correct synchronisation for projection in the theatre.

The projection of combined prints required a fundamental change in projector equipment, since the film had to move continuously at the point where the sound track image was picked up, but intermittently where the picture image was displayed. It was therefore necessary to separate these two points on the film path in the projector mechanism. The sound reproducer head was established in a position after the picture aperture and in the lower part of the projector assembly, the space between them being standardised at 20 frames along the 35 mm film path. Since any point on the film passed through the picture gate first and arrived at the sound head 20/24ths of a second later, every point of the sound track image had to be printed on the film in advance of the corresponding picture image so that each should arrive at their appropriate reproduction positions simultaneously. This difference in the picture and sound image position along the length of the film is known as the sound advance and has been standardised at 20 frames for all 35 mm projectors throughout the world, for this type of photographic sound record.

In both the recording equipment and in the reproducing projector mechanism movement of the film past the slit must be absolutely steady and uniform in speed, since irregular motion produces unpleasant sound distortions. Heavy rotating flywheels and complex devices to smooth out all possible irregularities of film movement were therefore an essential feature of the sound head drive and led to the basic redesign and improvement of many projector mechanisms.

The introduction of sound recording to motion pictures provided the first of a

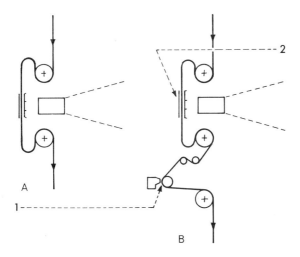

PICTURE AND SOUND SEPARATION
 As compared with the simple film path (A) of a silent projector, the path in a sound projector had to be lengthened to accommodate the sound pick-up point (1) and provide smooth continuous movement after the intermittent action at the picture aperture (2). The distance between the picture aperture and sound head is termed the sound advance and is standardised.

series of stimulating influences from the field of electronics into the basic mechanical engineering of the cinema of the period. The technology of radio and gramophone found a new application and the critical requirements of high quality sound recording and reproduction on film called for the production of new photographic materials and higher standards of processing and printing. In the cinema theatres not only new projection equipment with the associated amplifiers and loud-speakers were required, the acoustics of the theatres themselves and the distribution of the speakers had to be studied and modified to the best advantage, often involving major reconstruction.

In the production studios the use of sound as part of the creative process required a revolution of thought and techniques. The technology was rapidly acquired but it was some time before the new dramatic dimension that sound could provide was fully exploited. By 1929–30 all the major studios were producing sound films only and thousands of cinema theatres throughout the world were in the process of adaptation and reconstruction. The silent film, which had been internationally acceptable to a world audience, had come to the end of its thirty-year life and from now on it would be necessary to prepare prints with alternative sound tracks in each major language if the same wide distribution was to be obtained.

The established cinema

After the revolution caused by the introduction of sound there followed another period of some twenty years of consolidation and establishment marked by technical improvements in quality and efficiency but without fundamental

alterations in equipment or processes. This period may also be regarded as the time at which the cinema became established as the dominant form of mass entertainment throughout the world, replacing the last remnants of the live drama and the variety theatre in all except the largest cities of western Europe and the United States. The motion picture theatre offered its entertainment upon the widest popular basis on terms which the public could still afford even during the economic depression of the early 1930's. During the years of World War II and the period of restriction which followed, the cinema theatre represented a relaxation and release which could be found nowhere else. In terms of sheer numbers, cinema-goers in the years immediately following the end of World War II represented the high-water mark of success for the commercial film industry. But it was not only in terms of commercial success that the motion picture became established during these two decades. The introduction of sound had rounded out the range of dramatic resources available to the creative artist and as the techniques were mastered, the art of the film increased in power and in status. This power to influence large groups of the population both directly by exhortation and by more subtle and indirect effects was quickly recognised and the film became an important medium of propaganda in the hands of government.

It was during this period also that the motion picture was seen to have great potential value for educational and instructional purposes and the place for such films outside the regular entertainment field became established. In this area of 'non-theatrical' applications, the narrow-gauge 16 mm film with its smaller and more portable projection equipment was the obvious choice for presentation to the much smaller audience groups concerned. Huge demands for the rapid training and instruction of men for the armed forces in World War II accelerated this movement and 16 mm became fully established as the medium, transformed from its original amateur use into a fully professional application.

The amateur cinematographer had in fact been provided with an alternative film gauge even smaller and therefore cheaper than 16 mm; in 1935 the improvements in fine-grain photographic emulsions had made it possible to obtain a satisfactory picture on a film area only one-quarter of that used for 16 mm photography. This meant that a strip of 16 mm film could be used to expose two rows of pictures, first along one side and then along the other, which film, after processing was slit into two separate strips 8 mm wide. The small size of the picture meant that four minutes of moving snapshots could be taken on a small roll of film less than two inches in diameter at about a third of the cost of the equivalent on 16 mm, while the cameras used could be compact and easily handled. The 8 mm system thus provided a most attractive method for amateur cinematography and produced a rapid expansion of the hobby largely replacing 16 mm film in this field.

Colour motion pictures

In the period of technical improvement which followed the introduction of sound, the development of systems of colour photography for professional motion pictures was one of the most important achievements. A lengthy period was to elapse however before colour reached the universal acceptance that sound had attained so rapidly.

Many of the early inventors had experimented with colour systems, but these had all suffered from the disadvantage that they required special projectors on which to show the results. The only colour films for regular projection which

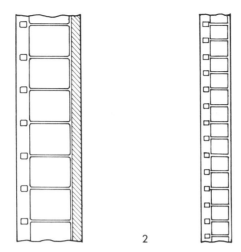

1 2

NARROW GAUGE FILMS
1. 16 mm film was introduced in 1923 for amateur movies but subsequently was established for professional non-theatrical use. 2. From 1935 Standard 8 mm (half 16 mm) was the most popular amateur material.

were available during the first years of the commercial cinema theatre were those in which black and white copies had been laboriously tinted by hand for each separate picture image, an expensive and unsatisfactory procedure. During the 1920's sequences in black and white pictures were also sometimes printed on film coated on a coloured base – blue for night scenes, orange for lamp-lit

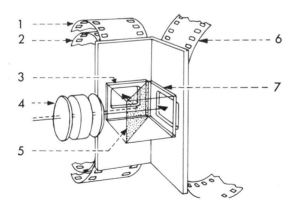

TECHNICOLOR CAMERA
The original Technicolor camera used a beam splitting prism (5) behind the lens (4) to divide the light and form images at two apertures (3) (7). Three separate strips of film recorded the Green (6), Blue (1) and Red (2) light components.

27

interiors, red for fire effects, and so on – but this could not be regarded as colour photography. Some two-colour processes were however in limited use.

It was not until 1932–3 that a system of colour cinematography capable of reproducing a reasonable range of hues became available on a regular commercial basis. This was the process introduced by the firm of Technicolor, who had been working in this field using various methods since 1919, and such was its success that for many years to follow the trade term Technicolor became synonymous with colour motion pictures. The system made use of a special camera in which three strips of black and white film were exposed simultaneously through a single lens to record as separate images the blue, red and green light from the scene being photographed. From these three colour-separation negatives three more strips of film known as matrices were printed, which were used to transfer dye images in the complementary colours yellow, blue-green and reddish-purple on to a piece of blank film by mechanical means. A colour print was thus produced much in the same way as a coloured book illustration is printed on paper using coloured inks. The blank film onto which the dyes were transferred also carried a standard black-and-white sound track image and the final copy was handled and projected in exactly the same manner as regular 35 mm black-and-white copies.

Although bulky, inconvenient, and expensive in its film consumption, the Technicolor three-strip camera provided practically the only method of professional colour motion-picture photography for a period of almost twenty years until the introduction of single-strip colour films.

Magnetic sound recording

In the late 1940's came a technical advance which, although it had no immediately obvious effect in the cinema theatre of that time, was of immense importance in film production methods both then and for the future. This was the introduction of sound recording methods using magnetic materials and was the first extensive adoption of processes which employed electronic rather than photographic methods.

As early as 1898 the Danish engineer Poulsen had been successful in recording sound on a thin steel wire as it ran past a recording head in which changes of magnetic field were produced in response to the amplified electrical signals from a microphone. These changes induced permanent alterations of the magnetic structure of the wire along its length and when it was run through a similar head these changes could be detected and amplified to become audible as sound reproduced over headphones or loudspeaker. Wire recorders based on this principle were subsequently improved so that high standards of sound quality could be achieved and the system had extensive application for both radio and gramophone recording purposes in the 1930's and early 1940's, using a stainless steel wire only a tenth of a millimetre in diameter at speeds of the order of one metre a second.

In 1928, in Germany, it was found that a magnetic powder could be coated on to paper or plastic for use as a recording material and this is now the basis of all modern magnetic recording processes. In general sound work the ferromagnetic powder is coated on a thin plastic base and used as a narrow tape $\frac{1}{4}$ in. wide. But for motion picture purposes it is naturally more convenient to have the coating on a base of the same dimensions as that used for photographic film and perforated with sprocket holes in the same way, so that the picture and sound records may be handled and measured together.

28

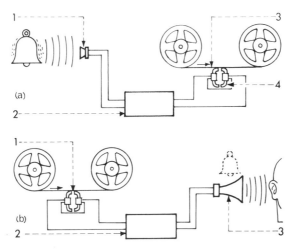

PRINCIPLES OF MAGNETIC RECORDING
(a) Electrical signals produced by the Microphone (1) in response to sounds are amplified (2) to create a varying magnetic field at the Recording Head (4) which affects the magnetic coating on a strip of film or tape (3). (b) In reproduction these variations in the tape set up currents in the Pick-Up Head (1) which after amplification (2) produce movements of the diaphragm of the Loudspeaker (3) which are heard as sounds.

Sound recording machines using magnetic tape were first produced during the 1930's and work continued during the war both in the United States and in Germany. Immediately after the war the application of magnetically coated 35 mm film to motion picture sound recording was the subject of intensive study and by 1950 it was clear that this system held such outstanding advantages for film production that its universal adoption followed rapidly. But for final presentation in the cinema theatre magnetic sound has still not proved either economic or convenient and its application has been limited to special forms of presentation, particularly those involving stereophonic reproduction.

Magnetic sound recording and reproduction depends on the close contact of the ferromagnetic coating with a narrow transverse gap at which varying magnetic currents are produced and induce corresponding variations of magnetism in the particles of the coating as it passes. This coating must have a very high capacity to retain induced magnetism and the component particles must be extremely fine to allow high frequency signals to be recorded. Sound quality is also determined by the width of the gap in the magnetic head. In optical sound systems a very narrow slit is required for high frequency response; in magnetic systems a very narrow gap is necessary. In the early stages of magnetic recording the frequency range which could be covered was limited and did not fully equal that which could be obtained optically, but rapid improvements both in materials and design soon reversed this position and records on coated film running at the standard 35 mm speed of 18 inches per second, or ips, (corresponding to 24 pictures per second) proved capable of a range appreciably in excess of optical methods.

For film production in the studio magnetic sound offered great advantages: the recording could be played back immediately for checking and no film processing operations were required. The recording could in fact be listened to, or monitored, during recording by means of a replay head positioned immediately after the recording head on the same sound track path. Recordings could be easily copied from one magnetic strip to another without loss of quality, sections could be magnetically cancelled, or erased, and new sections re-recorded in the same position and sound recordings could be easily combined and immediately checked. Finally, magnetic materials offered substantial economies, because when all operations were completed any unwanted recordings could be erased by demagnetisation and the material used over again.

For final reproduction in the cinema, however, the advantages of magnetic sound were by no means overwhelming. It proved quite practicable to coat a narrow stripe of magnetic material on the finally printed copy and to record high quality sound on this, but both these operations were additional to the normal photographic image printing process and were therefore an added expense. The convenient re-use of magnetic material which was such an advantage in the studio could not apply to the combined copies, since the photographic picture image could, of course, not be erased. Also the appropriate magnetic reproducer heads would have to be installed in all cinema projectors using such prints and this further item of expense was not widely acceptable. Thus, even when magnetic recording at the studios had become universal it was still normal practice to transfer the final magnetic recording to an optical sound track negative to make release prints for general distribution to cinema theatres.

The competition of television

During the period immediately after World War II, while the cinema industry was in a flourishing commercial condition, a rapid expansion took place in that most pervasive of all mass-media, television. This development fundamentally altered the pattern of popular entertainment throughout the world and induced far-reaching changes in all aspects of the motion-picture industry from intial production in the studio to final presentation in the cinema theatre.

Although a public broadcast service of television had been started in Great Britain in 1936, the outbreak of World War II in 1939 put an end to such developments in Europe for a period of almost ten years. In the United States on the other hand, the electronics industry which had expanded vastly to meet war-time demands provided a substantial foundation on which nation-wide television services were rapidly built. The sequence of events of some thirty years earlier was repeated, and again American technology and application was placed in a dominant position in the new field of television entertainment.

By 1950 the effect of the new medium was being felt by the motion picture industry in the United States and the same pattern of events was repeated slightly later in Great Britain and subsequently in the other countries of western Europe. Cinema attendances dropped drastically and substantial numbers of theatres had to be closed down as uneconomic. The reduced outlets of exhibition led to the reduction of the number of copies of film required for distribution and the smaller and cheaper type of feature productions could barely find any market at all. Production studio facilities were reduced or consolidated on a more economic basis and in some cases were bought by firms concerned in the production of films for television. From the outset, television entertainment made great use of film as a source of programme material but it was many years

before television technology exerted a significant influence on the craft of the motion picture.

The television picture

Although even an outline of the technology of television is beyond the scope of this book, it is necessary at this point to indicate briefly the manner in which the electronic formation of moving images differs from the photographic basis used in the cinema.

While the film frame contains a complete two-dimensional record of the whole of the scene before the camera at any one moment of time, television is concerned at any instant with the light and shade of only one point in that scene. In order to build up the whole picture every point in the scene must be examined, but this is done in an orderly fashion by scanning in a series of horizontal lines

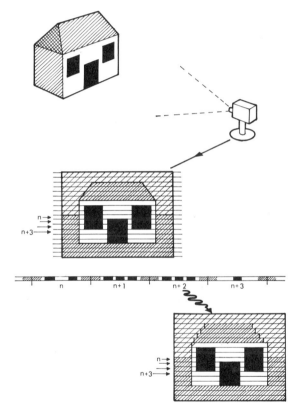

TELEVISION IMAGE
 The image of the scene formed by the lens of a television camera is scanned electronically in a series of horizontal lines termed the raster. The variations of light and shade along each line are converted to electrical signals for transmission and reconstitution.

which form a grid pattern called a 'raster'. The brightness of each point along each line is transmitted as a successive series of electronic signals and when the scanning of one line is complete the process is begun again at the start of the next horizontal line. When the whole series of lines comprising one full picture area has been completed, the scanning process commences at the first line once more. If the successive complete picture images follow one another with sufficient rapidity the appearance of movement can be reproduced as it is from successive frames on film.

As in motion picture photography, the lens of the television camera forms an image of the scene before it, but instead of this image falling on the surface of a photographic film it is received by a photo-sensitive target plate. The surface of this plate may be considered as consisting of a large number of minute photoelectric cells, so that the image formed by the lens sets up a corresponding pattern of electrical signals. A beam of electrons is made to scan this target plate in the line grid pattern by the influence of magnetic fields produced by lateral and vertical deflection coils. This produces a voltage output which continually varies in accordance with the brightness of the image at each point and this varying output can be made to modulate the radio waves from the television transmitter.

At the receiver, the radio signal is demodulated and the varying output corresponding to the picture image is used to control the brightness of a spot of

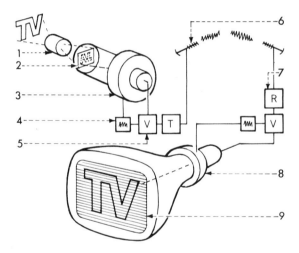

TELEVISION PRINCIPLES

 The lens (1) of the television camera forms an image on the target plate (2) where it is scanned by an electron beam moved by the deflection coils (3) under the control of the synchronising signals (4). The light and shade of the image set up electrical video signals which are amplified (5) and transmitted for broadcasting (6), together with the synchronising information.

 At the receiver (7) the video signal controls the intensity of an electron beam, similarly scanned by the deflection coils (8), to form an image of varying brightness on the fluorescent screen (9) of a cathode ray tube.

32

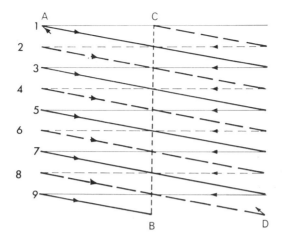

INTERLACED SCANNING
The television scanning raster consists of two series of interlaced lines, lines 1, 3, 5, 7 forming one field A to B, and lines 2, 4, 6, 8 . . . the second field C to D. On completing each pair of fields, known as a frame, the scanning spot returns from D to A to start the first field of the next frame.

light produced by another electron beam falling on the fluorescent surface of a cathode ray tube. If this electron beam is made to traverse the tube surface in exactly the same line grid raster as used in the camera the resultant pattern of light and shade will reconstruct the image produced by the camera lens. In practice, the electron beam moves along each line so fast that the whole image is completely covered in a fraction of a second and the phosphor material used on the tube surface continues to glow for a brief period even after the beam has passed, so that the persistance of vision of the eye allows the picture to be seen as a whole. As in the cinema, a successive series of picture images must be presented rapidly one after the other to give the sensation of motion, but, unlike the cinema, there is no period between successive pictures when the screen is dark.

Television image structure

Although the picture on the cathode ray tube screen is small, it must contain a large number of individual lines if it is to show reasonably fine detail. In the original broadcast system used in Great Britain a grid of 405 lines per picture and a frequency of 25 pictures per second were adopted. This rate was chosen because the electrical mains supply frequency in this country is 50 Hz and the relationship simplifies a number of problems. In the United States the mains supply is 60 Hz and a television picture frequency of 30 pictures per second was selected; a higher definition line structure was also adopted, the 525-line picture being standard there.

When television services were introduced in Europe after World War II a still higher definition system of 625 lines per picture was chosen, and this was

33

also adopted for the second BBC service in Great Britain. A picture frequency of 25 per second has however continued as the standard for all European services.

In order to improve the uniformity of the television image and reduce the appearance of flicker, the pattern of lines is not scanned strictly in sequence from top to bottom of the picture but in two interlaced patterns of alternate lines. For example, at the European frequency a complete picture corresponding to all the odd numbered lines 1, 3, 5, 7 etc., is transmitted first in a period of 1/50 sec, and immediately followed by the interlaced picture formed by the even lines 2, 4, 6, 8 etc., the pair being completed in $\frac{1}{25}$ sec. The individual group of half the number of lines is termed a field, the complete picture made up of two interlaced fields being a frame, on the analogy of the unit picture image on film. The field frequency is thus always twice that of the frame and is made to correspond to mains supply frequency.

In practice, not all the lines of the transmission system are available to produce a picture image on the screen as a number of lines are used for synchronisation and for the return of the scanning spot from the bottom to the top of the raster. For a 625 line system there are 587 lines used as picture elements and for the American 525 system 493 elements.

Reactions to television

Returning now the main theme of the technical history of motion pictures, the period from 1950 was marked by a number of important changes which affected all branches of the industry from initial production to final presentation. The attraction of the cinema theatre as a form of mass entertainment was clearly suffering from severe competition but it would be incorrect to blame the declining box-office attendances solely on the counter-attraction of television. In reality, television was only one of the compeditors for this public after the restrictions and shortages of the war and immediate post-war years were removed: private motoring, dining-out, foreign travel and all the attractions associated with a higher standard of living were making their demands on the potential cinemagoer's pocket. But to the cinema industry the threat of television appeared as a special menace since it represented a direct attack on their own, previously exclusive field, that of entertainment by sound, music and picture. The same sort of entertainment which the cinema had been providing on the large screens of its theatres was now available in the home on the small screen of the television set, every night of the week, without further payment once the cost of rental or hire-purchase for the set had been met. It was therefore not surprising that to provide a counter attraction to the small black-and-white picture in the home the cinema theatre chose to emphasise those features which only *it* could provide at that time — colour and big screen presentation. This was the positive approach.

The more negative approach, trying to reduce the entertainment which television interests could offer by denying them the presentation rights of earlier cinema films, was attempted, but in due course such opposition collapsed in the face of the attractive financial rewards offered for television rights and it was left to technical developments to make film presentation more appealing to the public. The result was the appearance during a comparatively short period of a multiplicity of new systems of photography and presentation, often in conflict with one another as the result of internal competition within the motion picture industry. The effects of these developments are still very apparent at the present day.

Improvements in colour film

The competition of television did not initiate the move towards simpler and improved means for the photography of colour motion pictures but it certainly provided circumstances that encouraged the application and growth of such methods when they became available.

The dependence of the earlier Technicolor process on the use of a special three-strip camera had always been a considerable limitation and, for many years, work by the photographic manufacturers had been directed to the development of a system by which a full colour record could be obtained on a single strip of film exposed in a standard camera designed for black and white work. Such a material had in fact been available to the amateur cinematographer since 1937 in the form of 16 mm colour reversal film but this was not at all suitable for the preparation of the large numbers of copies required for general distribution to cinema theatres. It therefore had no general application in the field of professional motion pictures.

During World War II manufacturers in Germany produced the first single-strip colour negative stock for 35 mm cinematography on a regular basis and after the end of hostilities the basic inventions concerned were made available to other countries. Work had also been going forward very actively in the United States and by 1951 colour negative materials for professional motion picture photography were available from several sources. Once these were fully estab-

TRIPACK COLOUR FILM

Three separate layers of sensitive emulsion are coated on a single strip of film base and record the red, green and blue light components of the scene being photographed.

(1) Blue sensitive layer
(2) Green sensitive layer
(3) Red sensitive layer
(4) Film Base
(5) Black Backing

lished the function of the specialised three-strip camera was at an end and it had completely disappeared from use by 1955.

In essence, the new colour negatives performed the same purpose as the three films of the Technicolor camera, but the images formed by the red, green and blue light components of the scene before the camera were recorded on three sensitive photographic emulsion layers coated on a single base support. Suitable processing chemicals allowed an image of a different colour to be formed in each layer, yielding a colour negative in which the hues of each part of the picture as well as their tones were the opposite of the original scene. These materials were known collectively as multi-layer films, or more specifically as integral tripack stocks, because of the three coatings on one base.

These integral tripack colour negatives could be printed on to another three-layer material giving a colour positive image suitable for projection and for reproducing a photographic (optical) sound track. Substantial changes in the equipment and methods used by the film processing laboratories were required to handle these new colour stocks, but Technicolor continued to make copies by the photo-mechanical dye transfer process even though the starting point was a multilayer colour negative instead of three separate film records.

By 1953 the use of single-strip colour film was well established in production studios, laboratories and cinema theatres in all major countries with substantial film industries. But for economic reasons black and white motion pictures continued to be made and distributed and it was a further fifteen years before colour became practically universal for the professional cinema in the United States and western Europe.

Widescreen presentation

The most marked changes in motion picture practice which arose directly in competition with television were those affecting the final presentation in the theatre, although even these were derived from the revival of experiments and developments of earlier years. In the pioneer days of the cinema there had been proposals and demonstrations using much larger screens than could be covered from the normal 35 mm image size. Some of these had employed films of greater width to give a larger image area while in others two or even three separate projectors with individual films had been used to show two or three pictures side by side to cover a wide area of screen. These methods had never come into general use in the cinema theatre as they required special cameras and projector equipment but they had often been employed in various forms for special presentations, particularly at international exhibitions and similar occasions.

One of these was at the New York World Fair (1939) where a group of five projectors showed a composite picture on the inner surface of a huge hemisphere which served as combined screen and auditorium. During the war similar equipment was used as a training device for anti-aircraft gunnery practice in which manoeuvering aircraft targets could be followed over a wide field of view provided by the vast curved screen. After the war a somewhat simpler system using three projectors and a large cylindrically curved screen was developed for entertainment shows with stereophonic sound effects provided from numerous loudspeakers all over the theatre, fed from multiple magnetic sound track records. Using black and white material, this system, under the name Cinerama, created much interest. But when the newly available colour film stocks were employed the size and quality of the presentation of picture and sound provided outstanding spectacular entertainment.

36

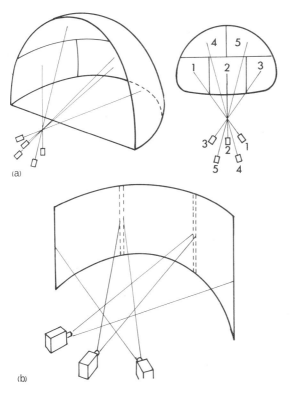

(a)

(b)

THE WALLER TRAINER AND CINERAMA
(A) During World War II an anti-aircraft gunnery trainer was used in which five separate projectors showed aircraft targets in motion over a very large spherically curved screen. (B) Subsequently the Cinerama System using three projectors and a large curved screen was developed for entertainment presentation.

Although such an elaborate system as Cinerama could only be used in re-built theatres with specially installed equipment the possibility of a similar style of presentation from a single simple projector in regular cinemas was being seriously pursued. One of the lines followed was based on the revival of the invention of Chrétien in France in 1928 for anamorphic photography and pro-jection, and in 1953 such a system was introduced with the trade name Cinema-Scope. Anamorphic optical systems are those in which the image formed is intentionally distorted by the use of lenses whose horizontal and vertical magni-fication factors are different, and Chrétien's system employed camera lenses giving picture images which were compressed laterally by a factor of two in proportion to their height. A scene twice as wide as that photographed by a nor-mal camera lens could thus be recorded on a film of standard 35 mm width. Corresponding prints could then be projected by similar anamorphic lenses to show a picture filling a very wide screen area in the cinema. Films having hori-zontally compressed, or 'squeezed,' images thus provided the first of the modern

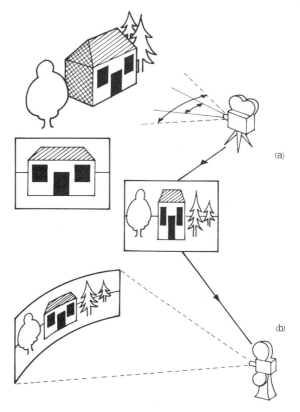

ANAMORPHIC PHOTOGRAPHY
(a) Compared with a normal photograph an anamorphic camera lens takes in a much wider angle of view and produces an image on the film which is laterally compressed. (b) On projection a similar anamorphic lens expands the squeezed image to provide a wide screen presentation.

widescreen systems and the '-scope' portion of the name CinemaScope was used in so many other similar processes that it became a recognized abbreviation for anamorphic systems in general.

Format changes

As originally introduced, the CinemaScope process combined all the competitive features of colour, widescreen presentation and stereophonic sound and although one strip of 35 mm film was employed, some alterations in the usable image area was necessary. The width of the sprocket holes along the film edges was reduced to make room for four magnetic stripes carrying sound records reproduced over four speaker systems. Three of these were placed behind the screen to give separate sound sources in the centre and to the right and left while a fourth set of speakers was distributed around the auditorium to provide

38

ambient sound effects. The maximum remaining area of the film was used for the compressed picture image although the early standard for frame height (four perforation holes) was retained to avoid the need for major mechanical changes to the intermittent movements of cameras and projectors. When this new frame area was projected using an anamorphic lens it provided a picture twice as wide in proportion to its height as the earlier standard frame. For many years the proportion of the picture had been standardised at 4 units wide by 3 units high, so the proportions of the new CinemaScope format when projected were 8 units wide by 3 high. It is convenient to refer to these proportions as the aspect ratio(AR) of the picture shown, that is, the ratio of the width to the height, taking the latter as unity. The aspect ratio of the earlier standard format is thus 1·33:1, while the original CinemaScope system with four magnetic tracks was AR 2·66:1.

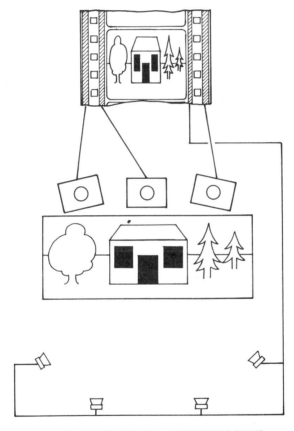

WIDE SCREEN PRESENTATION WITH STEREOPHONIC SOUND
On 35 mm prints the sound is carried on four magnetic stripes which are reproduced over three speakers placed right, centre and left behind the screen and a series of smaller speakers distributed around the auditorium.

39

Photography and projection in CinemaScope required only the provision of new lens systems and small alterations in the size of the picture gate apertures, but the multi-channel magnetic sound system involved many more complications. Multiple microphones were needed for sound recording in the studio and the final mixing of the sound track component was a complex operation where satisfactory balance between the channels had to be achieved. Prints of such films for general distribution had to be magnetically striped and recorded, involving additional manufacturing costs. In the theatre itself, not only had magnetic reproducer heads to be fitted as an addition to each projector but substantial alterations were necessary to the sound amplifier and loudspeaker systems, often involving a partial rebuilding of the structure in order to accommodate the large screen and multiple sound channel outlets.

For these varied reasons the use of CinemaScope prints with four magnetic sound tracks could not obtain universal acceptance, despite the excellent quality of reproduction obtained, and it was always necessary to provide additional distribution copies of such films with a photographic optical sound track to allow their presentation at cinema theatres which had installed large screens and anamorphic projection lenses but not multi-channel magnetic sound facilities. In some cases combination-type prints were made in which the width of the picture area was reduced to allow space for a narrow optical track next to one of the magnetic stripes and such copies were known as mag-opt type. But in the majority of cases, only a standard optical track was printed in the usual position and film stock with the normal size of perforation hole was used. This necessitated a slight reduction in the width of the picture image, but the original CinemaScope frame height was retained. On projection the picture had an aspect ratio of 2·35:1 rather than the 2·66:1 of the original CinemaScope format. This frame proportion became the standard for anamorphic type copies on 35 mm film, and within a few years a very large number of cinema theatres throughout the world were able to show this form of picture presentation.

Non-anamorphic widescreen

Not all production organisations were prepared to accept the cost of anamorphic lens systems for their cameras nor did all directors wish to compose the action of their pictures to fill the extreme width of the CinemaScope format. On the other hand, the new screen proportions appeared to attract the cinema-going public and it was therefore considered that a change from the old 4 × 3 proportions (AR 1·33:1) was desirable, even where normal camera and projection lenses were retained.

The simplest and cheapest way of doing this was to reduce the height of the picture image on the film by using smaller aperture masks in the camera and projector but making use of the normal image width. In this manner any aspect ratio wider than 1·33:1 could be obtained and a period of confusion ensued in which films were composed and photographed at any proportions that the director thought fit from 1·65:1 to 2·2:1. Prints of this type, having normal images rather than the distorted images of CinemaScope, were known as 'flat' prints as distinct from the 'squeezed' prints of the anamorphic systems. There is still no strict standardisation in the format of flat wide-screen films, but the extremely wide proportions sometimes used in the earlier period have disappeared and it is now general practice to compose the picture to allow acceptable projection at any ratio between 1·65:1 and 1·85:1.

Large-film systems

The new presentation systems such as CinemaScope created a demand for much larger screens in general compared with those previously used, with the result that the small picture image on 35 mm was now being enlarged to a greater magnification than before. It was not exceptional for the 22 mm width of a 35 mm frame to be expanded to fill a screen of 22 metres, or one thousand times as wide. So it was not surprising that the standard of image definition which had previously been found acceptable was now regarded as inadequate. One method of obtaining better results was to use larger image areas on the film and a number of systems came into commercial use which employed special cameras for the original photography.

One of the first of these was VistaVision, a non-anamorphic system using 35 mm film, the larger picture area being obtained by moving the film horizontally

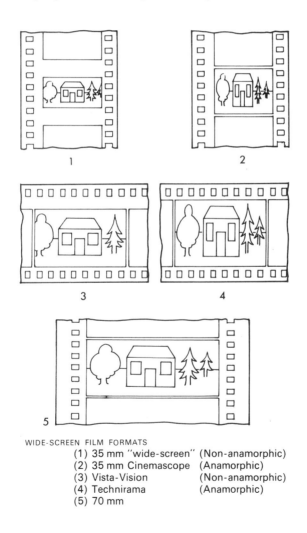

WIDE-SCREEN FILM FORMATS

(1) 35 mm "wide-screen" (Non-anamorphic)
(2) 35 mm Cinemascope (Anamorphic)
(3) Vista-Vision (Non-anamorphic)
(4) Technirama (Anamorphic)
(5) 70 mm

through the camera, instead of vertically as was normal, and using a length of eight perforations for each frame instead of the standard four. This provided an image area twice as large as could be obtained on regular 35 mm for a widescreen aspect ratio of the order of 1·85 : 1. Special projectors using 35 mm film horizontally, as in the camera, were introduced. But they involved too great a change of equipment in the theatre, and this practice was soon abandoned in favour of regular 35 mm prints made by optical reduction from the larger negative. Since many of the deficiencies of widescreen presentation had arisen from inadequate definition and excessive grain in the negative film rather than in the positive, the larger camera image gave improved results on the screen even from a standard size print.

The Technirama system was another process using an eight-perforation frame on 35 mm film running horizontally in the camera. Anamorphic camera lenses with a lateral compression factor of 1·33 : 1 were used and prints were made by

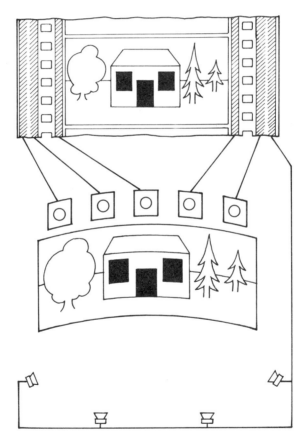

70 mm PRESENTATION
On 70 mm prints four magnetic stripes carry six sound tracks which are reproduced over five speakers behind the screen and a series of auditorium speakers.

optical reduction, either to produce 'squeezed' prints of the CinemaScope type or 'flat' prints with an aspect ratio of 1·85:1 according to the relative horizontal and vertical reduction factors of the copying lenses used for printing. Here again, the larger negative area gave improved results with standard size prints.

Other methods of large image photography employed film of greater width than 35 mm; several different sizes were used experimentally – 55 mm, 65 mm and 70 mm in width – but in a comparatively short time the position stabilised and 70 mm film was chosen to make prints for final presentation. This film was perforated with two rows of sprocket holes similar to those in 35 mm film and a frame five perforations high gave a picture image area having a widescreen aspect ratio of 2·2:1. The available image area was thus more than four times that of a similar ratio 35 mm frame. There was ample room both next to the picture area and in the margins outside the perforations to insert magnetic stripes for stereophonic sound reproduction. A six-channel sound system was adopted, feeding five loudspeakers disposed behind the screen with one channel for the sound effects speakers around the auditorium. In the projector the 70 mm film ran in the conventional manner, vertically, and it was therefore possible to design combination machines which could project either 35 mm or 70 mm width film with only small mechanical changes which could be carried out by the operator without difficulty. Special cameras using wide film were of course necessary and here a difference of fundamental practice developed. In the United States a number of experimental cameras using 65 mm width film had previously been manufactured and used to a limited extent and these provided the first equipment for the large-film wide-screen system developed by Todd-AO. Since the extra width for the magnetic sound tracks was not required for the negative used in the camera, a film width of 65 mm was sufficient for the picture area alone and American practice standardised on the two different widths of 65 mm for negative materials and 70 mm for positive.

In Russia, on the other hand, it was decided that many problems of film stock manufacture, printing and processing would be simplified if only one gauge of wide film was employed and so 70 mm film was standardised for both cameras and projectors. In the interests of international distribution, however, the format and magnetic track arrangement of the 70 mm print was adopted universally.

Wide film variants

Some use was made of 70 mm film with anamorphic lens systems for camera and projector to give an even wider picture presentation with an aspect ratio of approximately 2·8:1 but this did not prove sufficiently popular for widespread adoption and normal spherical lenses are now standard for both photography and projection of widescreen film.

However, photography on 65 mm negative is extremely expensive for both film stock and processing and the larger cameras necessary involve additional problems of mounting and handling during production operations. The possibility of preparing 70 mm prints from smaller and less expensive original negatives had therefore to be given serious consideration.

During the period when 70 mm presentation film became general the definition and grain of the available colour negative did not allow adequate results to be obtained by enlargement from a standard 35 mm frame, but the double-frame Technirama system was used for many years in this way, 70 mm prints being made by optical anamorphic printing to enlarge the frame width to the proportions required.

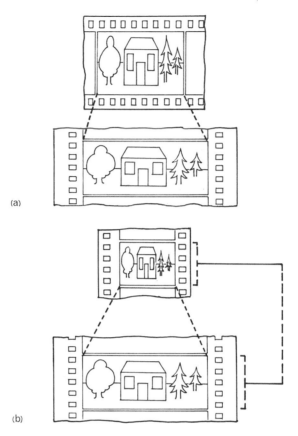

(a)

(b)

70 mm PRINTING BY ENLARGEMENT
70 mm prints can be made by optical enlarge-
ment from smaller size originals. (a) Technirama to 70 mm
requires a horizontal enlargement only, but (b) 35 mm
Cinemascope to 70 mm requires enlargement in both
dimensions, the horizontal magnification being twice the
vertical.

Within recent years, however, considerable improvements have been made
both in the grain and definition of colour negative film stock and in camera lens
systems, and it is now possible to print 70 mm copies by anamorphic optical
enlargement from 35 mm original negatives of the regular CinemaScope format.
This procedure is becoming increasingly popular, since it avoids the large addi-
tional cost of wide film for initial photography and yet provides the 70 mm copies
required for the most important presentations at special theatres in major cen-
tres. It may therefore be said that these technical improvements have substan-
tially reduced the need for photography using large area negatives.

At its best, projection using 70 mm film provides the most spectacular form
of audio-visual entertainment yet devised. The large frame area allows a very
much brighter picture to be shown on even the widest screens, the image size

produces excellent sharpness and lack of graininess and the multi-track magnetic recording gives stereophonic sound of the highest quality. In recognition of this, the main systems of multi-film projection using separate machines have now been replaced by single-film 70 mm equipment except for specialised display processes at international fairs and exhibitions which are outside the main line of the development of the cinema. Against this, 70 mm prints with magnetic sound cost four to five times as much as the equivalent 35 mm copy with optical sound and can only be shown in theatres which have been fully equipped and often re-constructed for stereophonic sound. Theatres providing 70 mm shows will therefore always be in the minority and will be limited to those key cities throughout the world where large concentrations of population can supply large audiences prepared to pay the necessary prices for such presentation. The 70 mm system must be regarded as too expensive a medium for universal distribution and for the present, therefore, 35 mm film is likely to remain the most extensively used material for professional motion pictures in the entertainment field.

Smaller formats

Within recent years improvements in colour negative film stocks have allowed a more economical approach to the production of widescreen subjects by the use of a half-size frame on 35 mm film. If a camera is modified to expose an image every two perforations instead of every four, a smaller picture area having an aspect ratio of 2·35:1 can be obtained on standard 35 mm stock and only half the normal length of film is required to photograph each scene. Direct prints from such a negative would be inconvenient to use on existing cinema projectors because of the change of speed, and different action of the intermittent

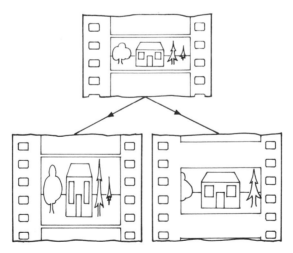

HALF-FRAME NEGATIVE
 A camera using an aperture of the normal width but only half the normal height records an image of widescreen aspect ratio which can be optically printed to make either a 35 mm anamorphic copy or a wide-screen "flat" print for normal projection.

45

mechanism. But at the processing laboratory standard 35 mm format prints can be made by optical enlargement, either anamorphically to give CinemaScope-type copies or by straight enlargement for widescreen 'flat' presentation. Although the image quality of the negative is not adequate for enlargement to 70 mm, this system has provided substantial economies in the cost of film stock and processing at the shooting stage and has been widely used to make prints for general 35 mm distribution under the name of Techniscope.

The 16 mm gauge is now completely established as a professional material with special applications in the non-theatrical fields of educational and industrial film production. Here also colour film has been adopted almost universally and there are, in fact, more types of colour material available in 16 mm form than in 35 mm. Nowadays 16 mm projection meets the majority of needs for film presentation to audiences other than those of the commercial entertainment cinema theatre and this gauge is also playing a significant part in the supply of film for television transmission.

For the amateur cinematographer the smallest film gauge, 8 mm, had dominated the American market almost since its introduction and substantially displaced the earlier 9·5 mm amateur gauge in Great Britain and Europe. From 1962 onwards there was increasing interest in the use of this cheapest form of motion pictures for educational purposes, particularly for small groups in the school classroom. Simple projectors which could be loaded with small cassettes containing a continuous loop of 8 mm film were introduced and could be used by the teacher to show a moving illustration, lasting two or three minutes. It was also capable of immediate repetition as often as required. These short silent films for teachers usually provided a demonstration illustrating only one feature of the lesson and became known as single-concept films.

Although the type of 8 mm film obtained by splitting normal 16 mm in half was

STANDARD-8 AND SUPER-8 MM FILM
Standard 8 mm (half 16 mm) was the most popular amateur material from 1935, but was replaced in 1967 by, 2. Super-8 which gives a larger picture on the same width stock.

46

easy and economical to handle, the actual area of picture image was extremely restricted because of the size of the perforations and in fact this arrangement made rather inefficient use of the film available. The small area limited both the sharpness of picture which could be recorded and the size and brightness which could be projected. From 1966 a new format overcoming some of these disadvantages was introduced, although the economical 8 mm film width was retained. In its new form, Super 8, the size of the perforation hole was reduced to allow a wider picture, and their spacing along the film was increased to give a greater picture height. These changes provided a frame area some 50% greater than the earlier 8 mm standard and also allowed room for a narrow sound track area, which might be either an optical or a magnetic stripe recording.

Super 8 was introduced initially for amateur cinephotography, where it has tended to replace the original standard 8 mm, but the availability of sound prints in this gauge and the introduction of magazine loading projectors showing up to half an hour's programme at one time has emphasised its application in the educational and industrial field, where increasing interest in Super 8 has been evident.

Film for television

In the early days of television there was great emphasis on the immediacy of the broadcast, on the fact that the home viewer was seeing what occured at the very moment it happened. But it was soon found in drama and entertainment programmes that facilities for exterior scenes in varied locations, for re-taking unsatisfactory action, and for subsequent editing and assembly of scenes to give their best effect, were essential for smooth presentation. It was therefore not long before much television programme material was being produced by photography on film using motion picture equipment and techniques, even for sequences under studio conditions, and the feature of instantaneous transmission remained important only for sporting events, news and special occasions. But the influence of television studio practice on production methods using film was very marked—longer sequences without a break were photographed from extremely mobile cameras and set construction and lighting equipment had to be modified to make this possible. Direct television production had always made use of several cameras simultaneously to allow instant presentation of the action from different viewpoints during a single sequence, and in due course this was reflected in filming. Electronic monitor systems were developed which allowed the director to view the action through the lenses of several cameras simultaneously on a series of television screens, so that it was possible to use a group of film cameras in the same manner as a group of television cameras with the additional facility of finally editing the resultant film to a finished form at a later stage.

However, photography was not the only method of picture recording available to the television industry. Systems for recording the television picture signal on magnetic tape were also developed, first for black and white images and subsequently for colour. Originally, video-tape was used primarily in recording a complete television broadcast programme for re-transmission on a later occasion, a facility of great importance in the United States where the existance of different time zones across the country meant that the most popular viewing time did not occur simultaneously in all districts. Such rapid advances in video tape technology took place that this form of recording became a much-used method for actual production. Processes for tape editing and for transfer from one recording to another were evolved so that video-tape provided almost all the facilities

47

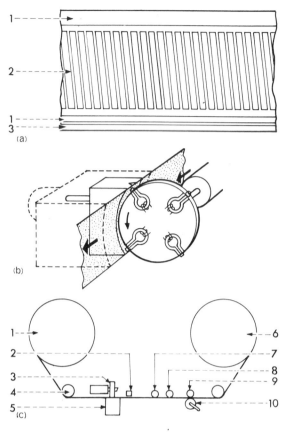

(a)

(b)

(c)

VIDEO-TAPE RECORDING

(a) Television picture and sound information is recorded on 2 in wide magnetic tape, the video signal corresponding to the TV scanning lines as diagonal transverse bands (2) and the audio (1) and synchronising control (3) signals along the edges. (b) To obtain sufficiently high velocity, the video signal is recorded by four magnetic heads as a rapidly rotating drum. The tape is curved to the circumference of the drum by a guide to which it is held by a vacuum. (c) The tape path runs from the feed reel (1) past an erase head (4) through the video head with its motor-driven scanning drum (3) and vacuum guide (5), followed by control track head (2), sound erase (7) and record (8) to the take-up reel (6). Drive is provided by capstan (9) and squeeze roller (10).

of film combined with the advantage of replay immediately after recording without the delays involved in photographic processing.

But the use of video-tape recordings as the source of television transmission presented considerable difficulties in international exchange because of the differences in line and frequency standards between various countries. A tape

recording made in the United States for 525 line, 60 field frequency could only be transmitted over a European system of 625 lines, 50 field by the use of elaborate standards conversion equipment not always available to the smaller organisations. Even more problems were involved with colour recordings since several different colour systems were in use, even in Europe. Film on the other hand was an internationally acceptable medium in either 35 mm or 16 mm gauges and was therefore frequently used in preference to tape for world-wide distribution. The transfer from television or video-tape to film, known as kinescoping in the United States and tele-recording in Great Britain, was fairly straight-forward for black and white but the transfer of colour video-tape raised new problems which had to be solved by a return to the earlier practice of preparing three colour-separation negatives on film.

Theatrical motion pictures and television

The vast numbers of entertainment films, both features and shorts, made for theatrical distribution since the introduction of sound in the cinema represented a very important source of programme material for television. The format proportions of the older films were identical with those of the television receiver screen and presented no difficulties but this was not the case with subjects photographed using wide-screen techniques, particularly anamorphic systems. If such prints were transmitted on television making the width of the picture match the width of the television screen an objectionable black area was seen at the top and bottom of the screen, while the alternative of enlarging to fill the tele-

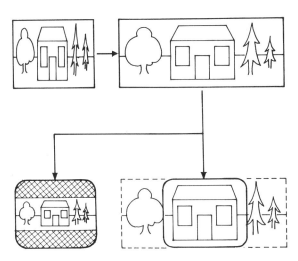

WIDE SCREEN AND TV COMPOSITION
The aspect ratio of the wide-screen picture from a 35 mm anamorphic print is not compatible with the proportions of the TV receiver screen. If the full width composition is shown, black areas will be left at the top and bottom of the picture while if the vertical height of the TV screen is filled, part of the picture will be lost on each side.

49

D

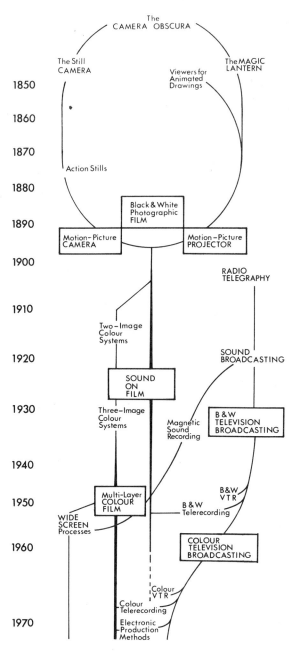

The Convergence of Photographic and Electronic Techniques.

vision height resulted in the loss of picture area at the sides of the original composition, often causing the disappearance of important action. In many cases it was therefore found necessary to make special prints for television by optically printing from the original negative to select the most important area of each scene individually and even in some cases to follow the essential centre of interest by movement throughout a scene.

Present-day practice

The point has now been reached where both the requirements of television usage and the technology of television production and electronic control are exerting a noticable influence on motion picture film practice and it is appropriate to conclude this chapter with a brief summary of the present-day practices.

The 35 mm width film, long established, retains its dominant position in the entertainment field throughout the world and is supplemented, rather than challenged, by the use of 70 mm for the most spectacular form of presentation. The 16 mm gauge is now a fully professional medium for non-theatrical purposes in education and commerce and also provides entertainment facilities for smaller audiences by means of portable projection equipment. The amateur market is now provided for almost entirely by 8 mm gauge film, with the Super 8 format replacing the original standard 8 size and extending its applications to education and industry.

Of the many image formats which have come into use, we may regard widescreen as universally established for entertainment films but with the variants of anamorphic and flat presentation in co-existence. The original 4×3 proportions are however retained in 16 mm for most purposes, for amateur cinematography and for all television film usage.

Sound films are of course used in all forms of professional motion picture presentation except for some limited educational and scientific demonstration purposes. Magnetic sound, although universal for recording, is only used exclusively for 70 mm presentation and still continues to have very limited application in 35 mm and 16 mm projection.

In the use of colour film, the professional motion picture industry has at last reached the position occupied by the amateur almost ten years earlier and black-and-white production is now the exception rather than the rule.

Television continues to make very considerable use of motion picture film but its use as a means of original recording is strongly challenged by magnetic systems using video-tape, even in colour. It is to be expected however that film will continue to be of importance to television for some time to come both as a source of programme material from the cinema theatre and as a convenient medium for international exchange. On the other hand, the influences of television production practices and electronic recording methods are only just beginning to be felt in the cinema industry itself.

2 Basic photography

The basis of all motion picture film technology is photographic and normally the first step in the chain of operations is the use of a camera to obtain a record of the subject on photographic film. The light reflected from the various parts of the scene passes through the lens of the camera to form an image on the surface of the film where it affects the light sensitive coating.

Although a good photographic lens is made up of several separate components, its optical function can be represented as that of a single transparent element or simple lens, the curved surfaces of which bend, or refract, the rays of light reaching them. All the rays from a particular point in front of the lens will be redirected

SIMPLE CONVERGENT LENS
Rays of light from any point in front of the lens
are refracted to meet at a point behind it.

to converge on a specific position behind the lens, where they are said to come to a focus, or to be focused. Light rays from the series of points forming an object in front of the lens are focused at a corresponding series of points behind the lens and thus form an image of this object. The position and size of this image in relation to the original object is determined by the curvature of the surfaces of

IMAGE BY CONVERGENT LENS
The rays of light from all the points of an object in front of the lens are refracted to a corresponding series of points behind it, thus forming an image.

the lens and the optical properties of the glass from which it is made. In cameras used to photograph scenes of real life lenses are used which produce a greatly reduced image of the original object at a position comparatively close to the lens, so that the whole camera can be made compact and easy to handle.

It is convenient to specify this dimensional characteristic of a lens by its focal length, that is to say, the distance between the centre of the lens and the position on its axis where rays from an infinite distance converge to a focus point. Rays coming from a number of infinitely distant points in different directions will converge on a number of points at the same distance behind the lens in what is termed the principal focal plane.

Where an object is not infinitely distant from the lens the rays from it will not converge to a point in this same plane but to another position further behind the lens. This position can be expressed by the basic optical formula:

$$\frac{1}{u} + \frac{1}{v} = \frac{1}{f}$$

where u and v are the distances from the lens of the object and image respectively. From this formula it can be seen that as the object distance u increases, the distance between the lens and image decreases until, when u is infinitely great, the image is formed at a distance f from the lens. The relative size of the image produced by the lens may be expressed in similar terms; if the actual height of the object is I_0, the height of its image, I_1, is reduced in the proportion of the object and image distances, u and v, so that

$$\frac{I_1}{I_0} = \frac{v}{u}.$$

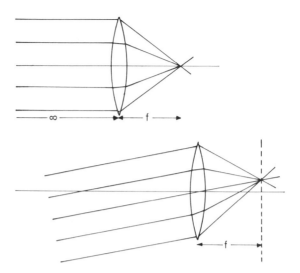

FOCAL LENGTH
 Rays coming from an infinitely distant point are
converged by the lens to meet in a point at a distance
f behind. Rays from such distant points in different
directions converge to points all of which are in a plane a
distance f behind the lens. This is known as the Focal
Plane and the distance f is the Focal Length of the lens.

This proportion is termed the magnification, M, although in normal practice it is a reduction factor and the value of M is always much less than 1. Since the relation of u and v is determined by f, the focal length of the lens, it can be seen that the magnification and the size of the image, is also determined by f. Thus

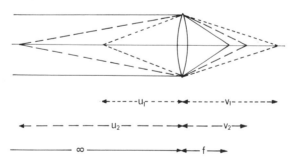

POSITION OF OBJECT AND IMAGE
 The relation between the distance u of the
object in front of the lens and the distance v of the image
behind it, is given by the formula $\frac{1}{u}+\frac{1}{v} = \frac{1}{f}$ where f is
is the Focal Length of the lens. When $u = \infty$ (infinitely
distant object), $v = f$.

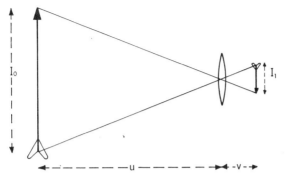

The relation between the size of the object I_0 and the image I_1 is given by: $\dfrac{I_1}{I_0} = \dfrac{v}{u} = M$.

This ratio is termed the Magnification although for normal photography it is a reduction factor and thus less than unity.

for an object at a given distance the greater the focal length the larger the image produced.

$$\frac{1}{u} + \frac{1}{v} = \frac{1}{f}$$

$$v = \frac{uf}{u-f}$$

$$M = \frac{I_1}{I_0} = \frac{v}{u} = \frac{u \cdot f}{u(u-f)} = \frac{f}{u-f}$$

so that where u is large compared with f, M is proportional to f

ORIENTATION OF OBJECT AND IMAGE

The image is produced as though all the rays which form it have passed through the centre of the lens: the image is thus inverted and reversed from left to right in relation to the object.

55

It is important to realise that in all lens image systems normally used for photography the image produced is geometrically both inverted and reversed from right to left in relation to the original object as a result of the passage of the light rays through the lens. The effect is as though all rays from the object were passing through a single point in the middle of the lens.

Focusing

When the light sensitive surface of a photographic film is placed in a camera behind the lens in the principal focal plane, it receives rays of light from all objects which are at a great distance away as a sharply focused image. But rays from nearer objects are brought to a focus at other positions further away from the lens, and images of points on these objects are not sharply defined in the same plane as the images of very distant points. They will in fact appear as circular areas, rather than true points, where the surface of the film cuts the cone of rays converging from the lens.

It is always necessary to adjust the distance between the lens and the photographic film in order to obtain the sharpest image (i.e. the 'circle of least confusion') of a point at a particular distance. This essential operation is known as

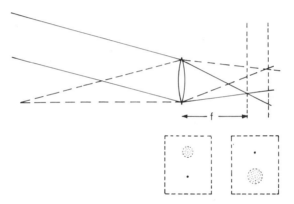

CIRCLES OF CONFUSION
Rays from points nearer than infinity converge to a point further behind the lens than the focal length, and thus appear as a circular area in the focal plane rather than a point. This area is termed a circle of confusion.

focusing. In practice, it is convenient to move the lens relative to the film by rotating it in a screw-threaded mount on the camera which can be marked to indicate the position of the lens to be used for a particular object distance. The basic formula for image distance shows that as object distances increase, the focus position rapidly approaches the setting for an object at infinity. Conversely, closer objects require larger and larger lens focusing movements as they near the camera. Focus setting is therefore most critical for nearer objects while beyond a certain distance there is no practical difference from the lens setting for infinity.

56

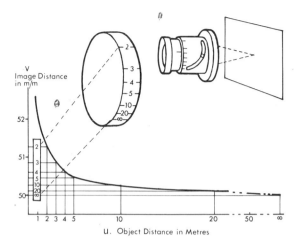

FOCUSING

The lens has a screw-threaded mount to adjust its distance from the film. The position at which the lens will focus an object at a known distance can be calculated and marked on the mount for easy adjustment. The curve shows the scale for a lens of focal length 50 mm.

Depth of field

In the photography of real scenes it would be unusual to find all objects at a single distance from the camera and therefore some objects are bound to be more sharply defined on the film than others, no matter what focus setting is used. However, there are practical limits over which these differences are not too serious and within which all objects yield images of acceptable definition. Although the image of a point may be actually a small circular spot rather than a point, it will be accepted as a point if it is sufficiently small in relation to the whole scene being photographed when the final photograph is viewed. Objects which occur at distances nearer to or further away from the lens than the ideal position for which the lens is focused will thus be acceptably sharp if points on them are imaged as circles of confusion which are sufficiently small. The range of object distances is known as the depth of field and is of great practical importance.

The actual dimension of the circle of confusion which can be accepted as indistinguishable from a point is of course primarily dependent on the distance from which the picture is viewed. It is generally accepted that a circle of confusion corresponding to one-thousandth of the focal length of the lens is an acceptable value for cinematography but since lenses of many different focal lengths may be used even with one size of film certain specific values have been adopted. For professional motion picture photography on 35 mm film the limiting diameter of the circle of confusion is taken as 0·05 mm (0·002 in.), which is one-thousandth of the most frequently used focal length of 50 mm (or 2 in.). For photography on the smaller 16 mm gauge the limiting diameter is taken as 0·025 mm (0·001 in.) and this same value is generally accepted for amateur photography on 8 mm film, since although the film image is smaller it is usually shown with less relative enlargement.

57

For any chosen value of the size of the limiting circle of confusion the practical range of object distances in the acceptable depth of field is determined by:

1. the distance of the main subject;
2. the focal length of the lens;
3. the diameter of the lens opening.

Each of these factors affects the angle of the cone of rays converging to the point of focus and the narrower this cone the greater the distance over which the image of a point forms an acceptably small circle. In general terms, the greatest depth of field is obtained when:

a. the lens is focused on a distant subject;
b. the focal length of the lens is short;
c. the diameter of the lens opening is small.

In motion picture work it is essential to know the effective depth of field when shooting, so that all the important details of the scene are sharply reproduced and unimportant features as the background can be made less conspicuous by appearing out of focus. The nearest and furthest distances of the acceptable depth of field may be calculated (page 335) but it is more convenient in practice to use tables showing these limits for lenses of different focal lengths at various apertures and focus distances. Simple calculator discs are also available, while some lenses for narrow gauge photography are marked with depth of field scales on the focus mount itself.

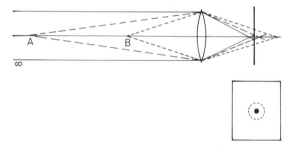

DEPTH OF FIELD
Object points at infinity and at A both produce images sufficiently small to appear well defined and in focus but the nearer object point at B gives too large a circle of confusion. With this lens setting the depth of field is said to extend from A out to infinity.

Lens angle and field of view

In motion picture photography the area of the film exposed and its proportions are fixed for each particular system, so that the dimensions of the scene being recorded are determined by its distance and the focal length of the lens in use. It is often convenient to refer to this as the angle of view embraced by a lens and this lens angle is normally specified as the horizontal angle subtended by the width of the image photographed at the effective optical centre point of the lens.

Motion picture cameras tend to have rather narrower angles of view, in comparison to those used for still photography. The value regarded as normal in motion picture work is a horizontal angle of 23° to 24°. This corresponds to a focal length approximately twice the length of the diagonal measurement of the exposed area on the film, and the normal is thus 50 mm for the lenses on professional motion picture cameras using 35 mm film. Lenses with substantially shorter focal lengths, of half the normal value or less, embrace a much greater angular field and are termed wide-angle lenses, while lenses with much narrower angles, having focal lengths two or three times the normal, are referred to as long focus lenses. It should be remembered that these distinctions refer specifically to the angle embraced by the image on the film rather than to a particular focal length; a lens of 25 mm is a wide-angle lens for professional 35 mm film but corresponds to the normal angle for the narrow gauge 16 mm film and is a long focus lens for amateur cine photography on 8 mm. A table giving the horizontal and vertical angles of view for various standard lenses with different film gauges is given on page 342.

In describing the magnification produced by a lens, it was noted that the greater the focal length, the larger the image of an object on the film. But of course it is also possible to obtain a larger image by moving the camera close to the subject. The selection of the best combination of lens focal length and camera distance is of fundamental importance, since not only must the movements of the camera provide the required viewpoints but the effect on perspective of lenses of various focal lengths must be taken into account. In comparison with the normal focal length, long focus lenses tend to give the impression of reduced perspective depth by showing more distant objects as larger, and therefore apparently nearer, than would have been expected. Short focal length wide-angle

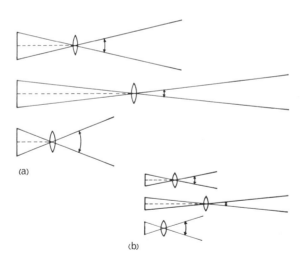

(a)

(b)

LENS ANGLE
The angle of view for a given lens is determined by its focal length and the size of the film used. The focal lengths of normal, long focus and wide-angle lenses for 16 mm film (b) are much shorter than those of lenses giving similar angles of view on 35 mm (a).

CHANGE OF PERSPECTIVE

From the first camera position shown (1) a long focus lens of narrow angle of view will give a close-up of reduced perspective (3) in comparison with the long shot with a wider angle lens (4). Even when the camera is moved back to position (2) to make the figure of the same size, the perspective with the long focus lens is still flatter (5).

lenses have the opposite effect, nearby objects appearing larger in relation to objects further away, sometimes to the point where objectionable distortion is introduced, as, for example, when faces are photographed at very close range.

Corresponding variations of apparent perspective are important in motion picture work when objects moving towards or away from the camera are shown. With a long focus lens the change in size of a distant figure in a given time may be comparatively small, so that the apparent motion is slow. With a wide-angle lens an object coming towards the camera may increase in apparent size surprisingly quickly, as though the motion had been greatly accelerated. Effects such as this are often intentionally selected for dramatic effect.

Camera angle

In composing the scene to be photographed, the combination of subject distance and focal length of lens, together with the desirable depth of field, forms an essential part of the cameraman's art and the overall effect is often referred to as the camera angle. There is a generally accepted terminology to describe the character of the composition which may be summarised as follows:

Extreme long shot (X.L.S.) A very distant landscape or interior scene in which any human figures appear very small. Usually photographed with a comparatively wide-angle lens set at distances approaching infinity.

Long shot (L.S.) A scene in which all the actors are seen as full length figures; wide angle and normal lenses may be used, set to give as much depth of field as possible to cover both the background scene and the action.

60

Medium shot (M.S.)	Here the actors are often seen as half or three-quarter length figures, close enough for all details of facial expression to be seen. Normal focal length lenses are used at settings to give somewhat out-of-focus background detail.
Close shot (C.S.)	The actors are typically seen as head-and-shoulder figures only, concentrating on the action of the features; rather longer focal length lenses are used and the focus setting chosen to suppress background detail almost entirely.
Close-up (C.U.)	In this the face of the actor occupies the whole height of the picture for dramatic emphasis; long-focus lenses are necessary to avoid distortion and focus is critical.
Big close-up (B.C.U.)	Here the camera view-point concentrates on a single object or a feature, which may be the actor's eyes or mouth, so that they completely fill the picture; long-focus lenses are essential and focus is extremely critical, since the depth of field available may be barely sufficient to cover the subject detail.

CAMERA ANGLE

The composition of a scene, resulting from the distance of the subject and the angle of view of the lens used, is described as:

1 XLS Extreme Long Shot
2 LS Long Shot
3 MS Medium Shot
4 CS Close Shot
5 CU Close up
6 BCU Big Close Up

Lens aperture

The properties of the lens as a light transmission system must also be considered on a quantitative basis, since in any photographic process it is essential to control the amount of light reaching the film. Fundamentally, the light transmitted by a single lens is determined by the area of its surface, and can be accurately adjusted by controlling this area. The transparent surfaces of a lens are usually circular and so this control can be conveniently carried out by using a hole of larger or smaller diameter close to the lens surface; this circular hole is known as the lens aperture or stop. The area of such a stop varies as the square of its diameter, so that if the diameter of a stop is doubled, the light transmitted will be increased by four times.

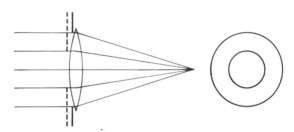

LENS APERTURE
A circular hole in front of the lens can be used to control the amount of light passing through it to form the image. The smaller circle has half the diameter of the larger one and therefore one quarter of its area, so that it only passes one quarter of the light transmitted at maximum opening.

The brightness of the image formed by the lens is determined not only by the diameter of the lens aperture but also the size of the image, which specifies the area over which the light passing through the lens is to be distributed. As noted earlier, the magnification of the image of a given object is decided by the focal length of the lens, so it is the combination of the lens aperture diameter with the lens focal length that provides the factor by which the light transmission of a lens is assessed. This combination is conveniently expressed as the relative aperture of a lens, which is the ratio of the focal length to the aperture diameter, expressed as a fraction of the focal length, f. So $\frac{f}{2}$ represents a lens with an aperture diameter half the focal length, $\frac{f}{4}$ one with an aperture one-quarter and so on. These fractions are often written $f/2$, $f/4$ or $f1:2$, $f1:4$ or still more briefly $f.2$, $f.4$ and are known as f-numbers. The larger the f-number the smaller the relative aperture and the less the light transmitted to form the image. This method of expressing lens apertures has the great advantage that equal relative apertures will yield images of equal brightness whatever the actual focal length of the lenses may be.

F-number scales

In order to control the light passing through the lens some means of accurately adjusting the lens aperture must be provided. At one time lenses for still cameras used a series of interchangeable metal plates with a hole of different size cut in each but all camera lenses have long since been fitted with continuously adjustable iris diaphragms in which a number of moveable leaves can be

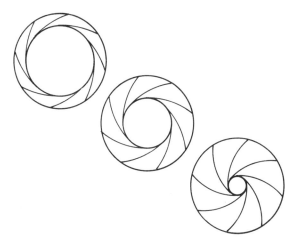

IRIS DIAPHRAGM
Most modern camera lenses have iris aperture adjustment in which a number of thin leaves can be moved to provide holes of various diameters.

opened or closed to provide apertures of various diameters. The size of the opening selected is shown on a scale of calibrated marks and these are normally expressed as the f-numbers or f-stops. It is convenient to provide a series of diaphragm settings which will have the effect of halving the amount of light passed at each stop, so the f-numbers marked are usually in a series increasing by the square root of 2, corresponding to the reduction of the aperture area by half for each setting. The series is thus $f1$; $f1\cdot4$; $f2$; $f2\cdot8$; $f4$; $f5\cdot6$; $f8$; $f11$; $f16$, etc. At the position of largest aperture, that is to say the smallest f-number, the scale marking may not correspond exactly to a stop on this series. Lenses may be found with maximum opening values of $f1\cdot8$ or $f1\cdot3$, but whose smaller settings correspond to the standard series.

In the complex lenses used for professional cinematography, the geometrical f-number will not accurately represent the true light transmission because of absorbtion by the numerous glass surfaces. Such lenses are therefore often calibrated with T-stop numbers, which represent transmissions equivalent to the f-numbers of a perfect lens having no absorption losses. T-stop calibrations therefore provide a more accurate basis for exposure control by diaphragm setting.

Effect of lens aperture

The chosen lens aperture has other important effects in addition to determining the brightness of the image formed. When discussing focusing it was noted that depth of field was affected by both the focal length of the lens and the diameter of the lens opening and it will therefore be seen that for a given lens this depth of field will increase as the lens is stopped down to each higher *f*-number setting. Depth of field tables and calculators thus normally specify the variations of depth of field for a particular focal length according to the focus distance and the *f*-number. The greater depth of field when the lens is stopped down to a small aperture provides acceptably sharp images over a greater range of subject distances and means that focus setting is not so extremely critical as when the lens is wide open.

The effects of many optical deficiencies and distortions which occur in lenses are also reduced when the lens is used at a small aperture since the larger the diameter of the lens used, the more difficult it becomes to correct such deficiencies completely.

In amateur cinematography on 8 mm film, where very short focal length lenses are used, such great depth of field can be obtained that a single focus setting of the lens is sufficient for all subject distances normally encountered, provided that the maximum opening of the lens aperture is not too large. Lenses mounted in this way, generally on simple models only, are termed fixed focus lenses and avoid the necessity for focus setting. A lens of $12\frac{1}{2}$ mm focal length and a maximum aperture of *f*3·5 can, for example, be set to give acceptably sharp images of all subject matter from a range of approximately $1\frac{1}{2}$ metres (about 5 feet) to infinity.

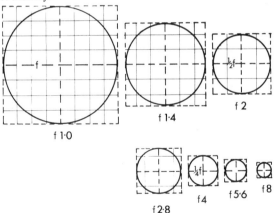

SERIES OF APERTURES
 The Relative Aperture of a lens diaphragm is its diameter divided by the focal length; if its diameter is equal to the focal length the aperture value is *f*1, while if it is half, the aperture value is *f*2. The circles shown have their diameters decreasing in the ratio of $\sqrt{2}$, so that their areas are halved at each step. Camera lens apertures in such a series thus reduce the transmission of light by half at each setting.

64

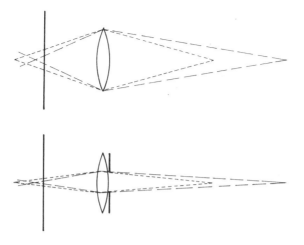

VARIATION OF DEPTH OF FIELD WITH APERTURE
As the aperture of a lens is reduced the cone of rays reaching the film becomes narrower and the circle of confusion becomes acceptably small for a greater range of object distances.

Recording the visual image

Having now considered the way in which an optical image of the scene is formed by the lens system of the camera it is now appropriate to study the mechanism by which this image is recorded.

All photographic processes depend on the formation of an image by action on the components of a sensitive layer. The most important processes in film technology are those in which this image is produced by light falling on a layer of gelatine emulsion containing minute grains of light-sensitive silver compounds, usually silver bromide, or other halides. Although the effect of intense light for long periods can produce an obvious darkening of the sensitive layer, the amount of light normally used in photographic processes produces only invisible changes in the silver compound grains which have been exposed and the image at this stage is known as the latent (or 'hidden') image. To make this latent image visible, the layer must be treated with chemicals which cause the exposed grains of silver halide to be changed to grains of metallic silver, leaving the unexposed grains unaltered. This process is known as development and the latent image now becomes visible as an image of black silver grains. However, the grains of unchanged silver halide are still present in the layer and would be subsequently affected by light if they were allowed to remain. At the completion of the developing operation the photographic material is washed with water to remove the developer chemicals and then treated to a further chemical process which dissolves away the grains of unexposed silver halide. This process is known as fixing and leaves only the developed silver image in the layer. A final water wash removes all the soluble chemicals from the preceding operations and the material can then be dried to remove the water which has been absorbed by the gelatine layer so that the resultant photograph can be safely handled. The complete sequence of operations is known as processing, but is sometimes loosely termed developing, which is strictly only one stage of the series.

65

In motion picture work the gelatine layer containing the light sensitive silver compounds is of course, coated on a flexible transparent base. The result of processing an exposed strip of film is thus in its simplest form to produce on a clear background an image made up of black silver grains wherever the light has reached the film. Where more light has reached the film, a larger number of grains will be affected and the image will be blacker. The processed film is therefore a record of the variations in light falling on its surface at the time of exposure. In normal motion picture production the first stage is the exposure of film in a camera, by which the varying intensities of light reflected from the objects in the field of view are recorded on the sensitive emulsion layer. After the exposed film has been subjected to the development process the resultant

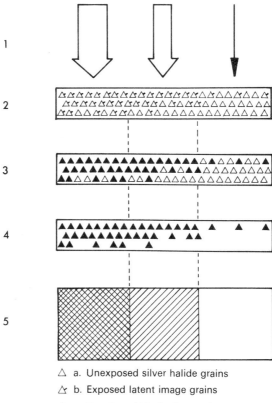

△ a. Unexposed silver halide grains

⋩ b. Exposed latent image grains

▲ c. Developed black silver grains

FORMATION OF PHOTOGRAPHIC IMAGE
(1) Varying amounts of light from the scene fall on the photographic film in the camera and produce changes in some of the silver halide grains (2), the latent image. On development (3) these grains are converted to silver and by fixing (4) the remaining unexposed grains are removed. The resultant image (5) is thus darkest where most light has affected the film.

66

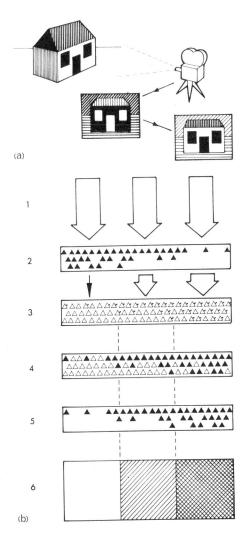

(a)

1

2

3

4

5

6

(b)

NEGATIVE AND POSITIVE IMAGES

a. After processing, the film exposed in the camera shows a Negative image in which the light and shade of the original scene appear in opposite tones. A photographic print from this produces a Positive image in which the tones are reproduced in their correct sense.

b. When printing from a negative (2) the varying concentrations of silver grains attenuate the uniform light (1) in the printer so as to produce different exposures in the emulsion layer of the positive film (3). The latent image so formed is developed to black silver grains (4) and the unexposed silver halide removed by fixing (5). The resultant image (6) thus shows a variation of light and shade corresponding to that of the original subject.

image records the various tones of the scene in such a way that the brightest areas which have reflected the most light, appear as the blackest portions of the film image, while the darker areas, reflecting less light, are much less heavy on the film. This film image is thus the opposite of the original scene in tonal values and is known as a negative image. To represent the correct tonal values of the original scene it is necessary to make a copy from the negative image by allowing light to pass through it on to another strip of photographic film, this process being known as printing. Where the negative image is blackest it will prevent most of this light from passing through, and where the negative image is less dark more light will reach the second film. When the printed film is developed it will thus show an image in tonal values opposite to those of the negative image and will represent the light and shade of the original scene in correct terms. This type of image is called positive and when produced by printing from a negative image it is called a positive print. Most of the photographic methods used for professional motion picture production in both black and white and colour are based on this negative-positive sequence.

Reversal processing

There is however one important variation of this normal system. Here the film exposed in the camera is processed in such a way that its image tones correspond in light and shade with those of the original scene, rather than becoming their opposite as in a normal negative. This system is known as reversal processing and produces the positive image on the actual film which has been exposed in the camera without the need to print a further copy.

In reversal processing the exposed film from the camera is first developed in the ordinary way, to produce a negative image, but before proceeding to the next stage of fixing, as in the normal process, the developed silver forming the first image is chemically bleached and dissolved away leaving only that part of the original sensitive silver halides which were not originally exposed. This residual material is then either exposed to light or chemically treated to have a similar effect and the film is now developed for a second time to change the newly exposed grains into black silver particles. The amount of silver developed at this second stage is greatest where the original exposure was least and proportionately less wherever the original exposure was greater, so that the image now produced is opposite in its tonal values to the negative image and is thus a positive corresponding to the original scene. The film is then passed through a fixing bath to remove any part of the silver halide which may not have been completely developed to silver, after which it is washed and dried ready for final use.

Basis of colour reproduction

In colour photography it is necessary to record not only the light and shade but also the colour characteristic of the illumination reflected from the various objects comprising the scene before the camera.

White light, such as sunlight or the light from an electric lamp, is made up of radiation of widely differing wavelengths, and these different wavelengths give rise to the sensation of colour when they reach the eye. White light can be separated into its constituent wavelengths and the individual components are then recognised as the colours of the visible spectrum. When this phenomenon occurs naturally by the refraction of light in raindrops these individual components are seen as the colours of the rainbow. Conventionally these colours are

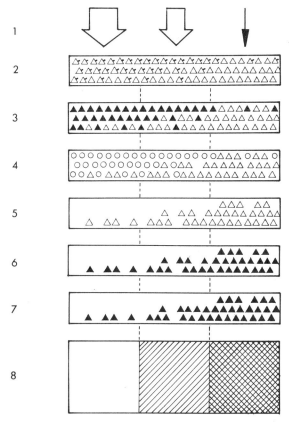

IMAGE BY REVERSAL PROCESSING

Varying intensities of light (1) from the subject being photographed produce a latent image (2) in the emulsion of the camera film. This image is developed to black silver grains (3) which are then chemically bleached (4) and dissolved away (5). The remaining silver halide grains are then exposed to light and after developing (6) and fixing (7) produce a positive image of black silver grains having the same tone distribution as the original scene (8).

taken to be violet, blue, green, yellow, orange and red but in fact they merge imperceptibly from one to the next with almost infinite gradation. The psycho-physiological mechanism by which we perceive colour is still obscure but it is generally accepted that the eye contains receptors which are sensitive to three main regions of the spectrum, blue, green and red, known as the primary colours. By mixtures of light of these three colours normal observers can match a wide range of the hues encountered in every day experience.

The classical experiments of Clerk–Maxwell over one hundred years ago (1861) showed that an acceptable representation of actuality can be obtained

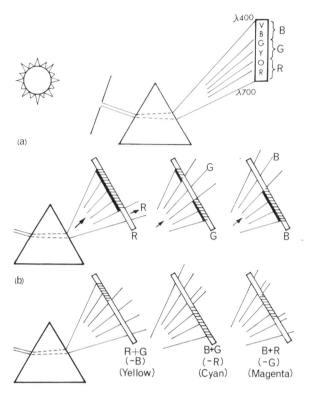

COLOUR PRINCIPLES

(a) White light, such as sunlight, can be broken down by a prism into the colours of the rainbow ranging from violet blue through green and yellow to orange and red. Although a continuous range of hues can be recognised in this spectrum, it is possible to obtain acceptable colour reproduction by regarding it as containing three main components, Blue, Green and Red, called the Primary colours. (b) Colour filters have the property of transmitting the light of certain parts of the spectrum only, thus a Red filter will pass only the red region. A filter passing red and green light and stopping blue may be regarded as a Minus Blue filter and the transmitted light appears Yellow.

Minus Blue transmits Red and Green = Yellow
Minus Red transmits Blue and Green = Cyan
Minus Green transmits Blue and Red = Magenta

These are the three Secondary colours.

if three photographic records are made of a scene by light from the blue, green and red divisions of the spectrum and these records are subsequently recombined so that the proportions of blue, green and red light reaching the eye for each part of the scene are correctly balanced.

Many systems of colour photography have been devised, although only a few

of these can be usefully applied to cinematography. All the more satisfactory methods have been based on first recording separate images of the scene to represent its blue, green and red aspects. The methods for combining these records to form a picture can be divided into two main groups, according to the way in which the colour reproduction is obtained.

In *additive* methods various proportions of blue, green and red light are

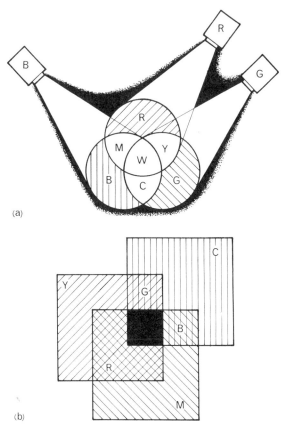

(a)

(b)

COLOUR MIXTURE

 (a) Additive mixture is demonstrated by the superimposition of three beams of light of the Primary colours, Red, Green and Blue. Where these overlap in pairs they mix to form the Secondary colours, Yellow, Cyan and Magenta, while where all three appear the result is white light. (b) Subtractive mixture is shown by the superimposition of colour filters of the three Secondary colours, which absorb ("subtract") some components of the incident white light. When these filters overlap in pairs they transmit the three Primary colours Red, Green and Blue, but where all three are present all colours are absorbed and the result is no light transmitted, or black.

71

combined to produce the required colour. Mixtures of blue and green produce the range of blue-green colours, mixtures of blue and red a range of violets and purples from blue-violet to red-purple, while mixtures of green and red light yield a series of yellows from greenish-yellow to orange-red. The addition of a proportion of the third light component to any of these two component mixtures produces lighter and paler effects until a mixture of all three components in the correct proportion produces white light.

In the second group of colour photography methods, called *subtractive*, the required colour is obtained by extracting from white light all the unwanted wavelengths leaving only the colour required. It is convenient to use three dyes which are opposite to the three primary colours and which are known as the complementary colours. The complementary of red is the colour which is left when all the red region of the spectrum has been removed from white and is thus blue-green in appearance; it is sometimes known as minus-red, but more conveniently as cyan. The complementary of green is minus-green, a red-blue mixture giving a reddish purple known as magenta, while the complementary of blue, the colour given by white light from which the whole blue component has been removed, is a mixture of green and red light, which is yellow. Mixtures of these subtractive colours filter out various proportions of the three sections of the spectrum and so provide a wide range of hues in reproduction. Mixtures of yellow and cyan give rise to greens from yellow-green to blue-green; mixtures of yellow and magenta give varieties of red from yellowish-orange through scarlet to reddish purple while cyan and magenta mixed produce a range of blues. When all these dyes are present all portions of the spectrum will be filtered out to some extent and with sufficient quantities of each the result can be gray or black.

Additive methods of colour reproduction are no longer in practical use in motion picture photography but they form the basis of all current systems of presenting a colour picture on the television receiver. Modern colour cinematography employs only subtractive methods of colour reproduction.

Colour photography

The first step of any system of colour photography is to obtain in the camera a record of the blue, green and red aspects of the scene being photographed. For many years the most widely used method made use of three separate negatives exposed by means of filters to blue, green and red light respectively and developed by conventional methods to give three black and white negative images. But this has been obsolete since the early 1950's. All colour motion picture photography now makes use of multilayer film materials termed tripacks, in which the three colour records are obtained in three layers on a single strip.

In these multi-layer tripacks the three sensitive emulsion coatings each contain chemicals known as sensitizers which make them react photographically only to light of a particular group of wavelengths. It is simple to obtain an emulsion which is sensitive to blue light only but it is not at all easy to produce emulsions sensitive to red or green light without some blue sensitivity as well. It is therefore necessary to include in the layers of the tripack a filter layer which will prevent blue light from reaching the layers where the other colours are to be recorded.

A typical film for colour photography is thus made up of a top layer which is blue sensitive only, under which is a yellow filter layer to stop the blue light component from going any further. The next layer is made from an emulsion

which is sensitive to blue and green light only, while the bottom layer is sensitive to blue and red light only. Light passing through the camera lens and forming an image on the film thus affects each layer to a different extent depending on the proportions of blue, green and red in each part of the image. Light from a blue part of the scene, such as a blue sky, will mainly affect the top layer, while light from red or green objects will be recorded only on one of the correspondingly sensitized lower layers. Light from a yellow object will affect both the red and green sensitive layers but will leave the blue sensitive top layer unaffected, while a purple object, reflecting both blue and red light will be recorded in both the top and the bottom layers. Light reflected from white objects and thus containing more or less equal blue, green and red components affect all three layers equally. Other coloured objects which reflect a certain amount of light in all three regions of the spectrum produce images which affect each of the three

(a)

FORMATION OF COLOUR NEGATIVE IMAGE
(a) A normal colour negative film consists of three separate emulsion layers on one base (5), and is hence termed a tri-pack. The top layer (1) is sensitive to blue light only and under this is a yellow filter layer (2) absorbing blue light. The middle layer (3) is sensitive to green and blue light but blue light does not reach it because of the yellow filter (2). Similarly the lowest (4) layer is sensitive to red and blue light but only red light reaches it. The three layers thus record separately the blue, green and red light components of the image formed in the camera.

layers to some extent and thus form a record representative of the original colour.

After exposure the film must be processed and as in black and white photography the first essential step is to develop the latent image produced by light to an image of black silver grains. In developing colour negative films, however, the chemicals used to form the silver image at the same time react with other components called couplers (which have been incorporated in the emulsion layers) so that a coloured image is produced at the same time as the silver image. The three colour couplers included in the three emulsion layers are chosen so that the colours of the images thus produced are complementary to the light for which each layer has been made sensitive. The top layer, which has been made blue sensitive, contains a coupler which yields a yellow image wherever silver has been developed, the middle green-sensitive layer forms a magenta image and the bottom layer, which is sensitive to red light, contains a coupler to form a blue-green, or cyan, image.

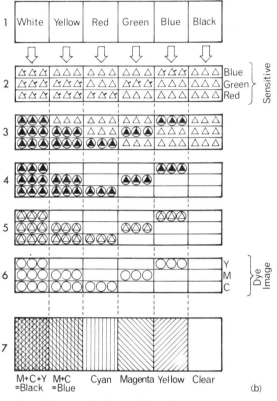

| 1 | White | Yellow | Red | Green | Blue | Black |

2 Blue / Green / Red } Sensitive

3

4

5

6 Y / M / C } Dye Image

7

M+C+Y M+C Cyan Magenta Yellow Clear
=Black =Blue (b)

△ a. Unexposed silver halide grains
△ b. Exposed silver halide grains (latent image)
◉ c. Developed silver grains with associated colour
 image
○ d. Colour image only.

FORMATION OF COLOUR NEGATIVE IMAGE
 (b) Light of various colours from the original
scene (1) reaching the colour negative in the camera
produces latent images in the three emulsion layers (2).
On development (3) complementary colour images are
formed in each layer wherever a black silver grain is
produced. Unexposed silver halide grains are removed by
fixing (4). To remove the remaining black silver image it is
bleached (5) to silver halide and dissolved out by a
second fixing process (6). This leaves an image consisting
only of the three complementary colour dye components,
which is a colour negative (7) of the original scene.

 The next stages in processing the film remove the unwanted constituents of
the emulsion. First of all the film is washed to stop the developing action and
remove the developer chemicals. The unused grains of unexposed silver halide
are then dissolved away by fixing, as in black and white processing. The black

74

developed silver image is still present, however, and thus must be removed by chemically bleaching it and then dissolving it away by a second application of the fixing solution. After washing with water to remove all soluble chemical residues the film is then dried.

The result of this sequence of operations is a colour negative, which is an image opposite to the original scene not only in the light and shade of its tonal values but also in its colours. Thus a bright red object appears as a dark blue-green image, a blue sky is recorded as dark yellow while a dark green object produces a light reddish-purple image.

To reproduce the original scene this colour negative must be copied by printing on to another strip of corresponding tripack film to produce a colour positive. Light passing through the coloured images in the three layers of the negative affect the three sensitive layers of the second film in the appropriate proportions. After a similar processing sequence the result is a representation of both the light and shade and the colours in the original scene. For example, light passing through the yellow area representing the blue sky area on the negative will affect both the red and green sensitive layers of the print film so, after processing, both cyan and magenta images will be formed in this part of the picture, which will thus appear blue in colour.

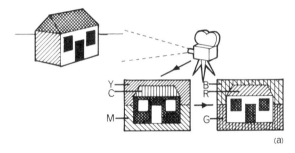

(a)

COLOUR NEGATIVE AND POSITIVE IMAGES
(a) The film exposed in the camera is processed to give a colour negative image in which both tones and colours are reproduced in the opposite sense: blue sky is recorded as a yellow image, green grass as magenta and the red roof of the house as cyan. By printing from this negative on to a similar tri-pack material a colour positive image is produced with the tones and colours in the correct sense.

Colour reversal processing

As in black and white work, some forms of tripack colour film are made in such a way that they may be processed to produce an image corresponding to the light and shade and colour of the original scene. This is known as colour reversal processing and is widely used in amateur cinematography although it is of somewhat limited importance in professional motion picture work.

With this system the exposed film from the camera is first developed to form silver negative images in each layer but at this stage chemicals are used which

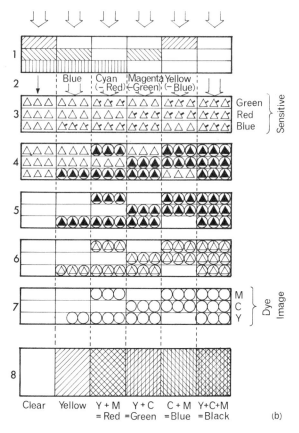

COLOUR NEGATIVE AND POSITIVE IMAGES

(b) In making a print the colour image of the negative (1) transmits light (2) which forms latent images in the three layers of the positive film (3). Development forms complementary colour images in each layer wherever a black silver grain is formed (4). Fixing removes the unexposed silver halide grains (5) and the silver image is then destroyed by bleaching (6) and fixing (7). The remaining colour dye images form a positive image (8) corresponding to the colour and tones of the original scene.

do not at the same time form any colour images. After washing, the film is uniformly exposed to light (or chemically treated for the same effect) and then developed for a second time using chemicals which produce colour images associated with the newly developed silver images in the three layers. All the silver from both the first and second developing processes is next removed by bleaching and fixing and after washing and drying the film is ready for use.

In this process the colour images are formed in those parts of the three layers which were not originally affected by light at the time of exposure, so the result

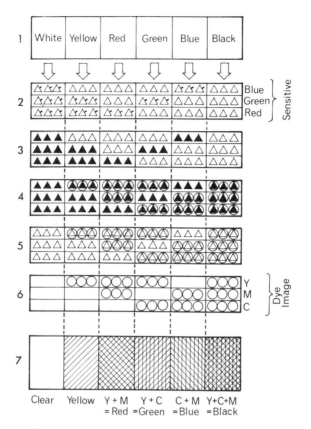

FORMATION OF COLOUR REVERSAL IMAGE

Light from the original scene (1) forms latent images in the three layers of the camera film (2), which are converted to black silver images by the first developing stage (3). The remaining silver halide grains are then exposed to light and by a second colour developing stage complementary colour images are formed when each of these grains is converted to silver (4). All the silver images from both developments are bleached (5) to silver halide and removed by fixing (6). The resultant colour dye images thus have the tonal character of a positive image (7) representing the original scene.

is the opposite of a normal colour negative and has the tonal values and colour of a positive print representing the original scene.

The chemistry of processing

A wide variety of chemical solutions is used in motion picture processing for different types of film, but developing baths all show a number of common

features. These solutions, which convert the exposed latent image into a visible image of silver grains, always contain the following constituents:

Developing agent which reduces the exposed silver halide crystal to metallic silver, itself becoming oxidised in the process. Developing agents used for black and white work are hydroquinone, paraphenylene diamine and the proprietary chemicals, metol and phenidone.

Preservative which protects the developing agent from the oxygen of the air and combines with the oxidation products of development. Sodium sulphite is almost always used.

Alkali to ensure the activity of the developing agent the solution must be made alkaline, usually by the addition of sodium carbonate but sometimes borax.

Restrainer which controls the rate of developing action so that unexposed silver halide crystals are not affected by the developer agent. The restrainer is always sodium or potassium bromide.

In the development of colour images, developing agents, usually known by trade references such as CD2 and CD3, are employed. These give rise to oxidation products that combine with couplers in each emulsion layer to form an insoluble dye. When any grain of silver is developed, the oxidation products formed in its immediate vicinity combine to form an associated particle of dye. Colour development thus produces at the first stage an image made up of both silver grains and dye, mixed together.

A developing process is always followed by a washing operation to remove the chemicals from the film; this wash is often made with an acid solution to neutralise the alkalinity of the developer and terminate its action. Such solutions are termed stop baths and the acid used is generally acetic acid.

To remove the unexposed and undeveloped silver halide from the emulsion a fixing solution is used. This contains a chemical which can combine with the silver halide to form a soluble compound that can be dissolved out. The traditional solvent chemical is sodium thiosulphate, more familiarly known as hypo, although the more efficient but more expensive ammonium thiosulphate is sometimes employed. A fixing solution generally also contains a small amount of sodium sulphite as a preservative and is made slightly acid by the addition of acetic acid or potassium metabisulphite. A hardener of gelatine, such as potassium alum, is often included to toughen the emulsion of the finished film.

Hypo has only a very small effect on the developed black silver, so in order to remove this from the combined dye and silver image produced by the colour developer it must first be reconverted to a suitable form of silver halide; this is termed silver bleaching. Bleach solutions contain sodium bromide as a source of the halide together with an active agent such as potassium ferricyanide or dichromate which converts the black developed silver to yellowish-white silver bromide. The dye image is not affected by this process and the resultant silver bromide can then be removed by a second fixing bath containing hypo.

A vital constituent in film processing is of course water, used in large quantities both to dissolve the solid chemicals which make up the solutions and for washing out of the film the residues absorbed by the gelatine after each processing stage. The final film washing at the completion of all stages is most important, since residual chemicals can cause staining and fading with age. Main city water

supplies often contain small amounts of calcium, which can give rise to deposits in pipes and on equipment in some of the solutions. When hard water must be used, water softening agents such as Calgon and Tetralon are often added to solutions in small quantities to prevent these deposits forming.

3 Characteristics of the photographic image

When photographed a scene is recorded on the film both geometrically, as a two-dimensional image, and photometrically in relation to the brightnesses of these objects. When the negative has been processed a positive print made from it can be projected on a screen to reproduce the appearance of the original scene. The character of this reproduction is of great importance.

Scene brightness range

The component objects of a scene appear light or dark to the eye according to the proportion of the light falling on them which they reflect. A freshly-painted white surface or a brilliant white card may reflect as much as 90% of the incident light, while at the other end of the tonal scale a piece of jet black velvet may only reflect 2%. For less extreme materials, a piece of average white writing paper could have a reflectivity of 70%, a medium grey fabric 10% and a black cloth 4%. The photographic film in the camera has to record not only these variations of reflectivity but also the differences of light and shadow falling on different parts of these objects. In an outdoor scene in brilliant sunlight with strong shadows the light falling on the directly sunlit side of an object may be many times stronger then the light on its shadow side where the only illumination is that from the sky and reflected from surrounding objects. On a dull day with uniform cloud on the other hand, there are no shadows and the light falling on an object can be almost the same from any direction – contrast between the lighter and the shadow side would therefore be very small. The lighting contrast factor is of fundamental importance in considering the brightness range that the film must record since it extends the extremes of lightness and darkness in the scene to well beyond that accounted for purely by its reflective ability. Thus the white paper and black cloth previously considered may reflect 70% and 4% respectively of the light falling on them but the illumination reaching them in

the shadow area may only be one-eighth of that on the lighted side. The relative brightnesses in the scene are thus:

On the light side: white paper 70; black cloth 4

On the shadow side: white paper $\frac{1}{8} \times 70 = 8\frac{3}{4}$; black cloth $\frac{1}{8} \times 4 = \frac{1}{2}$

The tonal range from lighted white to shadowed black is thus 70 to $\frac{1}{2}$, or a ratio of 140 : 1.

Densities

It is often convenient for photographic purposes to deal with tonal values not as percentage reflectances, where 100% represents a perfect white but as reflection densities on a logarithmic scale in which the darker the material the larger the density value. Reflection density is defined as the logarithm to the base ten of the reciprocal of the reflectance expressed as a fraction, or the log of (100 divided by the percentage reflectivity).

$$\text{Reflection } D = \log_{10} \frac{1}{R} = \log_{10} \frac{100}{R\%}$$

On this scale, a perfect white surface (reflecting 100%) has a reflection density of 0·0; a surface reflecting half the incident light (50%) has a reflection density of $\log_{10} 2 = 0.30$, while reflectances of one-tenth (10%) and one-hundredth (1%) correspond to reflection densities of 1·0 and 2·0 respectively $(\log_{10} 10 = 1.0, \log_{10} 100 = 2.0)$.

SUBJECT BRIGHTNESS RANGE
The white wall reflects 70% of the incident light and the black painted doors only 4%, but on the shadowed side the incident light is only one-eight of that on the sunlit side. The relative brightness range of this subject therefore varies from 70 to (4×1/8) = $\frac{1}{2}$, a ratio of 140:1.

Light and dark areas on a developed film which allow greater or smaller amounts of light to pass through, can be measured for transmission density—

F

or the light-stopping power of the image. This concept of transmission density is defined as the logarithm to the base ten of the reciprocal of the fraction of the incident light which that part of the image transmits, or the log of (100 divided by its percentage transmission).

$$\text{Transmission } D = \text{Log}_{10}\frac{1}{T} = \text{Log}_{10}\frac{100}{T\%}$$

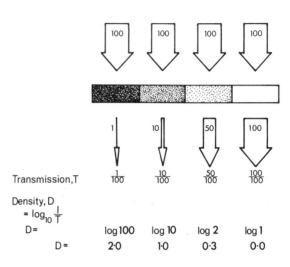

PHOTOGRAPHIC DENSITY

The light-stopping power of the developed black silver image in the film is measured by its density, which is defined as the logarithm to the base ten of the reciprocal of its transmission factor. Perfectly clear film having no light absorption would have a density of 0·0 while a heavy image passing only one-hundredth of the incident light would be given a density value of 2.0.

The relation between the brightness of objects in the original scene and on the negative is conveniently assessed by considering the reflection densities of the scene and their illumination, and the transmission densities which result on the exposed and processed film. The measurement of these relations is termed the sensitometry of that stage of the photographic process.

Sensitometry

In an ideal reproduction process, there would be a perfect uniform relation between all possible values of brightness of the objects in the scene and the density of their record on film but in practice there are very effective limitations. On one hand, the amount of light reaching the film through the lens from a dark object may be insufficient to produce a latent image in any of the silver halide grains of the emulsion, so that no record is produced. On the other, once all the available grains in the emulsion layer have been exposed, further light cannot produce any greater density in the developed image. Even within these limits

the change of image density with object brightness is not completely uniform. If the relation between the reflection densities of a uniformly illuminated series of objects ranging from a very brilliant white to an extreme black and their densities recorded on the film is shown graphically, the result is seen as a curve having a flattened S-shape between the limits of the minimum and maximum film densities. This shape is the characteristic curve typical of many photographic processes and is familiarly known as the H & D curve, after the scientists Hurter and Driffield who first established its basis about 1890.

Reflection densities have been used to introduce the idea; the more general practice is to consider the actual brightness of the objects before the camera taking account of both their reflectivity and the light falling on them. Each part of the scene can then be regarded as having its own brightness of intensity I and the curve to be studied would be that relating log I with the density D resulting.

The density of the image produced on a film is determined not only by the intensity of the light reaching its surface but also the length of time for which it is exposed. Over a wide range of such exposure times their effect is exactly

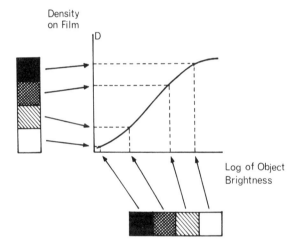

CHARACTERISTIC CURVE
If the relative brightness of a series of objects is expressed on a logarithmic scale their relation to the densities of the photographic image they produce can be shown on an S-shaped curve known as the Characteristic Curve.

similar to that of intensity variations. Reduction of light intensity to a half may then be offset by increasing the exposure time by a factor of two; exposure E is thus proportional to the intensity I multiplied by the time t, or $E = I \times t$, and in constructing the curve which is to represent the characteristics of a photographic process the relation to be shown is that between the density D produced and the logarithm of the exposure E, that is Log It.

In motion picture photography the exposure time in the camera is normally fixed and closely controlled. At the standard speed of 24 pictures per second the

the exposure time is generally taken as $\frac{1}{50}$th of a second. If the camera is run at a higher speed the resulting shorter exposure time must be compensated by increasing the intensity of the light reaching the film, either by increasing the illumination of the scene in front of the camera or by increasing the diameter of the lens aperture setting.

In general, however, tonal reproduction in cinematography can be conveniently studied by the relation between the density produced on the film and the logarithm of the intensity of the brightness of various points in the scene.

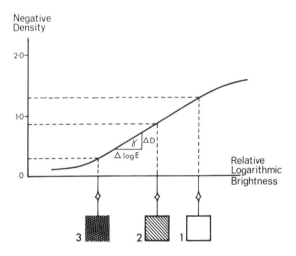

NEGATIVE TONAL REPRODUCTION
The characteristic curve of negative stocks shows low contrast, that is the ratio of the increase of density Δ D for a given increase of exposure, Δ log E, is about 0·65 over most of the range. This ratio $\Delta D/\Delta$ log E is known as the Gamma value, γ, of the film. The characteristic curve indicates the way in which objects of various reflectivities are reproduced as densities in the negative image.
1. White paper of 90% reflection
2. Grey card of 20% reflection
3. Black velvet of 2% reflection

Tonal reproduction in the negative

At its simplest, the tonal reproduction of a scene may be regarded as determined by the characteristics of the negative taking and the positive printing photographic materials, but in practice the optical effects of the camera lens and projection lens also have to be taken into account.

The film stocks used for photography are designed to produce negative images of low contrast in which the range of densities is not great but where there is a linear relation between the logarithm of the subject brightness and the resultant density on the processed film over as wide a range of intensities as possible. The slope of this linear portion of the characteristic is known as the

84

gamma value, usually a value of 0·60 to 0·70. With modern materials this portion can extend over a range of subject brightness intensities of 200 : 1 or so, corresponding to a range of 2·3 on the logarithmic scale. To provide accurate reproduction as much as possible of the brightness range of the subject should be recorded on this straight-line region. This means that the brightest whites in the scene must not produce too great a density on the negative, while the dark shadow areas must be sufficiently illuminated to yield image densities above the minimum. Measurement of the incident and reflected light in the scene and corresponding adjustment of the camera lens diaphragm to ensure a correct exposure of the negative image is therefore quite critical.

Light may be reflected and scattered from the glass surfaces in the camera lens and distributed as flare over the image on the film. This flare light produces an additional exposure on the negative which is proportionately much greater in the areas of lower subject brightness, (the shadows), than it is in the bright areas. Shadow regions thus receive more light than would have been expected and the effective brightness range between light and dark areas recorded on the film is reduced. With modern lenses this flare effect is reduced by anti-reflective coatings applied to the glass surfaces, a process sometimes known as 'blooming', but can still have an appreciable influence on tonal reproduction.

Tonal reproduction in the positive

When the negative is printed to give a positive image on another strip of film a further group of photographic and optical characteristics are introduced. The film stocks used to make positive prints for cinema projection normally show a wide density range with very low minimum levels, to allow high brightness in the white areas of the projected picture. For such materials the characteristic

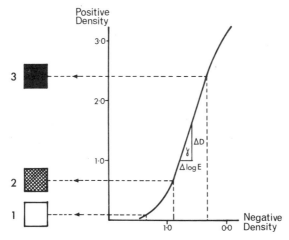

POSITIVE TONAL REPRODUCTION
Positive print materials show a high contrast, with $\Delta D / \Delta \log E$ value of the order of $\gamma = 3·0$ over the straight portion of the characteristic. The relation between the density of the negative and the resultant print is shown for the three tones 1, 2 and 3 in the previous diagram.

curve to be considered is that relating the density values of the negative with the densities produced in the print, both representing logarithmic scales of intensity. The slope of the main portion of the curve has a high gamma value, of the order of 2·5 or more.

It might have been thought that to provide an accurate representation of the tonal values of the original scene in the final projection the overall reproduction characteristics should have a value of unity, in other words that

$$(\text{Gamma of negative}) \times (\text{Gamma of positive}) = 1$$

but in practice this is not the case for cinema presentation. Just as light scattered within the camera lens reduces the effective brightness range recorded on the negative, so similarly light scatter and flare in the projector lens makes the dark areas of the picture much lighter than they would be with a perfect optical system. Any ambient light from the auditorium of the cinema theatre which falls on the screen has a similar effect, lightening the shadow areas but making a negligible addition to the bright portions of the scene. For these reasons the overall photographic reproduction characteristic of (Gamma of negative) ×

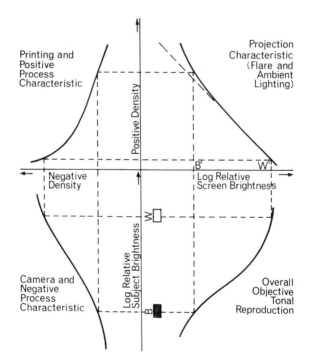

TONE REPRODUCTION
 Quadrant Diagram showing graphically the objective characteristics of stages of motion picture reproduction.
W = original subject White
B = original subject Black

(Gamma of positive) must be made appreciably greater than unity to offset the optical flare effects of camera and projector.

Overall reproduction

It is convenient to represent the characteristics of each stage of the reproduction in combination to show the overall effect in the form of a single figure, known as the quadrant diagram. Here the effects of flare in camera and projector and the nature of the tonal distortions caused by the photographic processes in the extreme light and heavy density regions can be followed in detail. It is found that the overall tonal reproduction characteristic relating the brightness scale of the original scene to its representation on the cinema screen is not a straight line but appears as a flattened S-curve, which indicates increasing compression of tonal steps at both the light and dark ends of the range.

Because of these limitations technical control at each stage of motion picture production, processing and presentation is essential:

1. The range of brightness in the original scene must be controlled by decor and lighting to fall within the scope of the photographic process;
2. The camera exposure must ensure that as much as possible of this brightness range is reproduced on the straight-line portion of the plotted characteristic curve of the negative film;
3. The laboratory must provide a standard and consistent developing process for the negative to produce optimum results from correctly exposed material;
4. Prints from the negative must be correctly exposed and processed to show the best reproduction of tones from highlights through to shadow areas;
5. In the final presentation projection must give the correct incident light brightness on the screen using lenses with minimum flare and avoiding stray light from other sources in the auditorium.

At each of these steps instrumental measurement, including especially the sensitometry of photographic processing operations at the laboratory, is essential, in combination with the talents of the creative artist.

Colour film characteristics

The basic requirements for colour films exactly follow those outlined above, but special attention has to be paid to a number of additional points. In the sensitometry of colour films image density measurements must take account of the three primary colours, red, green and blue, since the image is made up of three dye images normally representing these primaries. The photographic characteristics of an exposed negative film will thus be presented by three separate curves for the red-sensitive, green-sensitive and blue-sensitive components and the gamma values for each should be equal, otherwise objectionable differences of colour rendering from light to dark tones will result. (p. 96)

The tonal range recorded should also be equally reproduced in each colour record over the straight-line portion of each curve. This means that the colour of the light used to illuminate the scene must be that for which the particular film stock has been designed. Normally, camera films are made in two types, for exposure either by normal daylight or by incandescent lamps of a specified colour characteristic. When a film made for one type of light has to be used with

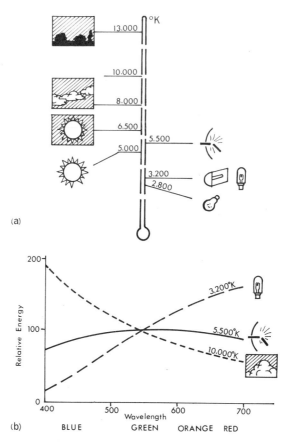

(a)

(b)

COLOUR TEMPERATURE
(a) The colour characteristic of a light source may be specified as its colour temperature: average noonday sun is about 5000°K, sun in a blue sky 6500°K, north light clouds in a blue sky 8000°K, and a blue sky alone up to 13000°K; a white flame carbon arc has a colour temperature of 5500°K. (b) As the colour temperature increases the proportion of the blue to the red component in the light increases; in the three examples shown, the relative energies have been made equal in the green region and large alterations in blue-to-red ratio are shown.

the other the light must be corrected to the required colour character by transparent colour filters fitted either over the light source or on the camera lens.

The colour quality of a light source is conveniently measured by its colour 'temperature'. At lower temperatures, 'red heat', the light given out by a glowing body contains most of its energy in the red and orange parts of the spectrum. As the temperature is raised to 'white heat' a proportion of yellow, green and blue wavelengths are emitted in addition. The higher the colour temperature, the greater the proportion of blue content to the red content of the light.

In practice, the scale used to specify the colour characteristic of a light source is given in degrees Kelvin: an ordinary incandescent electric lamp is rated about 3000°K, average sunlight between 5000°K and 6000°K, while light from a blue sky may exceed 10,000°K. A film made for exposure to artificial light of 3200°K will therefore give too heavy an image in the blue sensitive layer if used for photography by daylight, but this can be corrected by fitting a pale orange-yellow filter over the camera lens. This absorbs part, but not too much, of the blue component of the light.

Colour temperature ratings can only be applied to light sources which have a continuous emission throughout all regions of the spectrum. Some special types of discharge lamps, such as sodium lights and mercury vapour arcs, give out only limited spectral bands and cannot be specified by colour temperature.

Exposure control

In order to ensure that the aperture setting of the camera lens is correct for the best reproduction of the scene being photographed the intensity of illumination falling on the subject is measured with an incident light meter. In professional motion picture work the intensity is always measured in several directions, as it is necessary to know that the brightness range of the scene is not beyond the recording capability of the film.

Where the light sources are completely at the disposal of the cameraman, as in a film studio, they are normally distributed to provide a main directional light, the key light, and a general overall illumination, known as the filler light, which lightens the shadow areas cast by the main source. The ratio of the intensities of the key light plus filler to the filler alone is termed the lighting contrast. In colour photography this ratio should not be greater than about 3 : 1 unless harsh dramatic effects are called for, while films for television should have an even lower lighting contrast of the order of 2 : 1 for the best reproduction through the television system.

In exterior photography the effects of natural lighting must often be modified carefully. With strong direct sunlight the dark shadow areas must be filled in with illumination from reflectors or supplementary lamps, while the brilliance

EXPOSURE CONTROL
 (a) Object with three reflectances corresponding to a white of 90% reflectivity, a mid-gray of 20% and a black of 2% as lit by Key Light (1) and Filler Light (2) to a Lighting contrast of 4:1.

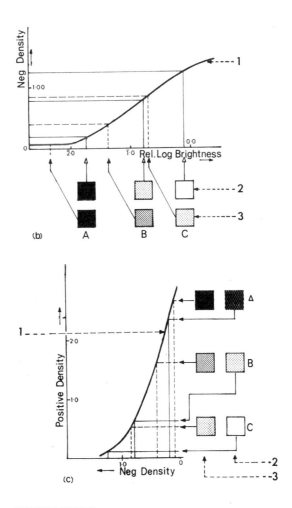

(b)

(c)

(b) Exposure level for the negative must be chosen to record as much as possible of the object tonal range on the straight line portion of the characteristic curve (1). A, B, C represent the three tones of the object, as the key-lit areas (2) and the shadow areas (3). (c) The exposure of the corresponding positive print from this negative must again ensure that the tones are reproduced on the most favourable part of the positive characteristic curve (1). The key-lit areas (2) and shadow areas (3) of the original tones A, B, C are reproduced as shown.

of the key light is tempered by shades or diffusing gauzes. Under dull weather conditions with overcast skies on the other hand, the natural daylight may only be sufficient to contribute the overall filler illumination and the key light required for modelling must be supplied by colour-matched artificial sources.

90

Light meters

An incident light meter consists basically of a photoelectric cell which can be held under the illumination, connected to a sensitive meter that measures the current so produced. The meter can be calibrated to indicate units of light intensity (as Lux, lumens per square metre, or as foot-candles) or it may be scaled to indicate the lens aperture setting required at a particular exposure time for a given film sensitivity. With professional motion picture photography in the studio the desirable lens aperture is often determined by the depth of field required in the scene, so the key light level is adjusted to the calculated intensity for the film being used. The filler light is then measured and modified to give the desired lighting contrast effect.

(a)

(b)

INCIDENT LIGHT METERS

(a) Paddle-Type Light Meter. Photocell is mounted separately on end of flexible lead and held wherever required to measure incident light. This type of meter is frequently used for accurate measurement of screen illumination.

(b) Incident Light Meters. Diffusing hemisphere, 1, over photocell is turned towards main source of light, but integrates light falling on it from many directions. In some designs the hemisphere is replaced by a diffusing cone, 2.

Incident light meters giving direct aperture settings are sometimes fitted with a translucent dome over the photocell so that they collect the light falling from all directions. The meter is held near the subject with the dome pointing towards the camera position. The meter scale is adjusted to the sensitivity of the film stock in use and the pointer reading indicates the lens diaphragm opening as an f-number setting for the required exposure time which is normally $\frac{1}{50}$ sec. for filming at 24 pictures per second. The aperture setting so obtained is determined only by the incident light intensity and assumes a subject of average reflectivity. So if an abnormally light or dark subject is being photographed, an allowance on the meter indication must be made for this fact.

Reflected light meters respond to the combined effect of illumination and subject reflectivity. In amateur cine cameras such a meter is often used to operate

(a)

(b)

REFLECTED LIGHT METER
(a) Unless the angle (1) over which a reflected light meter accepts light from the subject matches the angle of view of the camera lens (2), the readings may not provide an accurate guide to exposure. (b) Ideally, the light measured should be that actually received through the camera lens, as is done in some reflex shutter systems. The shutter (1) reflects the light from the camera lens (2) when the film (3) is being pulled down; part of the light is used to form the viewfinder image (6), while part falls on a photocell (5) which can be connected to a meter (5), to indicate the exposure required.

SPOT BRIGHTNESS METER

(a) Spot Exposure Meter. Reflected-light type of
meter with narrow acceptance angle for reading brightness
of small areas at a distance. Lens, 1, of instrument is
directed at subject by viewing through eyepiece, 3.
Button, 2, is pressed to take reading. Operating batteries
are contained in handle.

(b) Use of Spot Exposure Meter. Centre of field of
view shows point being measured, subtending 1° or 2° at
meter. Bright illuminated scale (actually seen as white
against face) is calibrated in foot-lamberts or as lens
aperture required at any camera speed for given film speed
rating.

the camera lens diaphragm automatically without adjustment by the user once
the film sensitivity rating has been selected. The acceptance angle of this type
of meter must closely match the angle of view of the camera lens and ideally the
meter cell should receive its light from the subject through the camera lens
itself. In some of the more sophisticated amateur cameras this is done by means
of a reflex optical system which directs part of this light to a photo-cell.

A form of reflected light meter used in professional motion picture photography is the spot brightness meter which allows the brightness of small areas of light and shade in the subject to be examined and its complete tonal range explored. Such meters usually indicate the brightness of an area subtending 2° or less and often include optical viewing devices to show the area being measured against the background of the whole scene.

Film sensitivity rating

The sensitivity of camera stock is specified by its exposure index or speed rating and several internationally recognised systems are in use. All are based on the smallest exposure required by the film (in absolute units of light intensity and time) to produce an image of given density above the minimum when the material has been processed under standard conditions.

Differences in sensitivity may be indicated in two ways. On the *arithmetic* scale the speed ratings are inversely proportional to the exposure level required. A film with a rating of 80 has twice the speed of one rated at 40 and requires only half the exposure, either in time or intensity, to produce the same results. One widely adopted rating system on an arithmetic scale is that specified by the American Standards Association and hence known as the ASA exposure index. A comparable British specification exists.

On the *logarithmic* scale it is the log of the minimum exposure which indicates the speed rating, and to provide convenient numbers these log values are multiplied by ten. A film requiring only half the exposure of another, having twice the speed on the arithmetic scale, will show a rating 3° higher on the logarithmic scale. Such a system was adopted by the German standards organisation and is known as the DIN scale (Deutsche Industrie Normalen).

Processing control

Satisfactory tonal reproduction also demands accurate control in the film processing, both for the development of the original negative exposed in the camera and in making the resultant prints. Sensitometry, measuring the relation of the exposure intensities to the densities of the image produced, is constantly employed to ensure the correct performance of developing and printing machines and of the chemical solutions involved. To prepare suitable standardised test material a sensitometer (controlled exposure device) is used rather than a camera. Short lengths of film are exposed to an accurately controlled lamp for a fixed time in such a way that a series of steps of different known exposures is obtained. When such a strip is processed the image shows corresponding series of densities, each step of which can be measured on a densitometer. By plotting these densities against the logarithms of the exposure intensities the characteristic curve of the process can be obtained and compared with a previously established standard to assess the condition of the developer where the test was made.

In processing laboratories where such tests are made at frequent intervals as a matter of routine it is often more convenient to expose the test strip to produce a continuous variation of density from light to dark rather than a series of steps. Such wedge exposures can then be measured on an automatic recording densitometer in which the pen of the recorder is moved to plot on paper the variation in density along the strip and so trace the characteristic curve directly.

Colour processes are studied by drawing the characteristic curve of the test

WEDGE EXPOSURE TEST STRIPS
Test strips for processing control are exposed with a graded series of intensities to provide a range of densities, either as a series of steps (1) or with continuous variation from light to dark (2).

strip three times to show separately the density variations measured by red, green and blue light respectively. The behavior of the three colour sensitive layers of the film is thus displayed. The exact relation of the three curves indicates any changes of developing machine conditions or chemical constituents which may occur and which require correction to ensure standard processing.

Motion picture film

The film used in motion pictures is essentially a sensitive photographic emulsion coated on a thin flexible transparent base. The base is manufactured and the emulsion layers coated on it in wide rolls which are subsequently slit to produce a number of strips of the final width required and these individual strips are then perforated with the sprocket holes necessary for their use in camera or projector. The dimensions of the film width and of the size and position of the perforation holes are internationally standardised for most gauges but the lengths of the rolls supplied may vary according to the manufacturer and the particular needs of the user. It is however general practice to coat the wide rolls of base in lengths somewhat greater than about 620 metres (2000 feet) so that continuous strips of this length can be supplied if necessary. The roll of base may be up to 1·35 metres (48 in) wide so that as many as 32 or 34 strips of 35 mm width can be slit from it after coating.

Base manufacture

Base manufacture depends on coating a viscous solution as a uniform layer on an impervious surface, leaving a thin film which can be stripped off after the solvent evaporates. The material used originally was cellulose nitrate with

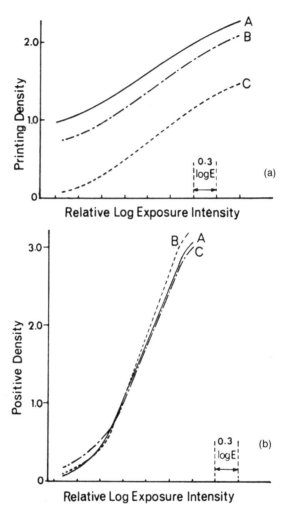

CHARACTERISTIC CURVES OF COLOUR FILM

(a) Curves of Masked Integral Tripack
Negative. Characteristic curves of typical material.
Densities to blue (A), green (B) and red (C) light are
plotted against logarithm of exposure. High minimum
values to blue and green result from masking system
which gives film an orange-yellow appearance in the
unexposed areas. (See p. 340.)

(b) Curves of Colour Positive Film. Exposed so as to
produce nominally neutral image in mid-tones. A. Yellow
image read by blue light. For ideal reproduction the
curves for each colour should be parallel. In this example,
the higher contrast of the cyan image. B, read by red light,
means that the shadow areas tend to be increasingly
blue-green. Flatter toe of magenta image, C, read by
green light, indicates that highlights and light tones will
appear too pink.

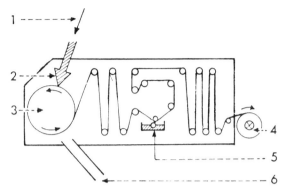

MANUFACTURE OF FILM BASE
Base-Making Plant. Dope from storage, 1, is fed into hopper, 2, which spreads it on highly polished drum, 3. Air conditions are adjusted to make solvents evaporate, and base is peeled off drum and passed over series of heated drums to complete curing. Substratum is applied, 5, to ensure subsequent adhesion of emulsion, and base is wound up, 4, ready for coating. 6. Solvent recovery.

solvents such as acetone and this type of base, celluloid, despite its extreme inflammability, was standard for motion picture film manufacture for more than fifty years. Since 1950, however, all film base has been made from cellulose tri-acetate, acetate-propionate or similar components of a comparatively non-inflammable nature. The specifications for the slow burning characteristics of such safety film are laid down by a number of national and international standards.

Film base was originally 'cast' on long glass sheets, and later as a continuous process on the surface of a high polished metal drum. Modern methods now increase the speed of the operation by casting on to a continuous band forming an endless loop. The viscous solution, or 'dope', is spread by an extrusion head to form a uniform layer on the horizontal surface of the moving band which passes through a heated tunnel to remove the solvent. As the band returns in its loop the layer has solidified sufficiently to be stripped off as a continuous web which then passes through drying cabinets to remove the last of the solvent, which is recovered at each stage. Absolute cleanliness and precision of drive and application are essential to ensure a consistent and uniform product of the standard required. Normal motion picture film base is made to a standard thickness of 0·13 mm (0·005 in), although for special purposes a heavy base of 0·20 mm (0·008 in.) is sometimes used. The use of nylon-type materials such as Estar and Cronar may lead to thinner bases of 0·003–0·004 in. becoming general.

Emulsion coating

Before the roll of base can be coated with its photographic emulsion layers it must be prepared in various ways. The most important of these is the 'subbing' process, in which one surface is coated with a thin layer which allows the emulsion to adhere firmly to the base. Other treatments to the opposite surface

97

involve the application of anti-static layers to avoid electro-static charges being built up during the handling of the film. For some materials a black dye coating is applied to absorb light passing through the base when the film is being exposed and prevent reflection causing halation of the image. At the final stage of preparation the edges of the base roll are trimmed and embossed with a raised pattern to prevent damage to the main surface in handling and storage.

The coating of the photographic sensitive emulsion layers on the base now follows — an operation which must be carried out in scrupulously clean conditions and usually in total darkness. The emulsion is applied to the base in a semi-liquid condition usually by extrusion from a coating head as the film passes over a large diameter drum which accurately supports it in position across its full width. Precise control of the emulsion thickness is needed both across the roll and throughout its length, as variations here can cause fluctuations in the final image. As the coated band passes from the drum it is chilled to set the gelatine of the emulsion so that it will not flow any further during its passage through the rest of the machine. Here the moisture present is removed by passing through drying cabinets so that the emulsion forms a stable and consolidated layer.

In colour films the base carries as many as six or seven separate coatings to provide the three colour sensitive emulsions and their interspersed colour filter layers, and originally it was necessary to pass the whole roll completely through the coating machine for each component, which was naturally an extremely expensive process. Improvements in coating technology and equipment now permit the use of a series of extrusion heads in sequence, so that modern multi-layer colour films are made on machines of great complexity by a continuous process which procedes without interruption from feeding the base to winding-up the final product. The wide coated roll, termed the jumbo roll, is now slit into a large number of strips of the width required, 35 mm, 70 mm or 16 mm, and these are spooled up on plastic cores of corresponding width. Slitting is a precision operation, since the width of the strips must be accurately maintained

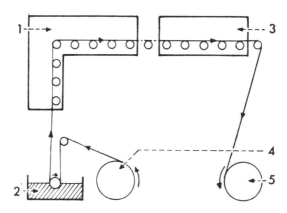

EMULSION COATING MACHINE
Raw base, 4, is drawn through pan of emulsion, 2, which clings to it by viscous drag, then passes to chilled air box, 1, which sets emulsion layer before reaching drying track, 3. After further conditioning, film is reeled up, 5.

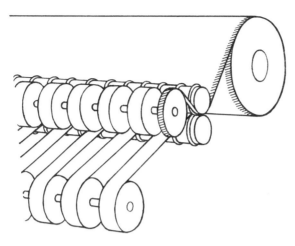

FILM SLITTING
Film base is coated in large ("jumbo") rolls up
to 60 inches wide and 2500 feet in length, which are then
slit into strips of the final width required — 70 mm, 35 mm
or 16 mm — and spooled for perforating. The embossed
edges of the large roll which have been used for transport
through the coating machine are discarded.

within limits of 0·025 mm (0·001 in.) and any possibility of dust or dirt from
roughly cut edges must be completely avoided.

After slitting, the individual strips of film are perforated with their sprocket
holes along one or both edges and wound up on plastic cores in rolls of the
length required for final packing and delivery. This is a further operation requir-
ing very high precision machinery, since most of the dimensions concerned must
be held to close tolerances of the order of ±0·01 mm (0·0004 in.) throughout the
whole length of the strip. To ensure this, perforating machines are operated in
rooms whose atmosphere is accurately controlled for temperature and humidity
as well as filtered for complete cleanliness from dust and dirt. To ensure
accuracy, sample strips are taken frequently from the output of each perforating
machine and their dimensions measured and recorded.

The perforated rolls are then packed, usually by wrapping in black paper bags,
and placed in circular metal cans which are sealed with strips of fabric tape.
This tape seal both prevents the can being inadvertently opened before it is
required for use and helps to maintain the correct humidity inside. As in all the
preceding operations, the film must be handled in total darkness or very re-
stricted safelighting in rooms whose air supplies are carefully cleaned and
conditioned.

It is not necessary to go into further details of the motion picture film manu-
facturing process, but in many subsequent technical operations it is useful to
recognise the identifying reference markings of the product. A series of numbers
appears on the label of the film can, on the sealing tape and often perforated
or stamped on the ends of the packed roll of film itself. The first group gives
the manufacturers code number for the type of film, negative or positive, colour
or black and white, etc. The second group of numbers indicates the particular
emulsion batch of this particular type, and a third group gives the numbers of

the wide rolls coated with this particular emulsion. The number of the individual strip cut from the wide roll is usually shown separately on the label of the can and as another perforated numeral or numbered sticker on the outside of the film roll itself. The full identification might thus be:

5254	202	37	17
Type	Emulsion batch	Roll coating	Strip position

The information thus given is of value in both studio and laboratory operations. For example, all rolls with the same emulsion batch number can be expected to have substantially identical photographic characteristics for exposure and processing. Similarly, a manufacturing coating defect in a particular roll may be found at a similar position along the length of several strips with adjacent slitting numbers. The foregoing identifications are normally found on the packing and on the film, or the raw stock, as it is usually termed. Other information may have been exposed photographically on the emulsion by the manufacturer and only become visible after the film has been processed. These often include the manufacturer's name or trade mark, or identification of the coating plant or factory and sometimes an indication of particular slitting and perforating machines. Another important identification, which is obligatory in some countries, is that which shows the film has been manufactured on safety base. This may be shown as the words 'safety' or 'non-flam' printed along the margin, or the letter 'S' between the perforation holes.

On negative materials for exposure in the camera it is usual for the manufacturer to print a group of numerals, called edge numbers or footage numbers, in sequence at intervals of sixty-four 35 mm perforations or forty 16 mm perforations (one foot) to identify a position along the length of a strip of film and as an aid in matching the original negative and the corresponding positive prints to the exact frame. Sometimes these numbers are printed in ink on the base of the film and can be read on the raw stock but often they are exposed photographically during perforating and can only be seen on the processed material.

Physical characteristics

Although initially manufactured with great accuracy, the dimensions of motion picture film can alter substantially due to changes of temperature and humidity, and such changes have to be taken into account in many printing and processing operations. Wherever image dimensions or position must be accurately maintained the film must be handled under strictly controlled conditions of temperature and humidity. In general film expands with moisture and shrinks on drying but the base and emulsion absorb and give up water at different rates and the changes are complex; they may be temporary and reversible, as in processing, or permanent as a result of age. Because of the method used for base manufacture the proportionate changes across the width of a strip of film are usually slightly greater than those along its length.

Dry film in air at room temperatures expands with increasing humidity by approximately 0·007% per 1% change of relative humidity. Heat also causes expansion, approximately 0·003% per 1°F or 0·006% per 1°C. Because of this,

measurements of film dimensions should always be made at specified conditions, usually 21°C (70°F) and 70% RH.

When film is immersed in water or processing solutions the gelatine emulsion may absorb two or three times its own weight of water and swell to ten times its dry thickness. The base will also absorb water and a total expansion of the order of 0·4 to 0·5% may occur even at room temperature is sufficient time is allowed. During drying however, the film returns very nearly to its original dimensions, although a small degree of permanent shrinkage or stretching may result, depending on the details of the treatment given.

Once the film has been processed, a certain amount of permanent shrinkage may occur with age over a long period as a result of the slow loss of solvent and plasticizer from the base. With negative materials stored under conditions which avoid high temperatures and humidity this shrinkage may reach 0·2% in the course of a few years. Positive prints, being more frequently handled during projection and stored without special conditions, will show a somewhat greater and more rapid shrinkage, reaching 0·4% to 0·6% over a period of years.

Film dimensions

Motion picture film dimensions have been officially standardised in many countries for a long time and in most cases there is general international agreement on these dimensions. The various types are specified by their width and the size and the arrangement of their perforation holes, measurements and tolerances always referring to the raw stock as manufactured because of the dimensional changes which may take place after processing.

Of the many film gauges which have appeared during the history of the cinema, the most important now in use are those of nominal width 8 mm, 16 mm, 35 mm and 70 mm. Of these the 35 mm gauge is the most widely used for professional motion pictures and is found with three different forms of perforation hole, each for a particular purpose.

One of the earliest types of perforation hole, known as the BH, from the equipment manufacturers Bell & Howell who originated it, has straight parallel sides (flats) with rounded ends which are arcs of a circle. When used with registration mechanisms in camera or printer this form allows very accurate location of the film but the sharp corners formed by the intersection of the arcs and flats were a point of weakness in copies which had to be projected many times. To avoid this, a rectangular hole with rounded corners was introduced and has now become almost universal for the 35 mm positive stocks used in release printing. This form of hole, known as the Kodak Standard, or KS type, has a slightly greater height than the BH and this reduces damage from interference by the projector sprocket teeth.

Proposals were made at international conferences in 1934 and 1936 for the adoption of the KS hole for all 35 mm film both negative and positive. This standard was not, however, accepted by the motion picture industry of the United States, although it was put into practice by Russia and eastern European countries. Great Britain and the other countries of western Europe followed the American lead in maintaining the BH hole for negative and duplicating film stocks in 35 mm with the KS hole for positive materials.

For the largest film gauges, the KS hole was standardised for both negative and positive material but again there is a divergence of practice; the United States and western Europe use a 65 mm wide negative and a 70 mm print stock, while Russia and eastern Europe use 70 mm for both materials.

In 1953 the introduction of anamorphic widescreen presentation required the use of a smaller hole on 35 mm film to provide a larger area of film for the picture and multiple sound tracks. This perforation is known as the CS type, from the CinemaScope system which initiated it. It still has a somewhat limited application, being restricted to positive stock on which release prints with four magnetic tracks are made. In eastern Europe the corresponding hole is slightly higher.

Only one type of perforation is used for 16 mm film, and this was originally used for the standard 8 mm amateur material produced by slitting a 16 mm width in half. Super 8, introduced in 1965, uses a much smaller hole to leave the largest area of film for the picture image.

Perforation pitch

Not only the size of the perforation holes but their interval or pitch from hole to hole must be maintained very accurately along the length of a strip of film if a steady image is to be obtained. Ideally, groups of holes corresponding to the

FILM GAUGES AND PERFORATIONS

The following sizes of film and types of perforation hole are in general use.

1. 65 mm film for camera use only
2. 70 mm film for large screen positive prints
3. 35 mm film for standard positive prints

All these are perforated with the Kodak Standard hole (KS)

4. 35 mm film for camera use, perforated with the Bell & Howell hole (BH)
5. 35 mm film for anamorphic multi-sound track prints, perforated with the Cinemascope hole (CS)
6. 16 mm film with two rows of perforations, for camera use or for silent prints
7. 16 mm film with one row of perforations for positive prints with sound track
8. Standard 8 mm, usually supplied as Double-8 for camera use and slit after processing to 8 mm width for projection
9. Super-8, generally used as 8 mm width in the camera.

Full details of all film dimensions are published as British Standard B.S. 677-1969 (pts 1-4).

height of the picture along the film length should be perforated together and this is done for 35 mm and 65/70 mm, where four, and five holes respectively on each margin are punched at the same stroke of the perforating machine. With smaller gauge films, however, for economic reasons several holes (corresponding to several frames) are punched together at each stroke, although it must be recognised that this is not ideal.

Release copies are usually printed from a negative on a continuous printer. The two films are held in contact on a rotating drum or sprocket at the time of exposure, the positive film on the outside. The surface speed of the two films at the moment of printing is therefore not exactly the same and to avoid slippage between them, which would cause unsharp or unsteady images, the length of the negative frame should be slightly shorter than that of the corresponding frame on the positive. For the most commonly used printing sprocket which has 64 teeth around its circumference the difference in pitch for film thicknesses of 0·15 mm (0·006 in.) is of the order of 0·3%.

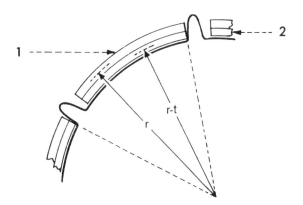

SHORT PITCH STOCK

To avoid slip and consequent loss of image definition when contact printing, perforation pitch of inner (negative) film, 2, must be less than pitch of outer (positive) film, 1, in the proportion (r−t)/r, where t = film thickness and r = average radius of outer layer.

When film coated on cellulose nitrate base was widely used, the negative shrinkage after processing provided this difference. But with the introduction of safety low-shrink supports this only occurs to a very small extent, and is now regular manufacturing practice to perforate negative film stocks to a shorter pitch than positive materials. The perforating difference between negative and positive standards in all gauges is set at just over 0·2% to allow for the further small shrinkage of 0·1 to 0·2% which still occurs with age.

It is now accepted international procedure to identify the manufacturing dimension of given film by coding giving the sequence:

Film Width in mm 8, 16, 35, 65, 70
Type of Perforation Holes for 35 mm BH, KS, CS
(or where appropriate
Number of Rows of holes 1R, 2R, 3R, etc.
 and their
Position across the width 1–3, 1–4, etc
Hole-to-hole pitch standard in inches or millimetres

A code 35-CS-1870 would therefore indicate 35 mm film perforated with two rows of CinemaScope type perforations with a pitch of 0·1870 in., while 65-KS-1866 would be 65 mm film with two rows of Kodak standard holes at the short pitch standard of 0·1866 in. Only one type of hole is used with 16 mm stock but it may be perforated with a row of holes down one or both edges – 16-1R-2994 or 16-2R-3000, for example.

For bulk printing operations, a number of film stocks are manufactured with multiple rows of perforations so that after processing they can be slit to provide a number of copies of narrower width. A typical example is 32 mm film perforated with 16 mm perforations which can be slit to two 16 mm width prints. Here several positions are possible for the perforation rows depending on the method of printing and the type of copy required, and have to be identified in the

MULTI-RANK STOCKS

Examples of film stocks perforated for multiple printing of smaller gauges:
1. Two 16 mm strips on 32 mm: 32-2R-3000, 1–3
2. Two 16 mm strips on 32 mm: 32-2R-3000, 1–4
3. Two 16 mm strips on 35 mm: 35-3R-3000, 2–4
4. Four 8 mm strips on 32 mm: 32-4R-1500, 5–8
5. Four 8 mm strips on 35 mm: 35-5R-1500, 5–7
6. Four Super-8 strips on 35 mm: 35-5R-1667S, 5–7

coding. In general, however, these details are only of importance for stocks used in laboratory processing, and do not occur in those for normal cameras and projectors.

Picture image areas

Whatever the gauge of film, provision must be made for the soundtrack, and this normally sets a limit to the width of film between the perforations which is available for the picture image. The dimensions of the camera aperture are normally slightly greater than that used in projection and the area printed on the

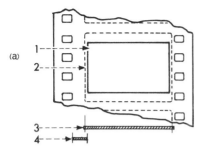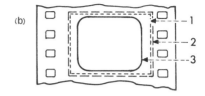

IMAGE AREAS

(a) The area of the projected picture on the film (1) is always slightly less than the picture area exposed in the camera (2) to provide a margin of safety. Even when the picture is composed to a wide-screen aspect ratio, it is recommended that a full camera aperture should be used. The width of the printed picture (3) is always at least as large as that of the camera exposure; it is usual practice to give a small overlap between the picture and track printed areas (4) to ensure a black margin between them. (b) The image area transmitted through a television system (1) is smaller than that used for projection in the cinema for the same aspect ratio 1·33:1 (2). Because of the loss at the edge of the picture as a result of incorrectly aligned equipment important action and titles should be composed to fall within an even smaller "safe area" (3).

film therefore overlaps the projector aperture by a small amount. This practice is followed for all gauges, and camera and projector aperture dimensions are internationally standardised.

The position of the picture area on the film is also specified, usually in relation to the one edge of the strip which is accurately guided in the projector mechanism. The centre lines of the image and the film coincide on 70 mm and 16 mm but are displaced in 35 mm and 8 mm. The vertical position of the image in relation to the perforations, known as the framing or rack position, is also specified.

With film for television transmission the printed areas are the same in size and position as those for cinema use but the areas scanned by the television equipment are slightly smaller than those normally projected. It is recognised that the position of the picture shown on individual T.V. receivers in the home may vary considerably and it is therefore usual to keep all important action and titles within a somewhat smaller inner area. In the United States a 'T.V. safe action' area and a smaller 'T.V. safe title' area are specified. The British standard defines one 'T.V. safe area' only, but the differences are not sufficient to cause serious difficulties.

Sound track areas

The soundtrack positions and dimensions are similarly standardised on all gauges of film. On 35 mm the 'optical' soundtrack is placed inside the perforations on the side which appears left of the screen when projected. With 16 mm,

the soundtrack is printed along the unperforated edge of the film and is adjacent to the right-hand edge of the projected picture.

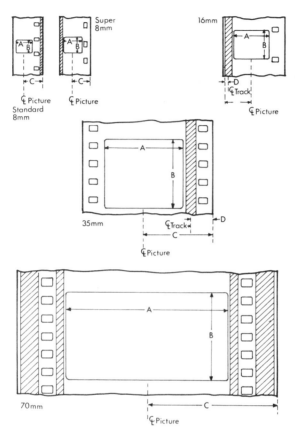

DIMENSIONS OF PROJECTED AREAS OF FILM
A Width of projector aperture
B Height of projector aperture
C Distance of picture centre-line
 from reference edge of film.

The projector aperture is usually made with rounded corners, of radius 0·010 in (0·13 to 0·25 mm).

The horizontal centre line of the picture is centred midway between two perforations in standard-8, 16 and 35 mm and on the centre of a perforation for Super-8 and 70 mm.

Optical sound tracks on film are specified by
D Distance of track centre-line from reference edge
G Track Width scanned by reproducer
The *printed* width is normally ·020 to ·030 in (0·5 to 0·8 mm) wider than the scanned area.

107

PROJECTED PICTURE DIMENSIONS

Type of Film	Inches A	Inches B	Inches C	Millimetres A	Millimetres B	Millimetres C
Standard 8 mm	0·172	0·129	0·205	4·37	3·28	5·20
Super-8	0·210	0·157	0·170	5·32	3·99	4·31
16 mm	0·380	0·284	0·314	9·65	7·21	7·97
35 mm Academy	0·825	0·600	0·738	20·96	15·24	18·75
35 mm Wide Screen A.R.1.85:1	0·825	0·446	0·738	20·96	11·33	18·75
35 mm Cinemascope A.R.2.35:1	0·839	0·715	0·738	21·31	18·16	18·75
70 mm	1·913	0·866	1·377	48·60	22·00	34·95
General Tolerances		±0·002			±0·05	
Areas reproduced in Television from film						
from 16 mm	0·368	0·276	0·314	9·35	7·01	7·97
from 35 mm	0·792	0·594	0·738	20·12	15·10	18·75

TRACK DIMENSIONS

Type of Film Track	Inches D	Inches G	Millimetres D	Millimetres G
Optical on 16 mm	0·058	0·071	1·47	1·80
Optical on 35 mm	0·244	0·084	6·20	2·13
General Tolerances	±0·001		±0·03	

4 Picture recording

The motion picture camera is the instrument on which practical cinematography was founded and whatever the future may hold in alternative methods of picture recording there is no doubt that this basic mechanism will continue to play an active part, not only in the direct photography of action but also laboratory and television processes.

Fundamentally, the function of the camera is to provide a photographic record in the form of a series of still picture images, called frames, on a continuous strip of film. These images must be accurately positioned on the strip and the photographic quality must show not only the highest standard of definition possible with the material used but must also be exposed with complete uniformity from one frame to the next. These requirements call for precise mechanical and optical engineering combined with simplicity of operation and great reliability so that valuable time is not lost during the film production period.

The essential features of any motion picture camera are therefore:-

1. The lens system which forms an image of the scene on the surface of the film.
2. The camera body in which the strip of film is moved and located for the exposure of each frame.
3. The magazine, from which unexposed film is fed into the mechanism and to which the exposed film is returned after it has passed through the camera.
4. The drive motor providing power for the passage of the film along its path.
5. The viewfinder by which the camera operator can observe the action being recorded on the film so that he can direct the movements of the camera mounting and adjust the lens focus setting as required.

Associated with these basic items may be a wide range of accessories designed to improve the control of the lens system for both focusing and exposure control, to indicate the amount of film (or the number of frames) which have been exposed and to check the operation of the camera mechanism. When sound is

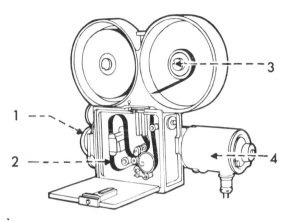

THE MOTION PICTURE CAMERA
The essential features shown are:
1. lens
2. camera body with the film transport mechanism
3. magazine containing the film before and after exposure
4. drive motor.

recorded at the same time as the picture image it may be necessary to enclose the whole of the camera equipment in a sound proof enclosure, or blimp, although improved design in modern camera mechanisms is moving strongly towards self-silenced units.

Camera lenses

The design of camera lenses for motion picture photography has developed into a specialised branch of optical industry where a comparatively small number of manufacturers in different parts of the world provide all the needs of the international market. The requirements are similar to those of all photographic processes: a high standard of image sharpness (now normally assessed as the modulation transfer function of the lens) must be combined with the maximum efficiency of light transmission, measured as the f stop number, or preferrably the T stop number. Both these needs are even more stringent in motion picture work than in still photography: image sharpness, because of the enormous magnification to which the film image is eventually subjected, and efficient light transmission because high levels of artificial illumination in the studio are expensive and inconvenient. Added to this, on sound film productions the motion picture photographer cannot give an increased exposure by lengthening his exposure time, as can the still photographer. All lenses for cinematography must of course be fully corrected for optimum colour image formation.

In general, the focal lengths of camera lenses used for motion picture work provide a rather narrower series of angles of view than would be usual for still work. The most frequently used lenses are those with a focal length of approximately twice the diagonal of the exposed frame size, thus providing a horizontal angle of view of some 24°. This corresponds to a focal length of 50 mm for 35 mm film, and 25 mm for 16 mm. Wide angle lenses may have focal lengths

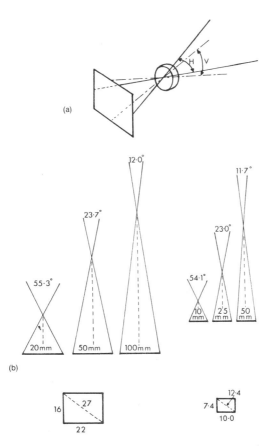

(a)

(b)

FOCAL LENGTHS AND ANGLE OF VIEW
(a) The horizontal (H) and vertical (V) angles of view are determined by the dimensions of the frame exposed and the focal length of the lens. (b) The most generally used lens has a horizontal angle of some 23°–24°, which is given by a focal length of approximately twice the diagonal measurement of the frame, 50 mm for the 35 mm frame and 25 mm for 16 mm film. A wide angle lens may have more than twice this acceptance angle, while a long focal length lens could have half the angle of view.

equal to the frame diagonal, or even less, while long focus lenses for regular studio work are frequently four or six times the frame diagonal in their focal lengths, providing correspondingly narrower angles of view. Telephoto lenses have very long effective focal lengths, often much greater than their physical dimensions, and extremely narrow angles of view. They thus allow concentration on a very small area of the scene, so that close-up shots can be taken from a considerable distance – a facility of great importance in newsreel and documentary photography.

111

For many years the professional motion picture camera has been provided with a range of interchangeable lenses of different focal lengths including several types of wide-angle and long-focus as well as the standard lens. In most studio cameras only one lens was mounted at a time but the rapid changes from one focal length to another required in newsreel work led to the development of camera lens turrets on which three, or sometimes four, lenses of different focal lengths could be mounted. These could be swung into position almost instantaneously on the optical axis of the film, whenever required. Cameras with such turrets became universal for news and documentary photography and in fact for almost all work where blimps for simultaneous sound recording were not required. Many attempts to provide satisfactory sound insulating covers for turret-mounting cameras were made but there were considerable problems.

Where lenses of large diameter are used, the outside rim of one lens barrel may appear in the field of view of another if they are mounted on the turret with their optical axes parallel. Many turrets are now designed with divergent mounts to avoid this and the rotation of the turret itself is angled so that the optical axis of the lens in use is correctly alligned with the film aperture. For amateur cinematography, interchangeable lenses were usually provided on all except the cheapest and simplest cameras but turret mounts with two or three lenses were only available on the more expensive 8 mm cameras of the amateur range.

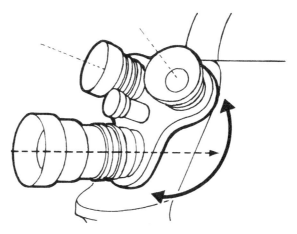

TURRET MOUNTING
Three lenses of different focal lengths may be mounted on a turret in front of the camera and rotated into position when required. The divergent axes avoid the interference of one lens barrel with the field of view of another.

Zoom lenses

The development of variable-focus lenses, known as zoom lenses, brought about striking changes in both the amateur and professional fields. Application of these lenses in television work and on amateur cine cameras advanced rapidly and improved designs were successfully produced to meet the more exacting

standards of professional motion picture work. At first the range of focal lengths over which a zoom lens could be adjusted was limited to a ratio of 4 : 1, usually covering focal lengths from a moderately wide-angle lens to a fairly long focus. Typical ranges for such zoom lenses are from 35 mm to 140 mm for 35 mm cameras and $17\frac{1}{2}$ mm to 70 mm for 16 mm cameras. Improved designs have now considerably extended the zoom ranges available and a ratio of 1 : 10, from an extreme wide-angle to a very long focus setting, is now quite common.

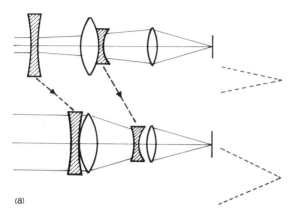

(a)

ZOOM LENSES

The relative movement of optical components of a lens allow it to function with different effective focal lengths.

(a) A simple zoom lens design in which two elements are moved in unison, giving a 4:1 range of effective focal lengths.

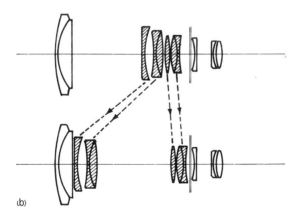

(b)

(b) A more advanced design in which two groups of adjustable elements can move relative to one another; this design provides a 10:1 range.

113

H

Zoom lenses are now almost universal on modern amateur cine cameras, except for the very cheapest. They are extensively used in 16 mm work and are finding increasing application in 35 mm professional practice, especially in association with new studio techniques.

The optical characteristics of a zoom lens are such that although its effective focal length may be altered, its focus setting for the object being photographed remains the same, as does its effective aperture setting. The focal length can be adjusted smoothly and continuously during a shot so that an effect somewhat like the camera moving in towards the subject from long shot to close-up can be obtained from fixed camera positions—without any exposure change. This greatly adds to the apparent mobility of the camera as well as providing the equivalent of a full series of lenses on a single mount.

An important feature of zoom-lens operation is the method used to produce the viewfinder image. With single lens mountings the viewfinder image can be formed by a completely separate optical system mounted close to the main lens and corrected for parallax (the difference in viewpoint relative to the taking lens). A similar arrangement, although involving several complications, is also possible on some forms of turret mounting. With a zoom lens, however, it is essential that the viewfinder image be produced by the main camera lens itself, since it is only by so doing that the camera operator can see exactly what is being recorded on the film at all times.. Through-the-lens (TTL) viewfinder systems are therefore absolutely essential for zoom lenses, as well as a desirable convenience for turret mountings.

Lens aperture

To obtain a high efficiency of light transmission in a camera lens a large numerical aperture is necessary. This means that the actual diameter of the glass elements of the lens must be proportionately large and the problems of satisfactory correction for the various forms of optical aberration are thereby considerably increased. For professional photography on 35 mm and with normal and wide-angle focal lengths the maximum working aperture is usually $f2$, although some extremely fast lenses of $f1\cdot4$ have been produced by some manufacturers in a limited range of focal lengths. For long focus lenses the maximum is usually $f2\cdot8$ or $f3$. Lenses for 16 mm photography, being of smaller diameter for a given angle of view, are more economically produced with large apertures and $f1\cdot5$ and $f1\cdot9$ values are available in most focal lengths.

With zoom lenses the limitation in lens construction is imposed by the size of components required to provide a large effective aperture at the longest focal length setting. For 35 mm zoom lenses the maximum aperture available is normally no larger than $f2\cdot2$ or $f2\cdot4$, but $f1\cdot8$ or $f2$ is generally obtained with zoom lenses for 16 mm and 8 mm photography.

Lenses for widescreen photography

The development of anamorphic systems of widescreen presentation in the mid 1950's led to the introduction of a completely different series of camera lenses for professional motion picture photography. All these made use of optical systems, usually with cylindrically curved components, giving a greater reduction of the image on the film in the horizontal dimension than in the vertical. Although in the first stages of development several systems using various anamorphic factors were produced, the widespread success of the CinemaScope

process led to the general adoption of its factor of 2:1 for this form of presentation. Anamorphic camera lenses therefore have a horizontal angle of view approximately twice that of a normal lens of the same focal length but the slightly different frame area used on the film introduces a new relation between horizontal and vertical angles of view.

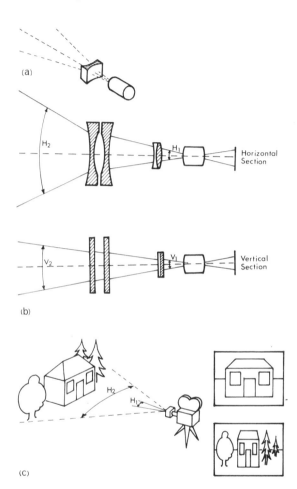

ANAMORPHIC PHOTOGRAPHY
 (a) A divergent cylindrical lens in front of a normal camera lens widens the angle of view in one direction but not in the other, giving an anamorphic image. (b) Actual anamorphic lens attachments comprise a series of cylindrical elements which are only effective in the horizontal plane. (c) Photography with an anamorphic attachment to the lens doubles the horizontal angle H_1 to H_2, leaving the vertical angle unchanged. The resultant image embraces a wider field but appears distorted as though compressed laterally.

115

Some anamorphic optical systems were produced as attachments to be mounted in front of standard lenses, but this involved complications as the main lens and the attachment had to be individually focused for subject distance and complete correction for unwanted image distortion and lens aberrations was not possible. Many of the early systems therefore gave images of inferior definition and showed a variation in image compression according to subject distance. A particularly objectionable feature resulted from the effective anamorphic factor being less than 2 on the shorter distances: faces in close-up appeared unnaturally wide when the picture was projected with a lateral magnification factor of $2:1$. Modern anamorphic lenses are now all designed as integral units in which the focusing of both the main and anamorphic components is effected by a single control and high definition systems well corrected for unwanted distortion are now available in a full range of focal lengths from 35 mm to 150 mm. The greater complexity of optical components does, however, result in lower maximum aperture values, $f 2 \cdot 3$ being used for the shorter lengths and $f 3$ or $f 3 \cdot 5$ for the longer. Anamorphic camera lenses in general cannot be focused down to working distances as close as normal lenses, so, for this, supplementary attachments are necessary.

Several types of anamorphic zoom lens have been produced but their design is very complex and their overall standard of performance is not yet fully the equal of the fixed focal length anamorphic lens.

In 16 mm practice and in the amateur 8 mm field widescreen photography is rare and has so far always employed anamorphic attachments, mounted on the normal camera and projector lenses.

Normal lenses are sometimes used for widescreen photography with other film formats. For example, 65 mm film (70 mm in Russia and eastern Europe) provides a frame more than twice the width of that on standard 35 mm film and normal spherical camera lenses can therefore be used without anamorphism to produce widescreen images, provided they are designed to cover the larger film area efficiently in terms of light distribution and definition. Different frame dimensions create a new relation between focal length and angle of view. For this form of the photography the most frequently used lens has a focal length of 75 mm with a horizontal angle of view of 48°. The range of focal lengths available for 65 mm cameras generally extends from 28 mm to 300 mm.

Normal spherical camera lenses are also used for the so-called half-frame systems of widescreen photography such as Techniscope. In these processes the wide angle of view required is obtained with short focal length lenses – in general approximately half the lengths of those used for normal format photography on 35 mm film. The most frequently used lens is one of 25 mm focal length, giving a horizontal angle of view of 47°, and the usual range employed is from 18 mm to 150 mm. The smaller frame height of this system restricts the angle of view in the vertical sense to the proportion of $\frac{3}{7}$ of the width, and 35 mm prints for regular anamorphic projection with $2:1$ lateral expansion are made by optical printing.

Camera mechanism

In all modern professional cameras for normal motion picture photography the mechanism has a dual function: firstly, to provide the continuous withdrawal of the film from the feed magazine and its return after exposure and, secondly, to position each length of film corresponding to a single picture accurately in the aperture at which it is exposed by light coming through the lens. Since cinema-

tography is based on the exposure of a series of still pictures, the film in the aperture must be alternately stationary and moving to bring the next section of film into position. This part of the mechanism is therefore essentially an intermittent one. To prevent light from the lens reaching the film while it is being moved a shutter coupled to the mechanism interrupts the beam for the appropriate portion of the intermittent cycle. Within the camera body, one part of the film is being driven intermittently while at the same time other parts are moving continuously, so the film path must provide flexible loops whose position and length can vary during the exposure cycle to give freedom to the two types of motion.

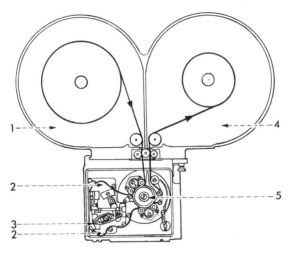

FILM PATH IN THE CAMERA
Film is drawn from the feed side (1) of the magazine by the drive sprocket (5) and is moved past the aperture one picture at a time by the intermittent mechanism (3). Loops in the film path above and below the aperture (2) take up the differences between the continuous motion of the sprocket and the intermittent. After exposure the film is fed back towards the take-up side of the magazine (4) by the sprocket and is wound up on a belt-driven centre.

Continuous drive

In all professional cameras the continuous movement of the film is effected by the rotation of driving sprockets, the rims of which carry teeth engaging with the perforation holes in the film. Sometimes two separate sprockets are used for feeding and returning the film but a single sprocket on which the film is engaged at two positions is more usual. The diameter of this sprocket must be sufficiently large to ensure that several teeth are engaged with the perforations at all times and so provide smooth and uniform film transport. The profile of the teeth is designed so that the rotating sprocket engages and withdraws from the perforation holes without interference to their edges, an involute tooth form usually being employed. The thickness of the sprocket tooth must be sufficient to spread

117

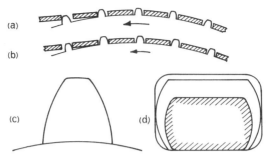

(a)

(b)

(c)

(d)

SPROCKET DESIGN

The sprocket tooth form and dimensions must allow smooth movement of the film on and off the teeth in both feed (a) and hold-back (b) conditions. The profile generally adopted (c) is a form of involute curve and the shape at the root of the tooth must give clearance for both negative and positive film perforations combined with as wide a contact face as possible (d).

the driving force over as great a width of the perforation hole as possible to avoid excessively high local pressures. But must not be so large that it presents a danger by interference at the sides of the hole. All tooth edges must be accurately formed and smoothly finished without sharp corners, which might be a source of damage. Hold-down rollers are positioned around the circumference of the sprocket to ensure that the film is held in contact with the basic circumference of the sprocket at all times and to prevent any possibility of it riding off the teeth. These hold-down rollers can be swung out of position while the film is being threaded in the camera initially and then locked in position for operation.

The intermittent

This precision mechanism, sometimes referred to as the camera movement, is at the heart of the invention of cinematography and during the early days of motion picture technology each designer developed an individual approach. From these very numerous forerunners have come the comparatively few well-established present-day systems. In all these the basic sequence to be performed is as follows:

a. The moving film from the continuous feed is carried downwards by the pins or claws of a shuttle mechanism for a distance corresponding to the length occupied by a single frame. This is the space of four perforations for normal 35 mm photography, but is the pitch of each successive hole in 16 mm, while for 65 mm or 70 mm film the distance moved is five perforations. During the whole of this period light from the lens is prevented from reaching the film by the interposition of the shutter.

b. When the shuttle has completed its traverse and a new section of film has been brought into position at the aperture, the shuttle claws or pins which have engaged the perforation holes are withdrawn and start to move upwards. At this point in the cycle a separate registration pin may be brought in to engage another perforation hole, locating the film in the aperture

with great accuracy and holding it steady during the period of exposure. In some camera mechanisms the film may be located and held flat by a pressure plate, likewise brought into intermittent operation when the film ceases to move.

The action of the shutter is synchronised with the intermittent and begins to open as soon as the film is stationary.

c. At the completion of the exposure the shutter closes and the registration pin and pressure plate are withdrawn. The shuttle has now reached the end of its upward motion and its pins or claws are brought forward to engage the perforation holes once more and repeat the whole sequence.

In normal motion picture photography the complete cycle of operations must be repeated 24 times a second and the image on the film exposed on each occasion must be uniformly located, relative to its perforations, to an accuracy of less than one hundredth of a millimetre. During each cycle as much time as

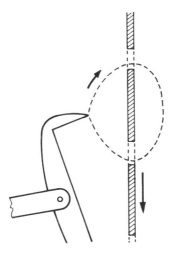

SIMPLE CLAW INTERMITTENT
A reciprocating claw enters a perforation hole and moves the film downward during the period while the shutter is closed. The claw then withdraws to leave the film stationary while the exposure takes place, and moves upward to engage the next hole to repeat its operation. The movement of the claw must be accurately adjusted to match the required distance between successive perforations.

possible must be available for exposure with the film stationary, so the moving shuttle transfer period must be as short as possible consistent with accuracy. The accelerations and decelerations imposed on the film and the moving parts of the mechanism are therefore very considerable. But the whole unit must be designed to function as quietly as possible, since it is the most serious source of camera noise and may interfere with sound recording in the studios.

119

Types of intermittent

Although many ingenious methods were devised in the early days of cinematography for the intermittent movement of film in the camera, all modern systems make use of some type of claw mechanism, whether or not these are associated with registration pins. In the simplest form used for amateur 8 mm and many 16 mm cameras a link mechanism operated by a rotating eccentric pin causes one or a pair of claws to engage with the film perforations, carry them downwards and withdraw to move upwards once more. The path of the claw moving the film is by no means truly linear and the claw does not enter and leave the perforation hole at right angles. But for less critical requirements the results are quite acceptable, at least until mechanical wear on the linkage points gives rise to unsteadiness. With this simple mechanism the film is located by the point

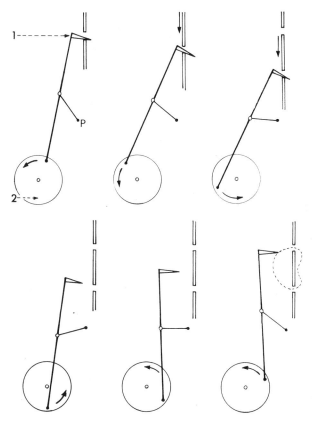

NEWMAN CLAW MOVEMENT
The intermittent movement of the claw (1) is produced by the continuously rotating disc (2) through the linkage fixed at the point P. The claw motion enters and leaves the perforation hole almost at right angles and the film movement is smoothly accelerated and decelerated at the beginning and end of the stroke.

at which the claw is withdrawn and held steady merely by the constant pressure of a spring-loaded backplate.

A basic advance in claw linkage mechanisms was achieved by A. S. Newman in the Newman-Sinclair design, while still retaining pinned links. This arrangement has the advantage of accelerating the film slowly at the beginning of the transfer stroke and decelerating it to rest before the claw is withdrawn. The pressure exerted by the backplate can therefore be kept low since its friction is not required to decelerate the moving film. Wear on the film surfaces is thus reduced.

If the claw can be made to enter and retract practically at right angles to the film it is possible to use a tapered pin which fits fully into the perforation hole engaged. This provides very accurate film location by the claw movement alone,

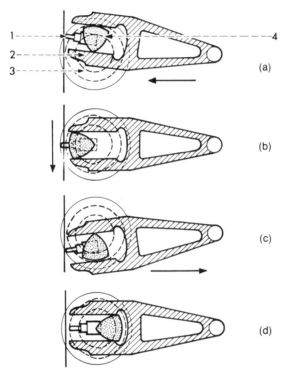

ARRIFLEX MOVEMENT

The claw (1) is carried on the arm (2) which is moved forward and backward by the rotation of the main cam (3); the up and down movement is by the action of the cardoid cam (4) between the faces of the arm. (a) Claw arm moves forward to engage with perforation hole in the film, no vertical movement. (b) Claw moves film downward in its forward position. (c) Claw withdraws from film at lowest position, claw arm moving backwards. (d) Arm in back position, claw moves upward clear of film ready to repeat the sequence.

and in fact is used for professional 35 mm work in the Arnold and Richter Arriflex camera. In this design the movement of the claw in and out of the film plane is produced by the rotation of one cam surface while the up and down motion comes from the action of an associated heart-shaped (cardioid) cam rotating between two parallel faces. The combination provides a short period at the beginning and end of the traverse when the full-fitting claw is engaged in the perforation hole and completely stationary, and this provides a high degree of accuracy in film location at the moment of exposure. A very steady picture image is thus obtained without a separate registration pin.

In most professional cameras, however, register or pilot pins operated in synchronisation with the action of the shuttle claws are used to ensure absolute accuracy in image location. One of the best known and long established designs is that employed in the American Mitchell BNC and Mark II cameras but the systems used in the British Newall and French Eclair cameras have many points of general similarity. In all these the shuttle claw actuated by a cam engages with the film below the aperture along a curved path. The shuttle follows a similar

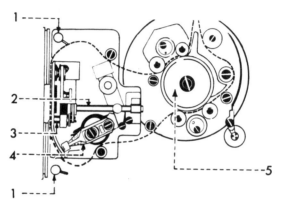

MITCHELL MOVEMENT

 The film is moved intermittently by the reciprocating action of the double claws (4) which are driven by a cam action. The film is held steady during the period of exposure by the register pins (3) which are moved in and out by the piston and shaft (2). The whole mechanism can be removed by the levers (1). Film is fed continuously by the sprocket (5).

curved path, so the relative movement of the film and claw is effectively linear. The pilot pins are moved in for registration horizontally by their own cam mechanism to a position immediately adjacent to the aperture as the shuttle brings the film to rest for each exposure and they are withdrawn again just before the next forward movement.

In 35 mm work, registration pins are used in pairs across the width of the film; on the edge closest to the picture the register pin is fully fitting to the perforation hole in both vertical and horizontal dimensions, but on the opposite edge, nearer the area occupied by the sound track, the pin is fully fitting in the vertical direction only. This allows for small variations in film width due to shrinkage

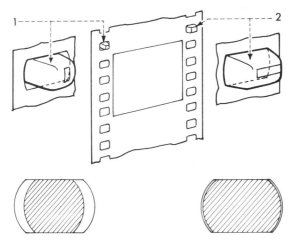

REGISTER PIN FITTING
On one side of the film the big pin (2) fits the 35 mm negative perforation exactly on all sides. The small pin (1) on the other side fits exactly vertically but has horizontal clearance to accommodate small expansion and contraction of the film.

without bruising the perforation holes. In modern intermittent designs small variations of pitch between holes along the length of the film can also be corrected for by fine adjustment either to the vertical position of the register pin or to the stroke of the shuttle.

A completely different approach was adopted for the Bell & Howell mechanism and is used not only in cameras but also in printing machines where very accurate image registration is required. In this design the register pins are integrally fixed in the aperture plate and the film travels between a pair of thin plates, known as leaves, which are moved backwards and forwards by a cam mechanism during the intermittent cycle. In the forward position of the leaves the film is engaged on the fixed register pins while the frame is exposed. As the shutter closes the leaves retract off the register pins and the film becomes engaged by the shuttle pins. These move downwards in vertical slots in the leaves carrying the film with them. At the bottom of the stroke the leaves move forward once more towards the register pins while the shuttle, now free of the film, returns upwards in preparation for the next cycle. The film is thus always fully located by either the shuttle or register pin, and pressure is only applied between the leaves and the aperture plate during the period of exposure. Since this pressure can be applied round all four edges of the frame and over the rear surface of the film this Bell and Howell mechanism is particularly well suited to use in optical printers and other equipment where the film must be held flat in an accurately defined plane at the moment of exposure.

Film path in the camera

The film path within the body of the camera must be carefully designed to guide the film accurately and safely and at the same time permit the operator to thread

123

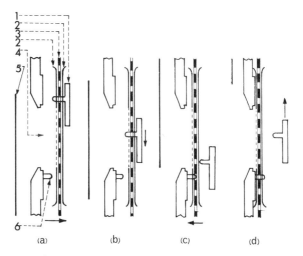

(a) (b) (c) (d)

BELL & HOWELL MOVEMENT

The film travels between a pair of thin plates which are moved backwards and forwards during the exposure cycle. (a) At the beginning of the film transit the leaves (2) are in the rear position and one perforation hole of the film (3) is engaged by the shuttle pin (1) which is about to start its downward travel. The printer shutter (5) obscures the printing aperture (4). (b) The shuttle pin moves downwards in a slot in the leaves, taking the film with it. The shutter is still closed. (c) At the bottom of the shuttle stroke, the leaves move forward, lifting the film off the shuttle pin and engaging a perforation hole on the registration pin (6) fixed to the aperture plate. The shutter starts to open. (d) The film is held by the registration pin during the period of exposure while the shutter is open and the leaves are in the forward position against the aperture. The shuttle pin now moves upward ready for the next cycle.

a new roll of film rapidly. In addition to the retractable pairs of hold-down rollers on the main drive sprocket, several other rollers guide the film to and from the intermittent movement and control the loop size. All these rollers have flanges to locate the lateral position of the film and are recessed so that they come in contact only with the perforated margins on either the base or emulsion surfaces.

All parts of the intermittent film path must be recessed so that the film surface cannot be touched in the area of the exposed picture. This is a particular problem with the pressure plate, which must exert sufficient force over the whole film to keep it flat at the time of exposure. In some mechanisms the back plate is made to move so that it only comes into contact with the film when it is stationary and is retracted as the film moves, while in other designs pressure is applied by a series of small free-running rollers of hardened steel or synthetic sapphire. In all cases the whole gate must be readily opened for cleaning so that any build-up of emulsion fragments or slivers of film, especially around the edges of the aperture, can be easily removed.

With many professional cameras a buckle switch is fitted within the camera body. If the film is incorrectly threaded or the take-up is faulty, the formation of an excessive loop in the body causes the film to press against a plate which operates a switch to shut off the motor drive. The operator is thus warned of the fault and damage to the mechanism by film piling up inside is avoided.

Shutter

Although in some simple amateur cameras the shutter takes the form of an oscillating blade the great majority of cameras employ a rotating disc with an open sector to allow light from the lens to reach the film during its stationary exposure period. During the period when the opaque sector of the shutter obscures the light the film is moved and relocated by the intermittent.

The maximum opening of the shutter is of course dependent on the proportion of the whole intermittent cycle for which the film is completely static and mechanical design strives to obtain as long a stationary period as possible to allow the maximum exposure time. In general, however, it is not possible for the film to be exposed for more than approximately half the cycle and the maximum angular opening of the shutter sector is between 170° and 180° out of the full 360°. This provides an actual exposure time of nominally $\frac{1}{50}$th sec for the standard rate of 24 fps. Some intermittent movements with exceptionally rapid pull-down permit a maximum shutter opening of 200° or more, but on the other hand certain 16 mm cameras only provide 130° or 140°, reducing the exposure to $\frac{1}{65}$th sec.

In very many professional cameras, both 35 mm and 16 mm, the angular opening of the shutter can be altered by the movement of a second blade to any value between its maximum and 0°, at which point it is completely closed. This

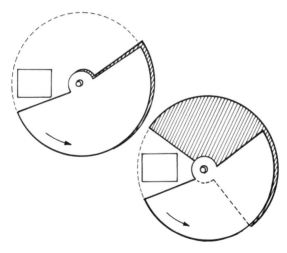

VARIABLE SHUTTER
 A double-bladed shutter allows the angular opening to be varied so that the time of exposure at the aperture during its rotation can be altered from a maximum down to zero.

allows the exposure time to be shortened and provides a further means of exposure control independent of the lens diaphragm setting. Reduced shutter openings are sometimes used to compensate for large lens apertures when the cameraman wishes to make use of a very limited depth of field. Another application is the progressive reduction of exposure frame by frame giving the effect of a scene fading out to complete darkness. Or, where by the superimposition of one scene fading out on top of another fading in, the effect of a dissolve or mix from one to the other is obtained. Nowadays such effects are carried out by the processing laboratory on an optical printer rather than in the camera but the technique is often used when photographing cartoons and animation material. The shutter opening control usually takes the form of a calibrated dial or lever showing the angular opening, and in some cameras both the shutter opening and its rotary position relative to the aperture is displayed. This allows accurate synchronisation of camera and projector shutters in back-projection work.

In special effects and animation cameras where fade and dissolve effects are frequently required the opening or closing of the shutter opening may be performed automatically by a cam or a train of gears, so that the change is made smoothly, in the course of a given number of frames. The length of the effect can be selected and pre-set to come into operation at a particular frame.

Originally, the conventional form used as a shutter was a disc rotating at right angles to the optical axis of the lens and occupying the minimum space between lens and film. However, the need for through-the-lens reflex viewfinder systems for use with turret mountings and zoom lenses led to the adoption of the 45° mirror shutter. In this arrangement a silvered surface on the opaque sector of the shutter reflects the light coming through the lens into a separate optical system which forms an image on a ground glass screen whenever light is not reaching the film.

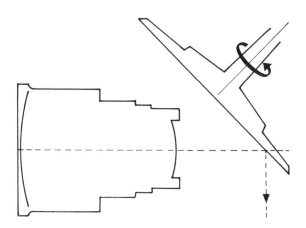

MIRROR SHUTTER
 A shutter rotating at 45° to the optical axis and provided with a silvered surface on its opaque sector allows light coming through the lens to be reflected during the period that the film is obscured and used to form a viewfinder image.

Magazines

The magazine normally consists of a pair of enclosures, one containing the roll of film to be fed into the camera and the other the film after exposure. In most designs the magazine is mounted on top of the camera body into which the film passes and returns through light-traps forming part of the magazine itself. In a typical form these light traps are formed by velvet covered rollers which are spring-loaded to press tightly against the film and provide a light-tight seal while the magazine is being handled. When the magazine is locked on the camera body the spring pressure is released so that the film can run freely without danger of scratches or abrasions.

The two film compartments must be completely light-tight, and access for loading or unloading is by either hinged doors with deep re-entrant flanges, or threaded discs which are screwed into the magazine body. The feed compartment must be loaded in a darkroom, or in a light-tight changing bag. It usually accepts a complete roll of raw stock on a plastic core as supplied by the film manufacturer. The end of the roll of film is left protruding through the light trap of the loaded magazine. When the magazine has been mounted and the film threaded through the complete camera path, the end is passed through the light trap into the take-up side of the magazine where it is attached to another core on the take-up spindle. This take-up spindle is usually driven through a friction clutch by means of a belt from the main camera motor but in some cases where very heavy reels are used it may be run from a separate torque motor. Hold-back tension is normally supplied lightly on the feed side spindle by means of a friction disc to ensure smooth unwinding of the feed roll. If the camera is capable of running both forwards and backwards, for special effects, both sides of the magazine must be provided with take-up drive belts.

In some magazine designs the feed and take-up enclosures are separate units and may sometimes be mounted side by side in parallel with co-axial drive. But this necessitates a somewhat complex film path and is less widely used.

Magazines for 35 mm cameras are made to take rolls 400, 1000, or 2000 ft. in length. The smallest is of course particularly convenient for the lightweight hand-held type of camera but only provides film for about four minutes of photography. In special cases, 200 ft. magazines may be used for utmost portability. The larger sizes of magazine are normal for studio productions and may be heavily insulated to suppress mechanical noise. 65 mm studio cameras take 500 ft. and 1000 or 1200 ft. rolls and for hand-held cameras 250 or 350 ft. These latter only allow two or three minutes photography without reloading but the extra weight of the 65 mm film makes larger magazines rather unwieldly. In 16 mm work 400 ft. magazines are usual but 600 and 1200 ft. versions can be mounted on some cameras.

In a number of 16 mm cameras the two-compartment magazine is not employed and a single enclosure containing both feed and take-up rolls together with a sprocket drive and sometimes even the rear pressure plate of the intermittent movement is used. In such magazines the film path is completely threaded when loading in the dark room with the loops ready formed, so that the camera is ready to run immediately the magazine is locked in position. This allows a very rapid change of pre-loaded magazines which can be a most valuable feature in shooting newsreel material when every moment is precious.

Another variation of camera loading used occasionally for 16 mm cameras, although very rarely in 35 mm, is to have a daylight loading spool in the body of the camera itself. This type of spool has two solid opaque flanges fitting very

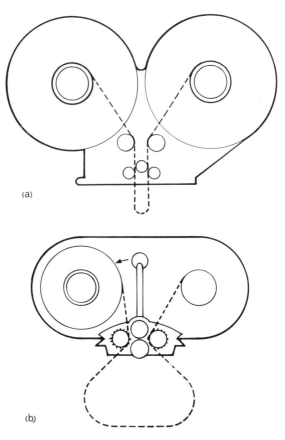

(a)

(b)

MAGAZINE FILM PATH
 (a) The film passes from the feed roll enclosure
on the left and returns to the take-up roll enclosure on the
right through a light-trap formed by velvet-covered
rollers.
(b) In some cases, feed and take-up sprockets, driven from
the main camera body form part of the magazine assembly.
The feed roll of film is normally wound emulsion side in
but the take-up may be emulsion in or emulsion out in
different cameras.

closely to the edge of the film so that light cannot penetrate at the sides for more
than a few layers. The outer turns of the roll of film are naturally completely
exposed to light when threading through the camera mechanism on to a similar
flanged take-up reel but once the camera door is closed this fogged section can
be run through clear of the aperture and new film from the feed reel exposed in
the usual way. At the end of a roll, sufficient length of waste film must be left to
provide a number of turns on the take-up spool for protection. Provided that the
flanges of the daylight-loading spool are not distorted and the roll is not handled

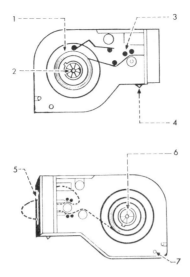

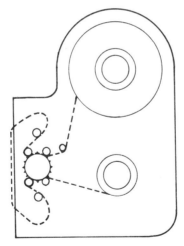

CO-AXIAL MAGAZINE

In some cameras the feed and take-up compartments of the magazines are built side by side, with the two rolls of film on the same axis. The drive sprocket is part of the magazine assembly rather than in the body of the camera and the face plate of the magazine engages with the camera intermittent.

INTEGRAL MAGAZINE

A single-chamber magazine containing both feed and take-up rolls with the drive sprocket can be directly attached to the camera body, providing a very rapid change of preloaded magazines without rethreading. The front of the magazine forms the back plate of the camera gate.

in bright sunlight, fogging due to unwanted exposure to light is confined to the beginning and end of the roll and the perforation area on each edge.

Film path in amateur cameras

Although the basic requirements are identical, amateur cine cameras using 8 mm film show many simplifications in design. The shorter lengths and smaller weight of film to be handled and the shorter distances for each frame to be moved mean that all the work of transport can be done by the claw mechanism and thus a continuous drive sprocket is not required. The stiffness of the film itself allows small loops above and below the aperture to be formed simply and transmit a reasonably steady pull from the feed reel. On the take-up side, however the film must be attached to a spindle powered by friction from the drive motor.

In the original form of 8 mm photography daylight-loading spools became almost universal and are still in wide use. They provide 25 foot lengths of film 16 mm wide but with twice as many perforations as conventional 16 mm film. When run through the camera one row of 8 mm pictures is first exposed along half the width of the film. The full take-up spool is then removed and placed in the feed position, turning the film over by so doing, and a second set of 8 mm frames is exposed along the other half. After processing, the film is slit down the middle to give two 8 mm strips which are then joined together to form one 50 ft length.

With the introduction of the larger Super 8 format completely prethreaded

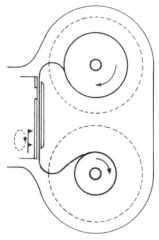

SIMPLE 8 MM CAMERA PATH
In simple 8 mm cameras there is no magazine, the film being fed and taken up on daylight-loading spools, which have tight fitting flanges to exclude light from all but the outermost turns of the roll when loading. The mass to be moved is so small that the film can be pulled off the top reel of the claw mechanism without any sprocket feed, the stiffness of the film allowing the loops above and below the gate to be maintained.

magazines containing 50 feet of 8 mm width film became available. These embody the camera aperture and back pressure plate and since they only have to be inserted into the camera body to engage with the claw mechanism they offer an extremely simple method of cartridge loading which appeals to the non-technical user. The cartridge also carries notches and projections on its edges which engage control levers in the camera body to indicate the type of film being loaded and adjust the exposure control system accordingly.

Motor drive

In the early days motion picture camera mechanisms were turned or cranked by hand and the rate of exposure depended on the cameraman's skill in maintaining a steady rate. Incidentally, even today the phrases 'under-cranking' or 'over-cranking' are still sometimes used to mean rates slower or faster than the normal.

A number of amateur cameras and a few specially portable small 35 mm and 16 mm cameras are clockwork driven, but the length of film which can be run at each winding is naturally very limited.

All professional cameras are normally driven by electric motors, of which there are several interchangeable types to meet varying needs. Absolutely steady running is essential to provide consistent exposure and when sound is being recorded simultaneously, synchronous or interlocked motors must be used.

The motors used for 'wild' shooting, that is, for photography without synchronised sound, are usually of adjustable speed and can be set to provide exposure rates from 8 to 32 fps with normal mechanisms. Cameras with specially designed intermittents are used for high-speed photography to give slow motion effects and will run at speeds up to 96 or 120 fps, four or five times the normal rate. Motor running from battery supplies of 8, 12, 16 or 24 volt DC are provided for independent operation on location and from 110 v AC or DC where normal power supply facilities are available.

For studio work with sound, a strictly controlled speed of 24 fps is the only one required, and 110 v. single-phase AC or 220 v three-phase AC are the normal supplies at either 50 or 60 cycles. In addition to synchronous motors, those which can be electrically interlocked to similar motors elsewhere are sometimes employed both with sound recorders and with background projectors in special effects photography.

Variable speed motors may be controlled by rheostat setting and checked against a tachometer giving the speed in frames per second, but electronic speed controls employing transistor circuits are now frequent. Governor or tuning-fork controls can also be used to ensure an accurate 24 fps rate on wild cameras and signal generators providing electrical impulses for synchronising sound records on tape may form part of the main drive unit, particularly with 16 mm cameras for location shooting.

Viewfinders

In early motion picture cameras a viewing tube with shielded eyepiece was built into the back of the camera to allow the operator to see the image formed by the lens through the back of the film. The picture could be composed within the frame of the aperture by inspecting in this way and the lens could be focused

131

with reasonable accuracy. Some cameramen even developed the skill of setting exposure by judging the brightness of the image and adjusting the lens diaphragm accordingly. The picture to be seen was of course small, inverted and reversed left to right and was therefore not easy to observe critically, but this method was used for many years in the pioneering days of cinematography, despite the fact that it completely precluded the use of back-plates to keep the film flat in the movement. When anti-halation backing to film stock was introduced, however, the film became completely opaque and this direct viewing method could no longer be employed.

A piece of specially prepared translucent film or ground glass could be introduced into the gate for examination of the image before threading the film for running, but this only provided a partial solution of the problem.

One method adopted was to produce a camera mounting with what was termed a 'rack-over' viewfinder. The complete camera body with the whole film path and shutter and with the magazine in position was mounted on a sliding carrier which was movable independently of the lens mounting. The lens mount itself was fixed firmly to the main camera base which was carried by the tripod or other camera support. But behind the lens the camera body could be moved laterally into either of two positions. In one of these the normal film path was brought into position in the focal plane behind the lens for normal exposure, but in the other a ground-glass screen at the end of a viewfinder tube was brought into exactly the same position. The lens formed on this screen exactly the same image as it would on the film and the optical system of the finder showed the operator an enlarged picture the right way up.

However, the rack-over method, although providing an accurate initial line-up of the lens with the scene, suffers from the major disadvantage that it cannot be used to follow the action while the camera is running and this procedure is now largely limited to the photography of titles and special effects work where the camera must be precisely aligned for each shot.

For continuous observation of the action during photography a separate optical viewfinder system can be mounted on the side or on top of the camera body. This finder has its own objective lens, located as close as possible to the camera lens in use, and an optical system which produces an enlarged image the correct way up from the operators' viewpoint. Masks may be inserted to match the size of the visible image to the angle of view of the camera lens in use and these are often made of semi-transparent material so that the action immediately outside the frame can also be observed. In some designs the field required is outlined by adjustable graticule lines shown in the plane of the finder image. The image provided is a bright one and is of course unaffected by any stopping-down of the camera lens. But it does not provide any direct check of the focus setting or effective depth of field. The operator is therefore entirely dependent on focusing by the distance calibrations on the lens mount.

Separate viewfinder systems also introduced problems of parallax, because the camera lens and viewfinder lens had to be slightly separated and therefore viewed the scene from slightly different positions. For objects a considerable distance away and with lenses of wide angles of view this displacement was unimportant. But for close-shots involving critical composition and with long focus lenses these differences could be serious. Viewfinder optics were designed to bring the two lenses as close together as was physically possible, often by additional prisms or reflectors in the finder path. Some finder optics also included a convergence adjustment connected to the focus control so that the two lines of sight intersected at the object point focused upon. Even with this refinement

132

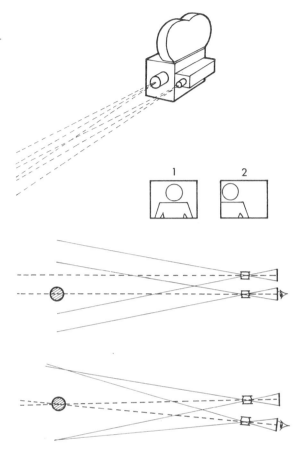

VIEWFINDER PARALLAX
Although the separation between the camera lens and the viewfinder lens is not important for distant shots, it can lead to serious errors of composition with close shots if the optical axes are kept parallel: an object correctly centred in the viewfinder field (1) will be badly misplaced in the film frame (2). For accurate close-ups the axis of the viewfinder lens must be adjusted to converge with the camera lens axis on the object.

there remains a small difference of perspective because of the separated viewpoints.

When three or four turret-mounted camera lenses were used and rapidly interchanged the separate viewfinder presented a number of practical problems in operation. Some turret cameras also carried an additional set of matched viewfinder lenses which were brought into operation on the finder system as each camera lens was rotated into position. This was an expensive solution and often difficult to apply because of restricted space around the turret mount.

133

Reflex viewfinders

Turret-mounted lenses emphasised the need for a true through-the-lens view-finder system and with the introduction of zoom lenses this became absolutely essential. Such systems are described as reflex finders and all depend on taking part of the light which comes through the main camera lens and diverting it to produce a separate image which can be viewed by the operator at all times, even when the camera is running.

Two different reflex systems are employed. In one of these the light for the finder image is reflected from the surface of the shutter when it interrupts the beam to the aperture, thus providing a view through the lens at the interval

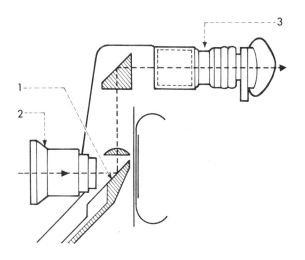

REFLEX VIEWFINDER
 Light from the lens (2) is reflected from the surface of the mirror shutter (1) into a viewfinder optical system (3) during the period when the film is obscured.

between every frame, normally lasting about $\frac{1}{50}$th sec. 24 times every second. In the most frequently used form the shutter is made to rotate at 45° to the optical axis so that the finder image is reflected at right angles into its own system. The reflecting surface of the shutter facing the camera lens is either a silvered mirror or of highly-polished stainless steel. Sometimes a reflex shutter at 45° is used in addition to a normal focal plane disc shutter solely to provide the finder image. In one particular case an oscillating focal plane shutter has a mirror surface facing the lens, the light being intermittently reflected from this into the finder optical system.

Mirror shutter reflex systems provide a through-the-lens view using all the light transmitted by the lens and showing exactly the frame recorded on the film. The intermittent illumination produces a sensation of flicker, which may be objectionable, especially with very bright images. In some cameras the flicker sensation is reduced by dividing the rotating mirror surface with an intermediate black sector, increasing the frequency to 48 per second.

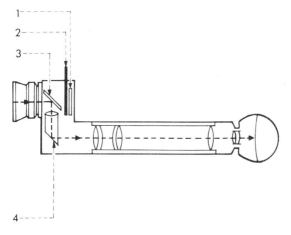

SPLIT-BEAM REFLEX VIEWFINDER

Light from the lens is reflected by a semi-silvered mirror (3) or an equivalent prism into a viewfinder optical system (4) at all times, independent of the rotating disc shutter (2) which obscures the film (1) during its movement.

COMBINED OPTICAL SYSTEM

In this unconventional 8 mm camera the mechanism and film magazine are mounted above the optical system. Light passing through the zoom lens system (2) is divided by the prism (1), the main beam passing through and being reflected upwards to form an image on the film (4). The reflected beam is again divided, part falling on the photocell (6) which controls the exposure level by altering the aperture (3), while the remainder forms the viewfinder image (5) which is seen from the eyepiece.

135

The other form of reflex system employs a semi-reflecting surface permanently in position between the lens and the shutter, either in the form of a prism block or a thin plate or pellicle. Light from this surface enters the finder system continuously, so that the image does not flicker. But the light so used is not available to form an image on the film, and, as a consequence the effective exposure level is reduced. This loss must be kept to a minimum, and in general a reduction of exposure by about half a stop is regarded as acceptable. This type of split-beam system is particularly important in small gauge cameras where space is not available for the 45° mirror shutter. Many such cameras also use the diverted beam to actuate a photocell for automatic exposure control coupled to the main lens iris. In one 8 mm camera the arrangement of beam subdivision reverses the normal practice and it is the reflected beam which exposes the film at the gate while the beam for the viewfinder image continues along the lens axis. This provides a somewhat unconventional camera layout but allows the use of a semi-silvered reflection surface in the beam-splitting prism which can be accurately controlled to give minimum exposure loss.

Electronic monitor viewfinders

All optical viewfinders, however accurately they provide an image, suffer from the deficiency that the scene can only be watched by one person at a time, often through a shrouded eyepiece. The optical system must form a part of the main camera assembly and therefore when the camera is working at extreme angles of tilt or on inconvient mountings it may be very difficult for even the operator to get his eye comfortably in place. With some cameras viewing periscopes can be added for use under such conditions and a flexible link provided by fibre optics has also been devised.

It was however the development of small television cameras which led to the solution of this problem by electronic monitor viewfinders. Essentially these replace the viewing screen of a reflex finder by the face plate of a television camera tube. The necessary alteration of magnification to match the size of the film image to that of the camera tube is provided by a supplementary lens system. From the camera the signal is taken by a cable to an electronic processing unit producing a television image signal which can be fed to any number of small monitoring screens. The processing unit also supplies power to all points and can add specially generated signals to provide various reference images which can be superimposed on the picture from the camera tube. Both mirror-shutter and beam-splitting systems of reflex optics have been used for electronic monitors and in some cases these have also retained the facility of direct optical viewing by the camera operator. In some of the earlier types the quality of the television screen image was not sufficiently good to allow accurate focus setting but with the improvement of the television link the necessity for making any adjustments by optical viewing has practically disappeared.

The rotary mirror shutter has the advantage that all the light coming through the camera lens is available for the television camera tube without loss to the film exposure but the intermittant nature of the illumination presents flicker problems with some types of camera tube. It is therefore necessary to divide the reflecting surface of the shutter into sectors to provide uniform light intensity during each field scanning phase of the television system. It is also necessary to make compensation in the television system for the image produced when the shutter is not rotating, since it must be possible to view the monitor even when the film camera is not running.

Where the beam-splitting reflex system is used these intermittancy problems do not arise, but the light available through the camera lens must be shared between the film and the television channel. The use of high-sensitivity television camera tubes such as Plumbicons allows the balance to be strongly in favour of the film path, a ratio of 9 : 1 being desirable to avoid inconveniently high lighting levels in the studio. Vidicon camera tubes are sometimes used with mirror-shutter systems when all the light through the lens can be used.

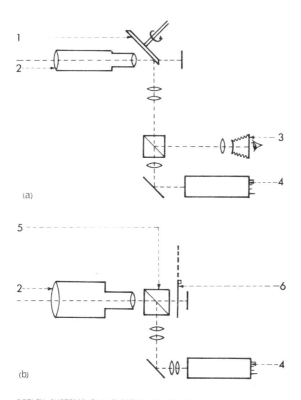

REFLEX SYSTEMS FOR ELECTRONIC VIEWFINDER
(a) The mirror-shutter (1) reflex system is preferred where the television camera tube (4) is the Vidicon type, requiring all the light available from the camera lens (2). A supplementary optical viewfinder (3) may be provided. (b) For high-sensitivity camera tubes of the Plumbicon type, a beam-splitting prism (5) can be used with a normal shutter (6).

The viewfinder monitor usually consists of a small flat-faced tube capable of giving a very bright picture of high definition on a screen measuring 5 or 7 in. diagonally. A highlight brightness of the order of 200 foot lamberts may be required for comfortable viewing under studio lighting conditions. This monitor screen need not be rigidly attached to the camera body or blimp but can be

137

mounted on a balanced swivel so that it can be easily viewed by the operator whatever the camera angle or position.

The monitor shows the whole of the image area recorded at the film gate together with a superimposed bright outline, generated electronically from the signal processing unit, to indicate the limit of the projected frame area so that the picture can be accurately composed. When using an anamorphic camera lens, the monitor image may be electronically unsqueezed so that the picture is shown in its correct proportions. The picture is of course always a black and white television image rather than the actual colours of direct viewing but this is not regarded as a disadvantage. The main function of the viewfinder normally is to check the composition of the scene, to follow the action and to adjust focus as required. The definition and colour reproduction characteristics of colour television systems differ considerably from those of film and it is considered that a colour monitor presentation would be of doubtful value even if it were conveniently and economically available.

Electronic monitor systems can be used both with normal and turret-mounted lenses and are of special value with vari-focus zoom lenses.

Camera controls

Camera controls may be divided into two main groups, those associated with the lens and those with the mechanical running of the equipment. Convenient layout of the operating controls is important for efficient working, particularly with hand-held mobile cameras which may have to be operated by a single cameraman.

The optical control group for the lens comprises the adjustment of the focus setting, the exposure control by adjustment of the lens iris diaphragm and, for zoom lenses, the selection and variation of the effective focal length.

Focusing

Lenses for cinematography are mounted in adjustable tubes with screw threads which can accurately position the distance of the lens from the film plane. These ring mounts are exactly calibrated by the manufacturer to show the setting for each particular object distance, usually in both feet and metres. In hand-held cameras and in most 16 mm cameras the focus ring may be provided with an extension arm or rotary control grip to allow the focus to be set by the operator as he views through a reflex viewfinder. In studio cameras with soundproof blimp enclosures the focus ring is toothed so that it can be rotated by a small remote control servo motor. The servo drive is also accurately calibrated to match the lens focus ring and is used by an assistant camera operator, or focus-puller, to follow the distance settings required during the action of a scene in accordance with the camera movements. In some cameras a special range-finder viewer is linked to the lens focus control to allow accurate focus setting and following, but this scheme was not widely adopted, except with some zoom lenses whose reflex viewfinders operate from beam-splitter prisms positioned before the focusing lens element. With 8 mm cameras for amateur use the greater depth of field provided by the short focus lens simplifies the problem and a single focus setting for each shot, checked through the reflex viewfinder where this is fitted, is normally all that is required.

Lens aperture control

The camera lens aperture is normally adjusted by a rotating ring on the camera mount, calibrated in the appropriate series of *f*-numbers. In some cameras this diaphragm setting may be remotely controlled, but this is not a frequent requirement because in studio photography the occasions when an alteration of exposure is needed during a shot are rare.

In professional studio motion picture photography the lighting level and distribution for each scene can be arranged and measured in advance and the

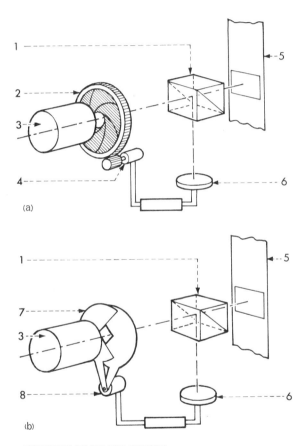

(a)

(b)

AUTOMATIC DIAPHRAGM CONTROL
(a) A beam-splitting prism (1) diverts part of the light from the lens (3) on to a photocell (6) coupled to a micro-motor (4). This motor adjusts the diameter (2) of the stop behind the lens so that the light reaching the cell and hence the exposure of the film (5) is constant. (b) In another system the light on the cell operates a moving coil instrument (8) to open or close diaphragm plates (7) to give a constant intensity at the cell.

lens diaphragm set accordingly for each shot. In newsreel work the available lighting has to be used as it occurs and the occasions for taking exposure meter readings may be very limited. A number of 16 mm cameras have therefore been produced in which light coming through the lens is used to determine the exposure level required. In amateur cinematography the limited exposure latitude of the colour reversal films most popularly used has led to the adoption of a similar procedure on many of the more expensive models.

Two systems are in use, providing either semi-automatic or completely automatic exposure control of the lens iris. The semiautomatic system effectively provides a light meter built into the reflex viewfinder optics, which is almost always of the beam splitter type. Part of the light coming through the lens is diverted to fall on the surface of a photocell, the output from which actuates a pointer which can be seen in the viewfinder field. In the simplest form the position of this pointer on a scale indicates the f-number of the aperture to which the lens iris should be set, while in another type the camera user adjusts the lens diaphragm setting until the pointer is brought to a standard calibration mark.

In the fully automatic system a moving coil unit or a small motor geared to the iris adjusts the lens aperture to produce a standard level of illumination reaching the photocell, the power for the motor being supplied from a small dry battery so that it is independent of the main camera supply and can be used even with springwound equipment. This system is very popular on amateur 8 mm cameras with zoom lenses but its use on professional 16 mm cameras with interchangeable lenses presents some practical problems and here also it has been mainly applied with zoom lenses permanently mounted. In all cases the light meter can be externally adjusted to take account of the ASA speed of the film being exposed and can also be compensated either manually or automatically for the exposure rate in frames per second when the camera is run faster or slower than normal.

Perhaps the most complete solution to the problem of lens aperture control under studio conditions is that provided by electronic monitoring. The television signal obtained from the camera can not only be displayed as a picture on a vision monitor screen but it can be simultaneously analysed for examination on an associated wave-form monitor tube. This serves the purpose of a spot-brightness meter continuously available for measuring the light intensity of any part of the scene. By the use of remote control servo mechanisms the lens diaphragm setting of the camera can be adjusted to provide a standard peak white level on the wave-form monitor and if necessary this setting can be smoothly altered in the course of a shot to meet the varying lighting conditions of the scene. Where multiple cameras are in operation the accurate balancing of the exposure levels provided by this method is invaluable.

Zoom lens control

Zoom lenses are employed both to provide several different focal length shots without changing lens and to produce the equivalent of camera movement to and from the subject by varying the focal length during the action. For the first purpose manual adjustment of a control arm by observation through the reflex finder during initial camera set-up is sufficient but where zoom effects are required during action a motor drive is a great asset. This provides smooth zoom operation either in or out and the zooming rate can be adjusted over a range of speeds to meet the requirements of the shot; a battery power source and resis-

tance speed control is usually employed. For studio operation some zoom lens motor drives can be present to start and stop at selected positions in the range of focal lengths and brought into action by a press-button at the required time. In the most elaborate drive systems the zoom motion is gradually accelerated and decelerated at the beginning and end of its traverse to ensure a smooth effect in final presentation. Even amateur 8 mm cameras are now frequently provided with motor-operated zoom lenses, although with a less elaborate range of controls and a limitation to only one or two zoom rates.

Other controls

In studio cameras the controls and other instruments are usually grouped at the back of the camera body for ready access, and are sometimes illuminated for easy reading. The main starting switch is mounted close to the entry of the power supply cable or it may form part of the cable itself. Footage and frame counters are provided to indicate the amount of film which has run through the camera and there is often an additional dial to indicate the quantity of unexposed film remaining in the magazine. The footage and frame counter is accurately locked to the camera mechanism and can be manually reset to zero either at the beginning of a new roll of stock or whenever it is required to measure accurately the length of a particular scene. The magazine indicator on the other hand is a more approximate device which works by a roller following the diameter of the roll of film remaining.

A tachometer or speed indicator is an essential part of a camera with a variable speed motor under rheostat control and is calibrated to show speed in frames per second. Even in studio cameras designed to run at a fixed speed of 24 fps a simplified speed indicator may be provided to show when the camera is up to speed and running at its synchronised rate. In some machines this indicator is replaced by a pilot light which operates when correct speed is reached. An external knob is sometimes provided which can be engaged with the main drive of the mechanism when at rest, so that it can be turned over, or 'inched,' by hand for a few frames at a time while threading the film path.

Controls for the variable shutter opening are also at the back of the camera with a lever or dial showing the angular opening and the maximum and minimum settings available. Press-buttons may be provided to effect this opening or closing automatically over a specified length of film to produce fade or dissolve effects.

In amateur 8 mm cameras the range of control is similar but of a simplified nature. Exact footage and frame counters are rarely supplied but a simple indicator is provided to show approximately the length of film run through. A warning device to show when a magazine is coming to an end may also be provided and is sometimes made visible in the viewfinder. Camera speeds are normally preset by an external dial rather than actually measured by tachometer and variable opening shutters are exceptional. Controls for zoom lens motor, if there is one, must be convenient and simple to use. With battery operated cameras an indicator showing the condition of the cells may be installed.

Camera accessories

One of the most essential accessories on professional cameras is the lens hood and matte box assembly. The first purpose of this is to prevent direct rays from oblique light sources striking the glass surfaces of the lens and causing flare or

internal reflections which might appear on the picture. The lens hood is usually supported by adjustable extension rods mounted on the front of the camera and is matched to the lens in use by a folding bellows extension. The second function, provided by the matte box, is to allow cut-out masks, filters, diffusion discs and other transparent or partly-transparent materials to be conveniently mounted. The visible sharpness in the outline of a mask depends on its distance in front of the lens for a given focal length and aperture setting and the position of the matte box on the extension rods therefore requires adjustment to obtain the desired effect. Deep bellows-type lens hoods are often provided on 16 mm cameras but are rare on 8 mm amateur cameras, where the lens hood is usually limited to a deep flange extension to the lens tube itself.

LENS HOOD AND MATTE BOX
A deep lens hood can be adjusted to suit different lenses by the bellows. Slides for cut-out masks, mattes and filters are provided and their distance from the lens adjusted on the slide bars.

The noise of the mechanism of almost all cameras used in studio photography with simultaneous sound recording means that an ordinary camera must be mounted in a soundproof enclosure. In the early days of sound films the whole camera on its mounting complete with its operating crew was enclosed in a large soundproof booth but this imposed overwhelming restrictions on camera movement within the studio. Most modern cameras are less noisy and can be satisfactorily used with soundproofing covers known as 'blimps,' although these add considerably to the bulk and weight which has to be mounted and manoeuvred. Much research and experiment has gone into the design of blimps for individual cameras and sound damping is usually provided by several layers of plastic foam or other absorbent material. In some types the whole camera may be run out of the blimp enclosure on internal rails for changing magazines and re-loading the film, while in others tightly fitting doors or removable sections are provided for the same purpose. All the main controls must of course be operated from outside the blimp, either by extension arms or by duplicated eternal switches and servo motors. A number of modern professional cameras are now 'self-blimped' and require no separate enclosure. The improved mechanical design of the intermittent movement and its drive has greatly reduced noise at

source, and the camera body and magazines are constructed with their own acoustic damping and insulation for soundproofing.

There is also a simpler form of camera cover known as a barney, the purpose of which is primarily protection of the camera together with a limited amount of noise suppression. The barney is a flexible waterproof coat of insulating materials tailored to fit a particular camera model and easily fastened in position. Heating elements may be built into this jacket to maintain the temperature of the camera mechanism when working under adverse weather conditions or in cold climates.

Special cameras

In professional photography the high-speed camera is the most frequently encountered special type, and is used to produce slow-motion effects. Such effects are often required to add dramatic emphasis in action shots and are essential to provide a realistic appearance when photographing models and miniatures. High-speed studio cameras are usually not required to run more than four or five times faster than normal, that is to say at speeds up to 128 frames per second, and at these rates conventional intermittent mechanisms can be used. The designs are usually modified to reduce the inertia of all moving parts by making them lighter and in some cases the rather complex registration pin mechanism may have to be omitted in the interests of speed. High-speed inter-mittent cameras are much noisier than regular cameras but as they are never used with simultaneous sound recording this presents no problem and blimps are not employed.

For scientific investigation, cinematography at far higher picture rates may be required and speeds of one million images a second have been achieved. The basic intermittent frame movement reaches its practical limit at running speeds of a few hundred pictures per second, even with specially designed mechanisms and the use of 16 mm film to reduce inertia. For speeds beyond this the film must be moved continuously and the image made to move along with it by means of optical compensators. These have taken the form of rotating mirror drums or lens assemblies, but many of most successful are based on rotating parallel-faced prisms, which can provide speeds up to 10,000 frames per second on 16 mm film. The whole subject of such high-speed photography is a very specialised one and somewhat outside the normal field of motion picture pro-duction. It involves not only particular mechanical and optical design for the camera but also problems of lighting the subject and synchronising electronic flash illumination with the camera and the action. As at these speeds a full 400 ft magazine of 16 mm film runs through the camera in less than two seconds, accurate timing is also essential.

A particular range of special cameras used in regular film production are the single frame exposure cameras intended for shooting animated cartoons, titles and models. These also have scientific applications for time-lapse photography in which action extending over many hours or days in reality may be shown compressed into a few seconds on film. Animation cameras normally have an intermittent of conventional design with precise registration mechanisms. A stop-frame drive must be provided to expose one frame at a time either by manual or automatic control. This drive must give uniform exposure from one frame to next no matter at what frequency it is operated, and various devices have been developed to ensure that there are no slow-start effects when switch-ing on. Synchronisation of the drive mechanism must ensure that the camera

always stops with the shutter in a standard fully closed position. It must also be possible to run the camera continuously at slow speeds exposing only a few frames per second. A shutter opening control is essential, not only to produce automatic fades and dissolves but also to allow compensation for the long exposure periods at slow running speeds. As animation cameras are so much concerned with various forms of trick photography, forward and reverse running is always provided.

Another special type of camera is that forming part of an optical printing machine that produces special effects in the studio trick work department or in the processing laboratory. The camera bodies of such equipment use essentially standard intermittant mechanisms with particular emphasis on steadiness and accurate registration to allow multiple exposures on the same film; a Bell and

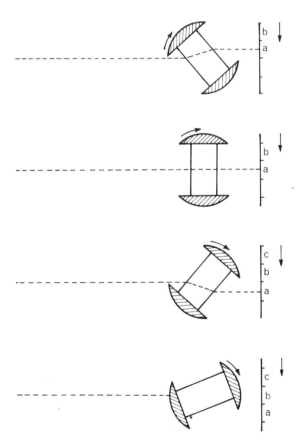

OPTICAL COMPENSATOR
The rotation of a parallel-faced glass prism can be made to keep the position of an image (a) and (c) fixed on a continuously moving film, thus eliminating the need for an intermittent mechanism. The ends of the prism act as shutters and obscure alternate frames (b).

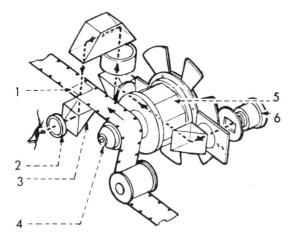

OPTICAL SYSTEM FOR HIGH SPEED CAMERA

A rotating 8-faced prism (5) acts as an optical compensator to hold the image formed by the lens (6) steady on the continuously moving film (1), which is driven by a sprocket (4) on the same shaft as the prism itself. The viewfinder (2, 3) shows the image in the film plane.

Howell design of movement is frequently employed. These heads always provide foreward and reverse running and often operate at much slower speeds than normal; single-frame exposures are also used both automatically and under manual control. There are usually facilities for running two strips of film in the movement, so that part of the image on the film may be printed in contact. Adjustable shutters are essential and are often designed with automatic cam or gear-train operation to give a series of shutter openings for a fade or dissolve over a selected number of frames. On an optical printer the lens does not form an integral part of the camera body but is separately mounted to allow a wide range of adjustment for image focus and position. There is no conventional viewfinder as such, but means are always provided for detailed examination of the image formed in the camera aperture, often by a supplementary optical system giving a magnified picture on a ground glass screen.

K

5 Sound recording and reproduction

Three basic systems of sound recording and reproduction have been employed in motion picture production and presentation, and may be termed the mechanical, optical and magnetic processes. Of these the mechanical method, where the sound is recorded as lateral variations of a spiral groove on a flat disc, had only a limited application during the early period when sound was first being introduced in the cinema and is no longer of practical importance in production. Of the other two, the optical method, producing a sound record on photographic film, was the dominant system for both recording and reproduction for the first twenty years from 1929 to 1949. But since that time the magnetic method using film or plastic tape coated with a layer of magnetic iron oxide has become the sole mode of recording. Optical sound, however, continues as the most favoured method for reproduction in the cinema theatre on the grounds of economy and convenience. Reproduction from magnetically striped film is recognised as giving superior sound quality, but the additional cost of making copies for general distribution in this form has so far limited it to special forms of cinema entertainment involving stereophonic presentation. Some kinds of small gauge film also make use of magnetic sound but the optical system is more general.

In television both methods of reproduction are employed, although optical sound is preferred where a copy of a normal motion picture film also intended for theatrical presentation is used to provide a television programme.

Magnetic system

Sound waves from the source to be recorded are picked up by a microphone which converts them into electrical signals. After amplification these electrical signals are fed to a recording head where they give rise to a varying magnetic field across a very narrow gap between two pole pieces. A thin layer of magnetic iron oxide coated on a suitable carrier strip is affected by these variations of field as it passes across the head in contact with the pole pieces. It retains the variations as changes in the magnetic structure of the coating, thus providing a

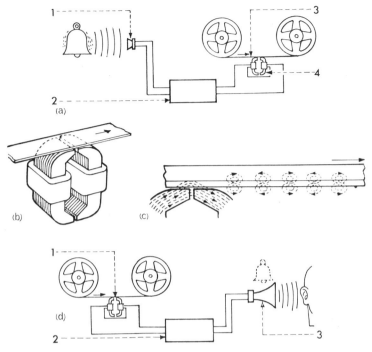

PRINCIPLES OF MAGNETIC RECORDING

(a) Electrical signals produced by the microphone (1) in response to sounds are amplified (2) to create a varying magnetic field at the recording head (4) which affects the magnetic coating on a strip of film or tape (3). At the recording head (b) the magnetic field is formed across a gap in the laminated pole pieces by current passing through coils surrounding them; field variations at this gap are retained by the magnetic layer on the passing strip (c). (d) In reproduction these variations in the tape set up currents in the pick-up head (1) which after amplification (2) produce movements of the diaphragm of the loud speaker (3) which are heard as sounds.

record of the original sound. Reproduction can be obtained by running the magnetic layer in contact with another head so that the recorded magnetisation gives rise to varying electrical signals which can be amplified and made to cause mechanical vibrations in the diaphragm of a loudspeaker. These are of course, heard as sound. The changes of magnetic pattern stored in the coating on recording are quite stable and can be reproduced many times without appreciable loss. But when necessary, the record may be erased by demagnetisation and the coating used again for another recording. The scope for repeated re-use combined with the ability to reproduce the sound immediately it has been recorded means that magnetic materials offer outstanding advantages for sound recordings in comparison with photographic film, which requires processing and which cannot be used again.

147

Magnetic materials

A satisfactory sound recording system must be able to accept a very wide range of frequencies, corresponding to those appreciated by the human ear in what

THE AUDIO SPECTRUM

The pitch of a musical note is measured by its frequency in cycles per second (Hertz: 1kHz = 1000 Hz). The range of a 6-octave piano keyboard covers 32 to 2048 Hz, with Middle C at 256. The fundamental range of musical instruments and voices is much extended by high frequency harmonics which give the sounds their characteristic timbre. Percussion instruments such as the castanets and triangle include extremely high frequencies. In reproduction systems a telephone covering 0·3 to 3 kHz provides good intelligibility, but a high fidelity system must have a range from 0·03 to 12 kHz. 16 mm sound film reproduction extends to about 6 kHz, and 35 mm to 9 kHz.

The sensitivity of average human hearing shows a marked peak about 3—4 kHz with practical limits approaching 16 Hz at the lower end and 16 kHz at the upper end of the scale.

148

may be termed the audio spectrum. In practice an upper limit of 15 kilo Hertz (15 kHz = 15,000 cycles per second) is generally recognised as sufficient. If the magnetic changes corresponding to high frequencies are to be clearly defined in the recording layer the magnetic particles must be extremely small and uniformly distributed. In addition they must retain a high degree of magnetisation after passing through the recording field to provide a good output for reproduction. And the magnetic changes must be permanent enough to remain unaffected by extraneous influences, yet allow complete erasure when required.

In modern materials these requirements are met by gamma iron oxide (γ Fe_2O_3) as the magnetic material. It takes the form of synthetic needle-like crystals approximately 1 micron long. These particles are carried in a plastic resin, known as the binder, for coating on the base material. Their exact concentration, and uniformity in their dispersion within the resin is of vital importance. Other substances may be incorporated in the binder to act as lubricants and improve the surface finish of the layer.

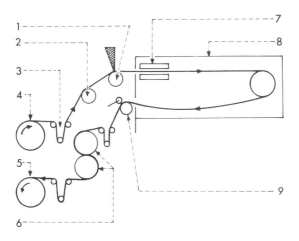

MAGNETIC TAPE MANUFACTURE

The wide web of base moves from the feed roll (4) through tension control (3) to the pre-heat roll (2) and coating head (1). As the coated web enters the drying enclosure (8) it passes through a magnetic field (7) to orientate the particles. After leaving the enclosure by the drive roll (9) it is polished by the calendering rolls (6) before taking up (5).

The combined oxide and binder are applied to the base in the form of a viscous solution either by extrusion from a coating aperture or by transfer from a coating roller. The base is usually in wide rolls from which a large number of strips are eventually cut. Uniformity of coating both across the whole width and along the length of the roll is essential, as variations in thickness would cause changes of magnetic sensitivity. In its final form the thickness of the layer may be only 0·01 mm and variations of the order of 10% are significant.

After coating, the base with the magnetic layer still in a viscous state is passed through a uniform magnetic field to orientate the needle-like particles of

magnetic oxide along the length of the strip. This treatment improves the uniformity of response and the sensitivity, particularly for lower frequencies. The strip then enters the drying ovens where the solvent is removed, and the thermoplastic binder sets firm. As in the manufacture of photographic film the air sup-

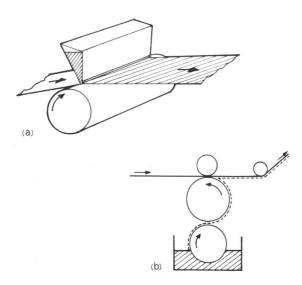

(a)

(b)

MAGNETIC TAPE MANUFACTURE
(a) The base web passes under a hopper containing the magnetic suspension which is extruded at a knife-edge slit. (b) In roller coating the suspension is picked up by the lower roll and transferred to the base by the rotation of the applicator roll.

plied to the drying path must be absolutely clean so that no dust particles can be trapped by the coating while it is still viscous. After drying, the surface of the coated layer is polished to improve its contact with the recording head and to reduce wear. It is then slit into strips of the width required for final spooling.

1 2

MAGNETIC TAPE MANUFACTURE
1. Random distribution of magnetic particles as coated. 2. Particles aligned longitudinally under applied magnetic field.

Tape and film

Magnetic materials for sound recording are used in two forms: magnetic *film*, which is in perforated strips similar to photographic film, and magnetic *tape* which is normally an unperforated band 6·25 mm in width for sound work although greater widths of 25·4 and 50·8 mm (1 and 2 in.) are used for video recording in television.

Magnetic film is normally coated on a cellulose acetate or cellulose ester base 0·14 mm thick similar to that made for photographic film, and is slit and perforated in the same way after manufacture. Full width coatings are available in 35, 17½, or 16 mm widths. Film with a magnetic coating narrower than the full width of the stock is also made. This material is prepared by striping the magnetic coating from a narrow extrusion head or applicator roll on to a strip of base which has already been slit and perforated. The stripe may occupy the whole width of 25 mm between the rows of perforation holes on 35 mm film, or narrower stripes of 8 mm or 3 mm can be used. Where a narrow stripe is used near one row of perforations it is usual to apply another very thin stripe near the opposite edge to avoid spooling difficulties caused by one side of the film

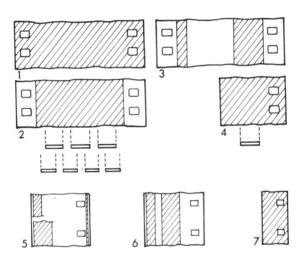

MAGNETIC FILM

35 mm film may be magnetically coated full-width (1) or between perforations only (2); in either case, three tracks of 200 mil (5.0 mm) or four tracks of 150 mil (3·8 mm) can be accommodated. A magnetic stripe 300 mil (7·6 mm) wide is also used on 35 mm film (3) with a balancing stripe of 100 mil (2·4 mm) on the opposite edge. With this and with 17½ mm fully coated stock (4) a single 200 mil (5·0 mm) track is used.

16 mm film (5) is used with 100 mil or 200 mil stripes, with a balancing stripe on the opposite edge. A central 200 mil stripe is sometimes used (6) with a 100 mil edge stripe. Regular fully-coated ¼ inch (6·25 mm) tape perforated with 16 mm film sprocket holes (7) is used with some synchronising systems.

being thicker than the other. This additional stripe is known as a balancing stripe and is not used for recording purposes.

Magnetic tape on the other hand is always manufactured with a full width coating and is only rarely made with any form of sprocket hole. A number of different base types are employed but these are always much thinner than cinematograph film material. So a spool of quite small diameter can accommodate a considerable length of tape and hence provide a long running time. Three base materials have been generally adopted; cellulose acetate and triacetate, polyvinyl chloride or PVC and polyethylene terephthalate, more usually known as polyester or P.E. The original acetate base was made to a thickness of 0·037 mm (0·0015 in.) and this is referred to as standard play (S.P.). When a thinner acetate base of 0·025 mm (0·001 in.) became available it was termed long play (L.P.). Acetate base is the cheapest material in general use but is of low mechanical strength compared with other types. PVC base has somewhat greater strength and can be made as thin as 0·014 mm (0·0006 in.) to give double play (D.P.) tapes. Polyester base, although the most expensive, has outstanding mechanical strength and by giving it a longitudinal stretch at the time of manufacture its liability to elongation under tension can be markedly reduced. This process is known as tensilizing. P.E. base treated in this way can be made as thin as 0·008 mm (0·0003 in.) for the manufacture of quadruple play tapes. Very thin base tapes call for great care in manufacture and handling, even those made with the best materials. There is also some danger of 'print through' when recorded tapes are stored for a lengthy period, because the magnetic layers of successive turns of tape on a spool are separated by such a thin base that the magnetic signal on one layer can affect the coating on the adjacent turns. Recorded tapes stored for several months should therefore be rewound from time to time to vary the relative position of the recorded patterns in the roll.

Tape speed

The faster the coated strip is moved past the recording head, the more the pattern of magnetic change is spread out along its length, and the greater the length of strip required to record a given performance. High frequency sounds will give rise to very closely spaced series of magnetic variations which may not be sufficiently clearly defined unless the strip speed is sufficiently high. Magnetic tapes were originally run at a speed of 30 inches per second (76 cm per sec.) and in this case a high pitch sound of frequency 12 kHz produces a pattern of magnetic variations with a spacing of 30/12,000 = 0·0025 inches (0·0625 mm). If this pattern is to be clearly recorded and reproduced the dimension of the gap in which the magnetic field is produced must clearly be much smaller.

With the improvements in magnetic coating materials and head construction it became possible to record satisfactorily at even closer spacings and speeds of 15 ips and then 7½ ips came into use. At the latter speed a 12 kHz signal corresponds to a spacing of approximately 0·0006 in. (7·5/12,000) or 0·0156 mm and a head gap of 0·0001 or 0·00015 in. (0·0025 to 0·004 mm) is employed. In general film studio work it is not necessary to provide continuous sound recording for very long periods, so the mechanically stronger long play or double play tapes are normally preferred. A tape running speed of 7½ ips (19 cm per sec.) is general although 15 ips (38 cm per sec.) is sometimes used when the highest quality of sound frequency response is required. The lower speed of 3¾ ips (9·5 cm per sec.) although common on domestic tape recorders, is rarely used

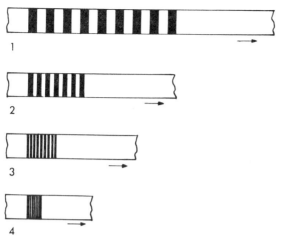

EFFECT OF TAPE SPEED
A high frequency note which is clearly defined at a tape speed of 76 cm.p.s. (1) can be adequately recorded at 38 cm.p.s. (2) and 19 cm.p.s. (3) but may not be satisfactory at 9·5 cm.p.s. (4).

professionally and when employed is restricted to speech and effects of a less critical nature. A 7 in. diameter spool (180 mm) can hold a 2,400 ft length of double play tape, giving a playing time of 64 minutes at 7½ ips or 1800 feet of long play tape for 48 minutes. Portable recording equipment is often designed to take smaller spools of 5¾ in. diameter or less, so the thinner triple, or quadruple play tape would be used if long recordings were necessary.

When the magnetic coating is on perforated film, normal cinematograph running speeds have been adopted. These work out at 18 ips for 35 mm film and 7·2 ips for 16 mm. Spools of 1000 ft (300 m nominal) give playing times of 11 minutes and 27 minutes respectively.

Synchronization

The principal differences in applying magnetic film and tape in cinematography lie in the methods of synchronisation between the camera and the sound recording unit.

With perforated magnetic film for the sound, the sprocket drives of the camera and recorder can be electrically interlocked so that exactly the same length of film passes through both mechanisms in a given time. If the camera is loaded with 35 mm photographic film the sound recorder can use either 35 mm magnetic film or, for economy, the half-width 17½ mm magnetic film which has identical perforation dimensions.

Sound recording on magnetic tape offers several advantages, however. The material used is cheaper and substantially smaller in size and weight, while the recording equipment is also very much more portable and convenient. Tape recording units were in fact first developed for location work away from film production studios when the much heavier film recorder could not easily be transported. Narrow tape with perforations has been developed but in practice

153

it presented many difficulties and the preferred method is now to gain synchronisation between picture and tape by means of a recorded pulse system which may be regarded as producing an electronic equivalent of the sprocket holes.

The advantages of tape are such that even in permanent studio installations it is now common to employ it for all sound recordings made while shooting and to transfer to magnetic film only those sections finally required for editing.

Many different pulse synchronisation systems have been developed but all involve using one portion of the tape width to record the sound while at the

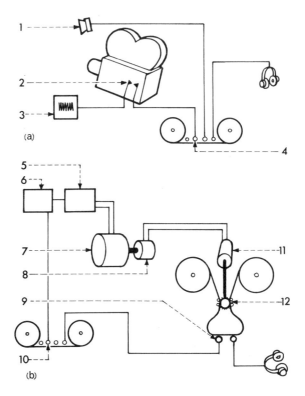

PRINCIPLES OF PULSE SYNCHRONISATION

(a) Contacts (2) operated by the camera mechanism allow a pulse from the signal generator (3) to be recorded on the tape by a separate head (4) at the same time as the main sound from the microphone (1).
(b) On transfer from tape to film the pulse from the head (10) is amplified by the signal amplifier (6) and power amplifier (5) to drive a synchronous motor (7). This controls the film recorder drive sprocket (12) by a selsyn motor (8) and slave (11). The film on which the sound is being re-recorded from the playback head (9) is thus driven exactly in accordance with the original picture film in the camera.

same time recording a series of signals (derived from the camera) on a parallel part of the tape. In its simplest form, the pulse may be derived from contacts in the camera mechanism which open and close once per frame. But more frequent pulse signals from the electrical drive of the camera motor are usually employed.

In some cases, especially working on outdoor locations, it is inconvenient to have to provide an electrical cable connection between a mobile camera and its sound recorder. A radio link can then be used with a small transmitter on the camera and a receiver at the recording unit. Or, alternatively, both camera and recorder can be controlled to run at exactly the same speeds by identical timing devices. Such devices are based on vibrating systems, such as tuning forks or piezo-electric crystals, which can be electrically operated and matched in frequency with great precision.

At a subsequent stage the sound record on tape must be transferred to magnetic film for cutting and editing to match the photographed picture. This transfer and re-recording operation requires the output from a tape reproducer to be fed into a recorder using magnetic film. The speed of the recorder is accurately controlled by signals derived from the pulses on the tape. Thus, if the tape has had two pulses recorded in the sync track for every frame which has passed through the camera, the re-recorder must be made to run two perforations of 35 mm film for every pulse reproduced. This can be done either by amplifying the sync pulses sufficiently to drive the motor speed through electronic means or, alternatively, the speed of the re-recorder may be accurately set, for example by mains frequency, and the sync pulses used to control the speed of the tape reproducer relative to the mains. In all cases the result is a sound recording on perforated magnetic film which can be directly matched to and handled with the photographic record of the scene.

Track dimensions

The breadth of the magnetic track is determined by the width of the recording head in contact with the coating and is always less than that of the coated layer layer itself to avoid any abnormal edge effects.

Track widths are often measured in units of one-thousandth of an inch, referred to as mils, hence the terms 100 mil, 200 mil recordings for track; 0·100 or 0·200 inches wide. These mils must not be confused with millimetres.

On 6·25 mm tape almost the full width may be used for recording with a head of 5·84 mm (230 mil) but it is more common to have a narrower head for the sound track, leaving the rest of the tape for the pulse control signal synchronising the sound with the picture information. Several different systems are currently employed. In many of them, such as the Synchropulse method, the audio track occupies a band 2·5 mm (100 mil) wide near one edge of the tape, while the synchronising signals are recorded on a corresponding band of the same width along the other edge. In the Perfectone system the audio track is central, and 4·70 mm (180 mil) in width while the control signals occupy the narrow bands along both edges. In other systems they may be recorded down the centre of a full width audio track in such a way that they are only reproduced by a special pick-up head.

When 35 mm film with full width magnetic coating is used either three track positions 5·08 mm (200 mil) wide or four tracks of 3·76 mm (150 mil) width can be accommodated conveniently, the former being the more frequent. Both these track widths can also be applied to 35 mm and 16 mm film with a wide magnetic

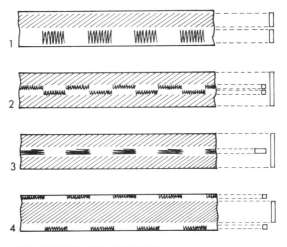

In several systems, such as Synchropulse (1),
the audio and the pulse track each occupy half the tape
width. In others, the pulse track is central, with the pulses
recorded in push-pull (2) (Neo-Pilote) or at right angles
(3) so as not to interfere with the audio record. In the
Perfectone system (4) the pulse tracks occupy narrow
bands at the edges of the tape.

stripe, but on the narrower stripe sometimes used on 35 mm or 16 mm film, a
width of 2·5 mm (100 mil) is normal.

Combined recording

Although the application of separate strips of film and tape for recording picture
and sound respectively is universal in 35 mm work and frequent in 16 mm, there
are some instances where the two are recorded simultaneously on the same strip
by the use of pre-striped photographic film in a special 16 mm camera. In such
equipment a combined magnetic record and play-back head is built into the
camera body at a position 28 frames below the intermittent movement where
the film motion is continuous. The necessary amplifiers and power supply are
carried by the operator as a portable pack, together with the microphone. The
16 mm film loaded in the camera has been previously coated with a narrow
magnetic stripe 2·54 mm wide on the base side and after exposure and processing
the recorded sound is transferred to a separate magnetic film so that the picture
can be handled and reassembled for printing. Since both picture and sound
have been recorded on the same film there are none of the problems of speed
synchronisation which occur with tape, and the transfer system goes direct
from the combined 16 mm film to a 16 mm magnetic record by straightforward
mechanical interlock.

Although there are some limitations in the sound quality that can be obtained,
this single film system is particularly appropriate for news work requiring a very
mobile camera unit, and is widely used in filming news for television. Reversal
film stock with magnetic stripe may be transmitted on T.V. immediately after

processing to save time, but the separation of 28 frames between the picture and its corresponding point in the sound track means that just over one second in sound running time will be lost wherever the film is cut for editing.

Recording equipment—Microphones

The function of the microphone is to convert the changes of air pressure caused by sound waves into mechanical energy which is then transformed into an electrical signal. In general the sound waves cause the vibration of a diaphragm and these vibrations are used to generate a corresponding variable voltage. Three main methods of producing this result are in use at the present time—piezo-electric, magnetic and electro-static.

Piezo-electric microphones, more commonly known as crystal microphones, make use of the phenomenon shown by certain crystalline materials which produce a voltage difference between two faces when they are mechanically

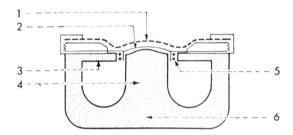

PRINCIPLES OF MICROPHONES
(a) Moving Coil Microphone
1. Perforated metal guard protecting, 2, diaphragm on extension of which the coil, 5, is wound. It lies in annular gap formed by central pole piece, 4, of permanent magnet, 6, and soft iron outer pole pieces, 3. Vibration of coil in magnetic field produces voltage.

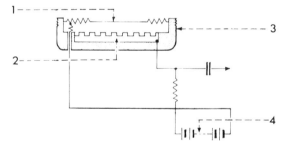

(b) Condenser (Capacitor) Microphone
Polarizing voltage, 4, of about 60 v charges capacitance between metal diaphragm, 1, and fixed plate, 2, held in insulating support, 3. Vibration of diaphragm causes capacitance to vary, producing alternating voltage. Clearance between diaphragm and fixed plate is held to a minimum to increase capacitance change, but low output necessitates use of pre-amplifier in microphone housing.

157

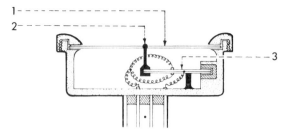

(c) Crystal Microphone

1. Diaphragm connected by link, to crystal bimorph, 3, consisting of two thin layers of Rochelle salt, fixed together back to back, forming one side of the generator; exposed faces are connected to form the other side. Deformation of generator by movement of diaphragm sets up varying voltage differences between sides of generator. Other mechanical arrangements are possible.

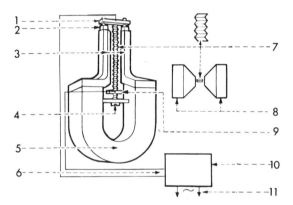

(d) Ribbon Microphone

Works on same principle as moving coil microphone, but ribbon acts as both conductor and diaphragm. Corrugated ribbon, 7, vibrates between pole pieces, 3, attached to permanent magnet, 5. Top contact, 1, separated from poles by insulator, 2, and bottom contact, 9, go to input, 6, of output transformer, 10, which raises impedance from less than one ohm. 8. Top view of pole pieces. 4. Ribbon tension adjustment. 11. Microphone output.

distorted. In a typical form the centre of a conical diaphragm is connected to the corner of a bi-morph, consisting of a pair of thin layers of Rochelle salt, to the surface of which electrical connections are made. Movements of the diaphragm caused by sound waves cause the crystal layers to bend and produce a voltage difference between the surfaces. This voltage can be led away for amplification.

Two types of magnetically operating microphones are in general use. In the moving coil type, a coil of wire attached to the back of the diaphragm is moved by its vibrations in the field formed within an annular gap of the poles of a

permanent magnet. An electric current is induced in the coil by these movements and is fed to the amplifier. In the other type, the ribbon microphone, the diaphragm takes the form of a narrow corrugated strip of extremely thin metallic foil suspended between the poles of a magnet. The action of incident sound waves causes movement of this conductor strip in the magnetic field, again giving rise to a varying electric current which can be amplified.

Electro-static or condenser microphones depend on a change of capacitance caused by the variations in position of the diaphragm in relation to a fixed back plate. A polarizing voltage is applied across the plates through a large series resistor and the voltage changes caused by the diaphragm movement are amplified.

Microphone directivity

Microphones can be designed with differing directional sensitivity characteristics and it is important to choose one with the effect required for each application in recording. The directivity pattern of a particular microphone can be conveniently displayed on a polar diagram, which shows how its response varies with the horizontal angle of the sound source from the microphone axis.

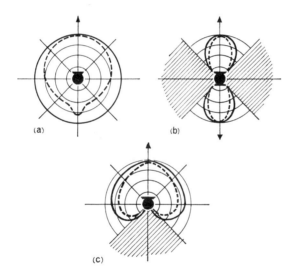

POLAR DIAGRAMS OF MICROPHONES
Polar diagrams in which 100 per cent response corresponds to curve reaching outermost circle, 0 per cent to curve falling in on microphone. (Solid line) Lower frequencies. (Dotted line) Higher frequencies. (a) Omni-directional pattern; slightly directional for higher frequencies. (b) Figure-of-eight. Sides of microphone are dead, response is symmetrical front and back, higher frequencies more directional than lower. (c) Cardioid; heart-shaped pattern gives dead area at back often convenient for speech recording and for rejecting noise behind microphone.

159

In an ideal design the polar pattern should be the same for all frequencies of sound but in practice it is always found that a microphone has more marked directivity for high frequencies than for low. Microphones designed for three general directivity patterns are to be found.

The omni-directional microphone has substantially equal sensitivity in all directions, so with this the polar diagram is almost a circle. At high frequencies the response to sources behind the microphone is reduced and for these it operates in a somewhat directional manner.

Bi-directional microphones have high sensitivities directly forwards and backwards but do not respond at all to sound sources at the sides; the resultant polar diagram shows a typical figure-of-eight form. This response distribution is particularly evident with ribbon microphones.

The uni-directional or one-sided microphone is often known as the cardioid type because of the heart-shaped pattern of its polar response curve. It shows its main sensitivity in a forward direction and retains a useful response on each side, but is quite unaffected by sound sources behind. A combination of two cardioid units with controllable relative sensitivities can be used to provide a microphone of variable pattern from multi-directional to one-sided.

Special microphones

Highly directional microphones are sometimes required to pick up the sound from one source only, over a very narrow angle. A cardioid microphone may be placed at the focus of a parabolic reflector which is directed towards the source. But it is more usual to employ a tube microphone, also known as a line, rifle or shotgun microphone. In these the microphone itself is mounted at the end of a tube or group of tubes directed at the source. The tube may be tapered and per-forated with holes along its length or it may have a narrow slit running its full length and be fitted with small external baffle plates to improve its frequency response. In all cases the directional effect of the system is much more marked for high frequency sounds.

When working with very mobile action on a studio stage or out-of-doors it is sometimes inconvenient to try to cover all sound recording from only one or two microphone positions. The actors may then be provided with their own personal microphones, known as Lavaliers, worn on lanyards around the neck or clipped on to the costume near the chest. Microphones of this type are small moving

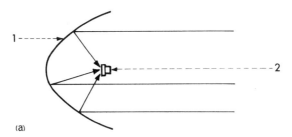

HIGHLY DIRECTIONAL MICROPHONES
(a) Reflector Microphone.
The microphone (2) is placed at the focus of a parabolic reflector (1) directed towards the source of sound; its position can be adjusted to cover a variable angle.

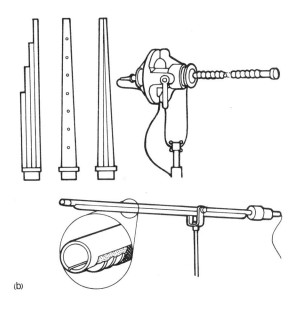

(b)

(b) Tube Microphones
The microphone is mounted at the end of a tube, which may have a narrow slit or holes perforated along its length to improve its response.

coil units with a frequency response designed to give best results over the vocal speech range under those conditions.

LAVALIER MICROPHONE
The Lavalier or Chest Microphone. It is worn by a neck cord and contains a small moving coil unit pointing upwards.

L

Although providing greater freedom of action normal Lavalier microphones still require cable connections back to the amplifier and recorder. The obvious solution is to use a radio link by means of a miniature transmitter carried by each actor. Radio or wireless microphone units have therefore been developed to provide the utmost flexibility of movement, although careful precautions must be taken against radio-frequency interference from outside sources. Such units combine a Lavalier microphone with a minute battery-operated transmitter providing a power of the order of 10 milliwatts, fully capable of covering all the space of a large studio stage or 100 to 200 metres out of doors. Up to four artistes can each use a different radio frequency for transmission, the signals being picked up by the aerials of four corresponding receivers from which they are passed to the recorder.

Tape recording equipment

The essential features of any tape recorder comprise on one hand the tape transport mechanism and on the other the amplifier with the recording and reproducing heads and associated electronic controls and instrumentation. The transport mechanism must drive the tape at the selected recording speed with extreme accuracy and uniformity. It must also provide fast re-wind from the spools in either direction to save time in tape handling. Preferably, all such mechanical functions should be controlled from convenient push-button or piano-key switches. In all professional equipment three separate motors are used, one to provide the constant speed tape drive through a capstan roller and the other two to operate the feed and take-up spools.

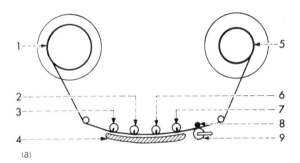

(a)

TAPE RECORDER
 (a) The tape is driven by the capstan roll (8) against which it is pressed by the pinch roll (9). On professional machines, four magnetic heads are provided: Erase (3), Pulse Sync (2), Record (6) and Replay or Monitor (7), good contact being maintained by the pressure pad (4). Feed (1) and take-up (5) reels have their own variable speed motors to run in both directions.

Where the recorder is to be operated in the studio from electrical mains supply, a high quality synchronous motor should power the capstan. But with portable equipment operated from batteries a constant speed electronically controlled

162

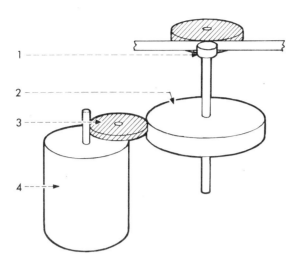

1 --------
2 --------
3 --------
4 --------

(b) The shaft of the tape capstan (1) is always provided with a heavy fly-wheel (2) and is often rim-driven from the motor (4) by an intermediate rubber disc (3) or by rubber belts.

motor is necessary. The capstan roller is not driven directly from the motor shaft but through an intermediate rubber disc or rubber belt to the capstan shaft which always incorporates a massive fly wheel to minimise irregularities in the drive. Tape speed variations, whether over a short period or from beginning to end of a reel, must not exceed 0·1% of the specified rate. The capstan roller is accurately ground and polished and the tape is held against its surface by another spring-loaded rubber covered roller, known as the pinch roller, pinch wheel or pressure roller. This must also be free from eccentricity and mounted with its shaft exactly parallel to the capstan axis. In most machines a single capstan drive pulls the tape past the magnetic heads but in some cases a 'tight-loop' path is employed with two pinch rollers, both before and after the head, to avoid any effects from feed reel irregularity.

The two spool motors must provide a constant moderate tension on the tape during recording and playback and a fast forward and reverse speed for rewinding. Torque motors are therefore used with voltage control to provide the various drive conditions. In some cases servo-mechanisms operated by changes in the tape tension are incorporated. Electrically operated friction or magnetic brakes are linked to the various drive switches to ensure that the spools are rapidly brought to rest without either snapping or spilling the tape. The tape is always automatically lifted out of contact with the magnetic heads and the capstan roller whenever it is being rewound at high speed in either direction.

In professional equipment three separate magnetic heads are used, for erasing, recording and replaying respectively, as it is always necessary to listen to the sound on the tape while it is actually being recorded, i.e. to monitor the sound recording. In the simple domestic tape recorder this facility is not provided and one common head is used for both recording and re-play. Each head in a recorder is designed for its particular function. The erase head for example,

163

has a considerably wider magnetic gap than that in the replay head, which ensures that every element in the track is subjected to a large number of demagnetisation cycles as it passes and complete erasure is achieved. Recorders employing a separate track for synchronisation have an additional head for this purpose located between the erase and record positions.

The material used for the head cores is mumetal or permalloy in very thin laminations and the gap between the poles is filled with a non-magnetic material, such as beryllium-bronze, or plated with cadmium or nickel-silver to prevent it from being clogged by particles of tape coating.

The curvature of the tape path and the tension applied to it while running must be designed to produce intimate contact between the tape surface and the head and most machines incorporate pressure pads or rollers to ensure this. During rewinding these spring-loaded devices are released and the tape path withdrawn from contact.

Modern tape recorder amplifiers are transistorized, although thermionic valve equipment is still found in studio installations. Separate record and replay amplifiers are always provided to allow continuous monitoring while recording. On the input side a pre-amplifier stage matched to the particular microphone in use is followed by an intermediate amplifier output stage to the recording head, while on the playback side the reproducer head feeds a pre-amp and power output stage to headphones or loudspeaker. A separate high frequency oscillator supplies the current to the erase head and the bias current to the recording head.

In addition to the mechanically and electrically interlocked operating switches, controls are provided for tone compensation, filtering and reverberation balance, with volume indicators, faders and mixers on all microphone inputs. If the tape recorder is designed to be used with a pulse sync system, a pulse indicator is also provided. Switches for generating and recording test tones are also handy.

Tape recorders for location work are naturally made as light and portable as possible but studio units can be more heavily built and mounted on wheeled trolleys for convenient movement around studio floor.

Magnetic film recorders

Recorders using perforated magnetic film follow the same general lines as tape units but are always of the much heavier construction, which normally restricts them to being a permanent studio installation. Film transport is by sprockets driven from a synchronous motor and the movement past the recording and replay heads is smoothed by drums with large flywheels before and after the heads. Feed and take-up of the magnetic film is on plastic core spools, the core spindles being belt-driven from the main motor as in a film camera. Erase heads are not usually fitted to film machines and it i normal practice to use bulk erasure by subjecting the whole roll of film at one time to the demagnetising field in a separate unit, known as a bulk eraser. Nowadays the film machine is mainly used for transfering magnetic records from tape to film for subsequent editing and assembly rather than for primary recording from the microphone while shooting. The drive must therefore be suitable for interlocking and operation with whatever sync pulse system has been adopted on the original tape. Once the transfer has been made from tape to film all subsequent handling, mixing and re-recording takes place in that form and the combination of the large number of separate sound components comprising voices, music, sound effects and background noises forms a most important part of studio production work, which is completed by the preparation of the final master recording.

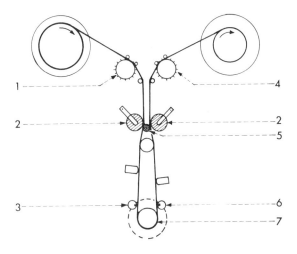

MAGNETIC FILM RECORDER
The main drive of the perforated film is by the feed and take-up sprockets (1 and 4) but the controlled movement past the recording (3) and monitor heads (6) on the tight loop path is by capstan (5) and pinch rollers (2). The drive is smoothed by the flywheel on the loop pulley (7).

Optical sound recording

Optical sound recording, in which the variations of the electrical signal derived from the microphone are used to control the exposure to light of a strip of photographic film, is no longer used as a primary recording method while shooting but is now solely a method of transferring the final master magnetic recording into a form which can be used for preparing combined sound and picture prints for presentation in the cinema theatre.

Two forms of optical recording on film have been in general use. In one the variations in the photographic image result from differences of light intensity, while in the other the width of the band of exposed film is altered. The first is the variable density system, while the second is known as variable area. In both cases the exposed zone or sound track forms a narrow strip running along the film next to the picture area. Both systems are capable of high quality results and both were widely used for a lengthy period in the preparation of black and white prints. With the increasing use of colour materials in recent years the variable area system has been preferred as it is easier to apply with colour processes.

In both systems the variable illumination exposing the film is produced at a slit past which the film moves continuously. For high frequencies to be recorded this slit must be very narrow and it is usually formed as a reduced optical image by means of a lens. In variable density recording the intensity of illumination passing into this lens system from a lamp and condenser lens is modulated by a light valve consisting of a pair of narrow metal ribbons mounted under tension in a magnetic field at right angles to the direction of the film movement. Ampli-

165

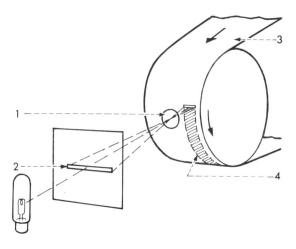

A lens (1) forms an image of an illuminated slit (2) on a strip of continuously moving film (3); if the light falling on the slit is modulated by a sound signal the film will be given a corresponding variable exposure to form a sound track (4).

fied electrical current signals corresponding to the sound pass through these ribbons and by setting up varying magnetic fields cause them to move together or to separate with the variations of the input signal. The space between the two is thus opened and closed to vary the amount of light passing through.

The exposure resulting from a variable density recording is thus a track of constant width in which the sound waves are represented by bars of varying

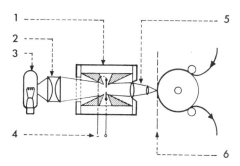

VARIABLE DENSITY RECORDING
The light beam from lamp 3 and condenser 2 forms an image on the film 6 through the objective lens 5. The intensity of this beam is modulated by the input of the sound signal 4 through the ribbons of the light valve 1, producing variable exposure of the film.

density, the spacing of the bars corresponding to the frequency of the sound. For loud sounds the density differences between the bars are large, resulting from large changes in the opening of the light valve (full modulation). For quieter sounds the density differences are comparatively small. When no sound is being recorded (zero modulation) the exposure is uniform in density and is recorded unmodulated.

In variable area tracks, on the other hand, the sound is represented by a wavy outline, the spacing of the peaks and troughs corresponding to the frequency. For loud sounds producing full modulation the amplitude of the wave is at its maximum, while at zero modulation the record shows a straight, continuous line.

In variable area recording the slit imaged on the film is fixed and the ribbons of the light valve move across it at right angles, so that a varying width of slit is opened or closed by their movement and recorded on the exposed film. An alternative method makes use of a mirror galvanometer in which the varying electrical signals corresponding to the sound cause angular movements of a coil suspended in a magnetic field. In its simplest form, a mirror attached to the coil reflects a beam of light from a lamp through the slit on to the photographic film, the oscillations of the mirror causing the edge of the light beam to move across the slit and thus expose a varying width of image on the film.

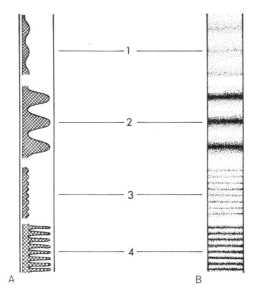

VARIABLE AREA (A) AND VARIABLE DENSITY (B) TRACKS
1. Low frequency, low modulation (low sound volume)
2. Low frequency, full modulation (high sound volume)
3. High frequency, low modulation (low volume)
4. High frequency, full modulation (high volume)

167

This early unilateral form of variable area recording was quickly improved and all modern variable area tracks are of the bi-lateral type where the changes of image width take place symetrically on each side of a centre line, which provides increased sensitivity for the system. The beam from the recording lamp passes through a triangular mask, an image of which is reflected by the mirror of the galvanometer to a slit which is itself imaged by a lens system on to the film. The sound signals produce movement of the mirror which causes the image of the V-shaped mask to move vertically across the slit so that a variable width is illuminated and reproduced on the film to give a bi-lateral recording. The base of the triangle in the mask is extended to an area with parallel sides so that maximum mirror movement can still only produce a limited width of exposure, known as the 100% or full modulation width. The apex of the triangle may also be extended into a narrow uniform slit so that when no signal is being recorded a thin unmodulated track area is still exposed. The position of the mask image at the slit can be biased in one direction so that the width of the recorded area is minimal at low sound levels, which improves the ratio of signal to noise in the resultant print.

The need for noise reduction arises from the fact that clear areas in the sound track print, corresponding to exposed areas in the recorded track negative, can be affected by dirt and residual silver grains in the print emulsion which can be heard in replay. It is therefore desirable to keep the clear areas of the print to a minimum, particularly during quiet sequences in the sound record.

For many years a preferred form of track recording has been the twin bi-lateral form produced by an inverted triangle or M-shaped mask with independent double noise-reduction shutters. With this arrangement the unmodulated signal produces an exposure of two thin lines on the film. As the degree of modulation increases, that is, as greater widths of the slit are illuminated by the move-

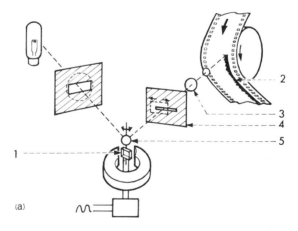

(a)

VARIABLE AREA RECORDING SYSTEMS

 (a) Electrical signals from the sound source cause angular movements of a coil (1) suspended in a magnetic field. A mirror (5) attached to this coil reflects a beam of light and causes its movement across the slit (4). The variable width of illuminated slit is imaged by the lens (3) to expose a unilateral variable area sound track on the film (2).

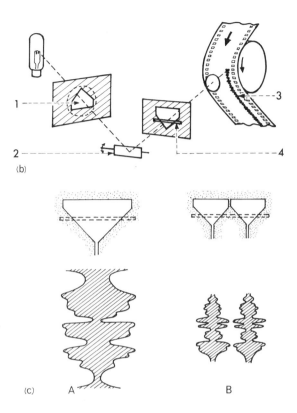

(b) In the bilateral variable area track the galvanometer mirror (2) rotates about a horizontal axis and moves the image of a triangular aperture (1) vertically across the slit (4). The width of the track exposure on the film (3) therefore varies symmetrically about the centre line. (c) Single (A) and double (B) bilateral variable area tracks.

ment of the mask, the noise-reduction shutters are opened up (by a diversion of part of the signal energy) to allow exposure of the image over a wider area up to the maximum. This again ensures that the recorded area is minimal at low sound levels without restricting the total width which can be employed.

In the most common use of optical track recorders the input signal is derived by replaying a magnetic recording, usually from magnetic film but sometimes from tape. For film-to-film transfer, synchronisation is maintained by a direct electrical interlocking of the sprocket drives of both machines. But for tape a sync pulse system is employed, similar to that used in magnetic re-recording.

Sound recording cameras

Many features of a sound film recording camera are similar to those of a magnetic film recorder. Accurate uniform film drive sprockets must be provided and

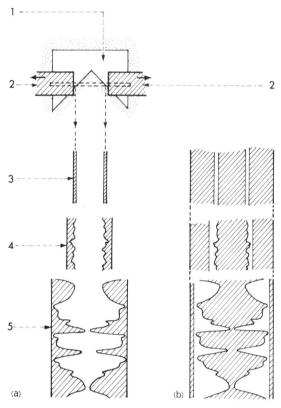

TWIN BI-LATERIAL RECORDING
(a) The vertical movement of an M-shaped aperture (1) across the slit produces a bilateral variable area recording, the outer limits of which are set by the noise reduction shutters (2). The resultant exposed areas on the negative are shown for unmodulated (3), low modulation (4) and full modulation (5) signals. (b) The resultant positive print from this negative shows minimum clear areas at all levels.

the movement of the film at the recording point controlled by sound drum fly-wheel, mechanical filters and stabilising rollers. The whole film path must be enclosed in a light-tight camera head and the film fed to and from it by a camera magazine. The lamphouse, optical components and modulating system must all be rigidly mounted as part of the whole camera assembly since the location of the track position and its dimensions are very critical. To ensure satisfactory resolution of high frequencies the image of the slit on the film must be as thin as possible; for 35 mm film running at a speed of 24 fps (18 ips or 27·72 cm ps) a slit height of 0·012 mm is desirable and should be even less for the slower running 16 mm film (7·2 ips or 11·29 cm ps). In general, optical track recordings are limited to a maximum frequency of 9 kHz for 35 mm and about 6 kHz for 16 mm.

170

OPTICAL SOUND RECORDER
Film is fed from the magazine to the sound recording camera at the top, where the sound track exposure is given by the lamp and galvanometer optical system. The sound signal from the magnetic original is fed through the amplifier and controls mounted on the body of the machine.

Sound film processing

The film used for variable area sound track recording is a special type of fine grain black and white negative capable of giving an extremely sharp high contrast image and usually coated on a grey base to reduce light scatter in the image. It is processed in a high contrast developer solution to give a density of the order of 2·8 in the exposed areas and a minimum density elsewhere; there should be no intermediate gradation. The exposure level for recording must be carefully set on the basis of photographic tests since both over- and under-exposure can cause distortion of the modulated image.

Variable density recordings, on the other hand, make use of a low contrast negative stock processed in a normal black and white negative developer to a gamma value of 0·45 so that the full range of density gradations is recorded.

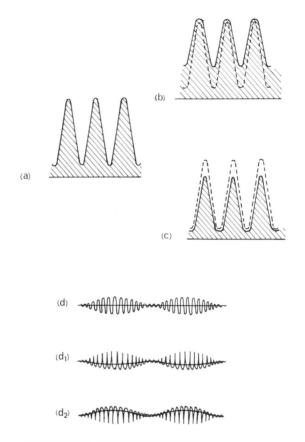

(a)

(b)

(c)

(d)

(d₁)

(d₂)

EFFECT OF OVER- AND UNDER-EXPOSURE
The correct wave form of the sound record (a) is
distorted with over-exposure (b) by filling in the troughs,
while with under-exposure (c) the peaks are incorrectly
formed. With a modulated track both these distortions
have the effect of introducing a spurious frequency (d_1
and d_2) not present at correct exposure level (d).

Prints from optical sound track negatives must be made on the same type of
positive film stock as that used for printing the picture negative, which is nor-
mally a high contrast material processed to a gamma of about 2·8. Here again,
the level of print exposure is critical if distortion in the image wave form is to be
avoided, so careful photographic tests are essential to determine the optimum
density required in the print. In general this density is approximately 1·4 for
variable area recordings.

Cross modulation tests

In practice neither the negative nor the positive soundtrack images can show an
absolutely sharp and clear outline: an unsharp boundary is always present to

172

some extent. However, by precise selection of the best negative and print densities for specific materials and conditions of operation, deficiencies at each stage can be made to correct one another to some extent. One form of test to establish the required combination is known as the cross modulation test. Cross modulation is in fact a form of distortion resulting from the scatter of light at the unsharp edges of the wave form image and the test determines when this distortion is at a minimum.

An audio signal produced by a test oscillator and combining mid-frequency 6000 Hz with low frequency 400 Hz is fed to the recorder and a series of tests exposed at different levels to give a range of negative densities, usually between 2·4 and 3·2. Each of these negatives is printed several times with different exposures to produce a series of prints covering a density range, in this case usually from 1·0 to 2·0. The resultant prints are all assessed on an optical sound reproducer, the output of which is fed to a volume indicator through an electrical filter which will only pass either a 6000 Hz or a 400 Hz signal.

The optimum combination is achieved when the lowest output at 400 Hz is obtained with the best output of 6000 Hz and the test results will show that for each negative density there is a print level in which the 400 Hz component is at its minimum. The reduction in this component relative to a reference tone of the same frequency is termed the cancellation and the print density to be selected for a particular negative is that in which this cancellation is most effective.

(a)

(b)

CROSS MODULATION TEST

(a) A negative combining 6000 Hz and 400 Hz is exposed at different levels and a series of prints made at different densities. (b) The relative reproduction level of the 400 Hz component is assessed for each negative-print density combination and the results plotted graphically. In the example shown a print density of 1·4 from a negative of 2·8 is the best and is better than the optimum results of negatives 2·6 and 3·0 at 1·2 and 1·5 respectively.

Optical track reproduction

Replaying an optical sound track print is essentially the reverse of the recording operation: the varying image on the film modulates the light from a lamp as it passes through a narrow slit to fall on a photo-electric cell. The cells used in film sound equipment are of the photo-emissive type, that is, they produce a small electric current under the influence of light, the current produced being substantially proportionate to the intensity of the illumination. The light modulated by the moving film therefore generates a varying electrical signal in the cell and this signal is amplified and fed to a loudspeaker system.

The problem of producing uniform film movement past the scanning head, which is common to all recording and reproducing systems, optical or magnetic, is further complicated in a motion picture projector by the fact that the same film must move intermittently at the picture aperture and continuously at the sound slit. If is therefore necessary to space these two points sufficiently far apart on the film path through the machine for the intermittent movement to be smoothed out before the film runs over the sound head. The point on the sound track corresponding to a particular frame of picture is not level with that frame but displaced along the length of the film and it is the practice in all 35 and

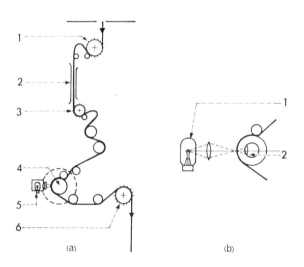

(a) (b)

OPTICAL TRACK REPRODUCTION
(a) The film is drawn from the top spool by the continuous feed sprocket (1) and moves through the picture gate (2) intermittently by the action of the sprocket (3). After passing various smoothing rollers the film is wrapped around the sound drum (4) which has a heavy flywheel to ensure steady continuous movement past the sound scanning head (5). It is then fed to the take-up spool by a continuous hold-back sprocket (6). (b) The essentials of the sound head: light from the lamp filament (1) is focused by an optical system to form a slit on the film. The varying transmission of the sound track modulates the light received by the photo-cell (2).

16 mm projectors for the optical sound head to be positioned below the picture gate so that a point on the film is scanned for sound after that picture has been projected. To ensure synchronisation of sound and action the sound record must therefore be printed on the film at a position ahead of the picture and this is known as the sound advance for printing and projection. For 35 mm copies this printing advance is standardised at a separation of 21 frames (15·75 in. or 40 cm) and at 26 frames (7·8 in or 20 cm) for 16 mm but in threading-up the projector a tolerance of plus or minus half a frame in the actual film path is permissible without obvious ill-effects.

The track dimensions on the print and the location of the scanning slit in the sound head are critical, however, and close tolerances must be maintained if distortions caused by incorrect scanning are to be avoided. The height of slit necessary to allow clear reproduction of high frequencies is particularly important for 16 mm film where the high frequency modulations are more closely spaced because of the slower running speed of the film. Slit heights, produced by optical means, of the order of 0·025 mm (0·001 in.) are normal for 35 mm heads and 0·015 mm (0·0006 in.) for 16 mm.

The amplification system consists of a head amplifier from the photocell signal, located in the projector itself, feeding the main amplifier and final power amplifiers for the loudspeakers in the theatre. It is usual to restrict the frequency range of the 35 mm system by a cut-off beyond 9kHz, which is generally regarded as the limit of optical sound in commercial practice, to avoid high frequency noise from film grain or the amplifier itself. At the other end, sources of low frequency noise such as electrical mains hum at 50 or 60 Hz must be carefully suppressed. A danger with 35 mm film is modulation resulting from the presence of sprocket holes adjacent to the sound track area which can give rise to a 96 Hz component if there have been errors in processing or film distortion due to mishandling.

Magnetic striped prints

Although prints combining the positive image with a photographic sound track have given satisfactory results in the cinema theatre for many years, it is recognised that reproduction from a magnetic record provides superior sound quality, both for high fidelity, frequency range and freedom from background noise. Several proposals have been made to introduce magnetic tracks on motion picture prints but the additional expense of their preparation and reproduction in the theatre has limited their application to specialised forms of presentation, particularly those where multi-channel stereophonic effects are required.

Magnetic coatings can be striped onto sensitised cinematograph film in the course of raw stock manufacture but this is a somewhat inconvenient process involving extra darkroom operations and it is simpler and cheaper to apply the stripes to the finished positive print after processing, and to transfer on to this all the appropriate magnetic sound recordings. Different stripe configurations are used for the various gauges of print film according to the form of eventual presentation. All 70 mm copies are supplied with multi-channel magnetic sound only, no optical track being used. Four stripes are applied, two wide ones outside the perforations and two narrow ones immediately inside the performations next to the picture area. Each of the two outer stripes carries two separate magnetic sound recordings while the inner stripes have one recording each, giving a total of six channels. In projection, the six tracks are scanned by a cluster of six magnetic heads mounted above the projector body and reproduced through six individual amplifier systems to feed five loudspeakers arranged

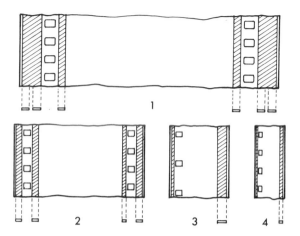

FORMS OF STRIPED PRINT

1. 70 mm film carries two wide stripes 5·0 mm (0·20") outside the perforations and two narrow ones 1·9 mm (0·075") inside. Six tracks each 1·6 mm (63 mil) wide are recorded.
2. 35 mm film with small sprocket holes has three 1·70 mm (0·067") stripes and one narrower one of 1·0 mm (0·038"). Recording widths are 1·50 mm (60 mil) and 0·89 mm (35 mil) respectively.
3. 16 mm film is striped 2·5 mm (100 mil) wide with a narrow balancing stripe outside the perforations on the other edge.
4. S-8 film also takes one stripe 0·7 mm (0·027") wide and an opposite balancing stripe.

behind the screen in the theatre, and a sixth group of speakers distributed throughout the auditorium for sound effects. A 35 mm print carrying stereophonic sound is striped with four magnetic tracks, two outside and two inside the perforations. One of these is narrower than the other three and is used for feeding the sound effects to the auditorium speakers, while the other three supply speakers positioned right, centre and left behind the screen. Copies for presentation in this manner are printed on to film stock with small performation holes to allow room for the additional tracks on each side of the picture and it is usual to print an optical sound track at the same time in the normal position so that the copy may be used in theatres which have not been equipped for magnetic reproduction. Such a combination is termed a Mag-Opt print.

When stereophonic magnetic presentation was first introduced the necessary reproduction head cluster had to be added to existing 35 mm projection machines as an attachment above the main body, and the term 'pent-house head' is still often used for the film path assembly even when it is designed as part of the whole equipment. As in all sound units a smooth and accurate movement of the film past the magnetic scanning points must be provided by flywheel drums and mechanical flutter filters. Since the pick-up points for both 35 and 70 mm prints

with magnetic sound are before the picture gate rather than behind it, the sound recorded on the magnetic stripes must be behind the corresponding picture image, rather than advanced as with optical sound. The sound retard is 28 frames for 35 mm film (21 in. or 53 cm) and 24 frames for 70 mm (22½ in. or 57 cm). In some cases a single magnetic sound record is carried on a single stripe occupying the same position as an optical track on stock with standard size performation holes, but this arrangement has not yet been widely accepted, although it can be applied in television, either as a separate film to be run synchronously with a picture print (*Sepmag*) or combined with a picture image on the same film (*Commag*).

With 16 mm prints, a magnetic sound stripe can be added in the same position as an optical track. Super 8 mm copies requiring sound can also be striped.

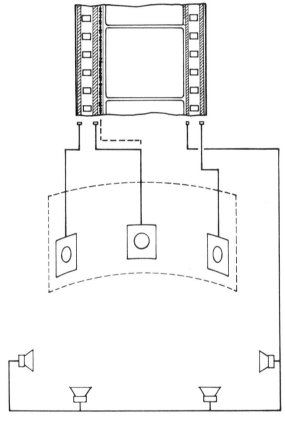

MULTI-TRACK PRESENTATION

On 35 mm prints the sound is carried on four magnetic stripes which are reproduced over three speakers placed right, centre and left behind the screen and a series of smaller speakers distributed around the auditorium. Where the single optical track of a mag-opt print is used, it is played over the central speaker only.

177

M

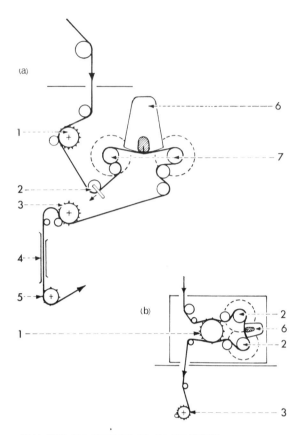

(a)

FILM PATH FOR MAGNETIC SOUND PROJECTOR

(a) The film is drawn from the top spool by the feed sprocket (1) and past the cluster of magnetic heads (6) by the sprocket (3), smooth continuous motion being ensured by the tension roller (2) and the pair of heavy flywheel drums (7). Intermittent movement through the picture gate (4) is provided by sprocket (5). (b) Where magnetic sound had to be added to an existing optical sound projector it was installed above the main body as a pent-house head. Film is drawn through this path from the top spool by the main feed sprocket (3); smooth movement past the magnetic head cluster is maintained by the free-running sprocket (1) and the pair of flywheel drums (2).

178

6 Studio production

The production of a motion picture represents the continued co-operation of creative artists and technicians and the main area in which these joint activities are normally centred is the studio. Here it is that the settings within which the action is to be played are designed and constructed under the guidance of the art director, and it is here that the creative recording of the action in picture and sound is brought about as the director determines it, through the work of the lighting cameraman and sound recordist. As the work of recording the components proceeds the editor in the studio cutting rooms gives realisation in exact lengths of film to the structure of the story that the director is bringing into being. As the final stages of its assembly are reached, the dubbing theatre brings together the many separate components of recorded sound and the sound mixer forms them into a single entity. The centre for all these varied but associated functions can be described as the studio complex.

Sequences of both picture and sound may have been recorded on locations far from the studio but it is nearly always at the studio centre itself that these take shape as a completed production. Of all the technical operations associated with motion picture production the only one which may not always be found as an integral part of the studio complex is the film processing laboratory and even this is normally located within reasonable transport distance.

Production organization

It is the Producer who first gives consideration to the creation of a motion picture and it is he who has to weld together all the varied aspects of business and technology, of finance and artistic ability to bring his concept into being. On the creative side, the screenwriter takes the first steps to translate the basic idea, whether an existing novel, a play or a completely original theme, into a screen play or scenario in which the fundamental units of picture and sound are given form.

The creation of the film itself is the responsibility of the director. In some cases he may be also the producer, but it is as a result of his work as director that the

179

Production
Planning

Shooting
Script

Sound
Effects

Location
Shooting

Music

Special
Effects

STUDIO
PHOTOGRAPHY

Magnetic
Tape

SOUND DEPT.

Exposed Picture
Negative

Magnetic
Film

Rush
Prints

EDITING

PROCESS
LABORATORY

FINAL
SOUND
MIXING

Work
Print

Sound Track
Negative

Optical
Transfer

Answer Print
(1st Combined copy
of picture and sound)

PRODUCTION ORGANISATION SEQUENCE
Progress and interrelation between stages.

motion picture really takes shape and it reflects his knowledge and under-standing of all the varied aspects of film making. The director will work closely with the screen writer and establishes with the producer the details of the studio and locations to be chosen, the artists to be engaged to play the parts concerned and the personnel of the production team. When the screen play and its detailed treatment in the form of a shooting script has been approved the detailed planning of production operations can commence. At this stage the director confers with his art director or production designer on the sets which are to be built in the chosen studio so that detailed structural designs can be prepared. Here also the views of the director of photography, or lighting cameraman, are sought to ensure that the sets provide for the necessary camera movement and lighting distribution envisaged. Where sequences of the film are to be photo-graphed on location in the open air or in existing buildings, the art director and director of photography must study these locations in order to determine what alterations and resources may be necessary when the times comes.

In due course, the producer and director, now aided by an assistant director

and by the resources of a production office for administrative detail, agree on the production schedule. The final selection of actors is made, often with the assistance of a casting director, their time allocated in accordance with this schedule and costume and make-up requirements established. The programme for building studio sets, the time that each set is to be occupied for photography and the periods for set removal must be worked out in exact detail so that the best use is made of such expensive studio resources. All the requirements of location work, for the artists, wardrobe, make-up and all the facilities for camera and sound recording crews must also be incorporated. The resultant shooting schedule, in which the sequence for the production of each individual scene of the script is established, inevitably differs to a major degree from the logical sequence of the story originally laid down in the screen play and requires careful study by the assistant director and the continuity staff to relieve the director from a mass of overwhelming detail. Wherever possible, alternative work inside the studio should be planned in such a way that it can be done if weather conditions should hold up work on exterior scenes, so the schedule must be flexible as well as thoroughly detailed.

Once photography starts, the editor and his cutting room staff must make their contribution. When working at a studio it is usual for the exposed picture negative of each day's operations to be sent in the evening to the processing laboratory, where it is developed during the night and prints made of those scenes selected by the director at the time of shooting as satisfactory for action. These action prints, known as 'rushes' or 'dailies', are synchronised with the corresponding magnetic sound recordings by the editor's staff early each morning so that the results of the previous day's photography are available as soon as possible for viewing by the director and other members of the production team. At this stage the director indicates to the editor the preferred take of each scene and explains in more detail the way in which he wishes the action of the script to be interpreted on the screen.

As production progresses, the editor and his cutter assemble the rush prints of individual scenes into sequences of the story and show them to the director and producer. Such an assembled section, known as a rough-cut, is almost always longer than the final version, but forms the basis for the detailed editing in which the dramatic tempo of continuity is eventually established. Even when the main period of photography has been completed, further material may be required. For various reasons, it may not have been possible to shoot every scene directly and trick shots are necessary, as for example for a combination of actors photographed in the studio with background scenes shot on distant locations. Scenes involving models and miniatures may be necessary and changes of action by speeding-up or by enlargement or reduction can be involved. All these are grouped under the general heading of special effects and are carried out by the appropriate department of the production studio, in some cases with the assistance of optical printing facilities at the processing laboratory. The design and photography of the main titles and credit titles for the beginning and end of the film must also be organised and often involves special effects work.

As the final editing of the picture proceeds, the corresponding sound records must be brought together. Dialogue recorded by the actors at the time of shooting may not always be of satisfactory quality, particularly on location, so separate sound recording in the studio to match the action already photographed must often be made. The requirements for background music must be discussed by the director and editor with the composer and the music scored and performed in the studio by the appropriate orchestra for recording. Sound effects

to emphasise the action must almost always be provided by separate recordings rather than at the time of shooting, so that the correct balance of sound level between spoken dialogue and sound effects can be obtained.

As all these sound components become available they must be assembled in synchronism with the edited version of the picture and eventually combined on to a single composite sound record by the sound mixer. This final re-recording or dubbing is a complex operation which may involve mixing as many as twenty separate track components, all of which must eventually be reproduced with the relative emphasis required for the dramatic effect. At this stage the director has the first occasion to assess the picture and sound as a complete entity and the final mixing operation is a critical one involving detailed co-operation between director, film editor and sound technicians.

Up to this point, all sound recording has taken place magnetically on separate strips, but when the final mixed track has been approved by the director the sound department must make the transfer from magnetic to optical recording in order to produce the optical track negative used for making composite prints of picture and sound for projection. These optical negatives are processed at the laboratory and positive prints of the sound track alone are returned to the studio sound department for a final quality check.

The remaining stages of the production are covered by the laboratory in the preparation of the answer print, which is the first composite print of the subject. The editor supplies the laboratory with the final cutting copy or work print of the picture material, including all titles and special effects, together with a similar work print of the approved optical track recording marked to indicate correct synchronisation. At the laboratory the picture negative of all the required scenes is brought together, cut and assembled to match the continuity of the work print, while the corresponding sound track negative is made up for printing in the correct relation. When the cut picture negative has been graded to assess the correct colour balance and printing level for each scene the first composite print is made and if necessary, further grading corrections applied in accordance with the guidance provided to the laboratory by the production team, particularly the lighting cameraman and editor.

When the finally graded answer print has been completed it is screened for approval by the director and producer, usually first at the studio review theatre but often subsequently at private shows in large cinemas. In some instances the reactions of a public audience may be sought, so an unannounced preview is arranged at a regular motion picture theatre and as a result of such 'sneak previews' changes in editing with the corresponding re-cutting of the negative and the preparation of a new answer print may be called for.

The work of the production team is almost finished when the final answer print is approved, although in many cases the lighting director or editor may be asked to co-operate with the distribution organisation to ensure that the copy to be shown at the first important public presentation, or premiere, is of the best possible quality for the particular theatre chosen. The last stages of studio work concern the provision of material for preparing foreign versions of the film and include completing the final continuities of picture action and spoken dialogue, recording separate music and sound effects tracks for eventual combination with foreign language dialogue recordings, and selection and duplication of picture material for title backgrounds and publicity purposes. These final steps are often handed over to a separate post-production group able to provide the necessary services for all the feature films being made at the studio centre, including film library facilities.

The studio complex

From the preceding outline it can be seen that film production calls for a very wide range of services and it is now general to refer to the grouping of these facilities, their organisation and administration as the studio complex, the buildings within which the sets are constructed and the action photographed being termed the stages.

While the size of studio complexes differs greatly from one organisation to another, the following facilities can be regarded as fundamental:

a. The stages, the heart of the complex, the size and scope of which determine the overall resources of the studio.

b. The associated workshop facilities for constructing and erecting sets on the stages, which must include the various trade groups, carpenters, joiners, plasterers and painters as well as working centres for the art director and set designer of each production. There must also be stores for furniture and other properties and for sets or sections which may be permanently retained.

c. Lumenaires, lamp units, electrical supplies and controls for lighting the sets on the stages and the crews to rig and operate them.

d. Camera services for photography, which include not only the cameras themselves but a wide range of special camera supports such as mobile trolleys, large and small camera cranes and control equipment, again with their operating crews.

e. The sound recording services which parallel the camera operations on the stage with their microphones on mobile boom mountings and magnetic recorders.

MULTIPLE STUDIO COMPLEX
A-K. Sound stages with auxiliary services appropriately grouped. 1. Dressing rooms. 2. Wardrobe. 3. Unit offices. 4. Make-up. 5. Props and electrical. 6. Main electrical store. 7. Assembly, pasterers, painters. 8. Carpenters, joiners. 9. Machine shop. 10. Set store. 11. Furniture store. 12. Editing suites. 13. Dubbing theatre. 14. Viewing theatre. 15. Recording theatre.

f. The whole range of services required by the actors and actresses engaged on the film — costume design and preparation, the wardrobe and its staff, the make-up department and the dressing rooms.
g. Editing and cutting rooms and the appropriate film storage vaults for each film in the course of production, and review theatres for viewing the picture and sound of each day's work as it becomes available from the processing laboratory.

All these resources, together with administration offices both for the overall studio management and for the individual producers and directors, provide the basis for day by day operation at the studio complex during the period of production photography, or shooting. Further facilities are called for as the work proceeds:

h. The special effects department may be required to provide such things as model work to be photographed using high-speed cameras or composite trick shots involving special set construction and lighting. In the larger studios this department may have its own specialised film printing and processing laboratory.
i. The whole resources of the sound department, including special theatres for orchestral music recording and dubbing theatres for the final track mixing, are brought into operation during the completion stages of the production.

Though the film processing laboratory does not form an integral part of the studio complex itself it must provide a rapid overnight service in the delivery of rush prints. So the laboratory should always be situated within reasonable distance by road and must provide transport to meet the studio's needs.

The sound stage

The essential production work of the studio complex takes place on the sound stage itself, and its design and equipment is of very considerable importance for efficient operation. As the size and scope of the sets required differs enormously from one production to another, a major studio complex is equipped with a range of stages from the very large 200×160 ft (60 m $\times 50$ m) to the more compact 80×50 ft (25 m $\times 15$ m) to allow varied demands to be efficiently met. Planning the shooting schedule to provide continuous occupation in periods of set construction, photography and set clearance in the most economical fashion for all stages is a fundamental matter of studio management and production organisation.

Whatever its size, the stage must provide effective working conditions; it must be completely sound-proofed against external noise and acoustically treated within to assist the sound recording characteristics. Its ventilation system must be adequate to deal in summer with the heat load of both crowds of artists and the large number of lamps used to light a big set and yet provide comfortable working conditions even for small set-construction crews in the depths of winter. Large doors to allow pre-erected set units or other equipment to be moved in and out are necessary, but must be effectively sealed for both sound insulation and air conditioning needs.

Stage floor construction has to provide the maximum uninterrupted working area and must reconcile the somewhat conflicting demands for a surface which is smooth and level enough for the movement of mobile camera mountings in all directions and one which allows sets to be rigidly built on firm foundations. For

many years it has been the practice in motion picture stages to emphasise the latter point by set constructions firmly nailed to a timber floor and to provide smooth camera movement by laying special tracks as required. In television studios, on the other hand, the practice has been to lay a very flat level floor with smooth finish so that camera and microphone mounts can move at will in all directions without laid tracks. This naturally precludes fixing set structures or lamp mountings permanently to the floor in any way and so free standing units with weighted bases are employed. In some of the new motion picture stages a combination of a smooth overall floor for camera mobility with a temporary timber flooring laid over in the areas required for set erection is being used.

The influence of television practice is also shown in the stage structure for lighting. For traditional motion picture work, lamps at operating level were mounted on the studio floor while any overhead lights which could not be fixed on the permanent catwalks in the studio roof were rigged from timber cradles and spotting rails hoisted by lifting tackles in the roof as part of the main set construction. Since each set thus required its own special overhead lighting cradle plan, the time taken for lamp rigging before shooting could begin was often very considerable.

In the television studio the demand for rapid working and more flexible arrangements led to a radically different approach in the form of a permanent overhead grid carrying a large number of lamps mounted on runners which can be moved along the slots of the grid to any required position and adjusted in height by telescopic extension bars. Power operated tools allow the necessary movement to be made rapidly and changing lamps and their enclosures is conveniently carried out from a raised loading bay running across one end of the stage. The overhead grid is also provided with a widely distributed range of power outlets to which the various lamp units can be connected. The switching and dimming controls for these channels can be centralised at a lighting console, where the requirements for a particular set can be established and recorded for further operation. The advantages of the lighting grid system and its controls have already been appreciated in the motion picture production field and a number of new stages have incorporated variants of this procedure, the use of which will increase as creative lighting cameramen with experience in both motion picture and television studio practice begin to exert their influence on operating practice.

STUDIO STAGE LIGHTING
Conventional film studio lighting is based on lights rigged to sets and catwalks and mounted on studio floor for prolonged single-camera shooting in restricted areas.

(a)

(b)

1

2

LIGHTING GRID
 (a) Studio floor with overhead lighting grid carrying suspended lamps on telescopic monopole mountings (one only shown). (b) The monopole mountings are transferred from one slot to another on the grid and lamps are changed by an operator in the loading bay, 2; the operator on the grid, 1, moves the units along the slots and raises or lowers them.

Light sources

In the early days of motion pictures, when only low sensitivity black and white film stocks were available very high levels of artificial light were required for indoor shooting, which could only be provided by carbon arc lamps fed from D.C. supplies. When colour photography first appeared, white flame higher-intensity arcs were essential and specially prepared carbons with metallic components incorporated were developed to produce light of the required spectral content.

In the course of time continued improvements in the sensitivity of film stocks were achieved, first for black and white materials and later for colour, and colour stocks were made which could be satisfactorily exposed with the much more convenient incandescent filament lamp. Such stock is now universal and carbon arc lamps are only needed when lighting very large spectacular sets on the stages of major studios.

For several years the standard light source was a tungsten filament incandescent lamp designed to operate at a colour temperature of 3200°K with a useful life of 100 to 150 hours. In such lamps tungsten evaporates from the burning filament and is deposited on the inner surface of the bulb, causing blackening which reduces the effective colour temperature and light output until eventually the lamp must be discarded. From 1965 onwards, however, an improved incandescent lamp was produced, known initially as the quartz-iodine lamp but now more generally called the tungsten-halogen type. In these the bulb contains a minute quantity of a halogen (iodine or bromine), the vapour of which combines with the evaporated tungsten from the filament. If the temperature of the bulb's inner surface is maintained above 2500°K this tungsten halide is not deposited but is decomposed in the vicinity of the filament. Tungsten is deposited on the filament itself and the halogen freed to repeat the cycle. Consequently tungsten-halogen lamps show practically no blackening with age and maintain constant light output and colour temperature for a greatly extended life, which can exceed 500 hours for studio type lamps.

The move from the earlier standard incandescent lamp to tungsten-halogen has introduced a number of changes in studio lighting practice and economics. Although in each size category, the tungsten-halogen bulb costs between one-and-a-half and two-and-a-half times more than the standard incandescent, a substantially increased operating life of two to four times is obtained. In terms of cost per hour for a given light output the advantage is even more marked; a 1000 w. standard incandescent lamp might have an operating life of 250 hours but its light output would have fallen to 70% of its initial value by the end of that time. A similar 1000 w. tungsten-halogen can have a life of at least 500 hours and will not drop below 95% of its initial value during that period, showing an increase in lumen-hours of nearly $2\frac{1}{2}$ times. This means that fewer units are required to maintain a given light level and the labour costs of replacing bulbs as they become blackened is greatly reduced. Both factors are important in studio operating costs.

Further advantages come from the very much smaller bulb size for the tungsten-halogen lamp, which means a more robust construction less liable to handling damage and more compact light weight mountings which are conveniently rigged in the studio. With tungsten-halide lamps brightness can be controlled by altering the voltage within certain limits, provided that the surface temperature is maintained to ensure the tungsten evaporation-deposition cycle. However, when the lamp is dimmed to below 60% of its normal value the reduction of colour temperature is of the order of 250°K which is unacceptable for colour photography. To provide a wider range of brightness adjustment, a twin filament lamp for studio lighting has been developed, in which two separately controlled filaments are mounted within the same bulb. The intensity of this lamp may therefore be adjusted from full (both filaments at full voltage) through half (one filament at full voltage) down to 30% (one filament at 60%), which gives a very flexible unit.

Although many tungsten halogen lamps have a group of closely spaced filament coils in a bulb, a linear type is used for wide flood-light illumination.

In these 'pencil' lamps, the filament coil is extended along the axis of a small diameter tube of fused silica, sometimes with a frosted surface to provide an extended diffuse source. The tube is sometimes bent into a U form to provide a more compact source for small portable floodlights.

Tungsten-halogen lamps are also made to serve as sources of higher colour temperature so that they can be used in conjunction with natural daylight for outdoor work. These lamps, which correspond to a colour temperature of 5000°K have a shorter filament life (about 50 hr) and are sealed in larger bulbs coated with dichroic filter layers to produce the bluer light necessary.

Another light source being developed for studio lighting is the xenon gas discharge arc. This can provide a compact source of high intensity and has a long life, but requires a special starter circuit to initiate the arc. Unlike mercury or sodium arc lamps the xenon lamp has a spectral output very similar to daylight and could be very useful for some applications of colour photography. Lightweight xenon lamps of 2 kw and 4 kw capacity operating from 30 v.D.C. at 6000°K have recently become available.

Where carbon arc lamps are employed they may be either the high intensity (HI) white flame type or the low colour temperature (LCT) variety. HI carbons operate at a colour temperature of 6000°K and when used in the studio with incandescent lamps must be screened with an orange-yellow filter to match their colour to the standard 3200°K for which normal colour negative film is balanced. When HI arcs are used out of doors to supplement natural daylight, however, the correction filter can be mounted on the camera lens only. LCT carbon arcs are intended to operate at a colour temperature of 3250°K, very similar to that of normal incandescent lamps, but for critical matching in the studio it is often necessary to add pale yellow filters as a trimming correction – at the lighting cameraman's discretion.

Lighting units

Studio lighting units or luminaires as they are now often termed, are provided in a wide range of sizes and mountings. They may be basically divided into two types – those intended for general large area lighting (flood lamps), and those for small concentrated areas of lighting (spot lamps).

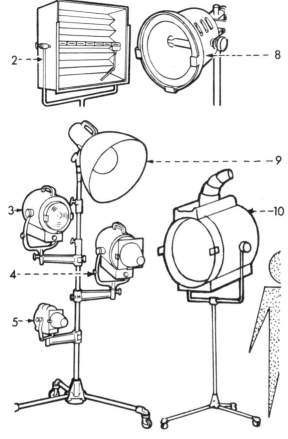

TYPES OF LUMINAIRES

Luminaires (Studio Lighting Units).
1. Skypan, wide-angle 5kw floodlamp.
2. Shadowless Flood with tungsten-halogen tube in diffusing reflector.
3. 2 kw spot with adjustable Fresnel lens.
4. Spot with snoot to narrow the beam.
5. Pup, a miniature 500-700w spot with snoot.
6. Quad, four 250 or 500w bulbs for general front or overhead flood lighting.
7. Tenlite, mounting ten 500w bulbs with filters and diffusion.
8. 1 kw flood with tungsten-halogen bulb.
9. Scoop, a flood lamp with 500 or 1000w bulb.
10. Brute, a large high-intensity carbon arc with Fresnel lens for adjustable spot.

Flood lamp units may consist of a single bulb set in a wide reflector which can provide a small degree of focusing to adjust the angle of the beam, or which may be defocused or completely diffused. Bulbs for these range in output from

189

1 to 10 kw. In addition to the general term, flood, varieties of these luminaires are broads, scoops and skypans.

Another form of luminaire used for general large area lighting is a single unit containing a number of bulbs, either within the same reflector enclosure or with separate reflectors for each lamp. The individual lamp may be rated at 250, 500 or 1000 w and as many as twelve may be grouped as a single unit. A form of

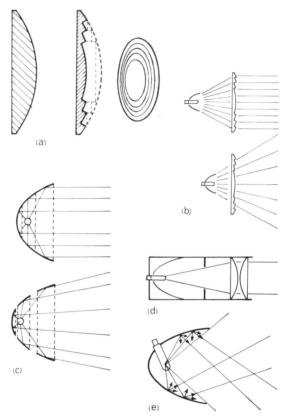

FOCUS AND FLOOD LAMPS

(a) A Fresnel lens has the same focal length as a condenser lens of the same surface curvature but can be made much thinner and therefore less likely to crack with the heat of the lamp. (b) Such a lens combined with a movable lamp mounting allows the beam to be focused from a narrow spot to a wider flood. (c) In another type of adjustable beam lamp a parabolic reflector is made in three annular sections which can be separated to provide a wider beam. (d) Condenser lenses are used in small spot lamps to give a narrow concentrated beam. A central stop is used to avoid internal reflections. (e) In a typical flood-light "scoop" the reflector is diffuse or dimpled giving a very wide angle of illumination.

190

tungsten-halogen lamp with an extended filament in a tube rather than a bulb is sometimes used for the uniform illumination of large areas such as sky backings, and these may also be used as multiple sources within a single diffusing reflector mount.

Spotlamps are always single bulb light sources and are provided with polished specular reflectors and condenser lenses to allow accurate adjustment to the beam of light produced. Except in the very smallest units, the condenser is a fresnel lens with a series of stepped annular rings moulded on its surface to provide a lens effect without an excessive thickness of glass in the centre. In some simple spot lamps no condenser is provided and focusing is entirely by adjustment of a parabolic reflector behind the lamp. But such units cannot provide the wide range in spot concentration produced by the condenser system. Bulbs for spotlamps may range in output from 500 w to 10 kw but the most widely used are 2 kw units, which with a 25 cm. diameter fresnel lens can be adjusted for a beam angle between 15° for full spot effect to 50° at the widest flood setting.

Carbon arclamps can provide very high power spotlight sources. The largest, known as brutes, operate at 225 amps and 115–120 v.D.C.; a variation of beam angle from 12° to 50° full flood can be obtained. A smaller version of the arc spot lamp, operating at 150 amps and 115–120 v.D.C., is also popular. For illuminating large areas, duarcs, which are pairs of carbon arcs in a single housing are sometimes used. In many studios arc lamps are gradually being replaced by tungsten halogen units.

Lighting equipment mounts

Luminaires designed for use on the studio floor are generally carried on telescopic pillars, allowing height adjustment, with a tripod base which may have castors fitted for easy movement but which can always be locked firmly at its operating position. Overhead lighting is still provided in many motion picture stages from rigged spotting rails and cradles but the alternative use of lighting grids on the pattern of television studios is increasing. With grid operation each lamp is carried on a telescopic rod called a monopole which can be readily adjusted for height by power tools. The carriage in which the monopole is mounted can be easily moved along the slots of the grid in all directions over the stage floor to the required position.

The lamphouses of all lighting units must of course be conveniently adjustable for tilt and rotation and must also provide easy attachment for a number of accessories. Both flood and spot lamps are often fitted with pairs of hinged flaps, known as barn-doors, which can be opened and closed to cut off the edge of the beam and reduce spill light. Four-way barn-doors have flaps both above and below and on each side of the lamp. The intensity and to some extent the direction of a beam can also be controlled by a baffle in the form of an adjustable louvred shutter. When the beam of a spot lamp must be reduced to an even narrower angle than can be obtained at its extreme focus setting a conical front attachment with a small circular hole, called a snoot, is mounted in front of the fresnel lens. Lamp mountings must provide for the simple attachment of filter and diffuser frames to change the colour and specularity of the light. The colour filter sheets, known as gelatines or jellies, although often made of other transparent plastics, should be mounted well clear of the main housing to reduce the heat to which they are exposed and must be easily replaceable when they discolour or burn. Diffusers known as scrims are often placed in front of the lamp

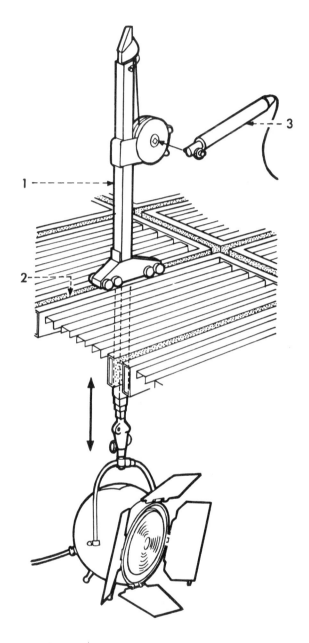

MONOPOLE MOUNTING
Monopole, 1, is mounted on slotted grid, 2, which allows rapid transfer from point to point. Power-operated tool, 3, enables light unit (luminaire) to be winched rapidly up and down on telescopic extensions.

to soften the light and can consist of wire mesh screens or more usually one or more translucent sheets of glass fibre.

To control the distribution of light and shade on the set the lighting cameraman also makes use of separate devices which can be placed and adjusted in front of the lamps. Separate scrims can provide varying diffusion in some areas,

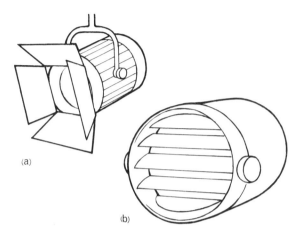

(a)

(b)

BARN DOORS AND LOUVRES
(a) Hinged flaps known as barn doors are fitted in pairs in front of a lamp to restrict the edges of the beam and reduce spill light. (b) The intensity of a beam may be accurately controlled without changing colour temperature by adjusting the opening of a baffle in the form of a louvre shutter.

while solid sheets of wood or fibreboard can be mounted to cast shadowed areas on the scene or to prevent light from a lamp falling directly on the camera lens. Large units for this purpose are called gobos and small ones flags. Sometimes a specific pattern of shadows is required and a perforated or cut-out board called a cookie will be made for the purpose. Reflecting surfaces, sometimes smoothly silvered for specular reflections but more usually granular or matted for diffusion, are also used to throw light into shadow areas but they are more often used in outdoor work with sunlight than in the studio where additional filler light sources can be employed.

Electrical supplies for lighting

In normal practice both incandescent and arc lamps are operated at 115 v. D.C. and the power to provide such supply to a studio complex represents a very considerable generating load, demands of 35,000 to 50,000 amps often being required for a group of larger stages. Although a basic load can often be met from outside commercial or national mains supply many organisations have installed their own generating plant to cover peak load demands. Whether the D.C. supply is obtained from local generators or by rectification from the mains, a high

degree of smoothing is essential to reduce the A.C. ripple content which can give rise to a low frequency hum from lamps and other equipment. This can cause grave sound recording problems if not adequately suppressed.

The efficient distribution of lighting power to the stages of a studio complex requires a very large amount of permanently installed heavy duty cable and switchgear, broken down on each operating floor into panels for local distribution. Here the supply is divided into circuits for various sections of the overhead lighting grid and selected positions around the stage floor from which local cables and distribution boxes are run to the lamps through the appropriate switch channels and dimmer controls.

Camera mountings

The cameraman must position and change the viewpoint of his lens within the set built on the studio stage to cover the movement of the actors in accordance with the artistic and dramatic requirements of the director. The planning of creative lighting and the movement of the camera itself are therefore inextricably linked, and the break down of individual script scenes into detailed camera set-ups by the collaboration of the director and cameraman is a vital operation. The camera angle, often continuously changing as the action develops, determines the form of camera mounting required and the component lighting equipment necessary. In motion picture studio work many individual shots are composed

STUDIO CAMERA TRIPOD AND GEARED HEAD
Handwheels control the horizontal panning and vertical tilting movements of the camera mounting through smooth rack and pinion gearing. On the studio floor the legs of the tripod stand on a wooden "star" or "spider".

DOLLIES
Dollies provide mobile camera mountings for studio operation, ranging from a simple four-wheeled trolley with castor wheels to power-operated units carrying the camera operator.

for shooting from a fixed camera position and the various floor mounted lighting units can be positioned as required for each set-up, but where the camera must move throughout the scene the lighting units must be accurately placed to provide the necessary effects without at any time being visible in the camera's field of view.

For a fixed camera position the tripod mount is still the simplest basic unit. Its three legs can be engaged with a floor triangle or star to prevent slipping, and its vertical adjustment can provide a reasonable range of operating heights. The camera itself is mounted on a rotating head which allows horizontal (panning) and vertical (tilting) movements and these can either be locked in position for a fixed set-up or moved manually or by servo motor control within a limited arc.

Where a low-angle camera position is required, too low for a regular tripod, a small fixed height mount, sometimes called a top-hat, can be used instead. But for high angles or long reach a hydraulic pillar or cantilever arm mount is necessary, usually on a wheeled trolley base. Smaller units in this form can

CAMERA CRANE
The working platforms of camera cranes can carry not only the camera and operator but often the director and other technicians.

provide adjustments up to a height of 8 or 9 feet but for greater heights up to 25 feet or so a more massive camera crane is required.

Mobile mountings, allowing the camera to be moved during the action, can range in size from a simple tripod on castor wheels to a large powered crane trolley providing a moving platform for the director and one or more camera operators. This gives movement in three dimensions. In television a hydraulic pedestal with three wheels, steerable in all directions across the open studio floor by the camera operator himself is very widely used but for the heavier equipment and larger working groups in the motion picture studio the four-wheeled trolley known as a dolly is preferred. The dolly provides a mounting of adjustable height with the usual pan-tilt head and all except the very smallest will have seats for the camera operator and an assistant. The trolley wheels allow movement sideways (crabbing) as well as forwards and backwards, but these movements are controlled by another crew member, leaving the camera operator

to concentrate on moving the camera head only. Motorised dollies provide power drive, usually hydraulic, to the trolley wheels as well as to the height control but must be completely silent if they are to operate while shooting the action. The heavy rubber-tyred wheels on larger dollies allow very smooth camera movement on level studio floors. But where the floor is uneven special tracks are laid for the trolley wheels, although this restricts the range of trolley movement. The term tracking shot is often applied to any scene photographed from a moving camera position.

The camera crane provides the largest form of mobile mounting. A very large trolley carries a power-operated boom which is counter-weighted or cantilevered, and at the end of this there is an operating platform. The platform is maintained in a level position at any boom elevation and carries the camera mounting with its pan and tilt adjustable head. Seats are provided for the director, camera operator and other technicians. Both the height of the platform and the position of the floor trolley can be varied in the course of shooting, so that the whole unit provides a basis for very flexible and spectacular camera movement.

Studio sound shooting

Camera operations on the studio stage are paralleled by those for recording the sound in synchronisation, although the sound so recorded, usually the speech of the actors, is only one component of the final composite track which eventually accompanies the scene. In normal studio work the operation is in the hands of a floor sound crew comprising basically the microphone boom operator, the floor mixer and his assistant.

The microphones used for dialogue recording on the floor are usually uni-directional, to avoid unwanted sounds being picked up, and must therefore be accurately manipulated by the boom operator to direct them towards each speaker in the course of the action. The boom is a long telescopic arm carrying the microphone in a gimbal mounting at one end and counterbalanced for easy movement in all directions. Cable or teleflex controls to the mounting allow the operator to follow the actors by rotation of the microphone as well as by

MICROPHONE BOOM AND MOUNTING
The microphone is gimbal mounted with cable
controls at the end of a telescopic boom arm.

197

the movement of the boom. The whole boom assembly is carried on its own mobile tripod although for enclosed sets a small lightweight boom known as a fishpole may be specially rigged. During the actual shot the boom operator must handle his unit to feed a sound signal of the necessary standard back to the mixer and at the same time avoid either the microphone or its shadow appearing anywhere within the camera's field of view. On large sets two or more separate microphones and booms may be required to cover the action. In some cases, highly directional line microphones are needed. These require extreme accuracy of aim at the sound source and for scenes where a boom-mounted microphone cannot be brought in radio microphones may be worn by the actors and connected to miniature portable transmitters which send a frequency modulated radio signal back to a receiver at the recordists position. In some instances, of course, the sound actually recorded during shooting is only intended as a guide for the synchronisation of another soundtrack, separately recorded under more favourable conditions. A typical example of this occurs in the production of elaborate musical song and dance numbers which are performed to the playback of a pre-recorded track which has been prepared in a sound recording theatre. The sound recorded during shooting then serves only as a guide for synchronising the picture with the original recording at a later stage.

The sound recordist, or floor mixer, with his tape recording unit, normally establishes a position close to the set, clear of the lighting and picture camera equipment but near enough to watch the action as he sits at the console of his mixing desk. This desk is a small trolley-mounted unit with inputs for the two or more microphones in use, each with their own volume controls, meters and monitors. The mixer listens to the sound while it is being recorded and judges both quality and level on his headphones in conjunction with his meter readings, so that all recordings are within the dynamic range of the system. Any unplanned noises which on the track may be objectionable must also be reported to the director. The sound camera technician checks the quality of the actual magnetic record by means of a separate monitor playing off the tape.

Rushes service

At the end of a day's work on the floor the resultant picture and sound records must be prepared for viewing by the director and his editing staff. Each take of each scene must be identified at the time of shooting by a number board photographed at the beginning, and a corresponding spoken identification is recorded on the magnetic soundtrack. During shooting, detailed records of each shot are made by the assistant technicians on the appropriate camera logs, to indicate which scenes and takes the director considered satisfactory enough for use in the final cutting. The tape recordings of the selected takes are transferred to 35 mm striped film by the studio sound department to provide the working tracks for the editing department but the picture negative from the camera must be developed before it can be used and must therefore be sent to a film processing laboratory. As it is essential for the results of each day's work to be viewed as early as possible the following morning, the laboratory must provide an overnight service. Negative received in the late evening is developed and printed during the night so that the resultant prints can be checked in the early hours of the next morning before delivery to the editing section or the studio for synchronisation with their magnetic tracks.

Each roll of exposed negative and its camera report is given a laboratory identification number and after development and inspection it is 'broken down'

CUTTING ROOMS COPY

CONTINUED FROM SHEET No.	SHEET NUMBER ONE	CONTINUED ON SHEET No.

THE SHEET NUMBERS MUST BE QUOTED ON ALL DELIVERY NOTES, INVOICES AND OTHER COMMUNICATIONS RELATING THERETO

PRODUCING COMPANY UNIVERSAL PICTURES STUDIOS OR LOCATION STAGE G SHEPPERTON
PRODUCTION ANNE OF THE THOUSAND DAYS PRODUCTION No. 696

DIRECTOR C. JARROTT CAMERAMAN A. IBBERTSON DATE 8TH AUGUST 69

STATE IF COLOUR OR B&W COLOUR **PICTURE NEGATIVE REPORT**

ORDER TO TECHNICOLOR LABORATORIES

STOCK AND CODE No. EST COL 5254 LABORATORY INSTRUCTIONS RE INVOICING, DELIVERY, ETC. RUSHES TO BE COLLECTED CAMERA AND NUMBER BNC 286

EMULSION AND ROLL No. 245 LABS NOTE: SOME YELLOW LIGHT USED FOR NIGHT-INTS. INTENTIONAL CAMERA OPERATOR P. WILSON

MAG. No.	LENGTH LOADED	SLATE No.	TAKE No.	COUNTER READING	TAKE LENGTH	'P' FOR PRINT B&W	COL'R	LENS F.L & STOP	ESSENTIAL INFORMATION	CAN No.
2	1005	510	1	60	60	P		50M	NIGHT-INT 'SOUND'	ONE
S11		511	1	140	80	P		50M	'DOWN IN KEY' INTENTIONAL	
		512	1	170	30		/	50M		
			2	250	80	P		"		
		513	1	350	100	P		75M		
			2	470	120	P		"		
		514	1	510	40		/	75M		
			2	580	70	P		"		
			3	650	70	P		"	80265	
		515	1	740	90		/	50M		
			2	830	90	P		"		
			3	910	80	P		"	ROLL 1 (910) EXP 95 WASTE	
4	1005	~~516~~ ~~1~~							NIGHT-INT 'SOUND'	TWO
S42		3000	1	20	20	P		50M	DOWN IN KEY INTENTIONAL	
		516	1	50	30	P		50M		
		517	1	160	90		/	50M	80266	
			2	190	30		/	"		
			3	250	60	P		"	ROLL 2 (310) EXP. 695 SE	
			4	280	30	P		"		
		518	1	310	30	P		50M	FOR OFFICE USE ONLY TOTAL CANS TWO	

TOTAL EXPOSED 1220	TOTAL EXPOSED	1220	TOTAL PRINTED	TOTAL FOOTAGE PREVIOUSLY DRAWN	
SHORT ENDS 695	HELD OR NOT SENT		B&W	FOOTAGE DRAWN TODAY	
WASTE 95	TOTAL DEVELOPED	1220	COLOUR 940	PREVIOUSLY EXPOSED	
FOOTAGE LOADED 2010				EXPOSED TODAY	

SIGNED
★COLOUR DESCRIPTION OF SCENE. FILTER AND/OR DIFFUSION USED DAY, NIGHT OR OTHER EFFECTS, DAYLIGHT, ARCS, INKIES OR MIXED LIGHTING. INTERIOR/EXTERIOR A.M. P.M.

B.L.P. 1067

CAMERA LOG SHEET
Detailed records of each scene and take are kept during shooting for use by the editor and to provide printing instructions to the laboratory.

into individual scenes and takes. Those which have been noted on the camera log to be printed are joined together, while the remainder, the 'out-takes', are spooled separately and stored for possible future requirements. After assembly, the negative to be printed must be assessed for its required printing levels, or 'timed', to compensate for all the small variations in exposure and processing which may occur. Short tests are often made, either on clippings taken from the ends of the scenes or on a special exposing machine which gives a number of frames with different levels of colour and intensity. This is known as a Cinex strip. These test strips are often sent to the cameraman at the studio with the laboratory report on the negative exposure level.

After the negative has been timed, prints are made, developed and viewed at the laboratory, usually by the contact man who acts as the link between the production team at the studio and the processing departments. If any defects

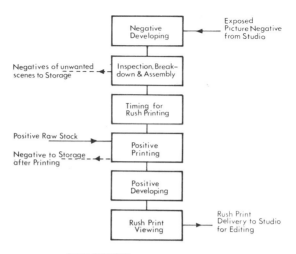

```
                          ┌──────────────┐         Exposed
                          │  Negative    │◀─────── Picture Negative
                          │  Developing  │         from Studio
                          └──────────────┘
Negatives of unwanted  ◀──┌──────────────┐
scenes to Storage         │Inspection,Break-│
                          │down & Assembly │
                          └──────────────┘
                          ┌──────────────┐
                          │  Timing for  │
                          │ Rush Printing│
                          └──────────────┘
Positive Raw Stock    ───▶┌──────────────┐
                          │   Positive   │
Negative to Storage  ◀────│   Printing   │
after Printing            └──────────────┘
                          ┌──────────────┐
                          │   Positive   │
                          │  Developing  │
                          └──────────────┘
                          ┌──────────────┐      Rush Print
                          │  Rush Print  │─────▶Delivery to Studio
                          │   Viewing    │      for Editing
                          └──────────────┘
```

RUSH PRINTING
Sequence of rush print operations.

are reported on the negative they must be promptly reported in case it is necessary to re-photograph the scene, and it is the general responsibility of the laboratory contact man to ensure that the rush prints supplied satisfy as far as possible the creative and artistic requirements of the director and cameraman.

Rush print synchronisation

When rush prints of the picture negative have been returned to the studio, the editor's staff prepare them for projection in synchronisation with the corresponding sound tracks which have been transferred to magnetic film for this purpose. In general studio practice, synchronism of picture and sound records is established at the head end of each scene by a clapper board operated clearly in the field of view. The movement of the clapper arm can be distinguished in each frame of the picture and the sharp sound of contact is accurately located and marked on the sound track when it is run through a sound reproducer head. When the frame of the picture print at which the arms of the clapper come together is aligned with the marked point on the track the separate picture and sound records are established in synchronisation and can be projected on a suitable double-head machine which runs the two strips at the same time.

In some types of clapper board the hinged arms are replaced by a spring-loaded shutter released by a trigger, which changes an aperture on the board from black to white and at the same moment makes a loud click for the sound recording.

More sophisticated electrical systems are also in use which by the operation of a control button simultaneously produce an electrical pulse recorded on the sound track and a flash of light from a lamp in the camera which exposes a portion of a picture negative frame. Such systems however require camera modifications and cable links to the recorder, which is not always convenient except where pulse synchronised tape systems are in use. For normal studio operation the simple combination of scene number board or slate with clappers continues to be widely used.

200

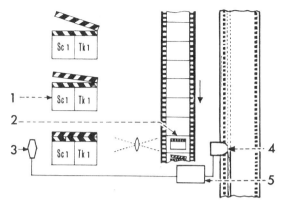

CLAPPER BOARD OPERATION
Synchronising sound and picture. 1. Clapper board in act of coming down. 2. Closing frame recorded by camera lens. 3. Microphone recording sound of clappers closing via amplifier, 5, and magnetic head, 4. Cutting sync is established when sound and picture frames shown are aligned parallel.

With the viewing of daily rush prints completed, the editing department proceeds with checking and cataloguing all the picture and sound material, as it becomes available from each day's work on the studio floor, in preparation for the first rough assembly in story continuity. Rush prints carry the printed edge numbers derived from the manufacturer's markings on the picture negative but the editing staff add their own coding to provide easy identification for each scene and take in the script sequence on both picture and track. From this point onwards the creative work of the editor, in collaboration with the director, can begin to make its contribution.

Editing

As the production proceeds, the editor and his staff give shape to the story by assembling prints of the selected scenes in the order outlined in the shooting script and as the details of the best presentation of the dramatic action are decided upon, these assemblies are modified from the first rough cut to the final continuity of an agreed work print. At each step, the corresponding sound tracks must be studied and assembled in synchronisation, while the manner in which the story is to develop leads to certain transition effect requirements such as fades and dissolves, and other items not covered by the original photography. The tools of the editing department are thus essentially devices for viewing, measuring, synchronising and joining lengths of picture and sound. At this stage the picture image is separate from its sound track and is termed a 'mute' print.

The simplest unit, a film measurer or counter, consists of a large sprocket on which the film can be located, connected to a revolution counter. In 35 mm work the sprocket has a circumference of one foot with 64 teeth numbered in groups of four to indicate 16 frame intervals. The revolution counter thus measures the film footage going over the sprocket while the number of frames can be read on

the sprocket rim. For 16 mm work the sprocket has 40 teeth and is marked for the 40 frames which make up one foot of 16 mm film. The exact running time of each length of film can be readily determined by the factor of 24 frames equalling one second at normal projection speed, but additional revolution counters geared to read directly in minutes and seconds are sometimes provided.

Synchronisers have two, four or six such sprockets mounted on one shaft with clutch devices which allow one pair to be rotated separately from the others or locked together as required. Synchronisers thus allow several picture and sound records to be wound through together and marked up exactly in step with each other. The synchroniser can be fitted with magnetic pick-up reproducer heads mounted between the flanges of some of its sprockets which can be individually switched to an amplifier and small loudspeaker to allow any of the soundtracks to be heard as the film is wound through.

(a)

(b)

FILM COUNTERS AND SYNCHRONISERS
Film lengths can be measured by passing over a sprocket marked in frames connected to a revolution counter to indicate feet. Groups of sprockets on a single shaft allow several strips of film to be wound through together in step.

202

(a)

(b)

1

2

3

(c)

EDITING EQUIPMENT
 (a) Editing Viewer.
An optical system and small back-projection screen form
part of a film counter or synchroniser to show the action
while the film is being wound through.
(b) Moviola
Separate picture and track records can be run in syn-
chronisation backwards and forwards at any speed and
stopped to allow individual frames to be scrutinised and
marked.
 1. Intermittent Picture Mechanism
 2. Back projection screen for picture image
 3. Sound Head with continuous motion drive
(c) Editing Table
Multiple film paths allow several picture and track
records to be run together for editing examination.

 Additionally, one or more of the films can run through a viewer to allow the
picture to be examined at the same time. In the simplest viewer the film is
illuminated by a small lamp mounted over the sprocket and the image of a frame
projected on to a small ground-glass screen. A rotating prism geared to the
sprocket serves as an optical intermittent to allow the action of the picture to
be seen in motion as the film is wound backwards or forwards over the sprocket.
 A more elaborate editing device, often known by the trade name of Moviola,

is motor driven and provided with feed and take-up reels to allow longer lengths of assembled film to be handled. There are usually two vertical film paths, one each for picture and track, the picture film being moved by a mechanical intermittent sprocket and viewed either through a magnifying lens or again projected on a small screen. The sound film moves continuously and plays through an amplifier and speaker. Either path can be operated separately or locked together to run in synchronism, either forward or backwards. Variable speed control is provided so that, when necessary, the film can be run very slowly and stopped to identify a particular frame at the picture aperture.

In recent years, multi-path editing tables with horizontal film paths have also become popular. In these, two, three or four film paths for picture or sound are provided, each capable of being driven forward or backwards independently at any speed or interlocked in any combination. Both picture and sound films run continuously and the picture is projected by an optical intermittent on to a translucent screen, usually about a foot wide. Anamorphic lenses for Cinema-Scope images can also be used. It is often possible to use the same table path for 35 mm or $17\frac{1}{2}$ mm magnetic film merely by changing the guide rollers, and combination 35/16 tables are produced. Elaborate motor controls for each path are provided and the general quality of sound reproduction is made as high as possible so that these machines can be used for rehearsing the combination of several magnetic sound recordings in preparation for the final re-recording.

When the editing department prepares work prints, many separate pieces of film must be joined and often re-assembled many times. For speed and simplicity joins in picture material are often made with transparent adhesive tape rather than the more permanent cemented splices generally used in the laboratory. Semi-automatic joiners which trim the film ends, apply the overlapping adhesive tape and perforate sprocket holes where the tape overlaps, are convenient and rapid to use.

When a more permanent join is required a cement splice is preferable. For this, the two ends of film must be overlapped and the emulsion layer removed from one, so that the cement, which is a film base solvent, can weld them together. The emulsion scraping must be done accurately to avoid weakening the base and the two films held accurately in position while pressure is applied to the join. Even simple hand splicers are usually fitted with semi-automatic scrapers which can be accurately set to remove exactly the correct thickness to expose the base, while more elaborate units have foot-operated pedals and levers to cut the film ends accurately and apply pressure, sometimes with heated blocks to speed up the operation. A fully automated splicer has been produced which trims, scrapes and applies the cement from an applicator disc, afterwards bringing the two ends together under pressure, all by a few movements of the control knobs.

Dialogue replacement

In the course of preliminary editing, it may be decided that some of the originally recorded dialogue sound is of unsatisfactory quality, particularly where shooting was on location with extraneous noise or limited equipment. Sections of dialogue may therefore have to be recorded again by the actors under better studio conditions to match the action originally photographed. This operation is termed 'dubbing' or 'looping'. The original scene is divided up into short lengths corresponding to convenient phrases or sentences of dialogue, and a

FILM JOINERS

(a) Tape Joiner. The cut ends of the two pieces of film are joined by transparent polyester tape which is trimmed and punched with perforation holes. (b) Cement Splicer. The emulsion is removed from a narrow strip at the end of the film by a carbide-tipped scraper blade and an over-lapped joint made using a solvent cement. The joint is held under pressure and heated for rapid setting.

positive print of this section is joined to form a continuous loop. The loop is then run continuously in synchronisation with a magnetic recorder and the actor rehearses his speech to match the action of the scene until a satisfactory recording has been obtained and approved by the director after playing back. The original unsatisfactory sound recording can often be used as a guide to the actor for timing speech to the lip movements and character of delivery, and a number of visual cue systems have been devised to assist in the work. As each loop is completed, the appropriate section of dialogue is transferred to magnetic film for inclusion in the edited sound track of the complete sequence.

Sound editing

Although the visual images of the picture material determine the main structure of a story, handling the numerous associated sound elements may often require a greater amount of work. For any one picture scene there may be two or more tracks of dialogue and speech, several tracks of associated sound effects and a musical background track, all of which have to combine not only in exact synchronisation but with the correct relative sound levels to convey the required dramatic mood. In the final editing stages especially, with a fine-cut work print, sound preparation occupies a very considerable part of editor's time.

In general, exact requirements for the musical background to the film cannot be determined until this stage. The editor must often work very closely with the composer and the music recording team to ensure a precise timing between the musical score and the picture cutting. At this stage also all sound effect requirements are determined, and few of these may have been recorded satisfactorily when the scene was shot. The studio sound department is called upon to record specially whatever is necessary, often with the help of the special effects department, or to identify suitable material in the sound library. The library can often supply general background sounds such as traffic noise, sounds of aircraft or automobiles, jungle effects, and so on, but the majority of specific sound effects for a film have to be recorded for the occasion, if necessary in synchronisation with a projected picture to act as a guide.

The physical assembly of various track components and their organisation for the eventual final sound mixing form an important part of the later editing stages. Careful arrangement of continuous tracks and loops of background effects can greatly speed up the actual operations in the dubbing theatre. If it appears that too many separate effects track components are involved some can be combined into a single track by a pre-mix. The closest co-operation between the editor and the sound mixer is essential in preparing the dubbing cue sheet for each reel of the production. This sheet should show in detail all the track components and their position within the reel.

Final dubbing

The final re-recording of track components, also known as dubbing, is the last step in the creative work at the studio. A special projection theatre is set aside there for this operation and it is equipped with a mixing console at which the outputs of a large number of magnetic reproducers can be selected, controlled and combined for recording. The reproducers, in the projection room, are accurately interlocked with both the projectors and with the sound recorder. As many as 15 or 20 track components may have to be run to make the final record for a single reel of film. Some of these may be complete reels, made up by the editing team to match exactly the picture cutting copy, while others are repeating loops which can be run continuously. Such loops are normally used for background noise and do not require exact synchronisation with the action of the film. Made-up reels on the other hand must be used for the various dialogue tracks, for music and for synchronised sound effects.

Faders on the console desk in the theatre provide volume control for each separate track channel, and, together with volume meters, equalisers and filters allow the sound quality on each channel to be adjusted to obtain the required character. Console operations are in the hands of the dubbing mixer and for the complex control work often required for a feature film two or more mixers have

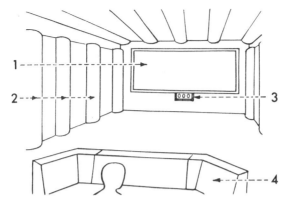

DUBBING THEATRE PLAN
Large screen, 1, simulates theatre conditions.
Wall surface, 2, as well as ceiling, are faced with poly-
cylindrical diffusers or other treatment to give desired
acoustic characteristics. Footage counter, 3, tells mixer
at console, 4, precise point reached by film being dubbed.

to work together. They usually work this out together by dividing the tracks
into groups covering dialogue, music and effects and each taking charge of a
group.

A detailed working plan in the form of a dubbing cue sheet is previous-
ly prepared by the editing crew, giving the footages at which each of the
component tracks is to be used and indicating the sound transitions which must
be made on the console faders. Illuminated film counters, showing the footages

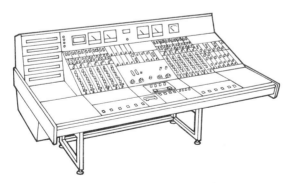

SOUND MIXING CONSOLE
A single re-recording console has up to twelve
input channels, each with its own volume control and
sound quality balance; the mixed output can be fed to
four recording channels. Console panels may be installed
in groups to handle even more input lines.

run through the projector from a start mark on each reel, are displayed below the screen in the theatre to allow the mixer to follow his cue sheet. This information is repeated on footage counters mounted on the console panel. Even with such prepared by the editing crew, giving the footages at which each of component

DUBBING CUE SHEET
 Simple documentary film with four continuous tracks and four loops. Numbers show footages from start, which appear on counter below screen and/or on console. Tapering heads and tails to sound sections indicate fades. Other transitions are direct sound cuts. A horizontal format is often adopted. Feature film cue sheets are similar but much more complicated.

tracks is to be used and indicating the sound transitions which must be made on the console faders. Illuminated film counters, showing the footages run through the projector from a start mark on each reel, are displayed below the screen in the theatre to allow the mixer to follow his cue sheet. This information is repeated on footage counters mounted on the console panel. Even with such preparatory work, the final sound mixing is a creative function in which the director, editor and mixer cooperate, and rehearsal and revision is necessary before the final dubbing can be made.

Modern dubbing theatre installations include facilities for running all projectors, reproducers and recorders both forward and backward in exact synchronisation in a technique known as roll-back, or rock'n roll. This greatly assists the whole crew during rehearsals, as any required sequence can be repeated several times without the considerable delay of rewinding and rethreading all the separate components. During the actual recording, a section can be re-mixed

and re-recorded in its correct position in the reel if the first 'take' of that portion is not satisfactory.

While the main purpose of the final recording session in the dubbing theatre is to produce a single magnetic track on which all components are combined to the director's satisfaction, it is usual to produce at the same time a record containing only the music and effects without any speech or dialogue. Such a recording, known as the M and E track, is required when foreign versions of the film are prepared, for mixing with dialogue tracks which have been recorded in the appropriate language.

When the final combined track, known as the master dubbing, has been recorded, it must be finally approved by the producer and director by running at one of the studio's review theatres on a double-head projector with the corresponding picture work-print. If satisfactory, it is transferred from the magnetic record to an optical sound track negative, so that married prints combining picture and sound can be prepared by the processing laboratory. This transfer is also carried out by the sound department at the studio, but this is a technical rather than a creative operation. The recorded optical track negative is then sent to the processing laboratory who prepare a print of the sound alone, for approval by the studio. At this stage recording tests and test prints are usually made to determine the optimum conditions for processing and to establish the laboratory printing standards for the best quality sound reproduction.

When the rush prints of the optical sound negatives have been approved, they are marked up by the editing department to indicate their correct synchronisation with the picture work print and both are sent to the processing laboratory to act as guides for cutting and assembling the picture and sound negatives prior to making the first graded composite print, or 'answer' print.

Multi-track recording

Where the eventual picture presentation is to be in one of the wide-screen systems using stereophonic sound, the final re-recording stages are somewhat more complex. In general, the normal operations of initially recording the dialogue and main sound effects are not altered and single microphones are employed. But for music recording, where multiple microphones are always needed, the mixer produces on a special control console three track recordings corresponding to the left-hand, centre and right-hand source positions. In the preparatory work before final mixing the complex effects tracks are usually pre-mixed into similar groups of three-position tracks, as, in the final presentation, the distribution of effects sound sources is dramatically important.

In the final dubbing operation, usually after the correct balance of dialogue, music and effects has been determined, the mixer must control the distribution of each component into the three position channels by operating rotary faders known as pan-potentiometers, or pan-pots, and thus provide a stereophonic effect even from original monophonic recordings. When necessary, some sound effects components must be recorded on a fourth track which will subsequently be reproduced over a series of loudspeakers in the general auditorium of the theatre, while the main dialogue and music is played over three speakers behind the screen. The final master for stereophonic presentation is therefore made on 35 mm magnetic film carrying four recording tracks. Prints of films for multi-track showings are always made with magnetic sound, so optical sound transfers are not necessary unless the subject is also to be distributed in

the conventional form. For 35 mm stereophonic copies the four records are transferred from the final master to a picture print which has been striped with four magnetic stripes. For 70 mm prints, which carry six magnetic tracks to serve five groups of speakers behind the screen and a group in the auditorium, the four track master is converted to a six-channel master by re-recording through dividing net-works which combine the centre and left hand tracks to give the inner-left position and the centre and right hand to give the inner-right. Prints of the picture on 70 mm are striped with the required magnetic stripes to which the six sound tracks are transferred from the six-channel master.

7 Further aspects of production

Location work

Operations on the floor of the studio may cover the greater part of the shooting of a feature film but it is rare for any subject to make use of no outdoor scenes whatever, and in some cases exterior photography provides the major part of the production. Exterior scenes may be shot either on the outdoor 'lot' which forms part of many larger studio complexes, where all the technical resources of the organisation are readily available, or on location, often in foreign countries, where a completely self-contained unit must be established.

When working on the studio lot the pattern of work closely parallels that on the studio floor with the exception of lighting and even here the power supplies readily available from the generating equipment can simplify many problems. The weather and the time of day for the correct direction of light are the biggest problems and a flexible shooting schedule is essential to take the best advantage of prevailing conditions. Natural daylight by itself may not provide the exact lighting character required by the director and cameraman and must be supplemented by artificial sources and by reflectors, particularly in close shots.

In much exterior photography the major problem is to ensure that the effective lighting contrast on the subject is not too great, particularly when the main keylight is provided by direct sun. In such conditions the illumination of shadow areas by reflected daylight is important, and both diffusing matte reflectors and more directional specular surfaces have their part to play. In close-up shots the harshness of direct sunlight can be reduced by interposing scrims or light gauzes but if this is overdone the essential character of true sunlit exteriors will be lost. With overcast skies the problem may be reversed, with the natural daylight producing too flat an appearance, so artificial light sources must be added to provide the key-light modelling required. Under these circumstances only arc lamps have the concentrated intensity capable of providing key-light brightness to be superimposed on diffuse daylight.

Colour negative stocks are manufactured for exposure by tungsten light at a colour temperature of 3200°K, whereas natural daylight may correspond to anything between 5000° to 12000°K, depending on weather conditions and the time of day. It is therefore essential to correct for the extra blue content of daylight by the use of a pale orange-yellow filter on the camera (Wratten 85) and correcting the exposure level accordingly. By absorbing a proportion of the blue light component such a filter provides the major part of the correction necessary to match daylight to tungsten. Further variations, which result from different sky conditions and the elevation of the sun are normally within the range of laboratory printing corrections. Any artificial light source must also match the characteristics of daylight; arc lamps using white flame carbons or high intensity sun carbons at 5000° to 5500°K are suitable. Tungsten-halogen lamps must be matched to daylight by the placing of blue filters over the lamp, although these result in considerable loss of light. Glass filters can be used in smaller lighting units but gelatine or acetate sheet filters are more general. Transparent acetate is much cheaper and more robust, but both are liable to fade with continued use. Dichroic filters, which contain minute particles reflecting the yellow-red component of the light and transmitting the blue, are more efficient but are not recommended for focusing spot-lights. Here the beam passes through at differing angles, and produces an uneven filter effect.

Location work often means shooting in real buildings and mixed lighting is a problem if daylighted windows are to be seen at the same time as the artificially lit interior. When the window areas are of moderate size, it is normal to cover them with large sheets of orange-yellow acetate filter material (corresponding to the Wratten 85) which is available in long rolls 42 inches wide. This matches the windowlight to the tungsten lighting inside. Grey neutral density sheets may also have to be added to reduce the brightness of the windows. Where the daylight areas are too large to allow this procedure, as might be the case with the large doors of an aircraft hanger or garage, it may be necessary to treat the scene as daylit and light the interior with blue-filtered artificial sources.

Work on location needs careful planning and lighting requirements must be accurately forecast to provide the correct lamp units and the corresponding electrical supply equipment. For outdoor photography with arcs mobile generating trucks are commonly used. A large 225 or 350 amp brute lamp may sometimes be mounted with its own D.C. generator on a Land-Rover or similar automobile chassis to serve as a completely self-contained lighting unit. Much has been done in recent years to reduce the noise level of portable generators but where sound is being recorded it is often undesirable to position them close to the shooting area. The voltage drop through the supply cables to the lamps may therefore be serious unless adequate sizes of conductor for the length of run required have been provided. For the operating 120 v lamps a power source of 125 to 127 v is normally employed, as it is generally accepted that a voltage drop of not more that 5% should take place though the cable to the working area. Too great a loss of voltage on distribution causes a significant reduction of light output and a lower colour temperature on tungsten lamps which can be serious.

For interior photography on location the small efficient tungsten-halogen lamps now available have greatly simplified the lighting requirements. Where sufficient current capacity is available from the local electric supply, mains voltage rated lamps can be used, operating at 220 or 230 v in European practice. If no mains supply is available, smaller lighting units fitted with 30 v tungsten-halogen lamps can be operated from portable heavy duty nickel-cadmium

batteries. A small power pack less than 10 in square and 4 in thick can run a 250 w 30 v tungsten-halogen lamp for some 50 minutes intermittent operation.

A very mobile type of supply unit takes the form of a power pack belt worn round the waist to supply a hand-held lighting unit known as a Sun-Gun; low voltage tungsten-halogen lamps of either 30 v or 11½ v are used, and the smaller power belt batteries will run them for periods of 10 to 20 minutes, depending on the lamp size. Both types of battery assembly can be recharged from mains supplies at 100 to 120 v or 200 to 250 v whenever they are available.

Sound recording on location now presents no particular problems. Portable equipment using quarter-inch magnetic tape rather than perforated film is always employed, with a pulse system for synchronisation with the camera. The units are completely transistorised and are thus very light and compact with very moderate power demands which can be met by 18 v nickel cadmium re-chargeable batteries forming part of the complete outfit. Playback monitor facilities are always provided for the recordist but it must be recognised that in many cases the sound actually recorded on location is only a guide track, subsequently replaced by dialogue re-recorded under optimum studio conditions.

When recording sound outdoors the problems of microphone operation are intensified by wind and other extraneous noises. Strongly directional microphones with windshield mountings are essential and close working positions must be maintained to ensure a satisfactory ratio of signal to noise.

Special effects work

The term special effects or process photography covers a wide range of techniques employed to produce scenes which are either impossible to obtain by normal direct shooting or which are impracticable on grounds of cost or convenience. Most special effects call for the integrated use of several different motion picture techniques but a general dividing line may be drawn between those which can be completed on the picture negative in the camera and those which involve final stages in the film processing laboratory. The first group is by far the more extensive and flexible and is normally in the hands of a specialist division of the studio organisation whose technical skills and resources can be made available to all productions working at that centre.

Many of the simplest types of effect shot require little or no special equipment and come within the field of operations of the cameraman himself, either by lighting or by direct adjustment of the camera mechanism or its optical system. Within the latter groups are such effects as fog filters and diffusion discs to change the image quality, prisms and ripple glass to distort the picture, and simple alterations of camera speed to produce the effect of slowed-down or speeded-up movement.

Perhaps the most widely used form of effects shot by direct photography is the day-for-night scene, in which an exterior shot with daytime lighting is required to give the impression of night. Most scenes of this sort represent a convention based on theatrical stage lighting, and have only limited success in reproducing the impression of what is actually seen by the eye under dim illumination. It is the practice to use back light with a degree of underexposure, to obtain undifferentiated shadow areas, and to give an overall cold balance to the scene, by omitting the 85 daylight correction filter or exposing through a blue or blue-green filter or, again, by instructing the laboratory to print it abnormally. Yellow filters should be used on any artificial lights or illuminated windows in the scene. Although in long shot the result may be reminiscent of a

A By Direct Camera Work (complete as photographed)	B By Camera and Laboratory Effects Photography	C By Direct Laboratory Work (not requiring special photography)
Lighting & Camera Effects:		Changes of Action:
Day—for Night Shots Firelight Effects Fog Filters Diffusion, etc.		Skip Frame Stretch Frame Stop Frame Reverse Action Flop-over
Model and Miniature Work, often involving high-speed photography.		Ripple and Diffusion, etc. Changes of Image Size: Blow-up Reduction Zoom Effects
Combination of Images:	Combination of Images:	Combination of Images:
(i) with static components: Glass Shots Hanging Miniatures Mirror Shots	(i) with static components: Painted Matte Shots Aerial Image Photography Superimposed Titles	Superimposition and Double Printing Dissolves and Mixes Wipe Effects Fades
(ii) with action components: Split Screen Shots Back Projection Reflex Projection	(ii) with action components: Split Screen and other Fixed Mattes Travelling Matte Shots	

stage moonlight effect, the faces in close-up are often unsatisfactory and it has been suggested that exceptionally pale or grey make-up should be applied in night scenes of this sort. Sky brightness is another problem. In reality night scenes have some very dark sky areas and these are difficult to obtain by daylight photography. Polarizing filters can be used to darken a bright blue sky but have no effect on a white, overcast one other than reducing exposure level. Graduated neutral density filters can assist if they do not affect important action in the foreground. At the present time, there appears to be an increasing tendency to move away from the conventional strong overall blue night effect and to aim more at a low-key neutral character, accentuated where appropriate with warm lighting effects from lamps in urban street scenes.

Model work and miniatures

Miniature scale models are frequently used for spectacular scenes which would otherwise be impossibly expensive to create in full size. In its simplest form a miniature may be built to appear as part of a background, as for example the decorated ceiling of an enormous ballroom, to avoid building an expensive set in full. It may be combined with the live action on the floor either when shooting or by combination printing in the laboratory later. More frequently the model is used with its own action—the railway train crash over the collapsing bridge, the erupting volcano, the space ship approaching the unknown planet—and here the field is unlimited.

The scales of model work vary enormously and can range from the representation of a solar system on a table top to replicas almost full size. Wherever

214

miniatures are to be shown in action the models are preferably built to as large a scale as possible. Greater reality can then be obtained in constructional detail, photographic perspective and depth of field and in the time-scale of movement. In photographing a moving model, the camera must be run at high speed to slow down the action in proportion. The smaller the model the higher the camera speed required. Strictly, the speed increase required is the square root of the reduction scale; thus if the ratio of real life to model dimensions is 4 : 1, the camera speed must be doubled, while for a scale reduction of 16 : 1 the camera speed must be increased by a factor of 4. In practice, models must frequently be photographed with short focal length camera lenses well stopped down to obtain adequate depth of field and this in conjunction with the increased camera speed can require high levels of illumination. It is often difficult to obtain satisfactory perspective from the required point of view when working with a small scale miniature and the model may have to be constructed with falsified proportions and local distortions to obtain the desired effect.

The behaviour of materials in scale models is another problem which increases with the reduction factor. Waves in a studio tank for scenes of stormy seas are particularly difficult on a very small scale since spray and foam cannot be formed in the correct proportion. In miniature tank work it is therefore particularly important to use as large a scale model as possible.

Image combination

Special effects scenes involving the combination of different images are perhaps the most widely used of all trick shots and can provide a very substantial saving to the production budget, either by avoiding the expense of constructing very large and elaborate sets or by presenting the action of the artists against background scenes which they have never visited. In the first category, for direct photography in the camera are glass shots and mirror shots.

In a glass shot the camera views the scene through a large sheet of glass mounted in a fixed position a short distance in front and on this are painted appropriate sections of the scene to blend exactly with the actual set. A typical application of this process is to add a ceiling or upper part of a building to a set on which all the action takes place at ground level, or to place distant buildings in a real landscape. To ensure accurate jointing between the painting and the actual scene seen through the glass the camera position must be rigidly established and the composition carefully checked through the camera lens while the painting is being made. In the hands of a skilled specialist artist this tech-

PAINTED GLASS SHOT
Part of the scene is painted on glass, 3, and is photographed by the camera, 2, at the same time as the main action seen through the clear portion. Separate lamps, 1, illuminate the painting.

HANGING MINIATURE SHOT
To avoid the necessity for building the whole of a set, a model, 1, of the upper part is hung from above so that it matches the actual set when seen through the lens of the camera, 2.

nique can produce outstandingly convincing results, although it has the limitation for outdoor scenes that the shadows on the painted scene will only match those of the real scene at a particular time of day for the right weather conditions. The fixed camera viewpoint, precluding camera movements and changes of lens, is also a restriction which must be accepted.

Closely allied to painted glass shots is the use of hanging miniatures, where a three-dimensional model representing part of the real set is mounted in front of the camera so that it matches the appropriate portions of the scene. A model with its own structural shadows works under varied lighting conditions and if the camera is mounted in such a way that it can rotate about the nodal point of the lens some degree of pan and tilt movement is possible.

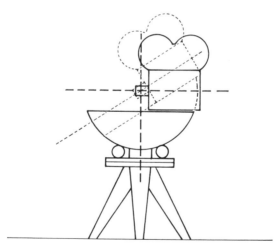

NODAL MOUNTING
For several types of special effects photography the camera must be mounted so that the axes of rotation for panning or tilting pass through the Nodal Point of the lens rather than through the centre of mass of the camera body as is usual.

216

Mirror shots of various types provide another method of direct image combination in the camera and the results can be assessed by the director and cameraman while shooting, without further processing operations. One of the most effective techniques, known as the Schufftan process after its inventor, makes use of a large surface-silvered mirror mounted at 45° to the optical axis of the camera lens. Portions of the reflecting surface are then carefully removed so that the scene photographed is a composite of the view seen directly through

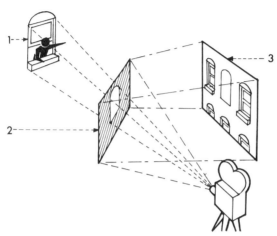

SHUFFTAN SHOT
To avoid constructing a full size set, a small section only (1) is built and photographed through the clear area of a mirror (2) set at 45° which reflects a painting or miniature (3) of the rest of the scene.

the clear glass and that reflected by its remaining mirror surface. In a typical application an actor would be seen against a small background set by the direct view through the mirror, while the whole of the surrounding area is provided by a painting or model mounted at the side and reflected into the camera by the remainder of the mirror surface. When carefully arranged with suitable subject matter, this process also can produce extremely convincing results, although it limits the camera to a fixed position.

Projection process photography

The second category of image combination by direct photography covers those systems in which live action on the studio floor is combined with a projected picture, either still or moving, as a background. These processes provide extremely versatile and effective methods of achieving a wide range of special effects and can be sub-divided into two basic procedures, back projection and front or reflex projection.

Back projection was the first of these to be developed. The background scene is projected from behind the actors on to a translucent screen which is photographed by the camera as the actors play their parts in the foreground. If the

217

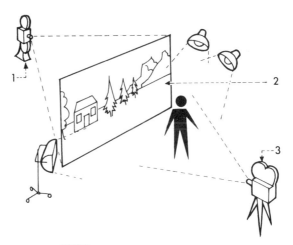

BACK PROJECTION
The background scene is projected by the projector (1) on to a translucent screen (2), in front of which the action is played. Both foreground action and background scene are photographed together by the camera (3), which is electrically interlocked in step with the projector intermittent mechanism.

background scene, known as the 'plate', is a stationary one, a still photograph of as large a size as possible can be projected. But for moving backgrounds motion picture film is necessary and here the 'plate' is in a special projector electrically interlocked with the camera so that the shutter action of both mechanisms is absolutely simultaneous. This background projector must provide an extremely steady image and it is usual to fit it with an intermittent register pin mechanism, as in a camera, while the films used as plates must also be printed on accurately registered step-printing machines. The colour of the projector light source must be accurately matched to the lighting on the foreground action and for colour photography this means yellow flame carbon arcs to balance the tungsten lighting of the set. The colour balance of the projection plates must also be carefully matched to the lighting and preliminary tests by actually shooting the combined foreground and background are most desirable.

The size of back projection screens can vary enormously. The moving background representing the view through the rear window of an automobile can be shown on a screen four feet wide while a scenic background for an elaborate musical number involving movement may require a screen of sixty feet in width. In all cases the fundamental problem is to obtain a sufficiently bright screen for satisfactory rephotography combined with uniform illumination when seen from every camera viewpoint. This problem increases greatly with the largest screens. All translucent back-projection screens are somewhat directional, as complete diffusion is extremely wasteful of the light transmitted, and it is not easy to avoid the effect where screen brightness appears uneven to the camera. A brighter central area, or hot spot, is particularly obvious when a short focal length lens is used on the camera and a long focal length on the projector. It is preferable to use the longer focal lengths on both if possible.

218

Side to side unevenness on the screen can best be avoided by ensuring that the camera and projector axes are in line with each other on opposite sides of the screen and the screen itself must be more or less at right angles to the projector axis otherwise it is difficult to focus the plate over the whole screen area.

With large screens it is difficult to obtain sufficient screen brightness for moving backgrounds. Double or triple-head projectors superimposing prints of the same plate from two or three separate light sources have been used but require most careful alignment and maintenance to keep the three images in register. Large area prints, for instance on 70 mm film, provide better screen illumination than 35 mm plates when suitable projectors are available. With still pictures as plates, even larger prints, up to 12 in wide, are placed in special projectors known as stereopticons. But these require very large and expensive optical systems and slides 4 × 5 inches are much more frequently used.

The lighting on foreground action requires skill and experience. The camera viewpoint, the level of illumination and its character of light and shade must all be balanced to that of the background plate so that when photographed together they are suitably matched. To keep both background and foreground within the available depth of field, the actors should be placed as close as possible to the plane of the screen but all foreground lighting must be kept from falling on the screen, as it would degrade the quality of the projected image. Careful lining-up through the camera viewfinder is essential at all times. Further tests to check the balance of lighting are recommended.

B.P. HOT SPOT

(a) A back projection screen with strong directional transmission gives a bright but unevenly illuminated picture, with a central "hot spot". (b) The effect is even more marked if the projector (1) and the camera (2) are misaligned or the projector lens is of narrower angle than that of the camera. (c) A screen with greater degree of diffusion will give a more uniformly illuminated picture but at the expense of light transmission.

Reflex projection

Within recent years an alternative method of shooting projected process scenes has become available as a result of the development of highly directional reflective screens. These screens, whose surface is made up of minute glass lens elements embedded in a dark foundation, have the property of reflecting a high proportion of the light falling on them directly back towards its source with practically no scatter in other directions.

Almost all the light from a projected picture on such a screen is therefore reflected back to the projector lens and could be photographed by a camera lens placed at this point. To achieve this the projector and camera are rigidly mounted at right angles to each other with a semi-silvered mirror at 45° between them. Light from the projector is reflected from this surface on to the screen from which it returns along the same path through the mirror to the camera lens which has been accurately lined up to occupy a position equivalent to that of the projector. Foreground action lit normally in front of the screen is photographed at the same time; the reflection of any light from the projection plate falling on the foreground is so small in comparison with that of the screen that its effect is negligible. With modern screen materials the screen reflectivity can be as great as 1000 times that of a white foreground object illuminated by the same projector.

This reflex projection process has valuable advantages over back-projection; the light efficiency allows very large backings to be adequately illuminated and

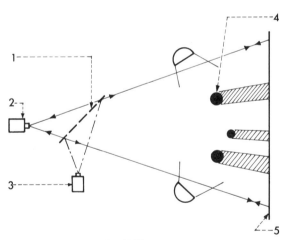

PRINCIPLE OF REFLEX PROJECTION
The background scene from the projector (3) is reflected by the semi-silvered mirror (1) on to a highly directional reflex screen (5) which returns the incident light along the same path. A camera (2) mounted behind the mirror in a position matching the projector photographs the background scene and the foreground action (4) together, any shadows cast on the backing being masked by the foreground object. Any foreground lighting falling on the screen is not reflected towards the camera but back towards its source.

In reflex projection the relative positions of the camera (4), projector (3) and mirror (1) must always be accurately maintained. For tracking and dolly shots, therefore, all three must be moved together as a unit by mounting them on a mobile platform (2).

lighting the foreground action becomes much simpler. Any foreground lighting falling on the screen will not be reflected towards the camera and therefore does not degrade the background image. Once the camera and projector have been accurately lined up, the two may be moved together for tracking shots on a dolly and camera movements and zooms within the limits of the projected background are possible. The range of movement towards the screen in a dolly shot must not be too great, however, as it would change the balance between the background and foreground brightness. As in back-projection the grain and definition of the plate are often limiting factors, and it is most desirable to use the largest possible size for projection, 70 mm prints for example, for moving backgrounds.

Laboratory special effects

All the process methods described so far result in an original negative from the camera which contains the effects required. But there are many others which involve making derivatives from the original and which are usually carried out in the laboratory on special printing machines. Typical examples are the varied effects used to provide transitions from one scene to another in the course of dramatic editing to indicate a change of place or time. These include the fade, in which the scene gradually darkens to an overall black, the lap dissolve or mix, in which one scene merges almost imperceptibly to the next, and the out-of-focus dissolve, where the outlines of the image are slowly lost until it becomes unrecognisable. Other alterations required for editing or continuity purposes can involve turning over the action from left to right on the screen (flop-over), speeding up (skip-frame) or slowing down movement (stretch-frame) or holding

221

it stationary (stop-frame, freeze frame) and even making the action take place in reverse. The size and position of the original negative image may be altered, a part of the frame being enlarged (blow-up) to provide a close-up shot or to eliminate a fault of composition at the edge of the frame. Zoom effects not covered during original shooting may be introduced for dramatic emphasis.

For all these effects an optical printer is used in which the processed negative is copied by a lens on to the print stock as they pass through separate mechanisms, or heads, one frame at a time. Each head comprises an accurate registra-

OPTICAL PRINTING EFFECTS

Examples of some of the special effects obtainable by optical printing:

1. The original action as photographed.
2. Skip-frame: only every alternate frame is printed, which makes the action appear twice as fast when projected normally.
3. Stretch-frame: each frame is printed twice, so that the action takes twice as long as it did originally.
4. Hold-frame: the action is frozen by repeating a single frame for as long as required (stop frame, freeze frame).
5. Blow-up: the action takes place normally but a part of the original scene is enlarged to fill the frame.
6. Reverse Action: by printing the frames in the reverse order from the end to the beginning, the action appears to go backwards.

7 8 9 10 11

7. Flop-over: the action is reversed from right to left, as though seen in a mirror.

8. Zoom: each successive frame of the action is printed with slightly greater magnification, giving the effect of moving towards the camera.

Transitional effects between scenes can be:

9. Fade: the scene gets progressively darker, until it appears completely black (fade-out). The opposite effect, progressing from uniform black screen to normal picture, is a fade-in.

10. Wipe: one scene is gradually replaced by another at a boundary moving across the frame. This boundary movement may be either hard-edged or diffused (soft-edge wipe) and may take an almost infinite range of shapes, directions and rates.

11. Dissolve or Mix: the image of the first scene gradually becomes fainter and fainter while that of the second scene becomes clearer until the first has completely disappeared. These effects may be extended over as many frames as required in editing.

tion intermittent movement, similar to that used in a camera, together with sprocket drive and feed and take-up reels. An accurately aligned lamphouse optical system illuminates the film in the negative head, also known as the projector head. The print stock is fed from a magazine to the mechanism of the positive head, or camera head, which is fitted with a dissolving shutter and

223

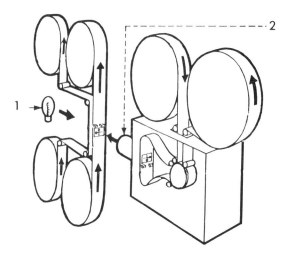

OPTICAL PRINTER
The optical printer consists essentially of the camera head (right) facing the projector head (left) through the copying lens (2), which is separately mounted to give adjustable magnification; light source (1) provides exposure, a variable opening shutter in the camera head giving fade and dissolve effects. Each head may move independently, forward, reverse or stop. Two films are shown in the projector head and sometimes another may be run in contact with the stock in the camera.

stop-frame device. The positions of both the copy lens and the camera head can be altered independently in relation to the projector head along the optical axis and at right angles to it to allow a wide range of enlargement, reduction and image placement. In the more elaborate models the lens and camera head positions can be linked for automatic follow-focus throughout a zoom effect and the lens iris mechanically compensated to give uniform exposure. Such machines also provide a wide range of automatic programmed operations for the more frequently required effects such as fades and dissolves of the standard lengths.

Matte printing

Most optical printers have provisions for running two strips of film in contact in both the projector and camera heads and these allow a further range of photographic effects to be obtained, with mattes. Mattes are lengths of film in which part of the image is completely opaque while the remainder is completely transparent and can be used during a printing operation to reserve an unexposed area on the stock, into which another image can be printed at a second stage. A simple example is the split-screen image technique in which two halves of the frame were photographed at different times. This effect can be done by double exposure in the camera using carefully positioned masks in front of the lens on both exposures. But it is nearly always more convenient to work

224

from two separate negative exposures after processing by double printing in an optical printer with a pair of complementary mattes. Another common example is where coloured letter titles are superimposed on a scene. Here a copy negative is made by double exposure, first with the background scene and a matte in which the lettering is completely opaque. The title area is thus protected from exposure and when the film is run through the printer again the coloured titles can be printed into this area, using a complementary matte with clear letters in an opaque frame to protect the first exposure of the background scene.

Painted matte shots

One widely used type of matte shot combines live action with a painting or model by double exposure rather than using a glass shot when shooting the scene. This is often done in an optical printer in the same way as a split screen shot by using a pair of complementary mattes exactly matching the outline of the painted area, one of which is opaque in this pattern, while the other is clear in the painted area and opaque in the area where the live action is to be shown.

An alternative method is to use a special process camera in which an additional strip of film can be run in contact with the negative being exposed, and photograph the painted scene as its own matte. The image of the live action seen on the original film is used to set up the camera in the correct position relative to the painting and the painted area is photographed on a new piece of negative, the unpainted area being made completely black so that this area is not exposed. The new negative is then wound back and run through the camera

MATTE PRINTING FOR SPLIT SCREEN
 Two separate scenes (1) (2) can be combined by printing with a pair of complementary mattes (3) (4). The use of matte (3) with scene (1) reserves an unexposed area, which is then filled in by printing from scene (2) in combination with matte (4) to give the composite scene (5). The same actor can thus be shown playing two roles.

SUPERIMPOSED LETTERING
A colour letter title (2) can be superimposed on a background scene (1) by printing with a pair of complementary mattes (3) (4). When printing from the background scene the opaque matte (3) reserves the title area unexposed, which is filled in by printing from the title with the title matte (4) to give the final combination (5).

again in contact with a print of the original scene, this time with the painted area unlit and the remainder of the area uniformly illuminated in order to expose only the required part of the original action. In another arrangement both the foreground action and the painting are photographed normally on separate negatives and the process camera is used as an optical printer with external mattes drawn in black on a white background. As in a printer, the film of the live action is run first in contact with new negative stock in the camera which is set up in front of a white board on which all the areas to be replaced by the painting have been blacked out. When the foreground area has been printed in this way the negative stock is rewound and run through the camera again. This time the film of the painted scene is run in contact and the white board is blacked out in all the areas corresponding to the foreground. The same technique can of course combine the parts of any scenes, whether live action or paintings, in which the actors do not move across from one matted area to the next.

Travelling mattes

Where foreground action is to be shown in movement across a moving background a more elaborate technique is necessary involving moving matted areas on the film, which are known as travelling mattes. The effect required is similar to that obtained by back projection, but this more direct process cannot be used if the background scenes to make the projected plate have not been photographed beforehand. Again, the effect required may call for a larger background

area than can be used in projection, or for foreground or background actions which are impossible by direct photography. Essentially the process requires the preparation of two complementary matte films. In one, the outline of the foreground action is shown as an opaque silhouette exactly matching the movement in every frame, while in the other, the action appears as a transparent moving area on an opaque background. The appropriate mattes are used with the film of the separately photographed foreground and background scenes to produce a composite image by double exposure in an optical printer.

This system depends on obtaining a matte of sufficient density in its opaque

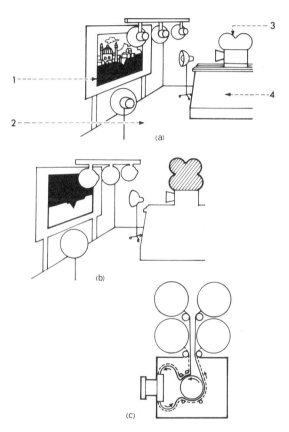

PAINTED MATTE SHOT
(a) The lower part of the artwork (1) representing the area occupied by live action, is matted out in black and the painting is photographed by the camera (3) on a rigid base (4) and floor (2). (b) The artwork is then changed to show the painted area in black and the live action in white and the camera is loaded for bi-pack printing. (c) A master positive print of the live action is now run in contact with the negative for a second exposure illuminated by the white area of the matte board to produce a combined image.

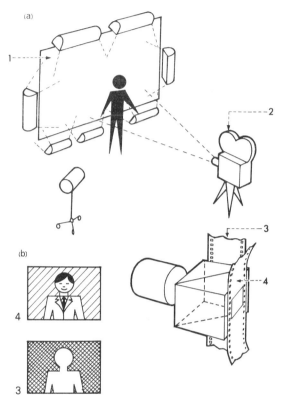

(a)

1

2

(b)

3

4

4

3

TRAVELLING MATTE FOREGROUND PHOTOGRAPHY
(a) In the sodium lamp system the foreground
action is lighted normally and photographed against a flat
screen (1) which is illuminated by deep yellow sodium
light only. The camera (2) uses a beam-splitting prism (b),
to expose two strips of film simultaneously. One film (4)
records the foreground action normally against its yellow
backing, but the other (3) is sensitive to sodium light only
and therefore records the backing only, with the fore-
ground as a clear silhouette.

area which exactly matches every detail of movement in the foreground action,
and two main methods of foreground photography are in use at the present
time. In both, the actors are photographed against a specially illuminated uni-
form background. One process employs a special camera in which two films
are exposed simultaneously through the same lens at two separate apertures
by means of a beam-splitting prism. One of these films is a normal negative
photographing the scene in the usual way but the other film records only the
light used on the backing. For example, the background may be lit with deep
yellow sodium vapour lamps while the actors in the foreground are lit normally.
In the camera one path from the prism is made to transmit only the narrow
spectral band of sodium light and this is recorded on a correspondingly sensi-

tised black and white negative, which thus records only the background behind the actors for each frame of action. In the other gate, or aperture of the camera a normal negative records the full detail of the foreground action seen against a yellow backing. Other variants of the beam-splitting shooting method use infra-red or ultra-violet illumination for the backing, with appropriately sensitive black and white films in one of the camera apertures to record the background light only.

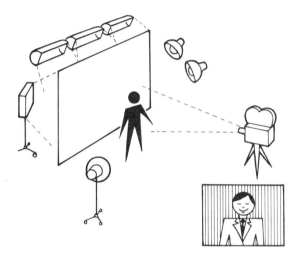

BLUE BACKING PHOTOGRAPHY
 In an alternative system of foreground photography for travelling mattes, the foreground action is photographed against a uniform blue background, often a translucent blue screen illuminated from behind, normal tungsten lighting being used for the foreground. Colour negative is used in a normal camera and the matte prepared by printing with colour filters to obtain an image of the backing area only.

The other widely used process for travelling matte photography does not require a special camera. The foreground action, lit in the normal way with tungsten lamps, is photographed on regular colour negative film against a uniformly pure blue background, which may be either a blue painted backcloth illuminated by arc lamps or a translucent blue screen illuminated from behind. The colour and lighting level of the backing must be such that it produces an exposure of only the blue sensitive layer of the colour negative to a density greater than that of any object in the foreground. A complex series of laboratory printing operations involving special black and white stocks exposed through colour filters is then carried out to produce a foreground matte with an opaque area corresponding exactly to the image of the blue backing recorded on the colour negative. From this a complementary background matte can be made in which the blue backing is shown as clear film with an opaque silhouette of the foreground action.
Combination printing of the components is then carried out on an optical

printer, the image of the foreground action being printed with the foreground matte, which preserves the background area as unexposed. The stock is then exposed again with the background scene using the background matte, which protects the previously exposed foreground image.

TRAVELLING MATTE PRINTING
A clear silhouette matte (3) of the foreground action (1) is obtained either by beam-splitting photography or by laboratory printing operations. From this foreground matte a complementary background matte (4) is prepared, in which the foreground action is an opaque silhouette on a clear background. Printing from the background scene (2) with this matte reserves the foreground area which is filled in by double-printing with the foreground scene and its matte to give the composite scene (5).

Travelling matte processes are a most valuable production tool and can produce outstanding effective results but meticulous attention to detail is essential at all stages of studio and laboratory work. The blue backing must be very uniformly illuminated to the correct level. Blue light from the backing must not be reflected by glossy areas in foreground objects, such as car windshields, glassware or polished furniture. Bright blue objects or costumes in the foreground must also be avoided as they may cause holes in the matte through which unwanted background areas could print. At the laboratory stages exact control in printing exposure and developing conditions must be exercised to obtain well defined edges to the mattes of the correct position and dimension. In some cases deficiencies must be corrected by handwork or by supplementary mattes in an additional path of the optical printer.

Aerial image photography

Aerial image photography combines some of the characteristics of back-projection with those of an optical printer to produce many useful trick effects.

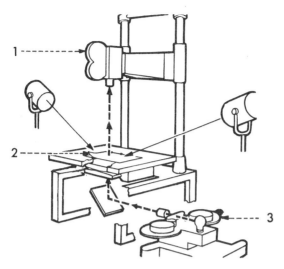

AERIAL IMAGE PHOTOGRAPHY
A projector (3) produces an aerial image in the working plane of the animation stand where it is photographed by the camera (1) in combination with titles or captions on transparent celluloid sheets (2).

particularly for the combining art work such as titles or cartoon figures with action background scenes. The background scene is projected from a print, as for a back-projection plate, but instead of falling on a very large translucent screen, the projector is focused to produce an aerial image in the plane of a condenser lens, where it can be photographed by a correctly aligned camera. This condenser lens can be mounted immediately behind the working surface of a title bench or animation stand and titles or other art work on transparent celluloid sheets suitably illuminated can be photographed at the same time as the background scene. The projector and camera may be operated frame by frame and the painted sheets changed each time to produce animated cartoon action as the foreground image. More elaborate effects, for example those involving split-screen or other changes in the background scene, can be worked out by running opaque mattes with the plate in the projector head and using double exposure in the camera. Aerial image camera stands can produce many effects by direct photography but are not suitable for zoom shots or other changes of image size, since the relative positions of projector, condenser lens and camera must be exactly fixed for each combination of focal lengths.

Electronic special effects

It will have been seen from the preceding section that many optical trick effects require the preparation and combination printing of a number of separate strips of film, which is naturally an expensive and time-consuming operation. Many similar effects can be obtained very elegantly in television by methods involving electronic switching from one image source to another at a preselected position or brightness level and combined results can be viewed at once on a television monitor screen.

231

ELECTRONIC IMAGE COMBINATION

For a superimposed colour letter title effect, the background scene is viewed by one television camera (2), while others view the title outline (black and white) (7) and the coloured pattern (1). The video signal from the title camera is fed as a keying input to the electronic switch (4) to control the points in scanning at which signals from background scene will be changed to signals from the coloured pattern. The resultant combination signal is passed to the video-tape recorder (5), and the effect can be viewed on the television monitor screen (6). When a satisfactory combination has been taped it can be transferred to film. Video signals from telecine machines (3) could be used in place of any of the cameras as the source of picture material.

The possibility of using electronically produced effects for film is therefore being actively studied, the image sources being film, run in two or more telecine units feeding a colour video-tape recorder through the appropriate electronic switches and pattern generators. The resultant effect would be viewed during recording and if necessary the magnetic record erased and remade until

a satisfactory combination of images had been achieved. The finally approved video-tape recording would then be transferred to film by one of the available kinescope methods of tele-recording.

This concept needs no intermediate film processing and printing stages and can display the resultant effect immediately; the source telecine units could even be made to use the original negative images by image inversion circuits. At the present time the line standards of regular television equipment are essentially based on broadcasting transmission practice, which cannot produce an image of sufficiently high resolution for large screen cinema projection, but the development of high definition television systems solely for closed circuit operation would open the way to such electronic printing methods as a film production facility.

Electronic aids to production

Quite apart from the preparation of special effects, electronic technology with television facilities is capable of playing an important part in film production methods, especially with the permanent studio operations. The outline of studio floor production methods discussed earlier shows clearly the complexities of communication which face all members of the production team once shooting starts. The director, lighting cameraman, camera operator, sound recordist, editor and continuity girl are all intensely concerned with the action being played in front of the camera and yet it is not until the exposed negative has been processed and printed that the results can be accurately assessed. It is not surprising therefore that the use of electronic aids to production has been an important subject of study, firstly to provide a more widely available representation of the camera viewpoint by means of closed circuit television, and secondly to allow a rapid playback of the image by means of video-tape recording.

Motion picture production techniques are already being strongly influenced by those developed for television and the adoption of electronic monitors and controls leads to even closer similarities. As noted in a previous chapter, systems are now available which derive a television signal from the image produced by the camera lens, either through a beam-splitting prism or by reflection from the mirror shutter of a reflex camera, and this signal can provide a display on monitor screens of the exact action being recorded on the film to all members of the production team, a view previously restricted to the individual camera operator in his optical viewfinder.

Even with a single camera as many as seven or eight monitors would be in service, of which two are directly attached to the camera and its mounting. One of these occupies the normal viewfinder position on the camera itself and is used by the operator to control the panning and tilting movements when he follows the action, as well as the zoom lens setting and focus. With well designed servo-mechanisms, one-man camera operation is thus possible. A position servo would be used for focus and a rate servo with pre-set position control for zoom adjustment. A second small monitor may also be positioned on the camera dolly or other mobile camera mounting as a guide to the crew operating the camera movements on the floor.

The heart of the production operation is of course the director's monitor which normally incorporates a larger screen placed at a convenient point on the studio floor with the signal processing and power supply unit. At all times the director can see exactly the field of view accepted by the camera lens,

both during rehearsal and at the time of shooting, and can be in direct communication with the camera operator and crew by individual talk-back units, so that composition, lens angle and camera movement are very directly under his immediate control.

The central monitor is also used by the lighting cameraman both to establish the lighting set-up in the scene during rehearsal and to control exposure during shooting by remote control of the lens diaphragm on the camera. As well as showing the whole picture for visual assessment the central unit incorporates a wave-form monitor. This provides a line-scan analysis of the picture elements effectively serving as a spot-brightness meter continuously available for examining any part of the scene in front of the camera. Any line of the television raster can be selected and the brightness variation along that horizontal picture element is reproduced as a cathode ray trace on a small supplementary tube below the main monitor screen, the position of the line selected being shown on the latter as a bright line. The face of the wave-form display tube is calibrated to indicate brightness levels so that the cameraman can easily observe the effective lighting contrast on the set as viewed by the camera in a way which takes into account both the incident key and filler light and the reflectivity of the subject. The desired subject brightness range can therefore be accurately set

(a)

(b)

ELECTRONIC VIEWFINDER OPTICS

In Electronic-Cam (a) and Mitchell System 35 (b), light from the camera lens (1) is reflected by the mirror shutter (2) when it obscures the film (3). This reflected beam is divided between the optical viewfinder system (4) and the Vidicon television camera tube (5). An intermediate ground-glass screen (6) is used in the Mitchell System 35.

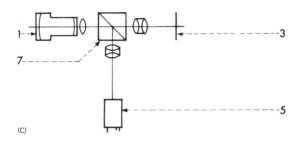

(C)

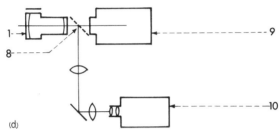

(d)

ELECTRONIC VIEWFINDER OPTICS
With Add-a-Vision (c) a beam-splitting prism (7) before the camera shutter allows the use of a Plumbicon television camera tube (5).

The Gemini system (d) is based on the addition of a complete 16 mm film camera (10) to a standard television camera (9).

during lighting rehearsal in accordance with the dramatic mood required. Exact exposure is also assessed with the wave-form monitor and the camera lens diaphragm operated by remote control. A specified level of brightness on the monitor is chosen as the standard for the whitest object in the scene and the lens diaphragm adjusted from shot to shot, or even if necessary during a shot, to ensure that this white level is maintained throughout the shooting. This results in film exposure giving a consistent negative density for a white object in every shot. Maintaining a uniform exposure throughout a whole production in this way greatly simplifies subsequent grading at the laboratory for rush prints and final copies. The calibration of the monitor display also indicates the minimum brightness level for shadow areas to show satisfactory gradation on the negative. Here again, the lighting cameraman can make use of the wave-form monitor to adjust his lighting contrast and so work safely within the limitations of the photographic materials. The work of the lighting cameraman is naturally at its most constructive stage during lighting rehearsals and at these periods standard reflectivity objects, such as white cards and gray scales, can be introduced into the scene and analysed on the wave-form monitor, while electronically produced brightness and contrast range signals can also be fed in for comparison and calibration.

Supplementary monitors fed from the central signal processing unit may also be employed both on the studio floor and elsewhere to allow all members of the production team to follow closely the direction and photography. It is of great assistance to the sound recordist to be able to see the action in detail as

ELECTRONIC VIEWFINDER ON CAMERA MOUNTING

The electronic viewfinder mounted on the camera itself is used by the operator to control all movements of the camera head to follow the action as well as the lens settings.

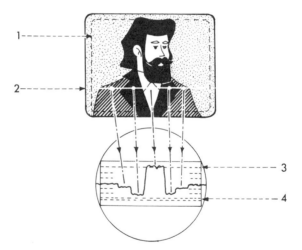

PICTURE ANALYSIS ON THE WAVE-FORM MONITOR

Any line element, 2, of the picture shown on the upper picture monitor screen can be selected and the brightness variation along its length displayed on the wave-form monitor tube shown below. Index marks on this show the standard white level, 3, and the minimum shadow brightness level, 4.

An outline showing the picture area recorded, 1, is also indicated on the picture monitor screen for checking composition.

well as hear the sound being recorded and he can give detailed instructions to the microphone boom operator immediately there is any danger of microphones appearing within the picture area. The work of the continuity girl is also much helped by viewing the action as seen by the camera.

Viewing monitors for the director, lighting cameraman, sound recordist and continuity girl are normally located on the studio floor. But the monitor signal may also be taken to other departments, for instance to the production manager and the editor, who are thus kept in constant first-hand touch with progress in the studio and with the director's requirements.

A further facility, video-tape recording, can provide immediate play-back of both picture and sound over the whole system of monitors. Even for action rehearsals when the film camera is not running it could often be helpful for a video-tape record to be made and played back to check details in the action or timing, or even used subsequently as an aid to editing. But the scene presented on the director's monitor at the time of shooting is usually adequate and it is rarely necessary to waste time on the studio floor in viewing the play-back of actual takes. However, in all such matters the requirements of the individual director are paramount and continuous talk-back communications with all sections are essential to ensure that the necessary information and service is available on demand.

Multi-camera filming

Further development of electronic control methods in the motion picture studio parallels television production in that two or three cameras can be used on the set simultaneously, to film the action as a continuous sequence lasting ten minutes or more. The multiplication of the electronic viewfinder and monitor systems described above for a single camera presents no particular technical problems and facilities for starting and stopping selected cameras from the director's control desk can be readily provided. The greatest difficulties are organisational, since the shooting script must be prepared in meticulous detail for simultaneous multi-camera photography. The lighting plan must be equally well worked out and the actors must be sufficiently rehearsed both in advance and on the floor to make possible the continuous action of a complete sequence. While not going as far as regular television practice, where a complete performance lasting an hour or so may be transmitted live direct from the studio, this all represents a very considerable change from conventional motion picture studio procedure, working scene by scene with detailed rehearsal for each single shot followed by numerous separate takes.

Studio lighting technology must match the multi-camera operations. The continuous shooting of longer sequences calls for considerable camera mobility, even with the variety of camera angle provided by zoom lenses, and neither set construction nor lighting equipment must impede this movement. Studios equipped with lighting grids carrying the majority of lighting units overhead are therefore better suited to apply this technique than those in which most units are floor standing. In a long sequence it is often necessary to alter the lighting during the action in order to provide optimum conditions for each camera angle. So it is most desirable to bring all the lighting controls together to a single console from which these changes can be made as the sequence proceeds. On large sets with much camera movement these alterations can be both frequent and complex so that a pre-set programme unit or 'memory', using punched cards or tape must be adopted. This will record in the required

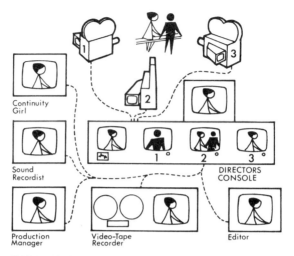

Continuity
Girl

Sound
Recordist

DIRECTORS
CONSOLE

Production
Manager

Video-Tape
Recorder

Editor

ELECTRONIC MONITORING

On the studio floor the action is covered by
three cameras, each with its own electronic viewfinder,
the signals from which are displayed on monitor screens
on the director's console. The cameras are switched on
and off by remote control as the director wishes and the
selected picture at any time is shown on an additional
monitor above. The vision control panel is at the left of
the console and the selected picture may be transmitted
to other members of the production team both on the floor
and elsewhere.

order the detailed lighting arrangements established at rehearsal and bring them
into operation while shooting, in accordance with the lighting cameraman's
instructions.

As in single camera operations, the heart of the control complex is the direc-
tor's monitor, which for multi-camera working is extended into a console where
the director's assistants sit with a separate monitor screen for each camera.
From this control desk each camera can be started and stopped as the direc-
tor decides. Indicator lights on both console and camera show which cameras
are running at any moment, since the view through the camera lens is always
shown on its monitor whether film is being exposed or not. Running-time
clocks and film footage meters are provided on the control desk for each camera
so that the points at which each camera should be brought in can be recorded
during rehearsal and serve as warning cues during the actual take so that cameras
are switched on and brought up to speed a few seconds before their selected
shooting period. The director chooses the output of one camera at a time as the
principal record of the action and this picture is transmitted to the subsidiary
monitors used by other members of the production team. It may also be re-
produced for emphasis on an additional 'picture selected' monitor above the
director's console. The lighting cameraman's monitor with its wave-form display
normally shows the same selected picture but in addition it can be indepen-
dently switched to the output of any other camera if necessary, to make an

advance check of lighting conditions and lens diaphragm setting. This also provides means for matching exposure on the three cameras in use. The video-tape recorder on the other hand, is always fed from the 'selected picture' signal and will therefore record the full sequence in continuity with the changes of camera and angle initially chosen by the director so that it serves as a very exact guide to the editor for the eventual film assembly.

Most multi-camera systems, however, have additional means to identify the film from the preferred camera for each section of the sequence. For example, coded tones of different frequency are allotted to each camera and recorded on a separate cueing sound track according to the director's selection. The point at which the appropriate tone commences on the cueing track is synchronised with an indicator lamp image appearing on the picture negative when the corresponding camera was switched in. The assembly of rush prints can therefore be made very rapidly in a form matching exactly the original selection made by the director and recorded on video-tape, but to allow greater flexibility, parts of the sequence may be photographed on one or both of the other cameras in addition to that first selected. Rush prints of the same action from another angle are therefore available and conventional editing practice is followed in the cutting room.

When fully applied, multi-camera techniques with electronic monitor control can contribute greatly to the output of the studio. The whole action is seen exactly as it is recorded on the film and can be viewed by all members of the production team during rehearsal and photography, and repeated from video-tape if necessary without delay. Longer sequences can be recorded as continuous action, more exact control of lighting effects and consistent exposure is possible and preliminary editing simplified and speeded-up. The use of well designed servo controls for focus and zoom as well as pan and tilt makes possible one-man operation of each camera unit. On the debit side, the emphasis on the use of zoom lenses has been criticised and doubt has been expressed whether even the larger monitor screens are adequate to judge fine details of lighting and action, but the really fundamental problems are those of organisation and preparation. There is no doubt that the techniques can only be applied after extremely detailed preproduction planning and some directors feel that this imposes unacceptable limitations on their creative abilities and prevents the essential close accord with their actors. Lighting cameramen may also feel that lighting techniques suitable for the multi-camera photography of lengthy sequences sacrifice the quality which can be obtained when each set-up is composed and lit individually and that the electronic aids enforce a degree of uniformity in which artistry is lost. However it is certain that these techniques will develop and find more extended application, especially with directors and cameramen equally experienced in both film and pure television studio procedures.

8 Film processing

Throughout the motion picture industry it is the usual practice for all film processing operations to be centred at the laboratory. The equipment and organisation required thus reflect the two somewhat different demands, on one side the more individual and specialised services required by the studio production and on the other, the manufacture of release prints in quantity for general distribution, where mass-production factory methods and automation have their part to play. While the basic operations of developing, printing and film handling are common to both aspects of laboratory work the equipment employed is designed for each particular purpose and considerable variations in size of machine and speed of operation are to be found.

Developing machines

All modern developing machines are designed to pass a continuous length of film through a series of chemical solutions and washes, followed by drying. The drive must provide a uniform movement without imposing undue stresses or tension on the strip and the path of the film must provide a sufficient length of time in each processing solution for the chemical action to take place. In order to make the machine reasonably compact the path usually takes the form of a series of vertical flat spirals of film passing over a series of free-running pulleys or rollers arranged on two sets of horizontal spindles mounted four to six feet apart. These rollers are recessed in the centre so that the film is only in contact with them along its perforated edges, outside the picture and sound track areas. Each spiral frame, known as a rack, is surrounded by the walls of a tank containing the appropriate solution in which the film path is immersed, or, where longer processing times are needed, several racks may be enclosed by one tank. The film passes from one rack to the next above the tank walls over separately mounted pulleys to guide its path.

A basic developing machine thus consists of 1, a feed station, at which the

rolls of exposed film are joined to the end of the strip already running through the machine; 2, the series of racks and tanks to provide the sequence of chemical processes; 3, a dry-box, where the film loses the water it has absorbed in the preceding baths and 4, a take-up station, where the developed film is wound into rolls ready for the next operation. The exposed film must be protected from light at the feed position and during the first part of the processing sequence. This is often done by dividing the length of the machine into two sections by a wall so that the first part is operated as a darkroom with safelight illumination. The second half of the machine including the dry box and take-up can be run

PROCESSING MACHINE RACK

 The film passes in a flat spiral path (1) over a series of rollers which have flanges to keep the film in position and which are recessed in the centre so that they make contact only in the perforation area.

 In some operations, processing solutions may be sprayed on to the film through submerged turbulation tubes (2) forming part of the rack assembly; the film is supported opposite these jets by backing rollers (3).

241

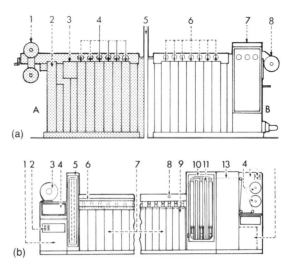

(a) Typical Dark and Light End Developing Machine. A. Dark end. B. Light end. 1. Film feed, alternating between upper and lower spools. 2. Film reservoir. 3. Pre-bath treatment. 4. Six processing tanks. 5. Light wall through which film passes on its way to 6, seven additional processing tanks. 7. Drying cabinet. 8. Take-up spool.

(b) Typical Daylight Developing Machine. 1. Solution pump and valve housing. 2. Flowmeters. 3. Enclosed film magazine. 4. Stapling compartment for attachment of new roll. 5. Film reservoir. 6. Daylight cover for first section of 7, processing tanks; open tanks are used for those after fixing stage. 8. Contact thermometer. 9. Final wash tank. 10. Drying cabinet. 11. Ducting for air jets. 12. Humidity control. 13. Film take-up. 14. Blower and main drive housing.

under normal lighting and is known as the light-end, while the feed station is termed the dark-end.

Many modern developing machines, however, are designed for operation in a lighted room throughout, the first groups of tanks being covered by light-tight hoods and the unexposed film being fed from enclosed magazines, so that only a very short length of film is exposed to the light while a join is made at the end of a roll. Such machines are termed daylight developers.

Reservoirs

In any continuously running machine it must be possible to stop the film movement temporarily at the feed or take-up positions while each new roll is joined on or taken off, without halting the whole machine. This is done by a variable film path known as an elevator, which serves as a reservoir from which or into which film can pass whenever the adjacent position is stationary. Such a reservoir consists of a series of pulleys over which the film passes on two spindles.

One spindle is fixed and the other movable vertically under gravity or spring tension to accommodate varying lengths of film.

At the feed position this reservoir is placed between the feed reel or magazine and the first processing rack. While the machine is running normally, the movable spindle is at its maximum distance from the fixed spindle and the amount of film in the reservoir is at its greatest. If the feed reel is stopped to join on the next roll, the drive of the developing machine continues and takes film out of the reservoir so that the film path is shortened and the movable spindle moves towards the fixed one. As soon as the join has been made, film is fed from the feed roll faster than the machine drive is taking it away, so that the reservoir is filled up again and the movable spindle returns to the position of maximum capacity.

At the other end of the machine the situation is reversed. While the machine is running normally, the take-up reservoir is at its minimum film path position, with the two spindles at their closest. When the take-up reel is temporarily stopped to change a roll, film from the machine feeds into this reservoir and the moving spindle separates to increase the film path and accept it. As soon as the new take-up reel is in position it is run to take away film from the reservoir faster than the machine feeds it in until the normal minimum film path running condition is restored.

ELEVATOR OR RESERVOIR
The distance between the fixed top row of pulleys (2) and the movable lower row (4) can be altered to accommodate varying lengths of film. An elevator is often fitted with alarm signals (1) which operate if the movable rollers reach too high or too low a position, an advance warning (3) being sometimes also fitted.

The time available for a temporary stop at the feed or take-up is obviously limited by the length of film the reservoir can accept between its maximum and minimum positions, and this in its turn depends on the number of film pulleys and the greatest separation of the fixed and moving spindles, which usually

243

cannot exceed six to eight feet. A system of loops on pulley spindles having a traverse of six feet will thus give a reservoir capacity of $2 \times 10 \times 6$ ft, or 120 ft of film, which would allow a pause of up to two minutes on the feed or take-up of a developing machine running at 60 ft a minute.

In its conventional form, the fixed spindle is over the top of the reservoir and the moving spindle rises and falls below it by gravity, hence the name, elevator. But reversed systems are sometimes found with the fixed spindle at the bottom and the moving spindle is above, rising and falling by a spring or counterweight. The elevator movement must not be allowed to exceed its designed limits and warning devices, such as buzzer or alarm bells, are usually fitted to warn the operator that the moving elevator is approaching its end stops. This is particularly important for the feed position in a dark room.

Rack film path

The time available for chemical reactions in each tank of the developing machine is determined by the length of film forming the path over the pulleys in the rack, and the speed at which film is being driven through the machine. Accurate control of processing times is essential, and it is therefore necessary to be able to adjust and fix the length of the path in each rack. This is again done by changing the distance between the upper and lower spindles within the rack framework to lengthen or shorten the film loops. Usually the lower spindle position is altered, and this adjustment is determined by a vertical rod to which the bottom shaft assembly is fixed, or by the effective length of a nylon cord or chain where it is free within the film loop. This loop length variation is normally limited to a range of about 3 : 1, because solution tanks deep enough to give a shaft separation of more than about 2 metres (or 6 ft) are inconvenient. If the loop length is less than about 2 ft the path between pulleys tends to introduce undue tension along one edge of the film because of the short distance in which the lateral shift along the spindle must be made.

It is recognised that this lateral shift from pulley to pulley is always liable to introduce some strain in the film and on some machines this is avoided or reduced by lower pulleys set with their axes at an angle to the line of the top shaft. Such skew pulleys may be assembled as a bank and positioned by a rod like a conventional lower spindle, or each pulley may be independently weighted and allowed to take up its own angle. Those of this latter design are known as diabolo pulleys. Although a skew pulley path reduces strain on the edges of the film running through the developer, this layout introduces mechanical problems in manufacture and maintenance, which has restricted its application.

Film drive by sprockets

While being processed, the film must be driven smoothly and steadily throughout the machine and the simplest method of doing this is by providing rotating sprockets to engage with the perforation holes along the film edge at regular intervals. Such sprockets may be placed where the film passes from one rack to the next, or a sprocket may be fixed to the upper spindle in place of one of the pulleys and the whole shaft rotated by the main drive. Then, the remaining pulleys on the same shaft, although still free on their bearings, are assisted in their rotation and are more easily moved by the passage of the film, which again helps to reduce tension.

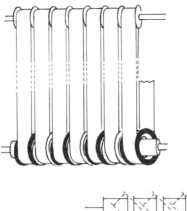

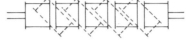

Pulleys with their axes set at an angle to the bearing shaft are sometimes used in a processing machine rack to provide a more uniform path and reduce the strain on the edges of the film.

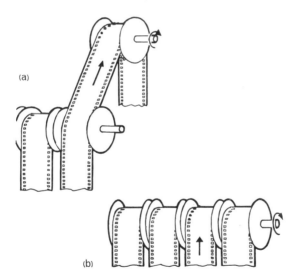

(a)

(b)

Film can be moved through a processing machine by rotating sprockets whose teeth engage the perforation holes. These drive sprockets may be fitted where the film passes from one rack to the next (a) or a sprocket fixed to a driven spindle may form part of the pulley series of a rack (b).

245

A strip of film changes appreciably in length when immersed in water or a processing solution, so the path between two successive sprockets must be flexible enough to take care of this. The lower shaft position is generally allowed to float by a small amount to accommodate such changes, the film being held taut either by the weight of the lower assembly or under spring loading. Too little tension in the loop would allow the film strands to flap loosely and become scratched against one another, while too much tension would strain the film, causing distortions or even breakage.

Friction drive

The film may also be moved through its processing path by friction rollers, which usually take the form of rubber tyres, ribbed or serrated to improve their grip on the wet film. Such drive tyres were originally made to come in contact with the narrow perforated edges of the strip of film but, from 1968, a new type called the soft-touch tyre was introduced. This supports the full width of the film. These tyres have a surface of small domed protrusions moulded in soft synthetic rubber or plastic and provide an excellent driving surface without excessive pressure at any point. All tyre drive systems have the advantage over sprockets that they can handle different forms of perforated film on the same path without mechanical alteration. Where soft-touch tyres are fitted to all film pulleys instead of the normal recessed rollers the same processing machine can be used for any width of film, however perforated, which is a very considerable operating advantage to the commercial laboratory dealing with various print formats.

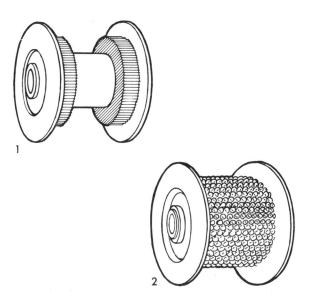

FRICTION DRIVE
The film may also be driven by ribbed rollers or tyres (1) or by moulded "soft-touch" rollers (2).

246

Although the majority of processing machines are constructed with the drive produced by the rotating upper spindle of each rack, there are some successful designs in which all the rollers on the top shaft are free-running and the drive comes from friction rollers on the bottom spindle. This has an advantage in that it provides a degree of automatic tension correction throughout the film path. But it involves considerable complications in transmitting the mechanical drive to a spindle which must, of course, be completely immersed in the solution at the bottom of the tank. In this arrangement the bottom shaft must be in a fixed position and alterations to loop length are provided by lowering the upper pulley spindle, sometimes by rotating a vertical screwed rod carrying the spindle mounting on a threaded collar. Bottom shaft drive machines are therefore mechanically complex and relatively expensive.

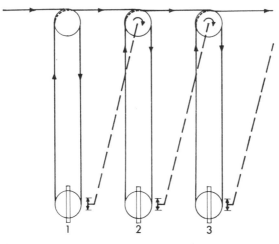

PRINCIPLE OF TENDENCY DRIVE
Small movements in the position of the lower pulley assembly of one film rack are made to control the drive speed of the rack following. Thus, if the length of film in Rack 1 increases, the lower spindle moves downward and this is made to increase the drive speed of Rack 2. Film is now pulled out of Rack 1 more rapidly so that the lower spindle rises and the speed of Rack 2 is reduced until equilibrium is obtained.

Principle of tendency drive

In all processing machines the changes of film length with wetting and drying and the tension caused not only by the weight of the submerged roller assemblies or their spring loading but also by the friction of all pulleys on their bearings can give rise to varying stresses to the film strands, which may be too slack at one point in the path and much too tight at another. In many modern machines these dangerous variations are corrected by a tendency drive system which automatically ensures constant film-loop size in each rack and hence evens out varying tensions in the film path.

Several methods are in use, but all rely on the principle of controlling the drive speed of each rack independently in accordance with the tension of the film in the preceding rack. Tension is assessed by the variations in separation, within quite small limits, between the fixed and movable spindles of each rack unit. Thus, if the film in the first tank of a processing machine is too loose, the distance between the two spindles increases to take up the slack, and this movement is made to speed up the drive of the following rack. This has the effect of taking film away from the preceding loops more rapidly than it is fed in so that the film path is shortened and the slack taken away. The movable spindle is thus pulled towards the fixed spindle once more, and as it reaches its correct position restores the drive speed of the following rack. Similarly, excessive tension producing too short a loop in one rack will slow the speed of the following drive so that film is not removed so rapidly from the preceding one. The extra film allows the loops to come to their normal required tension and the drive speeds become equal once more. In practice, a steady condition of balance for each rack throughout the path is very quickly achieved once the machine has been initially set up, and variations of drive friction and pulley conditions are then compensated automatically.

Tendency drive mechanisms

Several different methods of feed-back from one rack to the next are in use. In one well-known system the top shafts of all racks are driven by a long endless V-belt in contact with a grooved pulley on the end of each shaft, the speed at which the shaft rotates being determined by the pressure between the belt and its pulley. A vertical rod connected to the movable lower shaft of each rack operates a linkage of levers and controls the pressure between the drive belt and the grooved pulley of the following rack, so that a rise of the lower

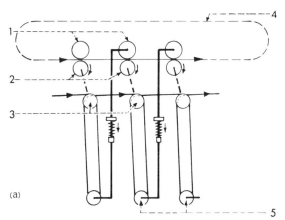

(a)

TENDENCY DRIVE MECHANISMS
(a) The upper shaft of each rack (3) is driven by a pulley (2) from an endless belt (4) which tends to over-drive. Contact rolls (1) controlled by the position of the lower shaft of the preceding rack (5) maintain pressure between pulley and belt. If any lower shaft falls, the drive of the following shaft is increased to take up the slack, and vice versa.

248

shaft reduces the drive pressure, and vice versa. In this way the rate at which film is taken away from each rack is automatically adjusted until uniform loop lengths and stable tensions are established.

In another design, each top drive shaft in the series of racks is driven by an individual electric motor, the speed of which is controlled through a rheostat

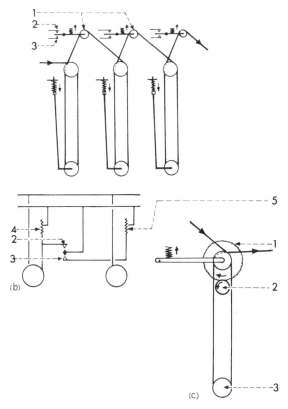

TENDENCY DRIVE MECHANISMS
(b) Each upper shaft is driven by a separate torque motor whose speed is controlled by the movement of the spring loaded pulley (1) in the path from rack to rack. If the tension in a rack is too small, the following pulley rises and makes the lower contact (3) which increases the motor speed of the following drive shaft by shorting out the resistance (5). Too much tension in a rack causes the pulley to move downwards so that the upper contact (2) is made to speed up the preceding motor by cutting out the resistance (4). (c) Each upper pulley of a rack is spring loaded or weighted and has a serrated rim (1) rotated by contact with a rubber-coated drive roll (2), which has a tendency to overdrive. The lower shaft (3) of the rack is fixed. Slack in the film path allows the upper pulley to rise out of contact with its drive shaft and slow down until the slack is taken up.

by the linkage arm from the lower shaft of the preceding rack. Tendency drive systems of both forms may be used either with sprockets or with friction drive tyres, but in modern machines the versatile tyres are more usual.

A further variation of the tendency drive system divides the tension balancing device still further so that each individual pulley is driven faster or slower according to the tension on the preceding strand. In this arrangement each pulley of the upper series has a friction drive tyre and is carried on a separate arm, counterbalanced by a weight on an opposing lever which provides the standard amount of tension on the film strand. Drive is applied by bringing the serrated rim of each pulley into contact with a rotating rubber-covered shaft positioned just below. The speed of the pulley is determined by the contact pressure between this shaft at its rim. When the film loop is too short, the excess tension pulls the rim more strongly to the drive shaft and the pulley is speeded up to put more film in the loop. Conversely, too long a loop allows the counterweight to lift the pulley away from the shaft which removes the drive until the loop position is rebalanced. Film tension and loop length is thus made uniform not only from rack to rack throughout the machine but also from one loop to the next on each rack.

Rack frameworks

All tendency drive machines in which the movement of one shaft relative to another is a critical control require the accurate mounting of both shifts within one rigid framework and this often makes access to the lower pulley assembly difficult for film threading and for servicing. Arrangements are therefore often made for the whole rack-frame, including the upper shaft and its drive, to be lifted bodily out of the tank by a hydraulic ram or by a lifting tackle with counterweights, even though this calls for considerable headroom above the normal machine operating space. In another design with bottom drive the two shafts are left in position and three walls of the tank surrounding each rack are removed for access. The drawback here however, is that the solution must be drained from the rack in question before the film path can be exposed.

Drying cabinets

After the film has passed through the whole sequence of processing solution and wash waters in the machine tanks it enters the dry boxes or drying cabinets where the moisture absorbed by both the emulsion and film base is removed. The rate at which water is lost from these two layers differs considerably. At first, the base dries the more rapidly, so the film strand takes a convex appearance with the emulsion layer outwards. Subsequently, loss of water from the emulsion causes it to shrink and the curvature of the strand is reversed, but excessive drying causing serious curling or cupping must be avoided. At the same time expansion of the film in the wet processing solutions is reversed and the film shrinks considerably in length as it dries. The film path through the drying cabinets is particularly critical, to avoid excessive tensions and undue stresses. The film drive system used for the wet tanks is usually continued throughout the drying cabinets but skewed pulleys are sometimes used to avoid strains even where they were not fitted to the submerged paths. Access to bottom and top roller assemblies is normally by doors at the side of the cabinets, so that lifting rack frames are not required. The last rack position is often used as the space for the reservoir immediately preceding the take-up reel,

FILM CURVATURE ON DRYING

Film which has been thoroughly immersed is normally flat (1) as it enters the drying cabinet. At first, water is evaporated more rapidly from the base than from the emulsion (2) but as drying proceeds, the emulsion shrinks and the curvature is reversed (3). After drying, the film can be conditioned to equilibrium at normal temperature and humidity and is then flat once more (4).

IMPINGEMENT DRYING

Efficient drying cabinets may be fitted with hot air distribution boxes which direct air jets at the emulsion surface of the film on the racks through a series of small holes.

251

and is normally operated at its minimum film capacity except when this reel is stopped.

Drying cabinets must always be fed with a supply of clean dry air to remove the moisture from the film and there should be accurate temperature and humidity control. This air may be circulated from one end of the series of dry boxes to the other by ducts at a sufficient velocity to dry the film in the available time but a more efficient system is to blow the air at the film strands through a number of small holes, giving a high air velocity locally at the film surface. This is known as impingement drying, and is widely used in modern processing machines as its greater efficiency allows more compact cabinets to be constructed with shorter film paths.

Processing sequence

The series of steps through which a film must pass on a processing machine differs greatly according to the type of material, and machines are usually constructed with a specific type of film and a particular level of output in mind. The sequence for black and white films is a simple one:

Developer
Stop bath and wash
Fixer
Wash
Drying

Developing times at the normal temperature of 70°F (21°C) are usually within the range of 5 to 10 minutes and the stop bath and wash is about one minute. Fixing is usually complete in five minutes and six to eight minutes will be provided for washing. A normal black and white processing machine thus consists of only four groups of solution tanks, with an overall wet process period of 20 to 25 minutes.

With colour negative and positive stocks the process sequence is more complex. Most colour materials carry an anti-halation backing on the base and this must first of all be removed, usually by a solution which softens it and allows it to be mechanically scrubbed away. The particles from this operation must be thoroughly rinsed off so that they do not adhere to the film surface. Colour developing times are comparatively long, 12 to 14 minutes, and the usual stop bath and fixing operations must be followed by chemical bleaching and fixing to remove the silver of the developed image before the film can be finally washed and dried. The total colour processing sequence may therefore involve twelve separate stages and a total immersed time of 50 minutes or so. With colour positive material, these times can be substantially shortened by using slightly raised solution temperatures 24° or 27°C (75° or 80°F) although this is not recommended practice for negative materials.

With reversal materials, the processing sequence is always more complex, even with black and white stocks, since a bleaching operation is necessary to remove the negative image formed in the first developer, and a second development is needed to produce the final positive image. Reversal processing machines therefore involve more processing stages. This would normally mean a longer overall processing time but with recent colour reversal materials this has been offset by substantially increased solution temperatures, up to 100–110°F (38–43°C). Such temperatures would cause considerable softening of the

TYPICAL COLOUR NEGATIVE AND POSITIVE
PROCESSING SEQUENCES

	Negative	Positive		
	at 70°F 21°C	at 70°F 21°C	at 75°F 24°C	at 80°F 27°C
Pre-bath	10 sec	10 sec	10 sec	10 sec
Spray rinse	15 sec	15 sec	15 sec	15 sec
Colour developer	12 min	14 min	8 min	5 min 20 secs
Spray rinse	15 sec	15 sec	15 sec	15 sec
First fix	4 min	4 min	1 min 45 secs	1 min
Wash	4 min	4 min	1 min	40 sec
Bleach	8 min	8 min	6 min	4 min
Wash	4 min	(2) 2 min	2 min	1 min
Second fix	4 min²	4 min	2 min	2 min
Wash	7 min	8 min	6 min	5 min
Stabilizer(1)	1 min	10 sec	10 sec	10 sec
Total wet processing time	45 min	45 mins	28 mins	20 mins

(1) The negative process may finish with a brief rinse and the application of a wetting agent before entering the drying cabinets.

(2) For positive prints with sound tracks a developer is applied as a stripe to the track area and followed by a water wash at this point.

gelatin emulsion layers and a preliminary hardening bath is necessary at the start of the wet processes to avoid this.

Solution systems

The maintenance of a uniform and consistent photographic process demands careful control of both the physical and chemical condition of the solutions applied to the film in the machine tanks. The time for each stage in the process is determined by the length of film in each tank motion and the speed at which film is run through the machine. In black and white film processing it is often necessary to alter the development time by adjusting the racks to accommodate different film lengths and also by altering the machine speed. But in processing colour negative and positive it is usual to work at standard processing times for each solution. In all cases the time in the developing bath should be accurate to within ±2% although other solutions are less critical.

Accurate temperature control is equally vital. Colour developer baths should be maintained to ±0.1°C (±¼°F) but other solutions are again less critical and tolerances of ±1°C (±2°F) can be accepted. In general terms, a rise of temperature increases the activity of any solution and has a similar photographic effect to an increase in processing time in that solution.

The way the solution is circulated in the tanks is also significant. Normal reactions which take place may cause local depletion of the constituent chemicals and unless fresh solution is constantly brought into contact with the film surface and the reaction by-products removed image development may be irregular and show streaks or blotches. This is most critical with the developer

TYPICAL REVERSAL PROCESSING SEQUENCE

Black & White

	68°F / 20°C	95°F / 35°C
First developer	2 min	40 sec
Wash	1 min	20 sec
Bleach	2 min	50 sec
Wash	1 min	20 sec
Clear	1 min	20 sec
(Re-exposure)		
Second developer	1 min	20 sec
Wash	1 min	20 sec
Fix	1 min	20 sec
Wash	4 min	1 min
Total wet processing time	14 min	4 min 30 sec

Colour

	75°–80°F / 24°–27°C	100°–110°F / 38°–43°C
Pre-hardener	—	2 min 30 sec
Neutraliser	—	30 sec
First Developer	6 min	3 min 15 sec
First Stop Bath	45 sec	30 sec
Wash	45 sec	30 sec
Colour developer	10 min	3 min 30 sec
Second Stop Bath	45 sec	30 sec
Wash	45 sec	1 min
Bleach	1 min 30 sec	1 min 30 sec
Fix	1 min 30 sec	1 min 30 sec
Wash	2 min 30 sec	1 min
Stabiliser	45 sec	30 sec
Total wet processing time	25 min 15 sec	16 min 45 sec

(b)

(a)

(c)

(d)

SOLUTION CIRCULATION SYSTEMS

(a) A processing solution is supplied to the bottom of the machine tank (1) from the bulk circulation tank (7) by the pump (8) through filter (4) and temperature control (3). The solution normally returns by overflowing from the top of the machine tank but the latter can be emptied completely when required by the drain valve (2). Replenisher solution is supplied to the system from the boost tank (5) through the flow control (6). (b) Additional solution agitation over the surface of the film can be provided by a separate turbulation pump (2) and tubes (1). (c) The main circulation pump can be connected to the turbulation tubes (1). In this case a branch valve (2) can be used to fill up the machine tank rapidly when starting operations. (d) Some processing installations have no bulk circulation system: the solution in the machine tank (5) is circulated by the turbulation pump (2) through filter and temperature control to the turbulation tubes (3). Replenisher solution is fed direct from the boost tank (1) to the machine tank and the excess volume overflows continuously to waste (4).

255

solution, but in all the others, including the wash waters, vigorous agitation is necessary for uniform processing. This is normally provided for by rapidly circulating the solution within the tank. In the more critical cases additional turbulation is provided by rows of submerged jets through which the solution is directed under pressure at the surface of the passing film. These jets actively break up any layers of by-products which might otherwise be carried along with the film, and ensures its contact with frequently replaced fresh liquid.

In some machines washing may be carried out by cascade jets directed to the top of the film strands so that water runs down the film surface in an open tank. This arrangement can be economical in the use of water and simplifies tank construction, but becomes ineffective with fast-running machines. In many cases, however, wash waters are applied under pressure as sprays through jets in open tanks rather than submerged below the surface of the liquid. This is particularly important where the contaminated wash water must be rapidly removed from the film, as in backing removal.

Replenishment

The chemical consistency of the processing solutions must be maintained by a carefully controlled system of replenishment, often known as 'boosting', to replace those components which are altered by chemical reactions and where necessary to provide for the removal of any by-products. Replenisher solutions, usually differing from the main solution formula in concentration and the proportion of chemical components, are therefore fed in at various steps in the process and used solutions are bled-off to maintain correct volume. In many large laboratories solutions are fed to the tanks from large central circulation containers to which replenishers are added as required, the total bulk of each solution in use being considerably greater than the volume in the machine tank itself. But with the increasing use of complex colour processing sequences, requiring many different solutions, there is a marked tendency to work with the solution volume in the machine tank only and to add the replenisher direct to this, usually at a rate proportional to the amount of the film being processed.

The most critical solution in the processing sequence is always the developer itself, whether for black and white or colour image formation, and chemical control must be accurately maintained. In determining the replenishment formulation and rate there are two main factors to be considered:

First, the active developing agents are destroyed by the formation of the photographic image, normally involving their oxidation, and this destruction may be further accentuated by aerial oxidation at the surface of the solution or during its circulation. Undue accumulation of the products of such oxidation can have very undesirable effects in the process, causing stains and incorrect image formation.

Secondly, the chemical reactions of development liberate halides, usually bromide and iodide, from the film emulsion and the accumulation of these ions in the solution can exert a considerable restraining effect on the action of the developing agents. The replenisher formulation must therefore replace the developing agents used up and dilute the released halides to an acceptable level. Differences in photographic processes and machine conditions mean that details of a replenishment system must be worked out empirically for each case, but the following shows typical comparisons between the original developer formula and the replenisher formula which was required:

COMPARISON OF ORIGINAL DEVELOPER AND
REPLENISHER FORMULAE

Black and White Negative

	Original	Replenisher
Metol	1·5 gr	2 gr
Sodium sulphite (anh.)	75 gr	80 gr
Hydroquinone	1·5 gr	2 gr
Potassium bromide	0·4 gr	—
Borax	4·5 gr	5 gr
Water to make	1 litre	1 litre

The replenisher contains a greater concentration of the developing agents, metol and hydroquinone, but no bromide.

Colour Positive

	Original	Replenisher
Calgon	2·0 gr	2·0 gr
Sodium sulphite (anh.)	4·0 gr	5·2 gr
CD2	3·0 gr	7·8 gr
Sodium carbonate	20·0 gr	20·8 gr
Potassium bromide	2·0 gr	1·3 gr
Water to make	1 litre	1 litre

Here again the replenisher contains a much greater concentration of the developing agent CD2 and much reduced bromide.

Much of the processing control work which has to be carried out by the technical laboratory staff is concerned with establishing and maintaining satisfactory replenishment of processing solutions. Chemical analyses of the solution components are constantly co-related with the effects appearing in the photographic image so that consistent results are obtained.

Reduction of solution carry-over

In a continuous processing machine the amount of liquid carried over by the passage of the film from one tank to the next may be quite substantial, partially with fast running machines, and may cause contamination in one bath by the contents of the preceding one. Therefore, as much liquid as possible must be removed from the surface of the film as it passes out of each tank, and wipers known as squeegees, or compressed air jets are frequently employed at this purpose. Fixed wiper blades of rubber or plastic are simple and effective but may cause scratches if not carefully maintained. In some cases vacuum suction may be connected to the wiper unit to take away the removed liquid. Another form of squeegee is a soft rubber roll bearing firmly on the surface of the film where it is supported by a hard roller so that liquid is squeezed off the

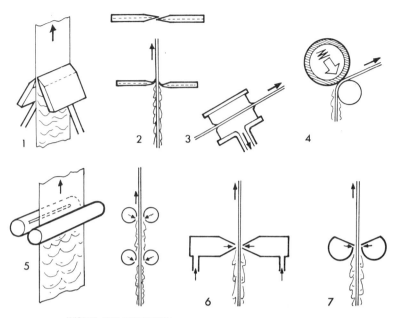

Excess liquid can be removed from the moving strand of film in a processing machine by rubber or plastic wiper blades (1), (2), which sometimes are placed at the end of a vacuum enclosure (3) to take away the liquid. Another method is the soft squeegee roll (4) bearing against the film on a hard supporting roll.

Air knives or blow-offs for the same purpose can take various forms, the simplest being the slotted tube (5) connected to a compressed air supply. Plenum chambers (6) (7) are sometimes used to provide uniform distribution of pressure.

surface. Squeegees are generally effective at lower processing machine speeds, up to about 25 metres per minute, but at higher speeds the air knife, or blow off, can be more satisfactory, particularly in removing liquid from the perforation holes. Compressed air is directed through narrow slits against each side of the passing film which is supported by rollers at this point so that it cannot come into contact with the jet surface. Efficient air knives require a considerable volume of air from large compressors and produce a spray of solution droplets which must be suitably ventilated from the working area.

Spray and viscous processing

Although the majority of professional processing machines employ solution tanks through which the film passes by immersion, two other forms of solution application are also to be found. In spray processing the solution is applied

from jets in an enclosed cabinet in fine droplets direct to the surface of the film. Solution turbulation and circulation is not necessary, as the film is being constantly sprayed with new solution and very efficient use of chemicals can be obtained. Excessive oxidation of developer solutions can be avoided with tightly sealed enclosures but although quite practical for black and white film processing, spray processing machines have not been widely adopted for colour operations.

In viscous processing the appropriate chemical solutions are applied to the emulsion surface of the film as a thin uniform layer of a viscous liquid, each layer being removed by a water jet after the necessary reaction time, before the next solution is applied. In this system also the conventional solution tanks are replaced by much simpler enclosed cabinets in which the temperature is accurately maintained at a high humidity level. No solution circulation or tubulation systems are required and since fresh viscous solution is used for every unit area of film there are no replenishment problems. Chemical usage is strictly proportional to the amount of work processed and changes from one set of solutions to another for different film materials on the same machine can be simply and rapidly effected. It is also claimed that viscous processing gives rise to photographic images of improved definition compared with conventional methods.

Viscous processing has been satisfactorily established for black and white films, particularly in small self-contained machines outside major laboratory organisations. But colour film picture images are not yet regularly handled in this way. However, viscous development of the sound track area forms an essential feature of colour positive print processing, because this area must be treated separately from that of the printed picture. A viscous solution can be applied in the form of a narrow stripe over the sound track without affecting the remaining area and is removed by water jets after the necessary reaction time before continuing with the rest of the process through conventional solution tanks and submerged film paths.

Printing machines

The second group of operations fundamental to film processing at the laboratory are those concerned with printing.

All printing machines consist basically of means for moving the processed original and the unexposed stock on to which it is to be copied, together, past an illuminated aperture at which the intensity and colour of light can be accurately varied to produce the required exposure. This operation is the same whether a positive print is being made from an exposed camera negative or from a reversal original. However it is convenient to divide printers into two types according to the way they move the film. These are either continuous printers, where both the original and printing stock are moved at uniform speed, or intermittent printers in which the two strips are moved one frame at a time and held stationary for the period of exposure. It is also important to define how the stock is exposed, either in contact with the original strip, or by optical projection in which an image of the original is formed on the print stock by a copying lens. Each type has its own field of application. Continuous contact printers are normally employed for the rapid manufacture of release copies in large numbers, while intermittent printers, both optical and contact, are particularly applied to preparatory work.

CONTINUOUS CONTACT PRINTER

Film from the feed reels of the picture negative (7) and the positive stock (1) are brought together at the feed sprocket (8). After passing over tensioning rolls (9) they meet the main sprocket (13) and are exposed at the aperture, pressure being applied by the spring-loaded roller (14). Light to the printing aperture comes from the lamp (11) with its blower-fan (12) through the light-change mechanism (10). After printing the two films are separated at the take-up sprocket (15) and the picture negative is wound up on its take-up reel (16). The stock now meets the sound track negative (6) at the feed sprocket (3) and both films pass over tensioning rolls to the track printing sprocket (4) to print the sound record on the film. After exposure the printed stock and track negative pass to their respective take-up reels (2) (5).

Continuous printers

The film paths of the simplest form of continuous contact printer lead the print stock and the original negative from their respective feed reels on to a drive sprocket whose teeth engage with the perforation holes of both films together and move the two in contact, emulsion to emulsion, past an exposure aperture, after which they separate and pass to individual reels for winding up. The movement of the films must be absolutely uniform to avoid irregular printing and intimate contact between the two must be maintained.

It is usual for exposure to be made while the films are actually in contact on the sprocket, the fixed printing aperture lying between the rotating sprocket flanges which carry the teeth and being illuminated from within. The sprocket must be large enough to permit this – a four inch diameter diameter is usual, with 64 teeth for 35 mm and 40 teeth for 16 mm film. The sprocket tooth is carefully designed to provide a smooth uniform drive to the films and lightly weighted rollers are provided in each film path to give constant tension.

Continuous contact printers can run at high speeds, up to several hundred feet a minute, and are therefore well suited for the bulk production of release prints. When copies are made from separate picture and track negatives, two exposing positions, or heads are provided in tandem, so that picture and sound images may be printed at a single pass of the positive raw stock. To avoid the labour of re-winding negative rolls between each printing one of two positions on each printing aperture can be selected for running film head first or tail first, alternately. Continuous printing operations are usually carried out in a dark room with only safelight illumination.

Intermittent printers

In an intermittent or step printer the two films, negative and positive, are held stationary while each frame is exposed after which the exposing light is cut off by a shutter. The two films are then moved by one frame bringing the next image into position for printing. The process is therefore very similar to that of a cine camera.

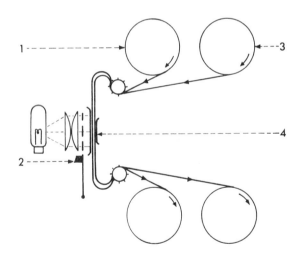

INTERMITTENT CONTACT PRINTER
The negative (1) and print stock (3) are brought together at the feed sprocket and exposed frame by frame at the gate (4) to the light from the lamp and optical system. At the time of exposure the two films are accurately located by a register pin mechanism; a shutter (2) cuts off the light from the films while they are moved from one frame position to the next.

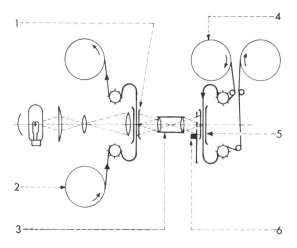

OPTICAL PRINTER

The negative (2) passes frame by frame through an intermittent mechanism with register pins at the gate (1) where it is illuminated by the lamp and optical system. The copy lens (3) forms an image of the negative frame on the positive stock (4) passing through a synchronised intermittent gate (5), a shutter (6) obscuring the exposure while the films are in motion from one frame to the next.

Step printers are made for both contact and optical printing work. In a typical intermittent contact printer the negative film and the unexposed positive raw stock are brought together, emulsion to emulsion, on to a continuously running feed sprocket which pulls the film off the reels. At the printing aperture, or gate, the two films are moved together by the reciprocating action of a shuttle mechanism between the periods when the rotating shutter opens to give the exposure. In precision step printers the two films are also very exactly positioned in the aperture by closely-fitting register pins which engage in chosen perforation holes of the two films in the gate. When the shutter has closed after the exposure of each image the claw or shuttle moves the films one frame and the operation is repeated. The two films then pass over a second continuously moving sprocket to their separate take-up reels. As in a camera, loops formed in the paths above and below the gate absorb film from and to the sprockets during the stationary period of exposure.

In an intermittent optical printer the same sequence of operations is followed, but the negative and positive films follow individual paths through separate but synchronised intermittent mechanisms and the copying lens produces an image of the negative on the surface of the positive stock during the stationary period when the shutter is open. The positive stock must of course travel in the opposite direction to that of the negative to allow for the optical inversion of the image through the copy lens. The whole optical system must be carefully designed to provide uniform illumination at the printing aperture and a high standard of projected image quality at the positive plane. Copying lenses are usually specially computed for each particular requirement and they differ from normal cinematograph camera and projector lenses in that they are usually of

low magnification with both the object and image planes comparatively close together. The lamphouse optical system is often complex, involving reflector, condenser, relay and aperture lenses and must be matched to the acceptance angle of the copying lens for greatest efficiency. These printers are discussed further on page 281.

Wet printing

The specular illumination used in optical printing tends to emphasise the presence of dirt, scratches and physical abrasions on the surfaces of the negative film. The objectionable appearance of surface defects can be greatly reduced by coating the negative with a lacquer of similar refractive index to the film base or emulsion, or by coating with a suitable liquid to provide a temporary surface layer at the time of exposure. A number of volatile organic solvents can be used for this purpose and the film may either be dipped into the liquid on its path to the aperture so that a smooth layer is formed on each face by surface tension, or it may be contained in a cell of liquid between glass plates forming the aperture enclosure. After the exposure cycle the liquid is removed from the surfaces of the film by air squeegees and the film is dried. The complete operation is known as wet printing and by its use very severe scratches on both base and emulsion sides of the film can be rendered almost imperceptible, provided that the photographic image on the negative has not been disturbed.

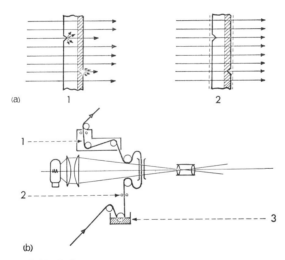

WET PRINTING

(a) Scratches and abrasions on the surfaces of the film cause light to be scattered (1) and are very obvious on optical printing. Coating the film with a thin transparent layer of lacquer or a suitable liquid (2) substantially reduces their appearance. (b) In wet printing the liquid can be applied to the negative film as it passes through a dip tank (3); air jets (2) remove excess liquid so that the film is evenly coated when it reaches the printing aperture. The film is dried in the dry box (1) before passing to the take-up reel.

263

Exposure control in printing

In all film printing operations it is essential to provide some means of regulating the exposure intensity to correct for variations in negative image density from one scene to another. For printing colour materials it is also necessary to alter the colour of the exposing light to compensate for differences between negatives or to provide the colour effect required. As quite large changes of exposure may be required between successive scenes in an assembled negative the required exposure alterations must be made extremely rapidly. The ideal is, of course an instantaneous change.

In grading the negative for printing, a series of exposure increments of known value must be available so that the effect of selected values may be estimated. In general photography, equal increments of print density are produced by logarithmic increments of exposure. The steps, or light points, in a film printer are therefore arranged to give logarithmic increments of light intensity and it was for many years a regular practice to provide a series of 21 steps increasing in steps of 0·05 log exposure intensity. This series was termed the printer scale. However, in due course the step of 0·05 log E was considered too large for satisfactory grading and a smaller interval was employed, usually steps of 0·025 Log E value. In some machines the original scale of 21 steps was retained with 'half-point' intermediate value, but with modern equipment it is now more usual to use a scale of 0 to 44 or 0 to 50 in steps of 0·025 Log E.

Light change methods

The light source most generally used in printing machines is an incandescent tungsten filament lamp, if possible run at a lower voltage than its manufactured rating to ensure stability and long life. Mercury vapour arc lamps are sometimes used for printing sound tracks on black and white film where a high output of ultra-violet radiation is required.

Although the light intensity from a tungsten lamp can be controlled by voltage adjustment, this method is not rapid enough for scene-to-scene changes at high printing speeds and can introduce an unwanted colour shift from the changes in colour temperature of the lamp. It is now normal practice to run the printer lamp at a fixed voltage and to modulate intensity by controlling the area through which the beam of light passes. One such system uses circular holes of varying diameter punched in a strip of opaque material which is moved as required into the light beam by a rapid advance mechanism. This control strip, which may be a heavy black paper 35 mm wide punched with holes up to 20 mm in diameter, provides a convenient programme of the various light values for a particular roll of negative, which may be used whenever the subject is printed.

Another widely used method of light modulation is the light valve. Here a slit of variable width is formed by the edges of a pair of rotating vanes suitably placed between condenser lenses within the optical system of the printer. The opening of the slit is accurately controlled to provide steps corresponding to 0·025 log exposure increments and is electrically operated either from a control knob setting or, more usually, from coded holes punched into a control tape specially prepared for the particular film to be printed. The moving vanes in a modern light valve are small and so rapid in operation that a change of intensity can be made in as little as 5 milliseconds, thus permitting satisfactory light changes even on high speed printers.

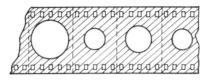

(a)

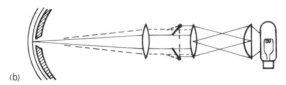

(b)

LIGHT CHANGE SYSTEMS
The intensity of the printing light at the aperture
of a continuous printer can be varied by (a) the diameter
of the hole punched in an opaque paper control band or
(b) the opening of a pair of shutters in a light valve.

Colour modulation

When printing colour film not only the intensity of the light but also its colour
must be changed from one scene to the next. Two different procedures are in use
based on either subtractive or additive methods of colour mixture.

In the subtractive system, the colour of the exposing light is altered by
inserting a colour filter, which absorbs ('subtracts') the unwanted colour
components. A blue-green filter absorbs red light and so reduces the exposure
of the red sensitive layer in the colour positive film. The change of log exposure
resulting from this absorption can be given as the density of the filter to red
light, and the printing effect of any filter can thus be assessed by colour
densitometry.

In practice, standard colour filters, usually of thin gelatine, are manufactured
to have specific colour density values within close limits. These colour correc-
tion filters are made in the three primary colours, red, green and blue, and the
three secondaries cyan (blue-green), magenta (red-purple) and yellow, with
specific density values in a series 0·025, 0·05, 0·10, 0·20, 0·40, which refer to

265

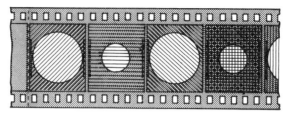

(a)

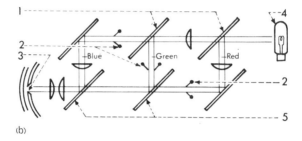

(b)

LIGHT CHANGES FOR COLOUR PRINTERS
(a) In subtractive methods coloured gelatine filters are attached to the punched opaque paper strip which controls the light intensity. (b) In an additive printer system light from the lamp (4) is divided by dichroic reflectors (1) into separate red, green and blue beams, which are individually controlled in intensity by the light valve shutters (2). Further dichroic reflectors (5) re-combine the three beams so as to expose the film at the printing aperture (3) with the required mixture of red, green and blue components.

their densities to complementary colours. Thus a filter specified as 0·10 Green (or briefly 10G) would have a density of 0·10 to both red and blue light and negligible density to green light. By the combination of a number of these standard gelatine filters a 'pack' of exactly the required absorption can be put together and used in conjunction with other methods of light intensity modulation. For example, the filter packs may be attached to a control band strip by clips or staples, so that for each punched diaphragm hole there is also a selected group of colour filters.

The additive system relies on mixing carefully controlled intensities of red, green and blue light to provide a correct balance in the exposure. Modern additive colour printing machines have optical systems with dichroic filters which permit the red, green and blue components of the light from a single lamp to be efficiently sub-divided by reflection and transmission at the filter surfaces. Three light valves situated in each individual colour beam allow the intensities of red, green and blue to be separately controlled and the three components are then brought together again with dichroic reflectors, and directed into the lens system which illuminates the printing aperture. Here again the programme

of printer light changes may be coded on perforated tape, three lines' of information being used to record the red, green and blue values for each scene.

Light change actuation

When printing a reel of assembled negative scenes often as many as 200 changes in printing exposure may be required, each of which must take place exactly as the join between the scenes reaches the printing aperture. The light change mechanism must therefore be actuated at an exact frame position along the length of the negative. One method is to notch the edge of the film at the required points by removing a shallow sliver of film. The passage of this notch or nick is detected by a lightly loaded roller bearing on the film edge, which operates a micro-switch as the notch passes and makes the required change in printer light intensity. This procedure is widely used but the physical weakening of the edge of the film is a source of damage and once made the nicks are inconvenient to remove if the negative is recut or rearranged. Alternative methods have therefore been developed in which the negative edge is not disturbed.

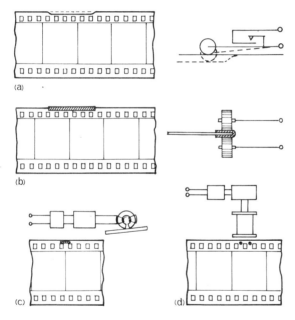

LIGHT CHANGE CUES
The actuation of printing light changes is provided by cue marks on the edge of the negative film. (a) A notch cut in the edge allows a lightly loaded roller to operate a micro-switch. (b) Metal tags or foil fixed on the edge complete the circuit between two contact rolls. (c) Spots of magnetic paint can be detected by a magnetic reading head. (d) Spot of metallic foil or paint can be sensed by an electronic proximity detector to actuate an electrical relay.

Cues, in the form of small metal tags or thin strips of conducting metal foil may be attached to the edge of the film at the required places. These allow an electric impulse to be sent by bridging a gap between contacts as they pass through. Metal foil or spots of metallic paint may also be sensed by an electronic proximity detector which need not actually be in contact with the film at all. A similar device can also be operated by spots of magnetic paint. Where a control band in the form of a punched tape coded for the required settings of an additive lamphouse is used, it may include additional coding to indicate the footage at which a light change is to operate and in this case the negative film itself need not be nicked or cued in any other way.

Laboratory organisation

While the operations of printing and developing are fundamental to the organisation of the laboratory, a wide range of additional services must be provided, to cover the various stages or preparatory work and release printing, and to control and standardise the photographic and chemical process concerned. Furthermore, both printing and film handling must be carried out in rooms ventilated with clean air at controlled temperature and humidity, while the temperature and flows of processing solutions must be accurately maintained. These demands require the provision of considerable auxiliary engineering plant and services.

The first stage of laboratory work is concerned with the development of the negative received from the studio and the preparation of rush prints. Machines for negative developing are designed to handle this valuable original material with great uniformity, and to avoid undue tension on the strip, sprocketless tendency drive is usual at speeds of 50 to 100 feet per minute.. Continuous contact printers are used for making rush prints with one exposing position only, since sound track printing is not needed at this stage. Developing machines for

RUSH PRINTS

Sequence of Laboratory Rush Print Operations.

From Studio { Picture Cutting Copy
Editing { Sound Work Print

Sound Track Negative } From
Selected Picture Negative } Laboratory
 Storage

MAKE-UP
TRACK
NEGATIVE

CUT
PICTURE
NEGATIVE

PRINT
PROTECTIVE
MASTER POS.

DEVELOP
PRO. MASTER

Storage

GRADE
PICTURE
NEGATIVE

PRINT FIRST
MARRIED PRINT

DEVELOP

VIEW

PRINT
CORRECTED
MARRIED PRINT

GRADING
CORRECTIONS

Submit as
Answer Print
for
Producer's To Studio
Approval

DEVELOP

VIEW

ANSWER PRINTING

Laboratory Sequence for Answer Printing.

processing rush prints are the same as those used for positive release prints, where sprocket drive at speeds up to 150 feet per minute or more is normal.

When eventually the picture editing is complete, the final work prints or cutting copies are sent to the laboratory for negative cutting and the preparation of the first composite copy, the answer print. The negative cutting department prepares a detailed continuity of each reel identifying each scene and take and its length by means of the stock numbers printed in the rush print from the negative. Each negative scene is then cut to match the corresponding section of the workprint, the sections are spliced together, head and tail leaders are added, solvent cleaning machine with ultra-sonic agitation, and the next operation is to prepare a protective master positive from which a duplicate negative can be made should any serious damage occur to the original. For black and white pictures this protection is a fine grain positive or 'lavender' but for colour and a printer card is prepared for each reel, showing the scene number, length and description and leaving space for timing data to be added.

By this time the final sound track dubbing is complete, the transfer from magnetic recording to optical sound negative carried out, and the exposed

sound negatives for each reel of the subject sent to the laboratory for developing. After rush printing, track workprints for each reel are sent to the laboratory to allow the track negative to be made up in synchronisation with the cut picture negative.

After cutting and joining a reel of picture negative it is cleaned, often on a negatives a colour intermediate cannot be regarded as completely permanent. It is therefore preferable to prepare a set of three separation masters by printing three times through red, green and blue filters on to a suitable panchromatic fine grain positive black and white stock. Protective master material is intended only for use in an emergency and is usually stored quite separately from the corresponding original negative.

Grading

The picture and track negatives are now ready for printing and the next operation is to assess the printing level required for each picture scene. This information may be obtained from records prepared at the time of rush printing or a series of tests may be printed from the assembled reel on a scene tester. If clippings of each negative scene have been taken prior to rush printing these can be joined together in sequence corresponding to the cut reel and a short test print can be made using only a few feet of positive stock. Many laboratories are now equipped with a closed circuit colour television analyser, which provides a rapid method of determining printing values for each scene. When the printing information has been collected, the corresponding control band is prepared for the type of printer in use, and the first composite print with picture and sound on the same strip of film is printed and developed.

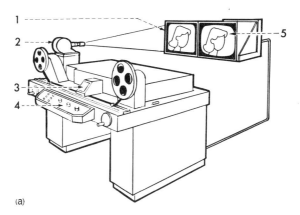

(a)

COLOUR FILM ANALYSER
 (a) General View. The negative being examined is wound through the scanning head (3) and a positive image is displayed on the colour television monitor screen (5) by a closed circuit TV system. Calibrated control knobs on the panel (4) allow the colour and density of the picture to be adjusted to give a satisfactory rendering. A still projector (2) can be used to project a reference picture from a film clipping on the adjacent screen (1).

270

Despite care in estimating the first printing levels, it is unusual for the first print from a cut reel of negative to appear perfectly consistent for colour and density in every scene, and some corrections to ensure scene-to-scene uniformity are generally necessary. These corrections are estimated visually by an experienced grader under review theatre conditions and at this stage co-operation between the laboratory contact man, the grader and the editor or other representative of the studio production company can be most valuable, as it is essential for the grader to understand and interpret the director or cameraman's intentions. The grader must ensure uniformity from scene-to-

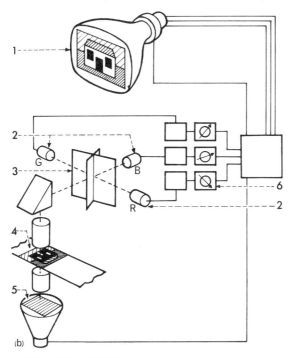

COLOUR FILM ANALYSER

(b) Schematic. A flying spot cathode ray tube (5) provides the scanning raster for the frame of negative film (4). Light passing through the film is divided by dichroic filters (3) into red, green and blue components to the three photo-multipliers (2). The signals from these are inverted and processed to produce a positive colour image on the monitor screen (1). Controls (6) allow the red, green and blue intensities to be separately adjusted in calibrated steps.

scene within a sequence and all reels of a feature film must also be consistent so that there are no marked alterations of colour and density when changing over from one reel to the next in the theatre. The grader is therefore required to exercise a considerable degree of personal skill and experience in making his assessments.

When the first completely graded copy is complete it is submitted to the

production company for approval and when accepted, the preparatory work by the laboratory may be regarded as complete.

Release printing

From this point onwards the picture and sound track negatives are handled in the release print section on specialised equipment designed for the bulk production of copies for general distribution. Rotary contact printers are used on which the picture and track are printed at a single passage of the raw stock and negatives may be joined in an endless loop to avoid loss of time in re-threading the printing for each copy. In some printers the running direction is reversible, so that the negatives need not be rewound, and repeated copies can be printed merely by feeding on a new roll of raw stock each time. For utmost efficiency a high speed printer can be continuously fed with raw stock through a reservoir elevator and linked to a positive developing machine running at the same speed to eliminate intermediate operations. Multi-head printers, in which several positive copies are produced at each pass of the roll of negative, are also employed when a large number of copies are required in a short time, as with newsreels.

The operation of high-speed continuous printers must be made as automatic as possible and methods of light-change control by punched tape programmes have important advantages. Cleaning units, usually rotating brushes with vacuum suction, are often installed on the picture and track negative paths through the printer to prevent the film from picking up dust and dirt.

After developing, the release prints are viewed by projection on a small screen to check that the quality of the copy is satisfactory and that it is free from dirt and physical defects.

After projection, prints are passed to the release assembly department for final inspection. Here, stock joins are cut out and censor titles and distribution trade marks attached. Each print is the packed in a can labelled with its title, part number and copy number and when all reels of a given copy are complete they are despatched to a distributor.

RELEASE PRINTING
Laboratory Sequence for Release Printing.

9 Duplicating methods

Many laboratory processes require photographic duplicates to be made from the original material exposed in the camera. Duplicate negatives, or 'dupes', must be made in the course of producing several types of special effect shots, for example, and they are frequently used when release copies are required in a different gauge or format from the original. Dupe negatives are often employed for bulk release print manufacture, either to protect the original from excessive use or to allow copies to be simultaneously made at several laboratories in different countries for international distribution. Library scenes are duplicated for use in other productions and on occasions dupes are made of seriously over-or under-exposed shots to allow them to be brought within the printer correction capability.

Printing stages

In the most usual process two photographic printing stages are involved, the first is to produce a master positive print from the original negative, and the second to obtain a dupe negative from the master positive. Special fine grain film stocks and developing conditions are needed for these operations in order to obtain a result whose printing characteristics of tone reproduction, grain and definition shall match the original as closely as possible.

In black and white work fine grain master positives are exposed to give a comparatively heavy image and are developed to a low gamma value (about 1.4), normally through a negative developer solution. The stock used for printing the dupe from the master is a slow speed fine grain negative emulsion, usually panchromatic, and coated on a grey base to reduce light scatter. It is developed through negative processing solutions to a gamma value of the order of 0.7. In theory, the product of the master and dupe gamma should be unity ($1.4 \times 0.7 = 0.98$) to give exact reproduction of the tonal scale of the negative, but in practice both figures may have to be modified on the basis of sensitometric and viewing

273

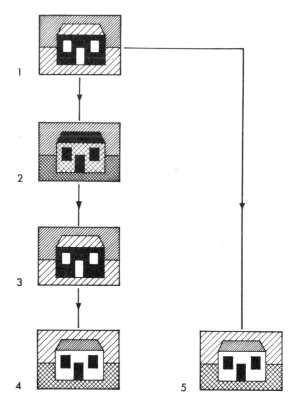

BLACK AND WHITE DUPLICATING SEQUENCE

From the original negative (1) a fine grain master positive (2) is printed and from this a fine grain dupe negative (3) matching the original can be obtained. A print (4) from this dupe negative is similar to the print (5) made from the original.

tests, to obtain the best result from the particular materials and their form of printing.

A fine grain master positive is often made from the finally assembled reels of picture negative of a feature production and held without further use to serve as protection in case the original should become damaged. Such protective masters should be printed incorporating the scene-to-scene grading changes finally adopted so that should it become necessary to make a full length dupe negative, this will have a completely consistent exposure level throughout. Release copies made from such a dupe would not require any printer light changes from scene to scene, and hence could be printed at a single printing level. The dupe is thus termed a one-light dupe.

Optical sound track negatives can be duplicated by similar operations using stocks of suitable characteristics for the master and dupe stages, but some loss of quality is inevitable and it is always preferable to make another negative by transferring again from the original magnetic recordings. In some cases however,

a specially prepared positive print of the sound track may be used as the source from which to re-record if the magnetic masters are not readily available.

Colour duplicating

Although the same two steps, master positive, and dupe negative, are often involved in duplicating colour negatives, the characteristics of the intermediate stocks introduce some changes in detail. In its simplest form, the process uses the same type of colour tripack stock for both stages developed for a reduced time in colour negative developing solutions, to give a sensitometric gamma value of 1·0 for each. The latitude of colour intermediate is somewhat limited and accurate assessment of exposure level and colour balance is essential to obtain the best results. Even so, it is difficult to avoid some degree of colour desaturation and increase in apparent graininess.

Although a colour intermediate positive can be made for protection purposes, as in black and white, it must be recognised that no dye-image colour material is completely free from fading over long periods. So for archival storage, as well as for optimum quality, it is most desirable to make colour protective masters in the form of a colour separation set in black and white. These are prepared by printing from the original negative three times onto separate strips of panchromatic fine grain master stock using respectively red, green and blue filters to give black and white positive images corresponding to the three colour sensitive layers of the original negative. Processing is carried out in a fine-grain negative developer to a gamma of approximately 1·0.

From such a set of separation positives a duplicate colour negative can be made when required by printing from them three times, again through corresponding red, green and blue filters on to a single strip of colour intermediate stock, thus separately exposing the three colour-sensitive emulsion layers of this material. Under suitable storage conditions black and white separation masters can be completely permanent with an almost unlimited storage life. And the colour quality of the dupe which can be obtained from them is usually superior to that from a colour intermediate positive. However, the process is less convenient and more expensive, so that it is in general only used for major productions where archival storage is required.

Colour reversal intermediates

A recently introduced material allows colour duplicate negative to be prepared at a single printing stage. This stock, known as colour reversal intermediate, is an integral tripack material and is printed direct from the original negative. It is then processed through a colour reversal developer system. The initially exposed image is bleached out and the previously unexposed areas converted to a colour image, which thus has the same tonal distribution as the original film from which it was printed. The elimination of a complete step in the normal master-dupe sequence improves the grain quality and sharpness and minimises the loss of colour quality in the result, as well as producing a dupe negative more rapidly and economically.

Reversal materials, however, must be recognised as having a limited exposure latitude and colour reversal intermediates must be accurately controlled for exposure level and colour balance. Processing is also critical, and requires high standards of chemical and mechanical control. Reversal intermediates must be exposed on an optical printer to ensure that the orientation of the image in rela-

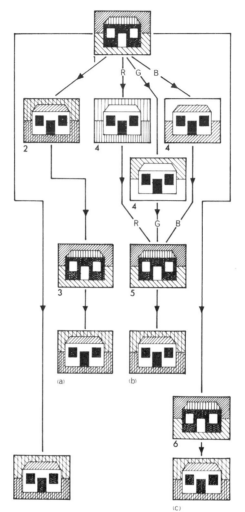

COLOUR DUPLICATING METHODS

Three methods may be used for preparing colour dupe negatives from an original negative (1). (a) A colour intermediate master positive (2) is printed from the original and from this a colour intermediate dupe negative (3) can be made. (b) An alternative procedure providing long term protection is to make three separation positives (4) by printing from the original negative on to black and white Panchromatic stock through red, green and blue filters. Combination printing through similar filters on to colour intermediate stock produces a colour dupe negative (5). (c) A colour reversal intermediate stock permits a colour dupe negative (6) to be printed directly from the original negative at one stage.

Colour prints (a) (b) (c) from all these duplicate negatives are similar to prints from the original.

tion to the emulsion surface of the film matches that of the original negative so that both may be inter-cut conveniently.

First and second generation duplicates

As all duplicating processes involve some loss of image quality in tonal and colour reproduction, in sharpness and in grain, it is important to identify the number of stages which have been used in arriving at the end product. The first derivative which matches the original is generally referred to as the first generation. A first generation dupe negative is thus one made either direct from the original negative by reversal or from a master positive which was itself direct from the original. Where a dupe negative is itself duplicated, the result is termed a second generation, and so on. Repeated duplications through the two-stage master-dupe sequence quickly lead to very severe colour degradation and the improvement offered by reversal intermediates is very marked.

Duplicating reversal originals

In many instances with 16 mm photography the original material exposed in the camera is a reversal stock, either for black and white or for colour, and may therefore be regarded as similar to a master positive for duplicating purposes. For general release printing where large numbers of copies are needed it is economical to use regular positive stocks and a dupe negative is therefore made from the original colour master to allow this. When the original is a reversal

DUPLICATES FROM REVERSAL ORIGINALS
Duplicates from a reversal original (1) can be made in two ways. An inter-negative (2) may be printed directly from the original and used to make release prints (3) on regular positive stock.
Alternatively a copy master or duplicate positive (4) may be made and release prints made on a reversal stock (5).

black and white master, a low contrast fine-grain duplicating stock is used, but, for working from original colour reversal materials, a special type of intermediate, known as a colour internegative, is available. This stock is designed for processing in a colour positive developer at reduced developing time and yields an integral tripack image of the same general form as other colour intermediates. It is normal to incorporate a number of editing effects, such as fades and dissolves, at the dupe-making stage, and white letter titles superimposed on action background scenes can also be added.

Very often, where reversal copies are to be made from the original reversal material, protection is provided in the form of a copy master, or duplicate positive, rather than a dupe internegative. In this instance the stock used is a reversal print material, similar to that employed for making release copies.

Change of format

Duplicate negatives are widely used when release prints are required in a format different from that of the original negative. Although such copies can be made directly by optical printing, this is a comparatively slow and expensive operation and becomes uneconomical when many prints are needed. It is therefore, the general practice to prepare an optical dupe in the new size so that further copies can be contact printed. However, an important exception to this is when 70 mm prints are made by anamorphic enlargement from 35 mm CinemaScope originals. These are always direct 'blow-up' prints in order to retain the best quality for large screen presentation.

Dupes are almost always made for 16 mm prints from 35 mm originals, and may be prepared either on normal 16 mm width strips or as double-rank 16 mm images on 32 mm or 35 mm stock, the latter mainly when very large numbers of prints are required. Likewise, multi-rank dupes are used for the bulk production of 8 mm copies when the originals are 35 mm or, more frequently, 16 mm. Again, depending on the size of order, these dupes may be double-rank 8 mm on a 16 mm width strip, or quad-rank with four 8 mm images on 32 or 35 mm film. From such facilities, large numbers of copies can be printed in the multi-rank form and slit to their final width after processing.

Reduction dupes are also prepared from original material photographed on 65 mm negative so that 35 mm release prints may be made by normal contact printing methods. In all cases, it is preferable to make the optical reduction stage the last one in the master-dupe sequence. Thus, in making a 16 mm dupe, the series:

$$35 \text{ neg.} \quad \text{Contact print.} \xrightarrow{} 35 \text{ master} \quad \text{Optical reduction} \xrightarrow{} 16 \text{ dupe.}$$

will give better results than:

$$35 \text{ neg.} \quad \text{Optical reduction} \xrightarrow{} 16 \text{ master} \quad \text{Contact print} \xrightarrow{} 16 \text{ dupe.}$$

for grain and definition. The use of reversal intermediate stock, however, eliminates the master stage and produces a reduction dupe by direct optical printing from the negative with good image quality as the result.

Optical printing must also be employed where a change of image format is required on the same gauge of film, for example, where widescreen prints for normal projection are needed from a negative photographed anamorphically. The copy lens used on the printer must then be an anamorphic one, giving a

MULTI-RANK DUPLICATES

 Bulk production of 16 mm and Super-8 prints is often made using multi-rank duplicates. Double-rank 16 mm dupes may be made either on 32 mm stock (a) and (b) or on 35 mm stock (c), the outer margin being discarded when slitting the final prints. Super-8 prints can be made from either double-rank duplicates on 16 mm width stock (e) or as quad-rank on 35 mm (d).

 Where all ranks show the same image geometry (a), (c), (d), the reduction duplicates can be printed at a single stage from the original by the use of beam-splitting optics. Where one rank is inverted relative to the other, (b) (e), the duplicate must be made by two printing operations, head first and tail first.

magnification in the horizontal dimension of the frame which is twice that of the vertical to compensate for the distortion in the original image, and to produce a dupe from which the so-called 'unsqueezed' copies can be made by contact printing. When a 16 mm 'unsqueezed' dupe is required, the copy lens must combine reduction with anamorphic correction, by making the horizontal reduction factor only half that of the vertical factor, in order to maintain the 2 : 1 ana-

(a)

"Unsqueezed" dupes can be made from anamorphic originals by optical printing either as 35 mm wide screen (1) or as 16 mm (2) to provide normal "flat" prints.

(b)

PAN AND SCAN PRINTING
When making "unsqueezed" dupes of A.R. 1.33:1 from Anamorphic originals the use of the central area of the frame only may cut off important action at the sides of the picture (1). It is therefore desirable to use an optical printer lens which can be traversed to select the required action area for each scene (2).

morphic ratio. The reverse requirement arises when a 35 mm CinemaScope-type of dupe negative is to be made from a 65 mm original negative. Here the horizontal reduction factor must be twice that of the vertical, to produce a squeezed image on the dupe.

In making unsqueezed duplicates from a widescreen original a problem of composition arises which is particularly serious when prints are to be used on television. The format of the television picture is strictly in the proportion of 4×3 (aspect ratio 1·33:1), so that when a widescreen picture composed in a proportion of 8×3 (aspect ratio 2·35:1) is to be copied some of the action

280

shown at the sides of the frame must be lost. If the widescreen format has been used dramatically this action may be very important. When making the un-squeezed duplicate it is therefore necessary to adjust the copying lens so that the part of the original frame containing the most significant action is reproduced rather than copying the central area at all times. The optical printer is therefore set up so that it can scan a number of positions in the original frame and where necessary traverse smoothly between any of these areas, in much the same way as a camera would have panned with the action during original photo-graphy. The movement of the printer lens must be controlled in accordance with a pre-determined programme based on a careful examination of the film in its original widescreen form. This operation is termed pan-and-scan printing.

Printers for duplication

The printing of master positives and dupe negatives calls for a high standard of image steadiness, definition and uniformity, and special machines are allocated in the laboratory for this purpose. Even when contact printing is required an intermittent printer exposing one frame at a time with a registration pin move-ment is usually employed and is essential in special effects work, where so many processes depend upon exact location of multiple images. The mechanism must provide extremely good contact between the two films over the whole area of the frame to ensure very high definition in the printed image.

A light source with a condenser optical system giving very uniform intensity over the printing aperture must be used, and must be provided with automatic light point control for exposure level and colour balance so that scene-to-scene

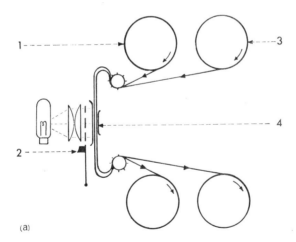

(a)

PRINTERS FOR DUPLICATION
(a) Intermittent Contact Printer. The negative (1) and print stock (3) are brought together at the feed sprocket and exposed frame by frame at the gate (4) to the light from the lamp and optical system. At the time of exposure the two films are accurately located by a register pin mechanism; a shutter (2) cuts off the light from the films while they are moved from one frame position to the next.

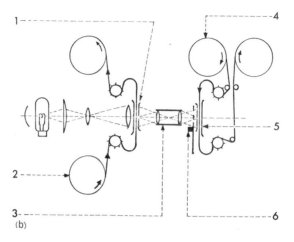

(b)

PRINTERS FOR DUPLICATION·
Optical Printer. The negative (2) passes frame
by frame through an intermittent mechanism with
register pins at the gate (1) where it is illuminated
by the lamp and optical system. The copy lens (3) forms
an image of the negative frame on the positive stock (4)
passing through a synchronized intermittent gate (5), a
shutter (6) obscuring the exposure while the films are in
motion from one frame to the next.

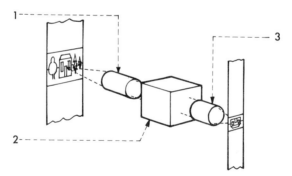

ANAMORPHIC COPY LENS SYSTEM
When a change of magnification and
anamorphosis are both required on an optical printer an
anamorphic prism or cylindrical lens system (2) may be
used between the two normal lenses (1) and (3) used as
a collimated pair. The ratio of the focal lengths of the two
lenses provides the magnification or reduction factor.

grading corrections can be applied exactly as in making positive prints from a
cut production negative containing many scenes. Such printers normally run
comparatively slowly, at say, 30 to 40 feet per minute, and light changes are
made during the inter-frame period when the aperture is closed by the shutter
of the intermittent movement. Some dupe printers for black and white work

were designed to operate in a darkroom with safelights and had open film paths and rolls of stock, but for colour it is more usual for the mechanism to be enclosed, as in a camera, and the stock to be fed and taken up in camera magazines, since in a darkroom only a very low level safelight can be used with colour intermediate materials.

Optical printers are always designed for operation in a fully lit working area, and the positive stock is exposed in a camera head with a magazine attached. For simple enlargement or reduction work only a single film path at the negative and positive positions is used but in making special effects such as travelling matte shots, additional strips may be run in contact in both positions to produce the required masked exposures.

The copying lenses used on optical printers are designed specially for the short working distances between the object and image planes and for the range of magnification and reduction factors involved. Anamorphic copy lenses are always made for a specific requirement only and cannot operate at any magnification other than that for which they were intended. An alternative procedure is to use a separate anamorphic prism or cylindrical lens system positioned between a pair or normal spherical camera lenses as a collimated unit. The ratio of the focal lengths of the two lenses gives the magnification or reduction factor required while the anamorphic unit provides expansion or contraction in the selected dimension.

Lamphouse optics must be carefully matched to the copying lens, particularly with anamorphic systems, where uniformity of field illumination is extremely critical.

Contrast in optical copies

Optical printing introduces a number of factors which alter the quality of the photographic image in comparison with that produced by contact printing. When black and white images are optically printed some of the light is scattered by the silver grains and does not pass through the copy lens to expose the stock. This effect is greater where the image is heaviest in density and least where it is lightest. As a result the contrast between light and dark areas in the resultant print is greater than in one made with the two films in contact. The extent of this effect depends on the characteristics of the whole optical system used and

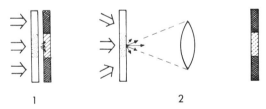

1 2

OPTICAL PRINTING CHARACTERISTICS
 Light passing through the grains of a photographic image of a negative is partially scattered. In Contact Printing (1) this scattered light is received by the positive and contributes to the print exposure, but in Optical Printing (2) some is scattered outside the acceptance angle of the copy lens and does not add to the image.

283

on the structure of the image being printed, so it is important to assess sensi-tometric data in making optical duplicates under actual operating conditions and not purely on measurements made on a densitometer with diffuse illumination.

Colour films, in which the image consists of more or less transparent dyes, show very much less scattering effect than black and white and the difference between optical and contact prints is therefore much less marked.

The Technicolor process

Although essentially a release printing process, the Technicolor dye-transfer system should be considered at this point. Introduced long before integral tri-pack colour materials became available, Technicolor prints were originally made by the photo-mechanical method of imbibition from colour separation negatives exposed in a special camera (page 27). Although the production of single strip colour negative materials from 1951 onwards completely replaced the Technicolor camera, this dye transfer printing process has continued and still provides a very large proportion of the release prints for professional motion pictures.

The first step in the imbibition process is the printing of three separation positives known as matrices, from the original negative. By exposing film stock of the appropriate sensitivity through red, green and blue filters, a set of three positive images is obtained, corresponding to the three layers of the original negative. The matrix stock used carries a carbon-loaded emulsion which con-trols the penetration of light in depth according to its intensity. By printing on an optical printer through the base of the stock, a latent image is obtained which varies in thickness according to the intensity of exposure and thus corresponds to the light and shade of the picture. The printed matrix is developed in a tanning developer which hardens the gelatine in the areas where it has been exposed. In the course of processing the unexposed and unhardened portions are removed by hot water to leave a relief image in which the tonal variations of the scene are represented by small variations in the thickness of the remaining gelatine layer.

The matrix image has the ability to absorb suitable dyes in exact proportion to its thickness and this absorbed dye can be transferred to a gelatine layer on another piece of film by bringing the two in contact under the right conditions. This transfer process is termed imbibition and can be repeated as often as needed by re-dyeing the matrix and bringing it into contact with a fresh piece of blank film.

In making prints by dye transfer, therefore, the three matrices printed from the green-record, red-record and blue-record layers of the original negative are respectively treated with dyes of the complementary colours, magenta, cyan and yellow, and made to transfer these dyes in succession to a single piece of blank film which has previously been printed with an optical soundtrack image. A subtractive three-colour picture can thus be produced on a comparatively simple type of black and white positive film, although the print stock actually used is specially manufactured and contains a mordant whose chemical affinity to the dyes prevents diffusion of the transferred image and retains its sharpness.

Once the dye has been transferred from matrix to blank, the matrix is ready for the cycle to be repeated and in fact from one set of matrices a very large number of transfers on to separate strips of blank can be made without any loss of quality. The Technicolor process is thus particularly suited to the economical manufacture of large numbers of release prints and the sound track printing

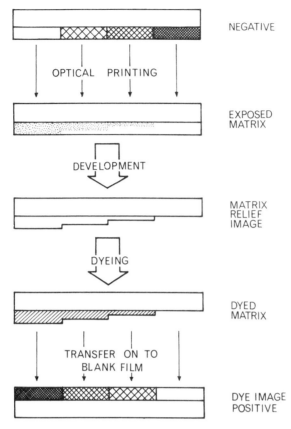

NEGATIVE

OPTICAL PRINTING

EXPOSED MATRIX

DEVELOPMENT

MATRIX RELIEF IMAGE

DYEING

DYED MATRIX

TRANSFER ON TO BLANK FILM

DYE IMAGE POSITIVE

TECHNICOLOR MATRIX PROCESS
Matrix stock is printed from the negative by exposure through the base on an optical printer. The latent image is developed in a hardening developer and the unexposed emulsion removed to leave an image in relief. This relief matrix can absorb dye in proportion to its thickness and can transfer the dye to a piece of blank film thus producing a positive image by imbibition.

and dye-image transfer is carried out as a continuous operation on large processing machines running at a speed in the region of 100 metres a minute, giving a very substantial output.

Complete transfer of the dye in the heavy density regions of the image takes about 30 seconds, and a fundamental feature of the transfer machine is the method by which the matrix and blank films are held accurately in register during this period.

As the film passes through the machine the two strips are brought into contact by rollers which seat them together on to a moving carrier belt which has accurately fitting registration pins engaging with every perforation hole in the film. Once located on the belt, therefore, the two films cannot move relative one to

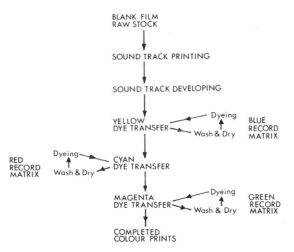

TECHNICOLOR DYE TRANSFER SYSTEM

Three relief image matrices corresponding to the blue, red and green negative records are used to transfer positive images in the complementary dyes, yellow, cyan and magenta, to a piece of blank film which has been previously printed with a black and white sound track. After each transfer operation the matrices are washed and dried and the process repeated for the manufacture of large numbers of copies.

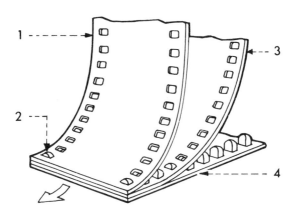

PIN BELT REGISTRATION

To ensure accurate registration of the matrix (3) and blank (1) during the dye transfer period, the two films are seated on a moving carrier belt (4) which has close fitting registration pins engaging with the perforation holes of the films (2).

286

the other, and they remain on the moving belt, which is an endless loop, for the length of time necessary to transfer the dye from the matrix gelatine layer to that of the blank. After this period, the two films are stripped away from the belt and from each other and dried. The matrix is then ready for further use and may be fed immediately on to the machine to make the next print. The blank film, however, now with its transferred dye image, passes continuously to the next transfer path to receive another colour. When the three dyes have been applied the final print is lubricated and projected to inspect the colour quality.

As the matrix image must be exposed through the base side of the stock, matrix printing is essentially an optical process and wet printing facilities are provided on the negative paths of all machines used for this purpose.

Scene-to-scene variations of density and colour required by grading are incorporated at the matrix printing stage. The relative printing levels of the three matrices determines the amount of yellow, cyan or magenta dye to be transferred.

Optical printing allows matrices of different formats to be prepared from an original negative without intermediate duplicates. The three 35 mm matrices for example, can be printed direct from large-area 65 mm negatives using anamorphic copy lenses. Unsqueezed 35 mm matrices can be made from 35 mm CinemaScope originals. Matrices with 16 mm images, usually reduced from a larger negative, are prepared in the double-rank form to give two transfers side by side on a strip of 35 mm blank film. After viewing, the two prints are slit to their 16 mm width and the unwanted 3 mm edge discarded. For this format a pin-belt with two rows of 16 mm register pins must of course be used on the transfer machine.

Some special effects, such as fades and dissolves, may be incorporated during matrix printing, direct from the original negative, rather than by the use of intermediates. For this there is a dissolve shutter at the positive head. Independent operation of negative and positive movements can also be programmed to allow sections of the negative to be omitted from the printed matrix, so that matrices of different continuity, for censorship or other reasons, may be selectively printed from one original-version negative.

International distribution needs are covered by the exchange of sets of matrices between different Technicolor laboratories rather than by the provision of intermediate dupe negatives. Since matrices carry the picture information only, they can be used equally well with an optical soundtrack negative in any language required.

International exchange

Apart from Technicolor matrices, the usual method of providing picture material for release printing in different countries is to supply colour intermediate duplicate negatives, more recently of the reversal intermediate type. Such dupes are printed with the variation of scene-to-scene grading required by the original negative, as so-called 'one-light' dupes, and background master material is supplied for any titles or inserts on which lettering is to be superimposed in translated wording.

For the more important feature films on which a soundtrack in another language is to be dubbed for general release in that country, a magnetic master of the finally mixed music and effects soundtracks of the original is supplied. These are combined with the foreign language voice tracks which have been separately recorded from the dialogue translation. The preparation of these dialogue

tracks is a specialised operation starting with a skilful translation of the original. This provides as far as possible a similar number of words and lip movements, yet preserves the dramatic style and character, while the actor chosen to speak the translation must also maintain the character of the original player.

In practice two alternative recording techniques are used, 'looping' or 'forward-backward'. In the loop system, which is the same as that used for dialogue line replacement at the studio when the original dialogue tracks were prepared, a guide print of the film is cut up into a large number of short sections which can be projected over and over again as continuous loops. A sound track loop giving the required cue lines is run in synchronisation and played to the actor over headphones or loudspeaker, while the sound recorder runs a loop of magnetic material of corresponding length at the same time. The actor can thus rehearse the dialogue a line or so at a time, concentrating on speaking it exactly to the lip action of the guide print shown on the screen until a satisfactory recording of that loop has been obtained. Eventually all the recorded loops for the new version are assembled to match the full length work print of the reel and re-recorded in preparation for the final mixing with the music and effects track.

With the forward-backward system the guide print is not cut up into loops but is run forward while each new dialogue sequence is being rehearsed or recorded and then run back to the chosen starting position for a repetition forward run or a replay of the previous recording. This procedure eliminates a great deal of work by the editing staff in loop preparation and re-assembly but calls for very experienced actors and sound crew if recording time is to be used efficiently.

Transfers from television

When the electronic signals of a television programme are to be converted to motion picture film, the transfer process known as kinescope in the United States and as telerecording in England must be employed. In its simplest form for black and white images the signals, which may of course be derived either directly from a television camera or from a previous video-tape recording, are displayed on the cathode-ray screen of a high-quality television monitor receiver and are photographed on film by a camera run in exact synchronism with the television film. The sound is recorded at the same time, usually on a separate magnetic record.

The nature of the television image introduces a number of very special problems: this picture is made up of a number of horizontal lines, in the pattern known as a raster, the image being formed by variations of brightness along each line. The number of lines transmitted differs with the broadcast system employed, 405 lines being used originally in Great Britain and 525 in the United States; a 625-line system was widely used in Europe and with the introduction of colour T.V. this became the standard for all European countries including Britain. Because of the need to provide synchronising and control signals not all these transmitted lines are available to form the picture, the actual numbers used for the final display being 377 on the 405 system, 493 from the 525 and 587 from a 625-line transmission.

In addition, because of problems of flicker and the transient image produced on the tube surface, the whole series of lines are not transmitted in strict numerical sequence but as two separate patterns, or fields. The first of these is made up of the odd-numbered lines of the raster, 1, 3, 5, 7, 9 etc., and the second the even-numbered lines, 2, 4, 6, 8 etc: these two patterns are interlaced to complete the whole picture image and are repeated one after the other at the

BASIC KINESCOPE

Telerecording consists essentially of photographing the television image produced on a cathode ray tube by a motion picture camera whose film movement is synchronized with the frequency of the television field signal.

field sequence rate. In Europe a rate of 50 fields per second has been adopted as standard, based on an electrical power supply of 50 Hz A.C., so that the television system provides 25 complete pictures, or frames, per second; American equipment, however, used 60 Hz supplies and a field frequency of 60, giving 30 complete pictures per second has therefore been adopted. Unlike motion pictures, there is no dark shutter period between frames or field, but only a very short field blanking period of 1·2 milliseconds, as compared with over 20 milliseconds for the film camera.

The process of converting these components of the television picture into film images for cinematographic methods of presentation without irregular exposure or loss of picture information thus raises many problems of synchronisation. The design and operation of the camera mechanism, the electronic signals generated and the decay characteristics of the phosphor tube coating must all be treated together. In Europe the difference between the television frame rate of 25 per second and the standard sound film rate of 24 can be ignored, but the problem of the very short inter-field time must still be overcome.

The ideal solution is obviously to design a mechanism with such a fast pull-down intermittent that the film is moved in the gate from one frame to the next during the field blanking period. This has almost been achieved with 16 mm film where a pull-down time of less than 2 milliseconds is attainable but the larger dimensions and greater mass of 35 mm film call for such high acceleration and deceleration in the movement that a complete answer by the fast pull-down method is, as yet, impracticable.

The simplest procedure is termed the suppressed field system, which consists in recording only one of the two fields which make up the television picture, the film being comfortably moved by a normal mechanism while the whole of the second field is obscured by the camera shutter. The gaps between the recorded lines are filled in by vertical spot wobble on the cathode ray tube of the monitor

289

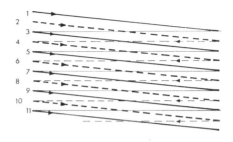

TELEVISION INTERLACED FIELD IMAGE
The scanning raster of a television image
covers the picture area as a series of lines which are
transmitted as two groups, one of the odd-numbered
lines and the other of the even-numbered. The complete
picture is thus made up of two fields of interlaced lines.

which broadens the lines. But the resultant image only contains half the number
of line elements and is therefore inferior in definition to the results of the more
sophisticated systems.

In the stored field system the whole line series of the television fields is recorded
by a camera with a standard intermittent mechanism, but the monitor uses a
special cathode ray tube with a slow decay phosphor coating. The long after-
glow of this phosphor ensures that the lines which had been scanned while the
camera shutter was closed are still visible during the exposure period as well as
the field which is currently being scanned. The difference of line brightness
which would result from the varying lengths of decay time are compensated
electrically, the signal to the stored field lines displayed during the closed
shutter period being stronger so that the image brightness has decayed to that of
the normal field by the time the exposure is made.

For optimum results on 35 mm film a combination of fast pull-down and field
storage can be adopted. A pull-down time of about 5 milliseconds is possible
by special design and although this is not as short as the field blanking period,
that part of the image which would be lost is retained by suitable slow phosphor
decay. Although some exposure brightness correction for the stored image is
still required, it is much less, and is limited to only a part of the picture area.

Attempts have been made to avoid the intermittent fast pull-down problem
by using continuous film motion with optical intermittents such as rotating
prisms and mirror drums or by the twin-lens scanning system used in telecine
projection but they have not yet been generally applied to tele-recording
equipment.

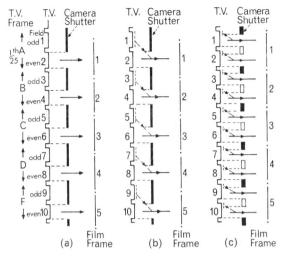

TELERECORDING FIELD SYSTEMS FOR EUROPEAN STANDARDS

The television picture is transmitted at a rate of 25 pictures per second, each made up of two fields.

(a) Suppressed Field. The film is moved by a normal intermittent mechanism at 25 pps but is exposed to only the alternate field images.

(b) Stored Field. Here the film is also moved normally but the image of the field previously lost is stored by the slow decay phosphor of the tube so as to be still visible while the camera shutter is open.

(c) Partial Stored Field. If the intermittent mechanism can move the film sufficiently rapidly the amount of image storage required can be limited to part of the picture area only. A double shutter is used to ensure that both fields are exposed in the same way.

U.S. kinescope practice

Unless the low definition suppressed field system can be accepted, it is necessary when a television standard of 60 fields a second is used (as in North America and Japan) to modify the recording methods and discard one field out of every five and produce 24 pps from the television 30 pps.

In one form, split field, a comparatively fast pull-down time is used corresponding to the duration of a half field, 1/120 sec or 8·3 milliseconds, running at a normal rate of 24 pps. The camera is synchronised with the television signal so that the first film frame exposed records TV fields 1 and 2, the second film frame the second half of field 3, field 4 and the first half of field 5, the third film frame TV fields 6 and 7 and so on, two half fields being lost in every 5, which are thus recorded on two frames of film. This system results in a join between the top half of one field and the lower half of the next field but one occurring on alternate frames of the film and unless the equipment is very precisely set up mismatching at this point can produce an overlap or a gap in exposure which is visible as a shutter bar in the middle of the picture. In modern equipment,

control signals are fed into the monitor system to act as an electronic shutter, matching the lines at which the changeover takes place.

With 16 mm film the very fast pull-down system of 2 milliseconds allows an improved solution. As before, the camera runs at 24 pps but a double shutter giving alternate shorter and longer closed periods is used. The first film frame is exposed to fields 1 and 2, then the film is pulled down in the field blanking period but the longer shutter closure blocks off field 3. The second film frame records fields 4 and 5 and the film is again pulled down in the blanking period

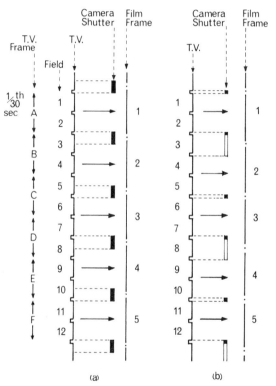

KINESCOPE FIELD SYSTEMS FOR AMERICAN STANDARDS

The television picture is transmitted as 60 fields per second, giving 30 pictures per second but the film is required to record at 24 pps.

(a) Split Field. A fast pull-down mechanism is used and the camera is synchronized with the television signal so that two half fields are lost out of every five fields, which are recorded on two frames of film.

(b) Combination System. A very fast pull-down allows the film to be moved in the blanking period between television fields and a dual camera shutter cuts off one complete field in five, which are again recorded on two film frames.

but this time the short shutter closure opens up to expose fields 6 and 7 on the third film frame. At the next pull-down field 8 is blocked by the longer shutter and the next film frame records fields 9 and 10, and so on. With this arrangement two fields are dropped out of ten but the four film frames resulting are all exposed from completely interlaced pairs of fields so that no shutter bar defects occur.

Basic telerecording equipment therefore comprises a specially designed camera mechanism providing both high-speed pull-down and accurate registration, a large magazine to provide continuous running up to 30 minutes, often with the feed and take-up enclosures as completely independent sections, a lens designed for high transmission with good sharpness at short working distances and a television monitor screen with all its associated controls.

The screen tubes used are always of small size giving a very bright picture about 4 inches wide on an optically flat faceplate. All the normal television controls for contrast, brightness and tonal reproduction are used and spot wobble in the scanning system is often brought in to reduce the obvious line structure of the television image. Electronic methods for enhancing the apparent visibility of the picture by generating edge effects at the boundaries of areas of different density may also be applied.

It is usual practice to display a positive picture on the television tube and to record this as a negative on a film stock having the desired photographic characteristics, but where only a single film copy is needed direct-positive recording is possible either by reversing the picture signal to give a negative image display or by recording the normal positive display image on a reversal stock. The television presentation may of course, be obtained either by a direct transmission 'off the air' or from a video tape recording.

Electron beam recording

A fundamentally different approach to the problems of telerecording or kine-scoping is provided by direct electron beam recording, in which the film itself replaces the face of the cathode ray tube and the latent photographic image is formed by the penetration of the electrons into the sensitive emulsion as the beam is scanned, without any intermediate optical lens system. This process presents a mechanical problem of some complexity. The whole of the film surface must be sealed into the high vacuum necessary for the electron gun in the tube to function, even though the film has to move in its intermittent mechanism and feed to and from its magazine. The problem has been solved by continuous evacuation using two pump systems. The film magazine enclosure and the camera body are maintained at a moderately low vacuum of approximately 0·15 Torr (0·15 mm Mercury), while the tube itself is run at a high vacuum of 0·001 Torr (10^{-3} mm Hg) at the image plane. The vacuum in the film enclosure ensures that any leakage through the film seal will be sufficiently small to be dealt with by the vacuum pump of the tube and yet is not so low that the film is dried out by it.

An intermittent movement with a short pull-down time of 6 milliseconds for 16 mm film is used and no mechanical shutter is necessary since the beam is electronically deflected away from the film aperture while the film is moving. For 625 line television at 50 fields per second 25 frames per second are recorded with suppressed field for film movement, while with the American standard 525 lines at 60 fields per second the split-field system is used to provide a recording of 24 pps.

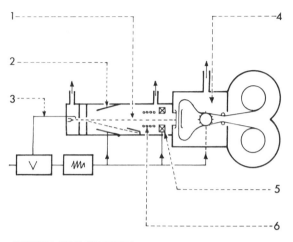

ELECTRON BEAM RECORDING
Film in the camera body (4) is exposed frame by frame directly to the electron beam of the gun (1) which is focused by the coils (6) and scanned in its raster by its deflector coils (5) synchronized with the camera drive. The video signal (3) controls the beam intensity; no shutter is used as the beam is deflected by the electro-static shield (2) during the inter-frame period.

The camera body is maintained at moderate vacuum (·15 mm Hg) and the film itself forms a seal to beam tube, where higher vacuum (10^{-3} mm Hg) is used at the recording head and high vacuum (10^{-5} mm Hg) at the emittor.

Despite the elaborate vacuum pump facilities required, electron beam recording offers considerable advantages in image quality. The high level of energy available for direct exposure allows very fine grain film emulsions to be used and by electronic controls either negative or positive images can be produced on the same type of stock. The electron beam has only a very limited penetration into the emulsion so that scatter and halation is negligible and since the electron beam arrives at the film surface as a cone of extremely narrow angle resolution is high and the depth of focus large. Spot wobble is essential to prevent the spaces between the lines of the raster being objectionably obvious in the vertical dimension but the high resolution can be fully retained with advantage in the horizontal scan. The elimination of the optical camera lens removes a source of flare and light scatter, and since no tube face image is produced the unevenness and grain structure of the phosphor coating no longer exists.

Telerecording in colour

The problems of telerecording are considerably increased where colour pro-grammes are involved. Although the television signal comprises information corresponding to the red, green and blue components of the scenes their transfer on to film in a manner suitable for photographic reproduction introduces many new difficulties.

294

Replacement of the black and white cathode ray tube in the kinescope monitor by a regular shadow-mask colour tube does not give satisfactory results when photographed by normal colour negative or reversal materials in tele-recording equipment. The colour phosphors of the tube can only be recorded with poor saturation and the three-dot pattern of the screen limits the definition obtainable.

A three-tube system, known as trinoscope, is capable of better results. In this arrangement, three separate cathode ray tubes display the red, green and blue component images and these are brought together by a suitable optical system with dichroic mirrors or prisms to expose colour film in the recording camera. Each tube shows a completely interlaced line image and the phosphors of the three can be individually selected and balanced by colour filters to match the film sensitivities. The main problem to be solved is the exact registration of the three colour pictures for size and position so that no colour fringing appears in the final image. Electronic stability and uniform scanning is essential and a high standard of optical alignment must be maintained. The problems of film movement are identical with those of black and white and 35 mm film is difficult to use because of the need for fast pull-down equipment. In the American 60 field, 525 line standard, kinescope recording with semi-fast pull down can be used for the split-field system, while in Britain a 16 mm continuous motion film mechanism with twin-lens optical scanning has been applied with a similar form of colour presentation.

When the transfer to film is to be made from a colour video tape recording rather than directly from a live transmission an alternative approach involving the preparation of colour separation records on film can be adopted, as by the

TRINESCOPE RECORDING

For recording colour television, three separate tubes (1, 2, 3) display the red, green and blue images from the vision signal. These images are combined by dichroic reflectors (4) and photographed on colour film by the camera synchronized with the television field signals.

VIDTRONICS RECORDING
 A colour video tape recording is played back (1) and the signal processed to give a black and white display (2) of the red record information, which is recorded by the synchronized camera (4) on black and white film. The process is repeated for the green and blue information so that three separation negatives are obtained which can be combination printed to give a single colour picture. The sound record of the video tape is transferred to magnetic film (3) and subsequently re-recorded optically.

Vidtronics process. In this method the video tape is run three times in succession and separate black and white kinescope records are made from a black and white tube image displaying on the first run the red signal, on the second the green and on the third passage the blue record information. Each record can be given individual treatment both electronically and photographically for optimum reproduction. The process makes exceptional demands on accuracy in tape image synchronisation and film registration, and for this reason all recording is done on 35 mm film using a register pin camera mechanism. From the three separate strips of black and white film so produced, colour prints can be made directly by the dye transfer (imbibition) process. Or integral tripack colour negatives can be made by triple printing and are then used for producing copies on regular colour positive film stocks.

 Although expensive in operational time and film stock consumption, this process appears to show the greatest promise for obtaining high quality colour reproduction on film from completely edited colour video tape recordings and is at the present time the only colour telerecording process which offers any possibility of being able to take advantage of the higher definition standards obtainable from electron beam recording methods.

10 Presentation

Final presentation of the motion picture film to an audience in the theatre must be recognised as a vital link in the chain of operations extending from the producer who initiated the film to the public who only see the final finished result. Film is still a mass medium and although the home viewing conditions of television have had a striking effect on the various forms of visual entertainment, it is by projection in a theatre that the majority of dramatic films will be seen throughout the world for some years to come.

The size and shape of cinemas have changed through the years in accordance with economic conditions. In the early days when motion pictures were a novelty any suitable small hall, or even a fairground marquee, would be employed for the small audiences and short performances then available. Later on, film shows became a part of vaudeville programmes and in due course both music halls and legitimate theatre buildings were taken over on a permanent basis. When new cinemas were built they conformed to the same general pattern, often differing only by the omission of the deep stage and associated scenery docks and dressing rooms. In many cases even though the motion picture programme was the main feature of entertainment, variety stage turns and an orchestra would appear in the course of the programme.

The ten years from roughly 1925 to 1935 may be regarded as the period of large cinema theatre building in western Europe and the United States. Every large city had several central theatres, often with seating capacities of 2500 or more, and they would be supplemented by suburban cinemas, with often only slightly less capacity, in all the larger neighbourhoods. This was the era of the 'movie palace', and exotic decor and names associated with flamboyant luxury all added to the popular appeal. The introduction of sound to motion pictures from 1928 onwards involved only the installation of new equipment in the majority of existing theatres, although a study of auditorium acoustics was to play an important part in the architectural design of buildings for future construction.

During the war years from 1930 to 1945 building ceased and in the years immediately following, financial and material restrictions greatly limited new

construction. The booming attendances of the late 'forties' were therefore almost everywhere accommodated in theatres built fifteen to twenty years earlier, often almost unchanged. By the early 1950's the competition of television and other factors were making themselves felt and cinema attendances began to decline, first in the United States, and subsequently in Britain and other European countries. Technical developments, such as the introduction of various forms of wide screen presentation, led to the modification of the interiors of theatres, but with the continuing fall in the numbers of cinema-goers drastic steps had to be taken. Some theatres were closed and their sites developed for more profitable purposes, while such new cinemas as were built were substantially smaller than the large halls of the earlier period. In the central areas of major cities large older cinemas were torn down and replaced on the same site by two smaller ones or by a small theatre forming the lower part of an office building, while in the lesser towns and suburban districts many cinemas disappeared entirely. More recently, ever-spreading housing developments into new suburban neighbourhoods have led to a revival of cinema theatre building in outlying areas, though here again these are smaller with a seating capacity of 500 or so, or, especially in the United States, the open-air drive-in theatre.

The projector

No matter what size the cinema theatre, its essential technical equipment comprises projectors, a screen and a sound reproduction system. For many years

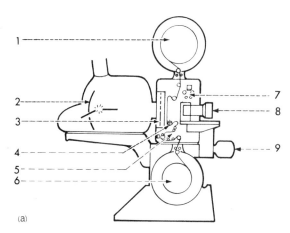

(a)

PROJECTORS

 (a) General Assembly
1. Top Spool Box
2. Lamp House with Mirror Arc
3. Shutter
4. Intermittent sprocket
5. Optical Sound Head
6. Lower Spool Box
7. Magnetic Sound Head
8. Projection Lens
9. Drive Motor

298

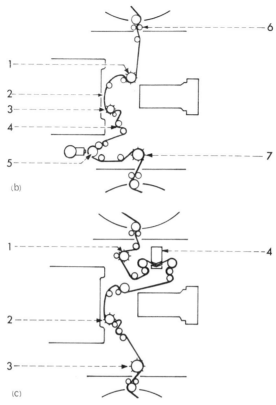

(b)

(c)

(b) Film Path for Projection with Optical Sound

The film passes between the fire trap rollers (6) from the top spool box, being pulled by the feed sprocket (1). Intermittent movement at the aperture (2) is provided by the intermittent sprocket (3). After passing through smoothing rollers (4), film is scanned at the optical sound head (5) and is fed to the lower spool box by the sprocket (7).

(c) Film Path for Projection with magnetic sound

An alternative path for magnetic sound reproduction is provided, in which the film is pulled from the top spool box by the sprocket (1) and passes through the magnetic sound head (4) with the associated smoothing rolls. After this it passes through the aperture and intermittent sprocket (2) in the usual way and goes straight to the take-up sprocket (3) leading to the lower spool box, by-passing the optical sound head.

35 mm film has been regarded as the standard material for presenting entertainment motion pictures, but projectors capable of taking both 70 mm and 35 mm have become familiar in the more important theatres in large cities during the past ten years, while 16 mm machines are beginning to appear in small

entertainment cinemas in addition to their more general application as portable equipment for educational and commercial purposes.

Every projector comprises basically an intermittent mechanism which moves the film one frame at a time past an aperture or gate illuminated by a lamp and optical system from which the image is projected by a lens. Film is fed to the gate from a spool enclosed in a spool-box and then wound up on another enclosed spool after it has passed through the mechanism. At a suitable point on its path, where the film is in continuous motion, a sound pick-up head for either optical or magnetic sound tracks is installed and connected through amplifiers to the sound reproduction system. The projector mechanism is driven by a substantial electric motor at an exactly controlled uniform speed and the whole machine is mounted on a massive pedestal except in portable units where extra weight must be avoided. In motion picture theatres, projectors are always installed in pairs, so that continuous presentation without a break can be given by changing over instantaneously from one machine to the other at the end of each film reel; in some of the larger cinemas an additional machine may be installed as a standby against breakdown.

The intermittent mechanism

Although many forms of mechanism were designed and used in the early days of the cinema, an intermittent sprocket drive is now universal for professional 35 mm and 70 mm projectors. This sprocket is positioned immediately below the gate and is driven by a maltese cross mechanism, also known as a Geneva movement, which turns it one-quarter of a revolution for each rotation of the driving shaft. The action of the maltese cross on the sprocket provides a rapid

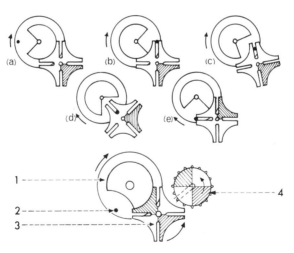

MALTESE CROSS MECHANISM
 The continuously rotating pulley (1) carries a pin (2) which engages with the slots of the Maltese Cross (3) during one quarter of its revolution to provide an intermittent movement of the sprocket (4) by 90° for every revolution of the drive shaft (a to e).

300

COMBINATION 70/35 MM SPROCKET
 An intermittent sprocket with sixteen teeth on
the 35 mm path and twenty teeth on the 70 mm path can
be driven from the same intermittent mechanism on a
combination 70/35 mm projector.

pull-down for the film in the gate, followed by a stationary period during which
the frame can be projected, the ratio of still to moving periods being normally
3 : 1. Although expensive to manufacture because of the mechanical precision
required and the highly resistent materials which must be used, the Geneva
movement is unequalled in providing the reliable and robust mechanism required
for lengthy periods of operation with the minimum of servicing attention. For
35 mm film, the intermittent sprocket used has 16 teeth, corresponding to four
frames, but for 70 mm film four frames require a 20-tooth sprocket of larger
diameter. Dual-purpose sprockets can therefore be made with the two sets of
teeth mounted on the same shaft and driven from the same intermittent move-
ment. Almost all 70 mm projectors are also designed to handle 35 mm film with
the minimum of mechanical alterations.
 Maltese cross mechanisms are employed on the most expensive types of
heavy duty 16 mm projectors intended for theatrical presentation, but in many
cases 16 mm projectors are used for more limited operating periods and factors
of cost and weight become important. Most of the smaller portable 16 mm
projectors make use of a reciprocating claw mechanism driven by a rotating
cam, similar to those in simple camera movements. These are considerably
lighter and cheaper to make, although likely to require more frequent maintain-
ance for good performance. Claw mechanisms of one type or another are also
used for 8 mm projectors.
 Directly linked to the intermittent movement of any projector is the shutter,
which serves to obscure the projection beam while the film is in movement
passing through the gate and which is therefore accurately synchronised with
the pull-down period. The standard projection rate for sound film is 24 pictures
per second but this shutter frequency gives objectionable flicker to the projected
picture. So an additional shutter blade is provided to cut off the projection beam

301

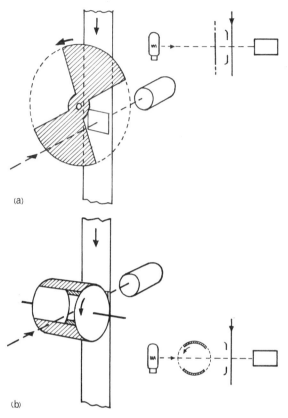

(a)

(b)

PROJECTOR SHUTTERS
(a) Normal two-bladed shutter rotating in a plane at right angles to the optical axis. (b) Drum shutter rotating at right angles to optical axis.

for part of the time that the picture is stationary in the gate. This increases the shutter frequency to 48 'exposures' per second and eliminates flicker. In most projectors the shutter takes the form of a two-bladed disc rotating behind the gate aperture but in some machines it is placed in front of the projection lens. Another type is the drum shutter consisting of a cylinder with two opposite openings rotating about an axis at right angles to the projector beam between the lamp and the gate. Projectors for 16 mm and 8 mm, which run silent film at 16–18 pps are fitted with a three-bladed disc shutter to provide a shutter frequency of at least 48 per second and so avoid flicker even at the slower picture rate.

Drive mechanism

In addition to the intermittent movement, the projector head mechanism must provide a drive for the continuously rotating sprockets which pull the film from

302

the feed spool and control its supply to the take-up. The spindle for this take-up spool is also driven by the main motor through a friction clutch device to provide enough tension to wind up the film after it has been through the projector.

An important feature of the film path in the projector is the sound head. Although the film movement at the picture gate is essentially intermittent, its passage through the sound pick-up must be continuous and absolutely uniform. Two positions for this sound head are possible, one for optical sound tracks, below the picture gate in the film path after the picture has been projected, and the other for magnetic sound, above the picture gate immediately after the film leaves the top spool box. Magnetic sound heads were sometimes added later to existing projectors as a superstructure on top of the main body and the term penthouse head is often used for the whole magnetic assembly. Modern projectors are now often built with both types of sound heads in the main film path enclosure and this is always the case with dual purpose 35/70 machines.

In both optical and magnetic sound heads the film passes through a guide path with spring-loaded tensioning rollers to filter out any irregularities of mechanical feed and is wrapped round the sound drum immediately adjacent to the pick-up head. This drum is part of a heavy precisely balanced flywheel which maintains smooth flutter-free movement of the film at the pick up point.

Sound head arrangements for 16 mm and 8 mm projectors follow the same general principles, apart from the fact that both optical and magnetic heads are located below the picture gate. On machines fitted with both systems alternative guide rollers allow the film to be threaded through one head or the other according to the material being used.

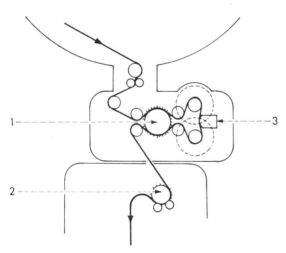

MAGNETIC PENTHOUSE HEAD

In some 35 mm projectors the magnetic sound head was added above the main projector path. In the arrangement shown, the sprocket (1) is free-running, the film being pulled from the top spool box by the regular feed sprocket (2) and passes over smoothing rolls and fly wheels to provide uniform movement at the magnetic head (3).

Spool boxes

When professional 35 mm film was made with the highly inflammable nitrate base the feed and take-up spool boxes above and below the main projector mechanism were an important safety factor. The film passed out of and into them through tightly-fitting flat rollers, known as fire-traps, which could prevent a fire on film in the gate spreading to the reels themselves. For safety reasons also, the size of film spool was limited to a maximum of 600 metres (2000 feet) of 35 mm film.

With the introduction of safety base non-flam film in 1951 the need for such precautions disappeared but the upper and lower spool box enclosures were retained for new machines to protect the film from general dirt while it was running. There was, however, a tendency to increase the size of the boxes to accommodate spools of larger diameter so that longer runs of film could be shown

PROJECTOR SPOOL BOXES
Most projectors are now fitted with spool boxes large enough to accommodate 6,000 ft of 35 mm, but a number of machines are also made with capacity for 15,000 ft or more, to allow a complete feature film to be shown from a single projector.

between changeovers. This move resulted in the 1800 metre (6000 feet) spool box now widely used, which allows a complete feature film up to 2 hours length to be projected with only a single changeover from one machine to the other. This greatly simplifies operations in the projection room and allows a considerable amount of automation to be introduced.

The ultimate development of large spool running is now to be seen in those projectors which can take lengths up to 5000 metres (16000 feet) at a single loading and which therefore permit a complete show of nearly three hours to be run from a single projector without changeover. The size and weight of this amount of film is such that spools cannot be lifted up to the normal feed position above the projector mechanism and both feed and take-up are placed below the main head on opposite sides of the mounting pedestal. Because of weight and inertia the feed reel must be motor-driven as well as the take-up reel and this drive can be reversed to allow a rapid rewind of the whole roll of film after projection without removing the spools from the machine. Ultra large spools have not yet been adopted for 70 mm film presentation and the substantially increased weight of this gauge normally limits the size of spool which can be lifted to the top feed enclosure to approximately 1100 metres (3500 feet), giving a running time of half-an-hour.

The small gauge films, 16 mm and 8 mm, have always been manufactured on safety base stock, so that spool boxes are never essential. The majority of these projectors, being designed for portability and cheapness, have retractable arms to carry the feed and take-up spools and the spindles of both of these can usually be driven in either direction to allow the machine to be used as a power rewind. All 16 mm projectors can take spools of 550 metres (1600 feet) capacity, with a running time of 45 minutes, but special attachments or projector stands with additional motor-driven spindles are sometimes used for larger spools, of one hour or an hour and a half capacity. On 8 mm projectors the 130 metre (400 feet) reel is commonly used, giving a projection time of over half-an-hour for silent film in the standard 8 gauge or twenty minutes for Super 8 mm with sound.

Light sources

For many years the only light source sufficiently powerful for 35 mm projection in a larger motion picture theatre was the carbon arc and this is still the most widely used. The size of carbons and their current capacity vary according to the size of screen to be illuminated. Maximum diameters up to 16 mm taking 250 amps at 120 volts D.C. are used for the very largest theatres. In all cases metallic compounds and metal coatings are incorporated in the carbon electrodes to increase the arc brightness and provide a colour temperature of 5500°K. The lamphouse optics are usually a mirror-arc system, the arc crater being imaged by a large concave mirror into the projector gate. To ensure that the arc crater remains at its correct position the feed of the carbon electrodes as they are burnt away must be very carefully controlled and elaborate automatic mechanisms have been devised to do this without constant attention by the operator. The carbon rods must still however be replaced manually when they are completely consumed, and this factor provides a limit to the period for which a carbon arc can be run continuously, even with automatic feed control. At the present time the largest carbons available to not allow a total run of more than about an hour before replacement.

Within recent years an alternative light source for all but the very largest

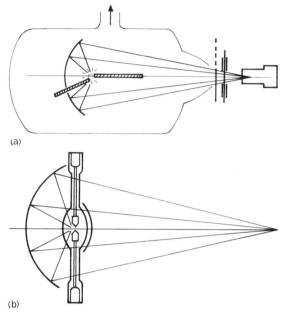

(a)

(b)

MIRROR ARC LAMP HOUSE
 (a) The crater of a carbon arc is reflected by the large parabolic mirror to pass through the film in the projector aperture into the lens. (b) The carbon arc may be replaced in a similar arrangement by a xenon arc discharge lamp.

theatres has become available – the xenon arc lamp. This is an enclosed discharge lamp in which the arc burns between tungsten electrodes in an atmosphere of xenon gas, the colour of the light so produced is very close to that of a high-intensity carbon arc. Although a D.C. supply and a special starter circuit are necessary, the arc requires no attention while running and once the lamp has been correctly set up in the optical system it provides an extremely steady and consistent light output for a considerable period. An operating life of 1000 to 1500 hours can be obtained from a single lamp. Originally the largest xenon lamps made were of 2 kw capacity, which was only sufficient for review rooms and smaller theatres, but larger lamps up to 6500 watts are now available and can meet the needs of a large proportion of modern medium-size cinemas. In many cases a xenon arc lamp can be substituted for a carbon arc in an existing lamphouse optical system but it is preferable to have a complete lamphouse designed around the new source, and both mirror and condenser lens optical systems have been provided to suit this type of lamp.

 The introduction of gas discharge lamps for projection led to the development of pulsed light sources in which the lamp is not burnt during the period when the film is moving in the gate. This permits the shutter to be eliminated from the projector mechanism and reduces the power required for lamp operation. The dark period of the lamp must of course be accurately synchronised with the intermittent movement and additional dark periods must be provided while the

306

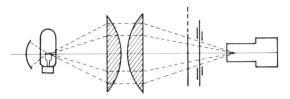

CONDENSER LAMP SYSTEM
 For small gauge projectors, an incandescent
lamp with reflector and condenser lenses is used to
illuminate the film in the projector gate.

film is stationary to avoid flicker. The earlier types of pulsed sources in specially designed projectors were high-pressure mercury vapour discharge lamps with metallic additions such as cadmium to improve their spectral emission. Although very satisfactory for projecting black and white films their irregular spectral distribution proved unsuitable for colour. But the development of pulsed xenon arcs removes this limitation.

In 16 mm projectors the emphasis on portability and simple operation ruled out carbon arc lamps as light sources except for a very few permanent installations and the standard source adopted was the incandescent tungsten lamp which could be run from a normal A.C. supply, either directly at 125 v or from 230 v through a transformer. Projectors for small screen presentation nearly always used 500 w or 750 w lamps, and 1000 w lamps were available for larger requirements. Condenser lens systems are almost universal for 16 mm lamphouse optics. The reflector however, is sometimes incorporated within the lamp envelope instead of forming part of the external assembly. Lamps with very efficient internal reflectors are used in some 8 mm projectors in place of a condenser system. To obtain high brightness levels the filaments of standard tungsten lamps are appreciably overrun in voltage and this results in a comparatively short operating life.

Tungsten-halogen lamps provided an improved source of light for the smaller gauge projectors so they were rapidly adopted. The smaller filament and greater efficiency of these lamps gives considerably more light without a corresponding increase in power consumption, while the absence of bulb blackening by evaporated tungsten allows a significantly longer life. Such lamps are now very widely used, especially for 8 mm projectors where the advantages over the smaller sizes of normal incandescent bulb are very marked. However, the small size of the tungsten-halogen lamp precludes the use of an internal reflector so that an external mirror or condenser system is necessary.

All incandescent lamps, both the normal and the tungsten-halogen type, operate at a lower colour temperature than an arc or xenon lamp, generally at a level of about 3200°K, and are therefore more yellow in colour. Consequently 16 mm colour prints are normally made with a somewhat bluer balance than 35 mm copies to correct for this characteristic. For many years this presented no particular problem, since all 16 mm copies are viewed under similar conditions. But recently the situation has been altered by the appearance on the market of 16 mm projectors fitted with small xenon discharge lamps. These lamps, even in the 300 w and 500 w sizes, are much more efficient than the older incandescent bulbs and are particularly suitable for 16 mm equipment permanently installed in small theatres where the necessary power supplies and starter

circuit can be installed. Colour prints made for projection with xenon must of course be balanced to suit the bluer light source, exactly as with 35 mm copies, and confusion is likely to occur unless the projection conditions are specified to the processing laboratory.

Projection lenses

Lenses designed for motion picture projectors differ from those on the camera in a number of important details. In the first place, a projection lens should have its optimum performance at its maximum aperture, preferably

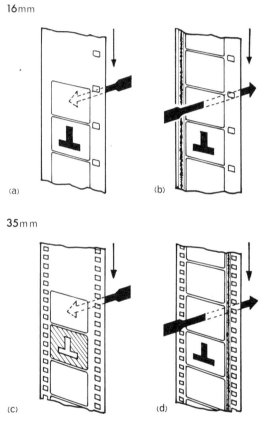

16mm

(a) (b)

35mm

(c) (d)

FILM USAGE

Because 16 mm film is often a reversal material standard projection practice, b, is the same as that for the camera exposure, a, emulsion side to the lens in both cases. The convention for 8 mm film is similar.

35 mm film, on the other hand, is normally exposed in the camera as a negative, c, from which a print must be made. This must be projected with the base side to the lens, d. 70 mm follows the same practice.

$f1\cdot8$ or better, and is not fitted with an iris diaphragm to control its light transmission. Secondly, it is normally required to produce an image at a great distance in comparison with the distance of its object, the plane of the film in the projector gate, and it need never be focused at short range. Lenses for 35 mm film projection theatres are rarely less than 75 mm (3 in.) in focal length and may often be 100 (4 in.) or 125 mm (5 in.), with distances of the order of 35 to 70 metres (100 to 200 ft) between projector and screen. Unlike camera lenses, those for projection do not have their own calibrated focusing mounts, but are carried in an adjustable sleeve whose position can be adjusted by the operator, either directly or by remote control, to focus the picture on the screen. The optical design of the lens must be capable of giving a well defined image over the whole screen area, even in the corners, with a minimum of scattered light which would degrade the picture by flare, and without serious colour aberration which can cause coloured fringes around the objects on the screen. The lens must also be efficient in collecting the maximum amount of light passing through the film from the lamp and in fact the whole optical system of mirror, arc, film, and lens should strictly be considered as a whole for optimum performance.

Lenses for 16 mm and 8 mm projectors must be designed with the same requirements in view but the need to provide an inexpensive product is often paramount and a compromise design must often be adopted which is more economical. The focal lengths of projection lenses for the smaller 16 mm frame are naturally shorter than those for 35 mm, and a length of 50 mm (2 in) is popular. With 8 mm the focal lengths are shorter still, 25 mm (1 in.) or even less. Variable focal length (zoom) lenses are sometimes fitted to 8 mm projectors for convenience in setting up projector and screen.

Anamorphic projection

The introduction in 1953 of widescreen systems using anamorphic images on the film meant that corresponding anamorphic projection lenses were needed to correct the distortion intentionally produced at the time of photography. After an initial period when a number of alternatives were being tried out, the position stabilised and all anamorphic systems now in use involve a lateral expansion factor twice that of the vertical magnification, as in the original CinemaScope process.

Anamorphic projection lenses may be designed as complete units, or attachments may be fitted in front of conventional projection lenses to produce the horizontal enlargement. At one time, lenses were made with an adjustable expansion factor but found only limited application. As with anamorphic camera lenses several different types of optical design are in use involving either concave cylindrical elements or wedge-shaped prisms. Another system, not used on cameras, has a pair of cylindrically curved mirrors to produce the same effect. Projection anamorphs do not suffer from the camera problem of varying expansion at short working distances, but colour aberration and flare are both intensified by the additional glass surfaces. The best performance is obtained from lenses in which the backing lens and anamorph are designed and mounted together as a unit, provided with a focusing element which can be adjusted for the exact projection distance at which it is to be used.

As 35 mm projectors in motion picture theatres often need to show both normal and anamorphic films in the same programme, an easy change of projection lens must be provided. When a separate anamorphic attachment is used with a single backing lens it can be mounted on a swinging arm to move it in and out of

309

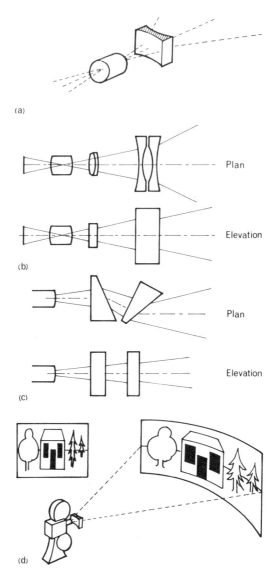

(a)

Plan

Elevation

(b)

Plan

Elevation

(c)

(d)

ANAMORPHIC PROJECTION
(a) A cylindrical concave element in front of a normal projection lens widens the horizontal angle without altering the vertical, as is seen in (b) which shows a cylindrical system in plan and elevation. A similar widening of the horizontal angle can be obtained by a pair of prisms (c); the expansion is adjustable by the relative setting of the prisms, to give a variable anamorphic factor. (d) A projector fitted with an anamorphic lens giving a horizontal magnification of twice the vertical is used for the wide-screen projection of anamorphic prints.

position but a lens turret mounting is often preferred for unit lenses and is more convenient for automated operations. When the same projector is used for 70 mm film as well as both forms of 35 mm a three-lens turret is desirable.

Different widescreen formats use different sizes of aperture in the projector gate and each projector must be provided with a series of easily changed aperture masks for the different aspect ratios employed. In many machines masks for 35 mm can be changed while the projector is threaded up but the switch from 35 mm to 70 mm involves a change of guides and runners as well as the gate aperture. As 16 mm projectors are not fitted with turrets a complete lens is replaced for anamorphic projection; the same size of gate aperture is used for all projection formats.

Screens

In the earlier cinema theatres the picture was usually projected on a flat canvas surface which was sometimes mounted on rollers for easy removal, and painted with matt white scene paint. Later, permanent screen frames with tension mounting were installed and with the introduction of sound, the uniform screen was replaced by a perforated one to allow the loudspeakers to be placed behind it. Various types of rubber- or plastic-surfaced fabrics were used, the screen being cleaned and re-sprayed at intervals when it became discoloured.

As the size of screens increased, the need for a brighter picture than could be obtained from a matt white surface became obvious, and various forms of semi-specular reflecting screen were introduced. These provided a considerable in-

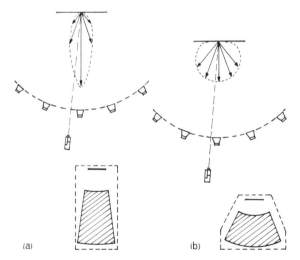

(a) (b)

SCREEN REFLECTIVITY
 A semi-specular screen (a) shows a higher reflectivity than a matt diffusing screen (b) but only over a limited viewing angle. Such a screen will appear too dark when viewed from seats outside the central area. Matt screens should therefore be used in theatres with widely disposed seating and highly reflective screens used in longer narrow arrangements.

crease of screen luminance but were markedly directional in their effect, so it became necessary to match the type of screen to the proportions of the auditorium. In theatres where the seating occupies a long narrow rectangle a narrow angle high-gain reflective screen can be used to advantage. But for the wider fan-shaped arrangement a widely diffusing low-gain screen must be employed, otherwise the picture will appear too dim from seats near the ends of the rows. The gain factor of a screen in any direction is a measure of its luminance compared with that of a normal matt white diffusing surface, but values greater than 3 can only be obtained over a restricted angle.

Often, the projector is positioned high up at the back of the theatre and projects its beam downwards at an appreciable angle to the horizontal. Where directional screens are installed, it is important that the screen be tilted away from the vertical to ensure maximum reflection towards the largest number of seats. It is sometimes difficult to find a satisfactory compromise of screen angle where seats are distributed on different levels, as in stalls and balcony, and marked differences in screen luminance are often to be observed from different parts of the auditorium. These problems are being recognised in many of the new, smaller theatres now being built and there is a general move to provide seating on one gently sloping floor only, with the projection room positioned so that its throw is as horizontal as possible.

Screen luminance

Film should be projected under standardised conditions of screen brightness. Too dark a picture is dull and difficult to see while too bright a picture looks burnt out and shows grain and flicker. Since both the intensity of the light from the projector and the reflectivity of the screen surface itself contribute to this, international standards specify the measurements of luminance at different points on the screen by a narrow angle photometer from various positions within the auditorium. The American standard luminance for the centre of the screen with no film in the 35 mm projector gate calls for 55^{+14}_{-21} candelas per square meter (equivalent to approximately 16 foot-lamberts in English units) when measured from a representative position in the centre (of the width) of the auditorium and two-thirds of the distance back from the screen to the rear row of seats. The edges of the screen should have between 65 and 85% of the centre luminance. The standards in other countries and those of the International Standards Organisation are generally similar in nature, although a somewhat lower norm of 40 cd/m² with a more limited lower tolerance of $^{+25}_{-10}$ have been adopted. The same values for projecting 70 mm have been proposed, except in Great Britain where the higher screen luminance possible from the larger projector aperture is recognised by the specifications of a standard of 80^{+20}_{-19} cd/m².

Often, 16 mm films are projected on a non-perforated screen with the speakers placed below or at one side, but in general, somewhat similar standards of screen brightness are set, although the lower power of 16 mm light sources is recognised by permitted lower tolerances in some countries.

The performance of directional screens presents many assessment problems, particularly in measuring luminance uniformity across the screen from different positions in the auditorium. No generally accepted practice has yet been adopted, although proposals embodying a degree of screen curvature to produce uniform brightness over as large a block of seats as possible have been put forward. Here again in modern small theatres these difficulties are recognised

and seating is installed only over the floor area where viewing conditions are good.

Screen formats

Comparatively early in the history of the cinema a screen proportion of approximately 4 (wide) by 3 (high) was established and this continued even after the introduction of sound, which reduced the area on 35 mm film available for the picture. Although special presentations at international exhibitions and other occasions had made use of other proportions from exceptional projection equipment, it was not until the introduction of CinemaScope in 1953 that a major change in format affected the screens of motion picture theatres throughout the world.

In its original form, CinemaScope made use of a larger printed area on 35 mm film perforated with smaller sprocket holes and when projected with an anamorphic lens having a 2:1 lateral expansion factor, it produced a screen proportion of 8 by 3, or 2·66:1 aspect ratio. This naturally required the installation of a much wider screen in the theatre, but in many cases either the structure of the building or the distribution of seats proved a limitation to the size that could be accommodated.

When it was found that prints of CinemaScope subjects were required with optical sound tracks in preference to the multi-channel magnetic records first provided, the width of the printed image area was reduced to that normally used on standard 35 mm film, resulting in a picture with a projected aspect ratio of 2·35:1, and this has remained the standard for anamorphic projection ever since.

When normal prints were presented in the 4 × 3 format in the same programme as those in CinemaScope, they appeared unduly small by comparison so the practice grew up of projecting such prints with a lens of shorter focal length than normal to give magnification out to the full width of the CinemaScope screen, even though this meant that some of the composition at the top and bottom of the frame would be lost beyond the screen area. Although this procedure of cropping pictures composed to the earlier format was most undesirable, the need for a change was recognised and a procedure was established by which non-anamorphic (flat) photography was composed to a preferred aspect ratio of 1·75:1. It was indicated however that the area photographed should permit projection to any proportions between 1·65:1 and 1·85:1, depending on local conditions in the theatre. This is now general practice.

Any motion picture theatre must therefore be able to present pictures with several different aspect ratios, in the course of a single programme − 2·35:1 for anamorphic projection, a ratio between 1·65:1 and 1·85 for flat, widescreen films, and in some cases the earlier 1·33:1 for old films or special presentation. If 70 mm films are to be shown, a screen with AR 2·2:1 is required. All these different screen sizes and proportions are provided by movable masks of black cloth which can be positioned to form the borders of the projected area and the setting of these masks to predetermined positions is carried out automatically by motor drives controlled from the projection box.

Sound reproduction

The sound signal associated with the projected picture is initiated at either the magnetic or the optical sound head of the projector, where it is preamplified

SCREEN FORMATS
 The aspect ratio of 1·33:1 was used for many
years until the introduction of the Cinemascope type of
wide screen which had the proportion 2.35:1 for
anamorphic projection. Non-anamorphic (flat) wide-
screen presentation is now generally projected with aspect
ratios between 1·65:1 and 1·85:1. The larger 70 mm
wide-screen presentation has the proportions 2·2:1.

by the local head amplifier and passed to the main channel. The outputs of both
projectors in a theatre installation are fed through equalisation circuits to the
same main amplifier, the switch-over from one to the other being coupled to
the picture changeover control. Volume control potentiometers, or faders,
are provided to ensure that the outputs of the two machines are accurately
matched and adjusted for the level of the print being run.

 The main power amplifier with its associated filter and balance controls feeds
the theatre loudspeaker system, together with a small monitor speaker in the
projection room itself. Overall volume control to the theatre speakers is pro-
vided for the operator and is often paralleled by a second volume control in
the auditorium. The speaker system in the theatre is located behind the screen

and comprises an assembly of bass and treble units, with the crossover networks dividing the signal between them. According to the size of the theatre an assembly may contain two treble and four bass units, the high frequency group being mounted in a single multi-cellular horn, while the low frequency speakers have their own resonant enclosures. Speaker design and position must be carefully matched to the characteristics of the auditorium in order to ensure a uniform distribution without reflections over the whole seating area. The space behind and around the speakers must be made completely sound absorbent to avoid reflections from any back or side walls behind the screen and thick acoustic blankets are used for this purpose.

The simple monophonic system here outlined must of course be greatly extended where multi-channel stereophonic reproduction is to be provided. Each of the separate magnetic tracks on the film, four on 35 mm and six on 70 mm, must be picked up by its own head and fed through its own chain of amplifiers and control circuits to the appropriate groups of speakers. In the 35 mm CinemaScope system three groups of speakers are located behind the screen, in right-hand, left-hand and central positions, and fed from the corresponding three main tracks on the film. The effects speakers distributed around the auditorium are fed from the narrow magnetic stripe and are only brought into operation on special occasions during the presentation. The appropriate amplifier is opened up to full output by a high frequency (12 kHz) signal recorded on the effects track immediately ahead of the point at which the

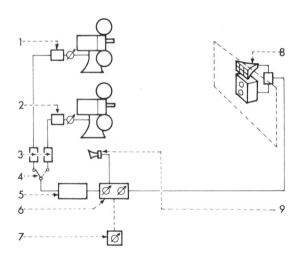

THEATRE SOUND SYSTEM
The sound signals from the two projectors of the theatre are balanced at their local head amplifiers (1) (2) and fed through equalisers (3) to the main amplifier (5). A sound change-over switch (4) is coupled to the projector change-over control. Overall volume and balance control (6) are provided for the signal passing to the speaker system (8) and the volume control may be parallelled by an additional control (7) in the auditorium itself. A small monitor speaker (9) is installed in the projection room.

315

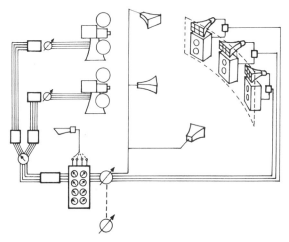

MULTI-CHANNEL SOUND SYSTEM
The general arrangement of amplifiers and controls for multi-channel reproduction follows the same pattern, but separate filter and balance controls for each of the four sound signals is provided as well as overall volume control. The monitor speaker in the projection box can be switched to select any of the four sound channels.

auditorium speakers are to be used. With 70 mm presentation five groups of speakers are used behind the screen as well as the effects speakers in the body of the theatre. On the 70 mm print all six magnetic records are of equal width, so that a high frequency control signal on the effects track is not necessary.

The speaker positions for a multi-channel system and the balance of their outputs for level and quality are extremely critical, particularly for the treble units which contribute the greater part of the directional effects in stereo presentation, but it is true to say that when the installation has been completed it is capable of providing a result of outstanding quality and realism.

When normal monophonic 35 mm films are to be run in a theatre equipped for 70 mm presentation the optical track is normally reproduced through the amplifiers and speakers of the three central positions only, with the outer speakers and the auditorium speakers disconnected. These can however be used for other purposes, for example to play background music from disc or tape before the main programme or during the interval.

The auditorium

The architectural design of motion picture theatres has developed over the years as the demands of presentation techniques have changed but the basic requirement remains to provide a given audience with an unobstructed view of a large bright picture accompanied by clear intelligible sound under conditions of reasonable comfort. The technical requirements of projection optics and acoustics must be given their full weight, while safety regulations by the local authorities determine many features such as gangway arrangements, number and position of exits, minimum lighting, etc.

While no very strict rules can be laid down for the size of screen and the distribution of seats to suit every possibility, it is generally accepted that the nearest row of seats should not be closer to the screen than one quarter of the distance of the rear row and that about one-third would be preferable, although involving much wasted floor space. With the moderately curved screens now generally used (which have a radius equal to the length of the projection throw) a screen width of about half the distance of the rear seats is acceptable for anamorphic pictures of AR 2·35 : 1. Such a screen subtends an angle of about 90° at the centre of the front row of seats, but for some forms of special presentation, such as Cinerama, a wider and more deeply curved screen embracing 120° at the same position is sometimes used. This is claimed to enhance audience participation and the sense of depth but only too often results in an extremely distorted picture when viewed from the seats at the sides, especially if the projector position requires a steep angle of throw.

Even with almost flat screens, seats at the extreme ends of the nearer rows give a somewhat distorted view and it is desirable to restrict the seating area within lines spreading outwards from the edges of the screen at about 20° or less. Within this wedge-shaped space the lines of seats should be slightly curved to face towards the centre of the screen and the positions of the individual seats should be staggered to avoid interference by the head of the person in the row immediately in front.

In the vertical arrangement it is also desirable that the level of each row of seats should be raised as they recede from the screen to give an uninterrupted view. A clearance of 10 cm (4 in.) for average row spacing is usually necessary. This leads to a sloping floor arrangement, but the front rows must not be taken too far below the bottom line of the screen or the viewers head is uncomfortably tilted back. To avoid strain it is considered undesirable for the top edge of

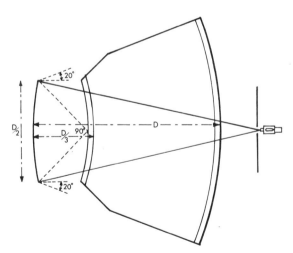

THEATRE SEATING PLAN
 The row of seats nearest the screen should be about one-third of the distance of the rear row; a screen width of half this distance is satisfactory for anamorphic wide-screen projection.

THEATRE SEATING ELEVATION
To provide a clear view of the screen from all positions, the rows of seats should be raised at a floor slope of about 1 in 8. The line of sight from the front row to the top edge of the screen should not be greater than 35° above horizontal. To avoid distortion the downward angle of tilt of projection should be as small as possible.

the screen to appear more than 35° above the horizontal line of sight. The safety regulations laid down by many authorities specify the maximum permitted gangway slope and seating may therefore have to be arranged in stepped rows rather than a continuously sloping floor. Where the seating in a theatre auditorium is extended by a balcony many of the same considerations apply. The bottom edge of the balcony structure must not of course obstruct the top of the screen from the rear seats below by coming too low or too far forward. Balconies are normally more steeply raked than the floor, so that most lines of sight to the screen are unimpeded, but if the projection room is to be located at the back of the gallery an unduly depressed angle of throw to the screen may be required. Where possible the projection room should be positioned within the balcony structure to provide a substantially horizontal direction of projection.

Acoustic treatment

Within the structure determined by the foregoing considerations the acoustic characteristics must be studied and modified to provide satisfactory sound reproduction. In general, this means the specification of reverberation times over the required frequency range and the control of sound reflections by dispersion and absorbtion. Reverberation times normally increase with larger volume auditoria and for a given building are greater for low frequencies of sound, below 500 Hz. In fairly large theatres with volumes of 8 to 10,000 cubic metres, reverberation times of 0·7 to 1·0 sec. at 500 Hz and above, provide a good standard of intelligibility for dialogue; at 50 Hz the time may be two to three times as long. Reverberation times of 1·5 sec in the middle frequency range are undesirable, however, and lead to unsatisfactory listening.

Unwanted sound reflections are most undesirable if they result in interfering echoes at any seating position in the auditorium and large hard surfaces which might cause appreciable delayed reflections must be broken up or given acoustic treatment. A completely absorbent structure on the other hand results in a very 'dead' reproduction. The object should be to achieve proper distribution and dispersion of reflected sound rather than complete suppression.

The science of acoustic engineering and experience with auditoria has reached the point where much initial architectural design work can be done towards producing a satisfactory result, but the final test must always be in the actual theatre and instrumental test methods are now available to ensure the optimum

318

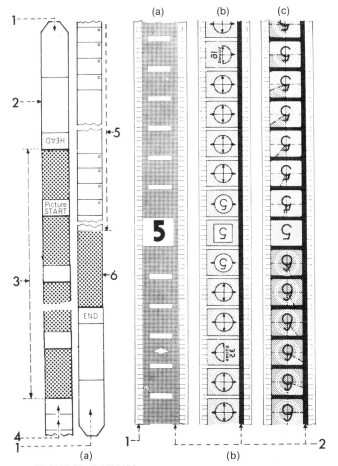

RELEASE PRINT LEADERS

 (a) Essential Features. Leaders provide the projectionist with identification and synchronising information and serve to protect the film from damage. (Left) Head Leader. 1. Protective Section. 2. Identification of subject, reel number, etc. 3. Synchronising section with numbered frames and start marks. 4. First frames of picture. (Right) Tail Leader. 5. Final picture section with cue marks to warn operator of change-over. 6. Opaque black run-out, followed by end identification and protective section. (b) Examples of Synchronising Sections. 1. Head End. 2. Sound Track Area.

(a) Academy Leader has number at 16 frame intervals; the Sound Start frame is indicated by a diamond. (b) Television Leader. The arrow heads in the frame show the TV scanned area; 35 mm and 16 mm sound start frames are shown. (c) SMPTE Universal Leader (1965). Synchronising numbers extend over 24 frames, indicating 1 second at standard projection speed. A rotating radial line marks the passage of a each second as an aid to exact timing.

arrangement of speakers and surface treatment. Ideally such tests should be made under realistic conditions with a seated audience, but the present practice of installing upholstered seats with absorbent panels underneath means that the acoustic difference between an occupied and an unoccupied seat is not too great and can be allowed for in assessing test results.

Projection practice

The projection room serves as the control centre for the whole performance at the theatre and houses the film projectors, a projection lantern for advertising slides and coloured lights effects, the equipment for background music from tape or disc in the intervals between showings and all the operating switchgear to control screen masking, stage curtains and auditorium lighting. The projection room may also contain rewind benches, preferably power-driven, and facilities for the assembly, inspection and repair of prints, although these film handling operations are often carried out in an adjacent separate room with accompanying film storage racks.

An essential requirement in projection practice is to change over smoothly and almost imperceptibly from one projector to the other at the end of a reel so that the dramatic continuity of the story is uninterrupted. All release copies have sections of information printed on the film at the beginning and end, and these portions, known as the leaders, assist the projectionist in his operations. At the beginning is a length of unprinted film to protect the outer windings of the roll. This is followed by the printed identification of the title and reel number of the subject, sometimes with instructions for the type of projection and the level at which the sound fader should be set. This is followed by the synchronising leader, which contains frames printed with symbols to indicate the position of the film in the projection aperture and sound head for correct running. This shows a series of numbers spaced at regular intervals up to the opaque black portion immediately preceding the first frame of the picture and occupies a length of 12 feet, corresponding to 8 seconds running time, from the frame marked 'Start'. At the end of each reel the last picture frame is followed by a section of black film run-out and the title and reel number are repeated, while within the final section of the picture itself, sets of dots known as cue marks are printed in the upper right corner of the frame at two specified positions. The last set of dots, the changeover cue, appears in four frames one second before the end of the picture, while the first dots, known as the motor cue, appear in four frames 12 feet earlier in the reel.

The motor cue appears on the screen as a warning to the projectionist to start up the second projection machine so that is is fully up to speed when the change-over cue comes up, at which point he operates the changeover switch which closes a shutter in front of the first machine and opens up the second, at the same time switching the sound from one head to the other. From experience, the projectionist knows the lengths of time taken by his particular machines to start up and he can therefore thread up the projector at the numbered frame in the head leader which gives a precisely-timed change.

Automatic operation

Projection changeover requires careful attention during the last portion of each reel. This is not easy when looking through the small window of a distant projection room at the back of the auditorium. Modern theatres are now often

AUTOMATIC PROGRAMME OPERATION

Coded signals from the film being projected and from a pre-set interval clock are used to control automatically a complete theatre presentation programme. A simple sequence might comprise—

Cues from clock {

Background music

Dim House Lights
Raise Stage Lighting

Start Projector
Fade in Film Sound
Open Projector Shutter

Open Stage Curtains

Dim Stage Lighting

(Film programme continues with automatic projector change-over when required)
At end of film:

Cues on Film

Start Interval Clock

Cues from Clock {

Close Stage Curtains

Raise Stage Lighting
Raise House Lighting

Stop Projector

Fade in Background Music

Sales Spotlight On

built with a separate control room from which the projectors can be operated by remote control, giving the projectionist a clear view of the screen for focusing the picture, adjusting sound level and making the changeovers. Switchgear for

321

v

starting background music, opening and closing the stage curtains, altering screen masks and operating the lighting is then all taken to the same control point, leaving the projection room solely for loading the film on the machines.

A further development, automatic operation to a predetermined programme, leaves the projectionist free to concentrate on focus and volume level control. He may even work from any position in the auditorium using a radio control link to relay devices attached to the projector.

A number of systems are now in use which combine inpulse signals obtained from the running film itself with clock timing devices to allow very complete programmes to be set up and operated over the whole period that the theatre is in use. General services operations, such as switching on air conditioning and ventilation, overall lighting and power generators are started by straight timing devices. But those procedures directly concerned with the film presentation such as setting screen masking, stage lighting, music effects, curtain opening and, of course, the projector changeover are triggered by cues on the film, usually by metallic foil contacts attached to the film edges, in accordance with a preset routine selected to meet the exact needs of the show. To take full advantage of these systems projectors with large spool capacity, motor driven lens turrets, automatic aperture change and long running carbon arc or xenon lamps are of course essential. Fully automated operations are particularly important in modern small theatres which have to make economies in labour.

Drive-in theatres

In the United States and a few other countries with favourable weather conditions, a large car-owning population and available space on the outskirts of built-up areas, the open-air drive-in theatre has become an important method of motion picture presentation. Here the structural problems are those of civil engineering, since a graded or terraced site often 300 metres square must be provided with all the associated roadways for the easy access of automobiles to their viewing positions. As in modern indoor theatres, a wedge shaped plan

DRIVE-IN THEATRE LAYOUT
Drive in Cinema for 650 cars. 1. Control gates. 2. Pay boxes. 3. Main entrance. 4. Administration offices, restaurant, toilets, etc. 5. Exits. 8. Parking area. 9. Projection suite. 10. Screen. 11. Car bays.

is usually adopted with the car bays arranged in curved rows centred towards the screen. The average capacity provided is usually 600 to 700 cars, but some locations take more than 2000. The screen must be well elevated and of massive construction to withstand wind and weather. Screens are normally built to the CinemaScope aspect ratio of 2·35:1 and may be over 40 metres wide for the larger installations. Sound distribution is entirely by local speaker units for each car, either mounted on posts distributed along the parking bays, or as portable speakers which can be hung inside a car and plugged into external permanent outlets.

The projection room is usually located within the viewing area, some two-thirds of the distance back to the rear rows, and must be designed not to obscure the view of cars parked behind it. The practice is therefore either to install a very low flat-roofed structure or to raise it on pillars above the lines of sight. With the very large screens, only high-intensity arc lamps can be used as projector light sources and it is often necessary to make specially light prints for drive-in theatres to improve the effective image brightness on the screen. The picture quality can be very considerably improved by using 70 mm projectors but the increased cost of prints makes this uneconomical except in large and well-attended theatres.

Non-theatrical presentation

The term 'non-theatrical' covers a wide range of motion picture applications, but normally refers to 16 mm material, which may be used for anything from the presentation of industrial and public relations subjects in the well-equipped private viewing rooms of large commercial organisations to showing entertainment feature films under the special conditions required for passenger aircraft flights.

Shows on 16 mm with portable projectors must usually be confined to comparatively small screen sizes because of the limited illumination available, so directional high-gain screens are often used to improve screen luminance. Anamorphic systems are infrequently used in 16 mm except where reduction prints from 35 mm anamorphic originals are shown. Viewing arrangements for 16 mm showing therefore tend towards long and narrow seating areas rather than the

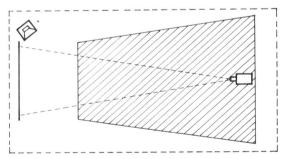

16 MM PROJECTION
The lower power of 16 mm projection light sources necessitate the use of high-gain reflective screens so that a long narrow seating arrangement is preferred.

323

fan-shaped layout preferred for 35 mm theatres, and speakers are usually placed beneath or at the side of the screen rather than behind.

Prints in 16 mm always provided a very convenient method of motion picture entertainment on ocean-going ships and liners and during recent years the extension to long-distance aircraft flights has proved an important field of distribution. Special equipment has been designed to meet the needs of safety and operation by non-technical staff under these conditions. Small high-gain screens must be used to allow adequate brightness even in a partially lit aircraft cabin and the sound must be fed to headphones at each seat, so that it does not interfere with passengers who do not wish to participate. In some cases dual language version prints must be used, so that members of the audience on an international flight can choose which to listen to. This has been done by providing combined optical and magnetic track prints, for example with the optical track in English and the magnetic in French, the version heard being selected by a switch on the passenger's headphones. Projection equipment must be completely self-contained, pre-loaded with a complete programme needing only to be switched on by the cabin crew and capable of meeting the stringent fire and safety regulations of the aircraft licensing boards. In one system a series of separate projectors distributed around the cabin provided a number of viewing zones each with its own small screen, the film passing through each projector head in turn in the course of a long continuous path from feed reel to take-up. It is now more general to use a single projector with a somewhat larger screen, although in the very big passenger aircraft now coming into operation two or even three complete units may be installed to provide reasonable viewing conditions for all seats. However in this case each projector is supplied with its own film and is often fitted with automatic rewind or loop facilities so that it is always ready for showing on the next flight. All loading and film handling is done by technical service staff at the ground terminals and the equipment has merely to be switched on when required, by the aircraft stewardess.

Educational usage

Sound film in the 16 mm gauge is widely used for projection of educational and cultural subjects in the classroom. A number of universities, and some schools, have the advantage of lecture rooms in which projection equipment can be permanently installed. But by far the greatest proportion have to make use of portable equipment temporarily put into position in the available working space. The inconvenience of setting up a projector and stand, erecting a screen and blacking-out a normal classroom, coupled with the reluctance of some teachers to operate the complex equipment, all combine to limit the use of this form of visual aid and have led to the development of smaller self-contained projection units designed specifically for educational use. One of these is the 8 mm cartridge-loaded loop projector. Many educationalists consider that the usual sound film lasting 20 minutes or more in a darkened classroom would provide a substitute for the teacher rather than an aid to his or her instruction, and that a much shorter moving picture illustration was needed which could be used by the teacher to illustrate a particular point whenever required. These single-concept films lasting only two to four minutes, are conveniently supplied as continuous loops which can be repeated as many times as required without rewinding. They are loaded in cartridges or cassettes for easy insertion into a suitable projector. For simplicity and cheapness standard 8 mm film was the original choice as only a small

EDUCATIONAL PROJECTION CABINET
A self-contained back-projection unit can be used in a lighted classroom without black-out. The projector mechanism is housed under the lower cover and uses 8 mm film loops in pre-loaded cassettes.

screen was necessary for the average size of class-room. In some cases the projector was mounted in a self-contained back-projection cabinet resembling a television set so that the picture could be shown in a normally lighted room.

Subsequently, the same cassette loading system was adopted for showing short silent films in the super 8 gauge, while other forms of film handling container for use with self-threading projectors became available, although without the loop repetition feature. A cartridge-loading sound projector using super 8 film with optical or magnetic track has also been developed; this provides a running time of up to 30 minutes, and also employs the loop principle to avoid rewinding between showings. Small highly directional reflection screens are now being produced which allow conventional front projection in a room without black-out, and these are very suitable for the class-room.

A completely different approach to educational presentation is represented by a number of systems in which a black and white picture is displayed on the screen of a normal television receiver. Some of these propose the use of regular Super 8 film but in the EVR process the original material is reproduced by electron-beam recording on to a special high definition film from which copies are printed on unperforated film 8·75 mm wide with two rows of pictures. The Selectavision system will use a non-photographic image in the form of coded information on a transparent plastic tape. In all cases the programme is to be supplied in pre-loaded cassettes and electronicly scanned on a self-threading replay deck to produce a television signal which can be fed into the aerial socket of the receiver. The international exchange of any material other than conventional film will involve some difficulties because of the different television standards in use in various parts of the world and the presentation of colour pictures from coded information will further complicate this problem.

EVR SYSTEM
A narrow sprocket-less film carries two rows of images either of which can be scanned on a playing deck to produce signals fed to a normal television receiver.

Film in television

Despite the wide use of video recordings on magnetic tape, motion picture film continues to be an important medium for producing television programmes and the special factors concerning its presentation by electronic methods must therefore be considered.

For television transmission, film must be analysed on a special form of projector known as a telecine machine or film scanner, of which there are two main categories. One of these may be regarded as a direct coupling of a conventional intermittent film projector mechanism and lamp with a television camera, normally using in the latter an image storage tube such as a vidicon. Here the projected image scanning is carried out entirely in the camera in accordance

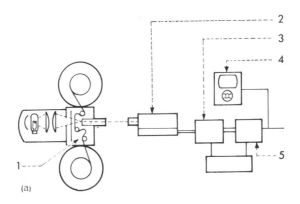

(a)

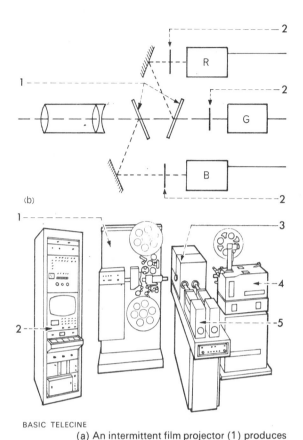

(b)

BASIC TELECINE

 (a) An intermittent film projector (1) produces an image in a Vidicon television camera (2) with its control unit (3) and gamma and light control (5). The output signal is checked by picture and waveform monitor (4). (b) In colour television transmission the beam is divided by dichroic filters (1) into its red, green and blue components which form images in three vidicon tubes R.G. and B. Colour filters (2) are used to trim the response for each channel. (c) In a multiplex telecine, projectors for 35 mm film (1), 16 mm film (4), and slides (5) can all use the same camera (3) and monitor control (2).

with normal television practice, the problems of colour analysis and image registration between the component vidicon tubes being exactly similar to those effective when the camera is used normally for live subject material. Vidicon cameras for colour may use three tubes for analysing the image into its red, green and blue components, or four tubes, in which case one tube provides the luminance signal only and the other three the red, green and blue chrominance signals. Although more complex, four-tube vidicon cameras show some advantages in colour reproduction and picture definition.

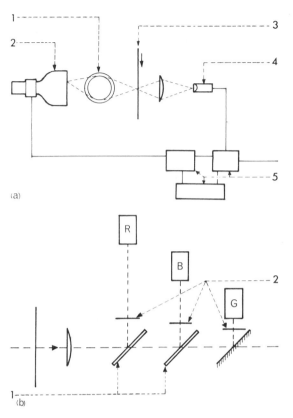

(a)

(b)

FLYING SPOT TELECINE
 (a) The raster on the face of the flying spot
cathode ray tube (7) is imaged by the optical compensator
(1) to scan the frame on the continuously moving film (3).
The light transmitted by the film is focused on the photo-
cell (4) to produce the video signal to the control units (5).
(b) For colour television the transmitted light is analysed
into its red, green and blue components by dichroic filters
(1) and colour trimming filters (2) for the three photo
multipliers R, G and B.

The second main type of television film scanner is known as the flying spot
telecine and uses neither a conventional film projector mechanism nor a normal
television camera. In this system the light source used to illuminate the film
is itself a scanning cathode ray tube in which an electron beam is made to tra-
verse the phosphor screen and produce a brilliant spot of light moving to form
the television raster. This raster pattern is focused on to the film frame and a
photomultiplier tube on the other side responds to the varying amount of light
transmitted through each point of the image to produce an electrical signal.
After amplification and correction this output provides the signal for television
transmission.

328

In flying spot systems for colour the light which has passed through the film must, of course, be divided into the red, green and blue components to affect three separate photomultiplier tubes which produce the corresponding signals. Photomultipliers must therefore be chosen which have good sensitivity in the required spectral region. Similarly, the colour of the scanning tube phosphor should ideally be a perfect white with equal energy for the three colours, but this is not easy to obtain and in practice the intensity in the red region is normally deficient and must be corrected by the relative amplification following the photomultiplier. Problems of colour registration do not arise with flying spot telecine since the scanning raster is formed before the film and no optical images are actually produced at the colour analysis stage.

Telecine mechanisms

The mechanisms providing the effect of intermittent film movement differ considerably in the two telecine systems, and differ again between television systems of different field rate standards. With vidicon telecines the tube retains the image temporarily (image storage) so that a fairly conventional projector mechanism can be used with a comparatively long period for the pull-down from one frame to the next. For European television systems, which transmit a rate of 50 fields per second, the film projector is run at a speed of 25 pictures per second, instead of the normal cinema rate of 24 pps, each frame being used for two fields by means of a two-bladed shutter. The alteration in the rate of the action shown and in the pitch of the sound reproduced by this change of projection speed is normally regarded as acceptable, although the faster running speed ($93\frac{3}{4}$ ft per minute instead of 90) must be taken into account when timing programmes.

In American television, where a 60 field standard is used, film is projected at the standard speed of 24 pps and various devices have to be employed to produce the correct relation between frames and fields. In general these require successive film frames to provide the information for two and three television fields alternately, the pull-down between frames being synchronised with one of the blank periods between fields by the use of a five bladed shutter. Another system has a pulsed light source similarly synchronised with the projector intermittent and the television field frequency.

In the flying spot telecine machines which are widely used in Europe a different set of problems arise because the system has no image storing capacity. This means that the pull-down from one frame to the next must be completed in the very short period between two successive television fields. The accelerations required have so far proved too great for the inertia of the larger and heavier 35 mm film, but special pneumatic intermittent mechanisms have been developed for 16 mm in which the film is held stationary in the gate for the period of two television fields and is then pulled down to the next frame in less than 1·2 milliseconds, which is the line suppression period.

For 35 mm, flying spot telecines use continuously moving film with optical systems to scan each frame twice and produce the two television fields. Two types of optical arrangement are possible, the twin lens, and the polygon system. In the former the scanning raster of the flying spot tube is projected on to the plane of the moving film through a pair of lenses which are alternately opened and closed by the rotation of a multi-bladed shutter synchronised with the field scan frequency. Each frame is thus effectively scanned twice in two positions as it passes through the film gate.

329

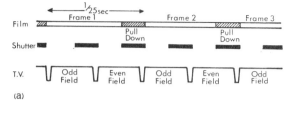

TELECINE SYNCHRONISATION
(a) For European TV standard of 50 fields per second, film is run at 25 pps so that each frame is scanned by two television fields. (b) In American 60 fields per second television, film is run at 24 pps and a pulsed light or five-bladed shutter used, so that successive frames are scanned by two fields and three fields, so that each two film frames correspond to five TV fields.
The image is stored by the Vidicon camera tube during scanning.

The continuous movement of the film must, of course be extremely accurate and uniform, and elaborate mechanical smoothing devices are employed. Variations in the height of the frame image as a result of shrinkage or perforating dimensions are also important since they can affect the registration of the frame in relation to the scanning raster. Such pitch differences can be compensated by a fine adjustment to the separation of the twin lenses, correcting the spacing of the two scanning positions at the film gate. This can be made automatically by continuous measurement of the pitch dimension as the film runs through the projector.

Polygon telecines make use of a rotating prism to produce an image of the scanning raster exactly in register with the continuously moving film. The principle of optical compensation for film movement by such a prism is similar to that employed in some forms of high speed camera and in simple editing viewers. But the accuracy required in a telecine system means that a multi-facet prism is essential—sixteen facets represents a reasonable compromise between optical performance and expense of manufacture. The film path is actually wrapped around part of the prism surface so that one frame lies exactly on each face. An external condenser system produces an image of the scanning tube raster approximately at the centre of the polygon so that as the prism rotates the raster appears to move in step with the film frame. As with the twin lens system the light passing through the film is collected by a condenser to fall on the photomultiplier surfaces.

330

Telecine reproduction

As a result of the combined characteristics of telecine analysis, the television system itself and the conditions under which television images are viewed, the end product differs considerably from the picture seen when the same film is projected in a normal cinema theatre or review room, and these differences are even more noticeable in the reproduction of colour film than black and white. The most serious problem arises from the inability of the telecine-television chain to handle the full tonal range of image densities on the film, with a result

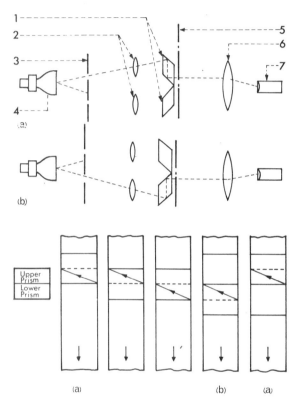

TWIN LENS TELECINE

The optical compensator for the continuously moving film (5) in a flying spot scanning system (4) consists of a pair of lenses (2) and prisms (1) which are used alternately by the movement of the shutter (3). The frame of moving film is scanned first by the upper prism system for the first TV field (a) and then for a second time by the lower prism system for the alternate TV field (b). The upper prism then commences the first scan of the next frame (a) and so on.

The light passing through the film is collected by the condenser lens (6) and falls on the photomultiplier tube (7).

331

that important gradation in shadow areas may be lost. The analysis of the three colour images existing in a colour film by an imperfectly matched telecine system introduces errors in reproduction and leads to reduced saturation and inaccuracies in hue. Typical conditions for television viewing—a room with ambient lighting—makes the viewer more critical of inconsistencies and variations in colour reproduction which would easily be accomodated in the darkened surroundings of a motion picture theatre. A number of errors can be partially corrected electronically in the telecine stage. Gamma correction improves tonal rendering and electronic masking is introduced to offset the distortions of colour reproduction. Overall correction of colour balance can also be applied if the original print grading has departed too far from the critical standards required. However, all these modifications represent an additional complexity in telecine operation which must be minimised wherever possible.

The problem of tonal limitation must be considered whenever photography is planned for eventual television presentation. Subject matter contrast should

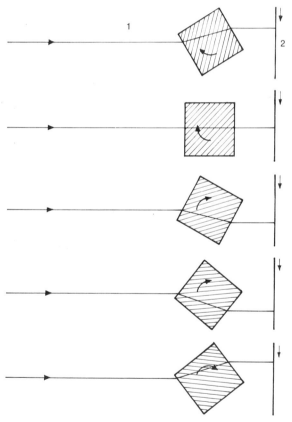

OPTICAL COMPENSATOR
A glass prism (1) can be rotated so as to hold an image stationary on a moving film (2), thus compensating for its movement until a new face of the prism is presented, corresponding to the next frame.

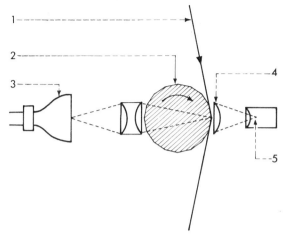

POLYGON TELECINE

The continuously moving film (1) is wrapped on a rotating polygon prism (2) so that one frame lies on each face. The optical compensation provided by the prism ensures that the image of the flying spot raster (3) moves exactly in step with the film. Light passing through the film is collected by the condenser lens (4) and falls on the photomultiplier tube (5).

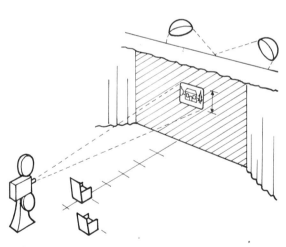

TELECINE SIMULATOR

To simulate the effect of telecine reproduction, film is optically projected on to a small screen mounted within a large illuminated surround, which may be a translucent panel lit from behind. Any surrounding drapes should be light in colour. The small picture is viewed from a distance of five to six times its height.

be limited by avoiding extremely reflective white and absorbent black materials: as a general guide whites of not more than 70% reflectance and blacks of not less than 4% reflectance should be used. Lighting contrast should be kept low, although this is often difficult in exterior scenes with natural lighting. Where possible, the ratio of key-light plus filler light to filler alone should be around 2 : 1. Film prints made specifically for television use should be processed to a lower contrast than normal if they are in black and white. With colour materials, special low contrast print stocks may be used, but these will show reduced colour saturation which can introduce further problems. In general, by a combination of these precautions, prints for telecine should have maximum shadow densities of not greater than 2·0 to 2·3, in comparison with prints for normal cinema projection, which may have such areas with densities of 2·8 to 3·0, or even higher.

As a result, prints which are well suited to telecine requirements tend to look flat and light, especially in the shadow areas, when optically projected in a normal review room. Ideally, such prints should only be assessed by actual telecine presentation over a closed circuit television system, but this is often impracticable or inconvenient. As an alternative, proposals have been made for special optical projection conditions to simulate television characteristics — a relatively small projected picture within a large illuminated surround. The picture should be viewed from a distance of five to six times its height and the surround should be lit to the same colour temperature as the picture to an intensity corresponding to one-third or one-quarter of the luminance of a white object on the screen. In practice this means the using of xenon lamps, or their equivalent in colour temperature (5400°K approx), for both projector and surround, and a surround luminance of 8 to 12 candelas per square metre when the screen luminance, measured without film in the gate, is of the order of 100 cd/m². A projected picture 1 m wide and 0·75 m high would be viewed from a distance of some 4 to 5 m. The illuminated surround conditions the eye so that the picture appears to have higher contrast than in a darkened room and provides a reference field against which colour uniformity can be more critically judged. Viewing conditions of this type are always to be recommended where a standard telecine system is not available for inspecting prints for television, both 35 mm and 16 mm.

Appendices

Hyperfocal Distance and Depth of Field

The hyperfocal distance of a lens is the distance at which it must be focused to give the greatest possible depth of field; at this setting all objects from infinity down to half the hyperfocal distance will be acceptably in focus. It is expressed as:

$$H = \frac{F^2}{f \times c}$$

where F = the focal length of the lens, f = the lens diaphragm setting, or stop, and c = the diameter of the circle of confusion for an image point which is regarded as sharp.

For motion picture work, c is generally taken as 0·002 inches for 35 mm film and 0·001 for 16 mm. If F and C are given in inches, H will be measured in inches.

For any particular focal length, F^2/c is a constant, so $H = k/f$ and the hyperfocal distance varies inversely with the stop; k is the value for the hyperfocal distance of a lens of that focal length at a theoretical stop value of f. 1. To simplify calculation, k can be specified to give a value of H in feet: in round numbers for 35 mm photography with a:

$$
\begin{array}{ll}
\text{1 inch lens (25 mm)} & k = 40 \\
\text{2 inch lens (50 mm)} & k = 160 \\
\text{3 inch lens (75 mm)} & k = 370 \\
\text{4 inch lens (100 mm)} & k = 640
\end{array}
$$

The Hyperfocal Distance for any stop setting can thus be quickly estimated; for example, with a 50 mm lens at f. 4, it is 160/4 = 40 feet; when the lens is focused at this distance, everything from 20 feet out to infinity will be reasonably sharp and this represents the maximum depth of field.

When a lens is focused at another object distance, D, the depth of field, can be calculated by the following simplified formula for cases where D is large in comparison with the focal length:

$$D_N, \text{ Near Limit of depth of field} = \frac{H \times D}{H + D}$$

and

$$D_F, \text{ Far Limit} = \frac{H \times D}{H - D}$$

For the 50 mm lens focused at 20 feet, these become:

$$D_N = \frac{40 \times 20}{40 + 20} = 13 \cdot 3 \text{ feet}$$

and

$$D_F = \frac{40 \times 20}{40 - 20} = 80 \text{ feet}$$

while if the same lens is focused at 8 feet,

$$D_N = \frac{40 \times 8}{40 + 8} = 6 \cdot 6 \text{ feet}$$

and

$$D_F = \frac{40 \times 8}{40 - 8} = 10 \text{ feet}$$

showing how much the depth of field decreases for nearer subjects. For very close work, the depth of field becomes so small that it must be calculated more exactly to allow for the focal length of the lens:

$$D_N = \frac{H \times D}{H + (D - F)}$$

and

$$D_F = \frac{H \times D}{H - (D - F)}$$

For 16 mm, the smaller frame size requires a more critical image, so the circle of confusion, c, is taken as $0 \cdot 001$ inches, but the focal lengths of the lenses generally used are shorter. For the formula $H = k/f$, the approximate values of k for 16 mm photography can be taken as 20 for a $12\frac{1}{2}$ mm lens, 80 for a 25 mm lens, and 320 for a 50 mm lens, to give H in feet.

When working with lenses scaled in metres, the same formulae may be used, the values for k in $H = k/f$ being $12\frac{1}{2}$ for a 25 mm lens, 50 for 50 mm, 107 for 75 mm and 200 for a 100 mm lens, in 35 mm photography. The value for D must, of course, be stated in metres to give the limits of the depth of field in the same terms.

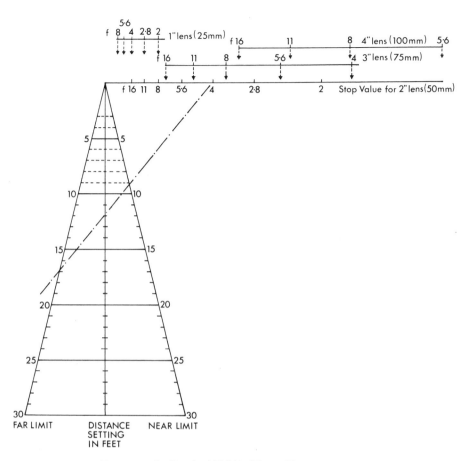

FAR LIMIT DISTANCE NEAR LIMIT
 SETTING
 IN FEET

Nomogram for Depth of Field in 35 mm Cinematography.
A line joining the distance setting to the *f*-stop used for
a 2 in lens shows the extent of the depth of field by its
intersections with the near and far limit lines. The *f*-stop
values for other lenses must be transferred to the same
axis for use.

In the example shown, a 2 in lens at *f*·4 is focused at
12 ft and shows a depth of field extending from 9·2 ft
(near) to 17·0 ft (far).

This diagram shows graphically

(a) Increasing depth of field with smaller aperture;
(b) Decreasing depth of field with shorter object distance;
(c) Decreasing depth of field with longer focal length;
(d) Asymmetric distribution of near and far limits about
object distance.

The stop required for a given depth of field can be
readily obtained.

337

Exposure Index Ratings

	ASA (BS) arithmetic	DIN (logarithmic)	Relative exposure required
Lower speed colour reversal materials	⌈ 16 ⎨ 25 ⌊ 50	13 15 18	× 6 × 4 × 2
	64 ·	19	× 1½
Colour negative	100	21	1
Higher speed colour reversal	⌈125 ⌊160	22 23	
Forced development of high speed colour reversal	⌈200 ⎨320 ⌊400	24 26 27	× ½ × ¼

Black and white negative stocks are available with ratings up to 400–500 ASA (27–28 DIN).

Strictly, the ASA exposure index is calculated on the basis of still photography rather than motion pictures, but may be used for all practical purposes.

Exposure Calculation

A useful formula for the calculation of exposure for average subjects is:

$$L = \frac{25 \times f^2}{s \times t}$$

where L = the required lighting level (key + filler) in foot-candles
f = the lens diaphragm setting, or stop,
s = the exposure index of the sensitivity of the film used, on the ASA arithmetic scale, and
t = the time of exposure, normally 1/50th or 0·02 of a second for photography at 24 pps.

For example, if a scene is to be shot on colour negative of rating ASA. 100 and a lens setting of f.4 is required to give the necessary depth of field, the lighting level for normal speed photography is:

$$L = \frac{25 \times (4 \times 4)}{100 \times 0·02} = 200 \text{ foot-candles}$$

For a lighting contrast of 3 : 1,

(Key light + filler) = 3 × filler alone = 200 foot-candles

so that the filler light alone would be of the order of 70 foot-candles and the key light alone about 140 foot-candles.

Similarly, the stop required for a measured lighting level can be calculated:

$$f = \sqrt{\frac{L \times s \times t}{25}}$$

For example, if the lighting level of an outdoor scene is measured as 1250 foot-candles, the lens diaphragm setting for shooting at 24 pps on colour negative rated ASA. 64 with the correction filter required is thus;

$$f = \sqrt{\frac{1250 \times 64 \times 0·02}{25}} = \sqrt{64} = 8$$

For light-meters scaled in Lux, 1 foot-candle = 10·76 lux

Masking in Colour Negatives

If the images formed in the layers of an integral tri-pack film by colour coupling during development were theoretically ideal, each would absorb light of one spectral region only and transmit all other regions perfectly. Thus the cyan dye image should absorb red dye light completely and transmit both blue and green light unimpaired. In practice, none of the dye images is perfect and all have some unwanted absorbtions in the regions they should transmit. In colour negatives this leads to undesirably degraded reproduction, particularly noticeable in bright saturated hues, unless compensated by the process of colour masking. In this context, the term mask is used to describe a positive image matching the negative and combined with it to modify its transmission characteristics.

In a masked type of colour negative such as Eastmancolor negative, the unwanted absorbtions of the cyan and magenta images are corrected by the use of couplers in the layers which are themselves coloured. In the red sensitive layer a coupler is included which forms a cyan dye by combination with the oxidised developer in the vicinity of the exposed image. This coupler is itself reddish-orange in colour. Where the cyan dye is formed on development, this orange colour is destroyed but where the coupler is not converted it retains its original appearance. The unconverted coupler thus forms a positive masking image which absorbs blue and green light to the same extent as the unwanted blue and green absorbtion of the cyan dye. The whole layer thus shows an image with specific differential absorbtion of red light only, blue and green being uniformly absorbed everywhere either by the cyan image itself or by the unconverted orange coupler.

Similarly, the green sensitive layer of the negative film contains a yellow coloured coupler which combines to form a magenta dye with oxidised developer. Where the magenta image is formed, the yellow colour is destroyed but where the coupler is retained it forms a positive masking image balancing the unwanted blue absorbtion of the magenta dye.

Processed Eastmancolor negative therefore appears orange in colour in unexposed areas because of the presence of unchanged yellow and reddish-orange couplers in the green and red sensitive layers. The overall absorbtion of blue and green light is considerable, the maximum transmission being only about 10% for the blue and 25% for the green, but the improved colour saturation to be seen in the resultant colour positive print is very striking in comparison with that from an unmasked negative. Masking is particularly important in colour duplicating processes to avoid undue degradation of colour reproduction by successive copying stages.

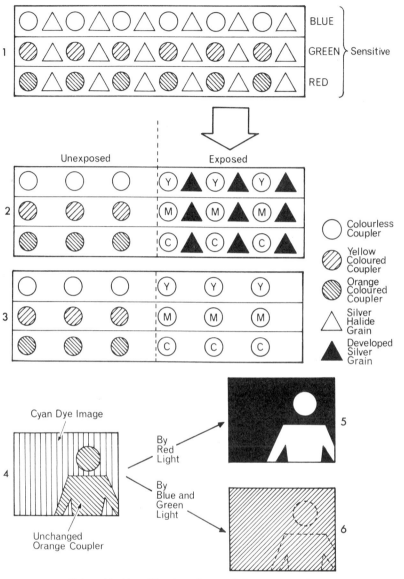

BLUE ⎫
GREEN ⎬ Sensitive
RED ⎭

Unexposed | Exposed

○ Colourless Coupler

⊘ Yellow Coloured Coupler

◍ Orange Coloured Coupler

△ Silver Halide Grain

▲ Developed Silver Grain

Cyan Dye Image

By Red Light

By Blue and Green Light

Unchanged Orange Coupler

Colour Masking. The three layers of the unexposed raw stock, 1, contain coloured couplers with the silver halide grains. After the first stage of processing, 2, these form coloured dye images, Y, C, M, where exposed silver grains are developed but are unchanged elsewhere. After the removal of the developed silver, 3, the exposed areas consist of dye images with unaltered couplers elsewhere.

The Red record layer, 4, thus contains a cyan exposed image and unchanged orange coupler and shows differential transmission of Red light, 5, but uniform absorption of blue or green light, 6.

341

Angles of View of Camera Lenses (based on projected film area)

Focal Length in mm	Horizontal angle	Vertical angle in degrees	
35 mm STANDARD LENSES	A.R. 1·33 : 1	A.R. 1·75 : 1	
Wide ⎰ 20	55·3	41·7	33·3
Angle ⎱ 25	45·5	33·9	26·9
50	23·7	17·3	13·6
Long ⎰ 75	15·9	11·6	9·1
Focus ⎰ 100	12·0	8·7	6·8
150	8·0	5·8	4·5

35 mm ANAMORPHIC LENSES. A.R. 2·35 : 1

Wide angle	25	91·2	39·9
	50	46·2	20·6
	75	31·7	13·8
	100	24·0	10·4
Long focus	150	16·1	6·9

65 mm LENSES (NON-ANAMORPHIC) A.R. 2·21 : 1

Wide angle	28	77·9	42·9
	50	52·8	24·8
	75	35·9	16·6
	100	27·3	12·6
Long focus	150	18·8	8·4

35 mm HALF-FRAME LENSES A.R. 2·35 : 1
(TECHNISCOPE)

Wide angle	18	61·3	28·1
	25	47·2	20·5
	40	29·8	12·9
	50	24·0	10·3
Long focus	75	15·8	6·9

16 mm STANDARD LENSES A.R. 1·33 : 1

Wide ⎰	10	51·5	39·9
Angle ⎱	12·5	42·2	32·2
	25	21·9	16·5
Long	50	11·1	8·3
Focus	75	7·4	5·6

Bibliography

Chapter 1 — General

Archaeology of the Cinema, C. W. Coram, London, 1965.
Technological History of Motion Pictures and Television, Ed. Raymond Fielding, Berkeley, U.S.A., 1967.
Film & Its Techniques, R. J. Spottiswoode, Berkeley, U.S.A., 1951.
TV Film Engineering, R. J. Ross, New York, 1966.
Principles of Cinematography, L. J. Wheeler (4th Ed), London, 1969.
All-in-one Cine Book, P. Petzold, London, 1969.
Colour Cinematography, A. Cornwell-Clyne, London, 1951.
History of Colour Photography, J. S. Friedman (Rev. Ed), London, 1968.
Focal Encyclopedia of Film & Television Techniques, London, 1969.

Chapters 2 and 3 — Basic Photography and the Photographic Image
Fundamentals of Optics, F. A. Jenkins and H. E. White, New York, 1957.
Photographic Optics, Arthur Cox, London, 1966.
A System of Optical Design, Arthur Cox, London, 1967.
Ilford Manual of Photography, London, 1960.
Basic Photography, M. J. Langford, London, 1967.
Photographic Theory, T. H. James and F. C. Higgins, New York, 1960.
Theory of the Photographic Process, Ed., C. E. Mees and T. H. James, (3rd Ed), New York, 1966.
Photographic Theory for Motion Picture Cameramen, R. Campbell, London, 1970.
The Reproduction of Colour, R. W. G. Hunt, (2nd Ed), London, 1967.
Photoprocessing Chemistry, L. F. A. Mason, London, 1966.
Sensitometry, L. Lobel and M. Dubois, London, 1967.
General Sensitometry, Y. N. Gorokhovski and T. M. Levenburg, London, 1965.
Principles of Colour Sensitometry, SMPTE, New York, 1967.
Eastman Motion Picture Film Reference Book, London, 1968.

Chapter 4 – Picture Recording
Technique of the Motion Picture Camera, H. Mario Raimondo Souto, London, 1965.
The 5 C's of Cinematography, J. V. Maxcalli, New York, 1966.
Professional Cinematography, C. G. Clarke, Hollywood, 1969.
Elements of Colour in Professional Motion Picture Photography, SMPTE, New York, 1969.
American Cinematographer Manual (3rd Ed), Hollywood, 1969.

Chapter 5 – Sound Recording and Reproduction
Acoustics, G. W. Mackenzie, London, 1964.
Elements of Sound Recording, J. G. Frayne and H. Wolfe, London, 1969.
High Quality Sound Reproduction, J. Muir, London, 1961.
High Quality Sound Production and Reproduction, H. B. Hadden, London, 1962.
Tape Recording and Reproduction, A. A. MacWilliams, London, 1964.
Magnetic Tape Recording, H. G. M. Spratt, (2nd Ed), London, 1964.
Microphones, A. E. Robertson, London, 1963.
Sound for Film and Television, BKSTS, London, 1970.

Chapter 6 – Studio Production
Designing for Motion Pictures, E. Carrick, London, 1941.
Technique of Film Editing, Karel Reisz & Gavin Millar, London, 1968.
Technique of the Film Cutting Room, E. Walter, London, 1969.
Editors and Editing, Ed. J. G. Gross, New York, 1962.
Technique of Editing 16 mm Film, J. Border, London, 1968.
Technique of the Sound Studio, A. Nisbett, London, 1962.
Motion Picture Studio Stage Survey, SMPTE, New York, 1970.

Chapter 7 – Further Aspects of Production
Technique of Documentary Film Production, W. H. Baddeley, London, 1963.
Technique of Special Effects Cinematography, Raymond Fielding, London, 1965.
Special Effects in Motion Picture Photography, P. P. Clarke, New York, 1969.
Technique of Film Animation, J. Halas and R. Manvell, London, 1968.
Animation Techniques and Commercial Film Production, E. L. Levitan, New York, 1963.
Animated Film, Dr. R. P. Madsen, New York, 1969.

Chapters 8 and 9 – Processing and Duplicating
Motion Picture and Television Film Image Control and Processing Techniques, D. J. Corbett, London, 1968.
Control Techniques in Film Processing, SMPTE, New York, 1960.

Chapter 10 – Presentation
The Motion Picture Theatre, SMPTE, New York, 1948.
Motion Picture Presentation Manual, BKSTS, London, 1961.
Motion Picture Projection and Theatre Presentation Manual, SMPTE, New York, 1969.

Monthly Journals
American Cinematographer. Hollywood.
British Kinematography (Journal of BKSTS). London.
Film User. London.
Journal of the Society of Motion Picture and Television Engineers. New York.

Glossary

A.R. Aspect ratio, the proportion of picture width to height.

A.S.A. American Standards Association, especially their exposure index or speed rating to denote film sensitivity.

Acetate Cellulose acetate, used for non-inflammable film base and in transparent sheets as colour filters.

Additive colour Colour mixture by the addition of light of the three primaries, red, green and blue.

Advance The separation between a point on the sound track of a film and the corresponding picture image.

Anamorphic An optical system having different magnifications in the horizontal and vertical dimensions of the image.

Answer print The first print combining picture and sound submitted by the laboratory for the customers' approval.

Aperture (1) The opening of a lens controlling the amount of light transmitted.
 (2) The opening in a camera, printer or projector mechanism at which the film image is presented.

B.P. Back Projection. Presentation of a picture on a translucent screen for viewing from the side opposite the projector. Used in special effects work to provide a background scene behind action being photographed.

Backing A black coating applied to the film base to reduce halation.

Barn-doors Hinged flaps mounted on studio lamps to control the light beam.

Barney A flexible camera cover used to reduce noise.

Base The transparent support on which the photographic emulsion of a film is coated.

Blimp A sound-proof camera housing.

Bloop A triangular patch used to suppress the noise made by a splice in an optical track.

Blow-up Enlargement of a film image.

Boom A long adjustable arm to carry a microphone.

Broad A large floodlight for general illumination.

Brute A high-intensity spotlamp.

345

Capstan The drive spindle of a magnetic tape or film sound recorder.

Celluloid Cellulose derivatives in thin transparent sheets used as film base or for the drawings of an animated cartoon film.

Characteristic curve A curve showing the relation between the exposure of a photographic material and the image density produced after processing.

CinemaScope Trade name of a system of anamorphic widescreen presentation.

Clapper A pair of hinged arms clapped together and photographed by the camera to establish synchronisation between the picture and sound records.

Claw Mechanism used in cameras and projectors to move the film intermittently.

Clip A short section of film removed from a scene or sequence.

Cluster An assembly of magnetic pick-up heads in a projector for multichannel sound reproduction.

Colour temperature Factor indicating the colour quality of a light source.

Console Control desk for the centralised operation of sound recording and mixing or of studio lighting equipment.

Cookie A perforated surface used to produce a pattern of shadows in studio lighting.

Core A plastic cylinder on which film is wound for transport and storage.

Coupler A chemical incorporated in the emulsion of colour film stocks which produces a dye image associated with the developed silver image.

Crane A large mobile camera mounting providing a range of elevated working positions.

Cross mod A test method for determining the optimum print requirements for a variable area sound track.

Cyan Blue-green colour, the complementary of red.

D log E curve The curve showing the relation between the logarithm of the exposure E and the resultant density D on processed film.

Daily The first positive print made by the laboratory from the negative photographed on the previous day.

Density A factor which indicates the light-stopping power of a photographic image.

Developing The chemical process which converts a photographic exposure into a visible image.

Diaphragm An opening controlling the amount of light transmitted by a lens.

Dissolve A transition between two scenes where the first merges imperceptibly into the second (Lap Dissolve; Mix).

Dolly A mobile camera mounting on a wheeled trolley.

Dubbing The combination of several sound components into a single recording.

Dupe A copy negative, short for duplicate negative.

Dye Transfer A photo-mechanical method of colour printing.

Edge No Coded numbers printed along the edge of a strip of film for identification.

Emulsion The gelatine layer of photo-sensitive material in which the image is formed.

f-number A measure of the diaphragm opening of a lens, expressed as a fraction of its focal length.

f p m feet per minute, expressing the speed of film moving through a mechanism.

f p s frames per second, indicating the number of images exposed per second (preferably pps – pictures per second).

Fade An optical effect in which the image of a scene is gradually replaced by a uniform dark area, or vice versa.

Fader A control for sound level in recording and reproduction.

Field In television, one complete sequence of raster lines forming an image.

Filler Light directed into the shadow area of the subject being photographed.

Filter A transparent material having the ability to absorb certain wavelengths of light and transmit others.

Fishpole A lightweight arm carrying a microphone.

Fixing The removal of unexposed silver halides from the film during processing.

Flag A small opaque shade used in studio lighting.

Flat (1) Referring to tonal gradation, of low contrast.
 (2) Referring to image form, suitable for normal projection optics as distinct from anamorphic "squeezed" images.

Flicker The alternation of light and dark periods which can be visually appreciated.

Flood A lamp providing general diffuse illumination on a studio set.

Flop-over An optical effect in which the image is shown reversed from right to left.

Focal length The distance from the effective optical centre of a lens to the point at which an image is formed from an object at infinity.

Focus The position at which a sharp and well-defined image is produced by a lens.

Fog Level The minimum density of the unexposed area of processed film.

Format The size or aspect ratio of a motion picture frame.

Frame The individual picture image on a strip of motion picture film.

Fresnel A lens with annular ridges used in studio spot lamps.

Gamma The measure of contrast of a photographic process, representing the slope of the characteristic curve.

Gate The aperture assembly of a camera, printer or projector at which the film is exposed.

Gobo An opaque adjustable shade used in studio lighting.

Grading The process of selecting the printing values for colour and density of successive scenes in a complete film to produce the desired visual effects.

H & D curve The characteristic curve of a photographic process, after Hurter & Driffield who established the basis of sensitometry.

H.I. arc High intensity arc, an efficient light source of high colour temperature.

Halation Unwanted exposure surrounding a photographic image caused by light scattered within the emulsion or reflected from the base.

Halide Compound with a halogen, such as chlorine, bromine or iodine.

Head The essential mechanism of a camera, printer or projector.

Hertz (Hz) Unit of frequency, 1 Hz = 1 cycle per second.

ips inches per second.

Intermittent The mechanism of a camera, printer or projector by which each frame is held stationary when exposed and then replaced by the next.

Iris An adjustable diaphragm to control the light transmission of a lens.

Jelly, or gel (for Gelatine). A transparent filter or diffusion sheet placed in front of a lamp in studio lighting.

^0K Degrees Kelvin, the unit of the colour temperature scale.

k Hz kilo Hertz, one thousand cycles per second in frequency.

k W kilo watt, measure of electrical power, one thousand watts.

Key Light The main lighting of a scene.

Kinescope American term for recording a television image on film.

LCT Arc Low colour temperature arc, a carbon arc lamp matching the colour of incandescent lighting.

Laboratory The organisation processing and printing film.

Latent image The invisible image in exposed photographic film before processing.

Lavalier A personal microphone worn on the artist's chest.

Leader A length of film at the beginning and end of a release print for identification and handling. Also blank film used for spacing in editing work or for threading up processing machines.

Log A report sheet giving details of picture or sound material recorded.

Loop A length of film joined head-to-tail for repeated continuous running.

Looping The process of recording short sections of sound using guide prints in loop form.

M & E Music and Effects. A sound track containing only these components without speech and dialogue.

Magazine The film container for cameras, printers and projectors.

Magenta Red-purple, the complementary colour to green.

Magnetic Track A sound record on a stripe of magnetic oxide applied to motion picture film.

Mag-opt A motion picture print with both magnetic and optical (photographic) sound track records.

Married print A motion picture print with both picture and sound on the same strip of film.

Mask The plate carrying the aperture of a camera or projector: also the black surround to the screen on which a picture is projected.

Master A positive print made specially for duplicating purposes rather than projection.

Matrix A film with images in gelatine relief used in the dye transfer printing process.

Matte An opaque outline which limits the exposed area of a picture, either as a cut-out object in front of the camera or as a silhouette on another strip of film.

Matte Box A box-like frame mounted in front of a camera lens to hold cut-out masks or mattes during photography.

Microphone An instrument for converting the mechanical energy of sound waves into electrical signals for recording.

Mix See Dissolve.

Mixing The combination of several sound components into a single recording.

Movement The main intermittent mechanism of a camera, printer or projector.

Moviola A motor-driven viewing machine used in film editing.

Mute A print with the picture image only, without a sound track.

Negative A photographic image in which the tones of the scene are reproduced as the reverse of those in reality, light areas appearing dark, and vice versa.

Nitrate Cellulose nitrate, a highly inflammable material once used as film base.

Non-flam Film base of low inflammability and a slow burning rate.

Optical Effects Trick shots prepared by the use of an optical printer in the laboratory, especially fades and dissolves.

Optical Sound A sound track in which the record takes the form of variations of a photographic image.

Out-take A take of a scene which is not used for printing or final assembly in editing.

PE Polyester, polyethylene terephthalate, a plastic used as base for magnetic tape and sometimes for photographic film.

PVC Polyvinyl chloride, a plastic used as a base for magnetic tape.

pps Pictures per second, indicating the rate of photography in filming.

Pan Rotation of the camera about its vertical axis in a horizontal plane.

Perforations Holes along the edge of a strip of film used for its location and transport.

Photo-cell Device for converting variations of light intensity into electrical signals.

Pin A component of a camera or printer mechanism which engages with a perforation hole to locate the film at the time of exposure.

Pitch The distance between two successive perforations along a strip of film.

Plate A picture photographed to serve as the background to separate foreground action.

Positive A photographic image in which the tones of the scene correspond to those of reality, light as light, dark as dark.

Premiere The first public presentation of a motion picture production.

Printing Copying motion picture images by photographic exposure or photomechanical methods.

Processing The chemical operation required to convert the latent image of exposed film to its final stable form.

Process shot A trick shot requiring special photography, especially the combination of separate foreground and background components.

Projector Apparatus used for the presentation of motion picture images by optical enlargement on a screen.

Pull-down The movement of film from one frame to the next in the intermittent mechanism of a camera, printer or projector.

Rack A frame carrying film in a processing machine.

Raster The lines forming the scanning pattern of a television system.

Reflex projection A process shot in which the foreground action is photographed against the background scene projected on a highly directional reflecting screen.

Reflex shutter Camera shutter with a reflecting surface used to form a viewfinder image.

Registration The accurate positioning of film or the images formed on it.

Release The general distribution of a film for public exhibition.

Reversal The processing of film to give a positive image on film exposed in the camera or to obtain a copy negative by direct printing from a negative image.

Rough-cut A preliminary stage in the editing of a film as the assembly of scenes takes shape.

Rush Print See Daily

Safety film Film coated on base of low inflammability.

Scanning The regular movement of a spot of light or electron beam producing the raster in a television system.

Scene Usually, the unit in a film story which is intended to be shot as continuous action.

Scoop A floodlight used for general illumination of a studio set.

Scrim Translucent material used to diffuse a light source.

Sensitivity The ability of a photographic emulsion to form a latent image when exposed to light.

Sensitometer An instrument used to produce standard exposures on photographic materials for processing control.

Shutter Device for interrupting the light beam in a camera or projector while the film is in motion.

Shuttle The component of some intermittent mechanisms which moves the film between periods of exposure.

Shot The unit of photographed action in motion pictures.

Skip frame An optical printing effect eliminating selected frames of the original scene to speed up the action.

Sky pan A flood lighting unit used to illuminate large backings.

Slate A board photographed at the beginning of each take to identify the production, scene and take number, etc.

Splice The join between two pieces of film.

Split Screen Trick shot in which two separate images are combined on each frame.

Spool A flanged roll on which film is wound for general handling, especially projection.

Sprocket A toothed driving wheel used to move film through various machines by engaging with the perforation holes.

Squeegee Wiper blades or rollers used to reduce carryover of liquid on the surface of film as it passes through a continuous processing machine.

Squeezed The laterally compressed image in anamorphic widescreen systems.

Stock General term for motion picture film, particularly before exposure.

Stop Frame An optical printing effect in which a single frame image is repeated to appear stationary when projected.
Also, camera exposure made one frame at a time rather than by continuous running.

Strip Part of a wide roll of manufactured film slit to its final width for motion picture use.

Stripe A narrow band of magnetic coating or developing solution applied to a length of motion picture film.

Studio The centre at which motion pictures are produced.

Subtractive Colour The formation of colours by the removal of selected portions of the white light spectrum by transparent filters or dye images.

Synchroniser Equipment used in editing to keep two or more strips of film exactly in step by passing over interlocked sprockets.

TTL "Through the lens", referring to viewfinders and exposure meters receiving light through the camera lens at the time of photography.

T-stop A measure of the actual light transmission of a lens at various diaphragm openings.

Take A photographed scene, repeated as necessary to meet the director's requirements for the action.

Take-up That part of a film machine where the film is wound up after passing through for exposure, processing or projection.

Tape A narrow unperforated strip carrying a magnetic coating used in sound recording.

Technicolor Trade name of a process for printing motion picture film by dye transfer.

Telecine Equipment for producing a television signal from motion picture film.

Telerecording The process of recording television images on photographic film.

Theatre General term for the building in which motion picture films are presented.

350

Tilt Movement of the camera in a vertical plane about a horizontal axis.

Top Hat A small fixed camera mount used for low points of view.

Track The narrow band along a length of film in which the sound is recorded.

Travelling matte A process shot in which foreground action is superimposed on a separately photographed background by optical printing.

Tripack A single film base carrying three distinct layers of photographic emulsion for colour photography and printing.

Turret A revolving lens mount carrying three or more lenses on a camera or projector.

Unsqueezed A print in which the distorted image of an anamorphic negative has been corrected for normal projection.

Variable Area Form of optical sound record in which the modulations are represented by the varying width of the image.

Variable Density Form of optical sound record in which the modulations are represented by the varying density of the image.

Videotape Magnetically coated tape used to record and reproduce television signals electronically.

Viewfinder Device used on a motion picture camera to show the exact area of the scene being photographed.

Viscous processing System of film processing in which the chemicals are applied as layers of viscous liquids.

Widescreen General term for form of film presentation in which the picture shown has an aspect ratio greater than $1 \cdot 33 : 1$.

Wild Shooting without synchronised sound recording.

Wipe Optical transition effect in which one image is replaced by another at a boundary edge moving in a selected pattern across the frame.

Xenon Lamp A high pressure gas discharge lamp used as a light source for projectors.

Zoom The effect of the camera moving rapidly towards or away from the subject.

Zoom Lens A camera lens of continuously variable focal length giving a wide range of adjustable magnification.

Index